WRITING A NEW WORLD:

Two centuries of Australian women writers

DALE SPENDER

PANDORA
London and New York

First published in paperback by Pandora Press, an imprint of the
trade division of Unwin Hyman Limited, in 1988

Unwin Hyman Limited
15–17 Broadwick Street
London W1V 1FP

Allen & Unwin Australia Pty Ltd
8 Napier Street, North Sydney, NSW 2060, Australia

Allen & Unwin New Zealand Pty Ltd with the Port Nicholson Press
60 Cambridge Terrace, Wellington, New Zealand

ISBN 0 86358 1722

British Library Cataloguing in Publication Data
Spender, Dale
Writing a new world: two centuries of
Australian women writers.
1. Australian literature—Women
authors—History and criticism
I. Title
820.9'9287 PR9608

Printed in Great Britain by
Billing & Sons Ltd, Worcester

To two Wonderful Women Writers,
Kylie Tennant and Florence James
and
to two Reliable and Resourceful Researchers,
Sue Martin and Debra Adelaide

Contents

PART THREE
Popular Prose

PART FOUR
Present Position

Acknowledgments

Without the research skills of Debra Adelaide, this book could not have been written; without some of the 'finds' of Sue Martin, it would not have been so comprehensive: to both I owe a considerable debt. To Elizabeth Webby who has been a generous source of expertise and advice, and to Isis Moses, Baiba Berzins and the staff of the Mitchell Library who, along with the staff of the London Library, have been such a co-operative source of information, I also owe many thanks.

In the absence of cigarettes to soothe and calm, I must thank my sister Lynne Spender and my friend Ted Brown for their patience and protection; without their understanding I might not have persisted with the non-smoking or the writing.

My parents, Ivy and Harry Spender have once more given their unqualified support, for which I am deeply grateful; and Renate Klein and Sally Cline have been constantly available as representative readers and sympathetic friends.

With her usual enthusiasm and efficiency, Glynis Wood has transformed my pages into clear and clean type, assisted on this occasion by my cousin, Frances McHarg, whose mammoth and model effort is much appreciated. My thanks too, to Philippa Brewster and Candida Ann Lacey at Pandora.

While researching and writing this book, I spent many hours with Florence James and Kylie Tennant, who kindly and willingly gave me the benefit of their wisdom. For their information on themselves and the traditions of Australian women writers, I give them my thanks. It has been a joy to know them and a privilege to share some of their insights; they symbolise the values of this book.

Dale Spender
May 1987

Introduction

Not even I suspected that my search for women's literary history would reveal so many Australian women writers, and so many of note. And while approximately 200 women are listed here as contributors to the cultural heritage of the country during the 200 years of white settlement, it should not be assumed that this coverage is complete: some have slipped through the far flung net, but with time their absence will be discovered and their work recovered and reassessed. Perhaps in the future there will be so many recognised women writers that there will even be a debate about which ones qualify for the top two hundred. While I have yet to be convinced of the desirability of ranking the efforts of writers, I would find discussion of this aspect of women's literary achievements preferable to those which have prevailed too often in the past. For while one factor which influenced me to undertake research on Australian women writers was simple curiosity – how many were there and what did they write? – another was a more practical and political consideration. I was tired of the general disparagement of Australian literature (in its country of origin as well as abroad) and I was tired of the particular disparagement of women writers; and I was sorely tried by the unsubstantiated and unsatisfactory explanation that the reason there were so few women writers included in the literary canon and studied in educational institutions was because so few women writers were any good. How could this be known? How could the 'experts' tell?

When I began this study there was no readily available list of Australian women writers[1] and I certainly could not presume that I had read and assessed even a representative sample of women's work. So I had no way of knowing whether the assertion of women's inadequacy had any foundation, whether indeed the contributions of women writers were good, bad or worse. But then neither did anyone else. Neither did those

who were content to assert that women had no place in literary history because women had not written much, and what little they had produced was generally without merit.

Given the contradictory assumptions about women's worth it was clear that the only sensible resolution possible was to go back and find the number of women who had written and to read their work. This I attempted to do and I soon found that my sceptical stance had been more than justified. For there have been many women writers but they have been dropped from the literary canon, and what is more, this cannot be because their work is no good or because it lacks contemporary significance. If women writers are underrepresented in the Australian literary heritage the explanation cannot be found in the contributions of the women. The basis for their exclusion has to be located somewhere else.

In the face of assertions to the contrary, I started this study with the premise that women had probably written significant works, but their efforts had been buried, and it is reassuring to report that my faith was justified. But of course my findings are not at all surprising. The nature of the research process itself affords considerable assistance. Apart from the fact that it is difficult in many disciplines to write a report (and virtually impossible to write a book) on the basis of *no* findings, there is the more fundamental issue that the study of literary history cannot be objective. All literary assessments are the products of personal preference and it would be a poor presentation of an investigation that did not take this into account.

The attempt to get round this 'personal' problem poses some difficulties in the organisation and documentation of this work. In the pages of one book it is simply not possible to adequately present and evaluate the work of 200 writers. Even if they were all in print and readers could themselves check up on the authors' worth the filter that I had used initially – intentionally or otherwise – could still prejudice any assessment of the writers' work. And of course, as the majority of women who are discussed here are not even in print, readers cannot go and judge for themselves whether my version of literary history is justified.

So what are the responsible options? Should I be guided by my own personal preferences? Should I devote space to Ethel Turner, for example, on the grounds that *I* think she is good, and then quote extensively (and selectively) from her work so that readers will be in a position to agree? And should I promote Ethel Turner at the expense of other women writers? On the grounds that I think they are not so good – and this I hasten to add is only hypothetical – should I simply mention in passing the work of 'Capel Boake' and Mona Brand?

To do this would be to impose my own personal preferences on the construction of women's literary traditions; it would be to encourage the

prominence of Ethel Turner and to discourage further study of 'Capel Boake' and Mona Brand. It would be to exclude certain women from the canon without allowing them the benefit of a fair hearing. And as one of the premises that underlies this study is that in the past women have been excluded from the literary heritage *without* being read or fairly assessed, it would seem rather remiss on my part if I were to replicate the very system that I have so consistently condemned.

So I have tried to list the women and some of their work without necessarily passing judgment or ranking them; no doubt for this, in 'lit. crit.' circles, I will be criticised. That I have not given my verdict on who is better and who is best could be seen as a failure to fulfil the basic requirements of literary criticism; for my part I think that the preoccupation with hierarchies is a failure of the 'discipline'.

What I have done throughout this study is to indicate which books I have read (and which I have not) and the extent to which I found them informative, enjoyable, entertaining. I have tried to introduce each author in a positive way in the hope that she will spark interest and further study, rather than pre-empt it. For there is still an enormous amount of work to be done on these women and their writing.

And because so many of the women are out of print I have tried to include as many examples of their work as possible. In this way readers may be influenced by, but they are not totally dependent upon, my subjective judgments.

But even the use of extracts has presented something of a problem. Not *all* the writers can be quoted at length, so once more exclusionary and 'gatekeeping' practices are employed. The extracts selected are mainly those of the nineteenth century and of the women who are out of print, on the grounds that the further back the study goes the more difficult it is to obtain samples of the work.[2] The closer they are to the present time the more cursory the treatment of the writers and more minimal the quotes from their work. Of course this means that the survey is not chronologically even; there is a great deal of information, for example, on the early settler, Elizabeth Macarthur, but little on the more recent and internationally established writer, Christina Stead. For as it is not possible to allocate the necessary space to assess the work of all women, I have often elected to cover the unknown at the expense of the well known. Because I believe that Elizabeth Macarthur deserves to be rescued from the relative oblivion to which she has been consigned – and that she should be placed firmly as one of the founding mothers of Australian women's literary traditions – I have emphasised her contribution and reduced that of women of reputation (and availability) accordingly.

In placing alongside the few women writers of note, those whose work has for so long gone unrecognised, I have been able to roughly map the

'submerged' heritage and to identify the underlying continuum which characterises the traditions of women's writing. When the majority of women are presented chronologically it is possible to form an overview, to see some of the connections that can be made between the women and their writing, and to trace the styles and patterns that flow through their work.

Within the Australian context, literary studies of individual women have been undertaken, sometimes by established women writers themselves who have wanted to present the contribution of their peers. Nettie Palmer, for example, wrote a study of Henry Handel Richardson; Henrietta Drake-Brockman about Katharine Susannah Prichard; and Marjorie Barnard about Miles Franklin. While each such study affords valuable insights (and all are made use of here) it is also evident that the individual approach has its limitations. Concentrating as they do on one woman, such studies can divorce her from her context, artificially sever her from her connections, and present a false image of the writer as solitary and the work as an isolated achievement. This is why an overview is useful along with the more detailed studies, for it can help to show the relationship between writers. For instance, it can document the personal and literary features which link the lives and the writing of Nettie Palmer, Henrietta Drake-Brockman, Katharine Susannah Prichard, Marjorie Barnard and Miles Franklin. For these women were all part of a 'literary community' and in order to understand the nature and significance of women's literary traditions it is necessary to know about the interrelationships and the antecedents, as well as the individual detail.

The task of locating the origins of women's literary heritage and of tracing the development through to the present day is one that can give great delight. For within women's literary records is a history of women's existence in Australia; in the absence of an encoded history of women's experience in the early years of colonisation, women's 'world of letters' provides an alternative and rich resource of information. Women's thoughts and feelings find expression in a literature which stands as a repository for women's consciousness and a record of their endurance in the strange land. So the letters of Elizabeth Macarthur and Rachel Henning, for example, tell a story of settlement, create heroines of stature who experience a series of adventures which could readily and reassuringly be recounted 'back home'; but at the same time these letters plot personal struggles with independence and identity. Miles Franklin begins *My Brilliant Career* at the point at which Elizabeth Macarthur and Rachel Henning leave off: when the work of all is brought together it is the history of women's emotional life which emerges along with the traditions of women's writing in Australia.

Once the patterns of women's writing begin to appear it is obvious that women have been motivated by very different concerns and have

produced a very different view of the world from that encoded by men. While there are some common themes, the extent to which women have created 'a literature of their own' is demonstrable and impressive. First and foremost in their work is the fact that women must take account of men in a way that men do not take account of themselves; on this foundation stone a very different framework is built. For women's literature takes women as its starting point and the world is mediated through women's eyes, as individuals, or as members of their sex.

Because the audience of the early letter writers – and fiction writers – was thousands of miles away (and worlds apart!) much of Australian women's literature was necessarily explanatory. Because many of the old rules did not apply in the new world, much of Australian women's literature was necessarily exploratory; in account after account the heroine juggles the contradictory demands of her life and tries to find some way through to sense and security. Because for those who went willingly or unwillingly to Australia (and for those who were already there) so much was 'unknown', much of women's literature is necessarily speculative; in letters, poems, novels, plays, essays and articles, women used their writing to test out the range of possibilities, to ask what would happen if . . .?

Because these women writers were so often aware of the existence of two worlds, their writing is frequently philosophical, encompassing more than one reality. Because so many of them were cut off from their roots, separated from loved ones and the relationships which sustained them, they invariably questioned who they were and what they were doing in a strange land; which is why much of women's literature embodies a search for individual and communal identity.

Australia has a distinct and distinguished women's literary tradition; it is one which deserves to be better appreciated in its country of origin and better known abroad. For while the origins of this tradition are uniquely Australian, the concerns expressed are common to women's cultural heritage throughout the English-speaking world. Since the novel was invented, for example, women have used it to explain and explore the dimensions of women's role and to educate and inform the members of their sex; so while the Australian heroine may ask her questions in the unusual setting of the 'outback', she raises much the same issues about the place of love, motherhood and marriage, and the necessity of independence, relationships, art and work, as her British and North American counterparts. Because she brings a new perspective to these old themes the Australian woman writer has a refreshing contribution to make to international literature.

The persistent preoccupations of Australian women writers soon become apparent once their work is brought together and treated as an entity in its own right. From the first letters which left the colony it is

clear that white women were concerned about the plight of the Aborigines and often identified strongly with black women; they could see them as sisters in subordination – and labour – and they portrayed them with sensitivity and empathy. It was not confrontational literature, but rather a realm in which the human connections between black and white were evocatively made. It is no coincidence that the majority of Australian women writers have written powerfully and poetically about black women, about a common colonisation and oppression.

Nor is it any coincidence that women have more often than not chosen the novel as the form for conveying their meanings. If primacy is given to the novel in the following survey of women's writing it is because I believe that the novel has been the primary genre for women. The novel has allowed women to explore the dimensions of their world; it has allowed them to construct and question their own reality – free from the interference of men. The novel has linked women writers and women readers; it has been part of the network of women's communications and reflects women's priorities and values. In the Australian context many a young woman has been prepared for the world by novel knowledge and education; this affords women a very different literal and literary experience from that of men.

And this is the last but by no means the least justification for the construction of women's literary history. Again and again, the explanation that can be found in the archives for the disappearance of women from the literary records is that their concerns, their views and values, were *not* those of men. It was men who early took charge of the Australian world of letters; it was they who became the gatekeepers in universities and publishing houses and on literary pages; it was (and is) mainly men who have controlled the entry of contributions to the cultural heritage. And they have ordinarily elected to praise, preserve and transmit to the next generation, the achievements of men.

While this practice is in itself neither ethical nor equitable, it is not the major cause of my complaint. For me the crux of the issue is that the literary heritage which has been selected is unbalanced, unfortunate and unfair. With its preponderance of men and male values, with its view of the world from the position of those who have power over half of humanity, it reflects a distorted reality. It presents an unchallenged, uncorrected and in the end unaccountable perspective which is partial but is presumed to be the whole. And unless and until women's *different* view of the world is included in the literary canon, unless and until there is the representation of power from those who are on the receiving end, it is not possible to speak of a balanced, *inclusive*, fully human heritage.

The proof of the pudding is in the eating. When women's contribution is included, the extent to which the perspective shifts is immediately evident. If the images of Australia and its inhabitants were to be based

upon the views and values of its writing women rather than its men, then the images would be substantially and significantly different. In their own time and on their own terms Australian women writers have been disproportionately successful; the time has come to reclaim them, to reinstate them and to recognise the contribution they can make to present enjoyment and understandings. Women have a right to equal representation; Australian women writers deserve nothing less.

PART ONE

Personal Epistles

Annabella Boswell 1826–1916
Eliza Brown 1811–96
Margaret Catchpole 1762–1819
Eliza Hamilton Dunlop n.d.
Rachel Henning 1826–1914
Anna Josepha King n.d.
Elizabeth Macarthur
 1769–1850

Georgiana McCrae 1804–90
Ellen Moger n.d.
Mary Reiby 1777–1855
Susan Dowling Spencer n.d.
Mary Talbot n.d.
Ellen Viveash n.d.
Eliza Walsh n.d.

CHAPTER 1

•

Private and public sources

Letters are the starting point of literary traditions and because women have been writing letters since women first learnt to write, women's literary heritage can be traced back through the centuries. And for women, this tradition of letters contains a doubly rich resource, for not only does it provide a history of literature, it also provides a history of women. In the collective letters of women we can find not only the early forms of later literary genres – such as the epistolary novel – but also some of the daily detail of women's lives which allows us to piece together the patterns of women's heritage.

While through the centuries many letters have been written by many different women – for many different reasons – most commentators, including Virginia Woolf,[3] cite Margaret Cavendish, the Duchess of Newcastle (1624–74), and her letters as the beginning of the modern literary tradition of women. It is not at all surprising that Margaret Cavendish should be accorded the status of the one who started it all, for she was among the first (if not the first) to unashamedly declare that she was a woman and a writer, and would be taken seriously. At a time when women's reputations were ruined if they attracted attention to themselves, Margaret Cavendish courageously defied convention when she chose to 'go public' and insisted on being treated as a professional and public writer. And as she used the letter as a vehicle for her public and political pronouncements, her epistles were not always personal letters to friends but more often were directed towards a public audience – and aided by the services of a printer.

The reason why Margaret Cavendish used the letter form is a simple one: there were few other genres available to her. With no magazines, newspapers, periodicals or 'advice' manuals like we have today – with no short stories or novels in which to couch her meanings[4] – Margaret

Cavendish had little choice but to use the letter, and she used it creatively and constructively for a range of purposes. In letter form she published everything, from social advice (*Sociable Letters*, 1664) to philosophical concerns (*Philosophical Letters*, 1664) and scientific explanations (*Observations upon Experimental Philosophy*, 1666) and she used the letter to launch her exploration into new literary territory. It is because her writing is so innovative and varied, because it extends across the genres of autobiography and biography to science fiction (*The Description of a New Blazing World*, 1666) that Margaret Cavendish has been called an originator of women's literary traditions (see Virginia Woolf, 1974).

Of course not all women – not even all women writers – followed in Margaret Cavendish's pioneering and public path. Historically, considerable pressure has been placed upon women to refrain from publishing (see particularly Joanna Russ, 1984) and this has helped to create a dual tradition in women's world of letters: within women's literary heritage there is both a 'public' and a 'private' strand. Even as Margaret Cavendish used the letter to forge a variety of new literary forms her contemporary, Dorothy Osborne, deplored such presumptuous behaviour and practised the more personal and private art of writing letters to her lover. And women's literary heritage encompasses both women – and their very different forms of writing.

In uncovering women's literary antecedents, Virginia Woolf returned to Margaret Cavendish and Dorothy Osborne and the public and private nature of women's writing: in *A Room of One's Own* (1928/1974) she notes that women who have entered the public literary sphere have often received little encouragement and a great deal of abuse, and that this is an integral part of women's traditions. The brave and brilliant efforts of the Duchess of Newcastle caused her to be labelled 'Mad Madge', and she was mocked even by women who stood to gain from her work – among them Dorothy Osborne, who declared of the Duchess in her letter to her lover William Temple, 'Sure the poor woman is a little distracted, she could never be so ridiculous else as to venture at writing books and in verse too, if I could not sleep this fortnight, I should never come to that' (quoted in Virginia Woolf, 1974, p. 63: modernised spelling).

Because it was considered unseemly and unsafe to 'go public', Dorothy Osborne's writing remained well within the confines of women's private world: like so many women before her and after her, she kept out of the public literary arena and restricted herself to writing the letters which nurtured and sustained relationships. Yet this private strand of writing is as much a part of women's world of letters as those epistles which were written with the aim of publication.

While it is helpful to note that women are the fortunate inheritors of a dual tradition, it would be unwise to make too much of the distinction

between the public and the private, partly because letters which may once have been intended solely for a private audience can later cross categories and go public. This is what happened to Dorothy Osborne's efforts: we do not know whether she would have given permission for the publication of her private papers – or what her reaction to such an event would have been – but when we now read her correspondence we should note that we are in the paradoxical position of dealing with a public account of her personal world.

However, it is this interweaving of the public and the private which has helped to add an extra dimension to women's written heritage: through it we are afforded glimpses of women's literary development and women's historical development. From this blend of the personal and the political we can gain insights into the way women lived, the way they thought about themselves and their society, and the way they forged new literary forms to express their consciousness.

CHAPTER 2

Transportation and communication

Personal chronicles (such as letters, diaries, journals, autobiographies, memoirs), whether published or not, mark the beginnings of women's literary endeavours in England in the seventeenth century: and personal chronicles also mark the beginning of white women's literary traditions in Australia in the eighteenth century. Women wrote letters from the time the First Fleet set sail from Portsmouth in May 1788, and to begin with the art of letter writing varied little between the old country and the new. But the further women moved away from the British experience and the role played by the letter within that tradition, the further Australian women moved towards creating a distinctly different world of letters of their own. Such a development is of course to be expected: women who went to the new world used letters in a new way. For the women who embarked upon the journey into the unknown, who were forced to take account of new realms of experience and who were engaged in a struggle for emotional and physical survival, letters played a very different role in their lives. For the women who had uprooted themselves from their families and all that was friendly and familiar, letters were a link with the past – with what they had known and what they had been; but letters were also a bridge to the future – a means of conceptualising and comprehending the strange and the new and of conveying the experience to a distant audience. This is not to suggest that the twenty-eight 'wives' of officials and 192 convict women who landed on the Australian shore in 1788[5] deliberately determined to write letters as one way of solving their difficulties: even had they felt the inclination most of them assuredly lacked the means. But because they were isolated and wanted the opportunity to order and reflect upon their unprecedented ordeal – and because there were many items 'back home' which they desperately needed – the

early women settlers felt an enormous pressure to write letters and other forms of personal chronicles.

On the historical voyage from Portsmouth to Botany Bay, 'None of the women kept a journal that has yet been discovered' (Eve Pownall, 1980, p. 37), although some of the officers of the First Fleet kept diaries and travel accounts.[6] So while we do have some records of the effects of the trip on women passengers, none of them was written by the women themselves. Presumably letters were written – at least by some of the twenty-eight 'wives' – but none seem to have survived. But when Mary Talbot reluctantly set sail for Australia in 1791 she provided one of the earliest first-hand accounts of women's experience of the difficult and dangerous voyage. At a time when not all news was made by journalists – when a 'Letter to the Editor' could be a means of conveying information as a foreign correspondent[7] – Mary Talbot had her account of the voyage published in *The Dublin Chronicle* (1 November 1791). Her husband had been injured at work and could no longer support the family so Mary Talbot had stolen food – and she had been caught, convicted and condemned to transportation. En route to Australia she wrote to her patron and her letter was published as 'foreign news':

St. Jago, 29th March, 1791
... We sailed from Portsmouth the 23rd February, with the wind much against us, and were so much in danger that we feared we should have shared the fate of a ship which was lost within sight of us. ... On the 25th and 26th along the coast, we had a violent storm, which lasted twenty-four hours. During every moment of its continuance we expected to perish, and were washed out of our beds between decks, while the sea-sickness and the groans and shrieks of so many unhappy wretches made the situation we were in truly distressing for there were 138 women and five children, two of the latter born after we sailed, and only one died on our passage hither, where we remain no longer than is necessary to repair the ship and take in water. Our captain hopes we shall arrive at Botany Bay in August, if it please God the weather should prove favourable. . . . I have been greatly distressed by want of money, because I came away without being able to see my husband.

If, sir, you have any success in your application for my pardon, you can send it me by any of the captains coming out to Botany Bay, which, I am sure, your goodness will endeavour to do for the sake of my motherless children. ... Pray, sir, be good enough to let my husband know you have had a letter from me, and beg him to take care of my dear children. I think it hard I did not see him before I sailed for we laid a week at Gravesend, and I should have

left my country less sorrowfully had I given him my last charges
and bade him farewell . . .

I hope you will excuse my being so troublesome to you. I sent you
two letters from Gravesend . . . but as the man never came I hope
you did not send anything . . .

(Source: Historical Records of New South Wales, Vol. 2, Appendix
 E: B. M. Papers, pp. 779–80, reprinted from *The Dublin Chronicle*,
 1 November 1791: quoted in Helen Heney, 1985, pp. 6–7)

In some ways Mary Talbot's experience was typical of many women
who left Australia in the early years: she had such a sad tale to tell and
so much was against her. In writing her letter she could not even rely
upon the availability of materials or the reliability of the post. Pens and
paper were scarce, so much so that it was common practice after
completing a page to turn it at right-angles and to write across and over
the original script, thus using the same page twice. And, of course, there
was no postal system: letters had to be entrusted to friends, fellow
travellers and co-operative captains. When ships sank, letters – and
sometimes high hopes – went down with them, and, even if the ships
were to get through, the many months could stretch to years before the
letter writer could reasonably expect a reply.[8] Yet such faith was placed
in such fragile links.

Mary Talbot's emotional epistle does more than alert us to the vulner-
ability of her situation and the bleakness of her plight. It is often assumed
that the women of the past who helped to form the literary framework
were necessarily educated, leisured, and of the middle class: one thing
that Mary Talbot makes clear is that among the *convict* women there
were those who possessed the skill and obtained the means to write –
and who were therefore in a position to make a contribution to the
Australian literary heritage. While it is perfectly possible that the
published letter of Mary Talbot had been polished and edited, the fact
that she could write, that she could convey a compelling impression of
her circumstances – and that her letter can now be quoted as part of the
literary tradition – cannot be disputed. One could only wish that her
evocative and eventful accounts could have continued to be published in
The Dublin Chronicle as news from abroad, but no more of her letters
have come to light. No doubt the explanation for their absence is to be
found in the Sydney Cove burial records for 1792, which 'included a
Mary Talbot (not a very common name) making her another humble
victim of the general brutality of her time' (Helen Heney, 1985, p. 6).

CHAPTER 3

New ways in the new world

That the times were brutal and that many were brutalised is the evidence offered by most convict women who put pen to paper. But in some cases, more remarkable than their achievement in finding the means and the time in which to write, is their ability to survive. If it were not the pinching conditions of their penal servitude, the privations of the passage, or the punitive ('pleasure-seeking') practices of their overseers, there was still flood, fire, drought, starvation and disease with which to contend. The terrible conditions in which many women lived in the early years helped to set the pattern for what they wrote – and why they wrote it. They began to develop a literature which was rooted in the realities of their new world, and although the seeds of their literary tradition were planted in hard ground, they have done much more than survive: they have adapted, and flourished.

Margaret Catchpole was one convict woman whose life and letters reflect this growth and change. Writing at a later date than Mary Talbot, and providing a more continuous account of her experience, her letters home show the shift from early desperate struggle to later security and hardy independence. Taught to read and write by her mistress, Mrs Cobbold (for whom she was housekeeper), Margaret Catchpole's trials began when she was dismissed for refusing to abandon her criminal lover. It was for him that she stole a horse and was captured, convicted and condemned to death: she was then reprieved and sentenced to transportation. While clearly a colourful character and a wilful woman, Margaret Catchpole none the less felt at first despondent and depressed; her early letters are records of her many regrets. She laments her losses of home, family and friends, and the wherewithall to support a decent life. Like so many letters from the Colony at the time, her epistles contain inventories of the prohibitive prices in New South Wales. The following

example, taken from her correspondence which spans the period 1801–11, comes from a letter to her patron, Dr Stebbing:

Sir,
 I will write more about the country when I write again. Tea is 29s. to 20 and 15 shilling, sugar 2 shillings to 18 and 15 pence per pound, salt beef 1 shilling per pound, mutton 2 ss. per pound; fifteen shillings for a pair of shoes, 10d. for a pair of stockings, five shillings for a yard of common print, 3d. for a yard of calico, 3 shillings for a pound of soap, six pence per pound for onions, 2 pence per (pound) for potatoes, sixpence for a cabbage, five shillings for a quart bottle of rum, 2 shillings for a quart of porter, 1 and 3 pence per pound for salt pork. Fish is as cheap as anything we can buy, but we have no money to trade with here.

(Source, A 1508, Mitchell Library: quoted in Helen Heney, 1985, pp. 24–5).

Given these exorbitant prices it would not have been surprising to find that Margaret Catchpole – and most other women – were neither adequately dressed nor well fed. And in a country where money was 'unavailable' and where the only reliable (albeit irregular) source of food was home-grown, it was nothing short of sensible for women to seek to have their own plot of land. Not that this solved all their problems: apart from the vagaries of the climate they often had to deal with the reaction of the displaced Aborigines.

Accounts of Aborigines and their culture – couched in varying tones of compassion – are frequently to be found among women's letters home: Unfortunately Margaret Catchpole's version is not uncommon:[9]

Sir, I pray, give my best respects to all my old fellow prisoners and tell them never to (?be) down hearted at the thought of coming to Botany Bay, for it is likely you may never see it is not inhabited only by the blacks, the natives of this place, they are very saucy for they always carry with them spears and tommyhawks so when they can meet with a white man they will rob them and spear them. I for my part, I do not like them, and I do not know how to look at them, they are such poor naked creatures. They behave themselves well enough when they come into our house for if not we would get them punished. They very often have a grand fight with themselves, 20 and 30 altogether, and we may be sure some of them are killed. There is nothing said to them for killing one another.

(Source, A 1508, Mitchell Library; quoted in Helen Heney, 1985, p. 24)

Margaret Catchpole, however, survived: she escaped the hangman and survived the voyage to Botany Bay. She came through the difficulties and the despair of the early days and, despite her convict status, she went on to acquire her own land and to lead an independent life. Although she seems not to have placed her faith in a man again after the ordeal with her lover, in 1811 she wrote to her uncle, William Howes, and contentedly described her lot:

2.9.1811

I am not (married) and almost fifty years old nor do I intend. I hope to see home once more and to see dear cousin Charles weigh me a pound of tea for me and that fine young man Samuel to make me a pair of shoes and poor Lucy to thread my needle, for my eyes are not as good as they were, but thank God I can do as well as I do. I rent a little farm of about fifteen acres, but half of it standing timber and the cleared ground I hire men to put in my corn and I work a great deal myself. I have got thirty sheep and forty goats, thirty pigs and two dogs, they take care of me for I live all alone, not one in the house. There is a house within twenty roods of me. I have a good many friends that I go to see when I think proper, such as I have nursed when they lay in cannot do without me, I am looked upon very well thank God. I hope to get a few pounds to come home with.

(Source: Margaret Catchpole; letters to relatives, typescript copies ((A3D59)) Mitchell Library: quoted in Helen Heney, 1985, p. 48)

In 1814 Margaret Catchpole was granted a pardon, yet she did not return home. It is unlikely that it was the cost of the fare which prevented her, for while in general the trip back was made more difficult for women than men (men had the option of 'working' their passage and women did not), Margaret Catchpole would have had ample means to pay her own way. Rather, she elected to reman in her new country where she had made her life and found a sense of satisfaction and self-esteem.

Margaret Catchpole was by no means the only convict woman who made the most of her circumstances and who as a result of luck and good management – and a great deal of hard work – ironically went on to carve out for herself a better life than the one she had left behind. Mary Reiby's[10] rise from convicted horse thief to the rank of rich and respectable matron (who returned to England in triumph to the place she had left in disgrace, see Eve Pownall, 1980, pp. 44–5) is an illuminating example of the way in which the established social order was cast aside in the new land: in this lack of respect for the old rules there are implications for women's literature as well as for women's lives.

Unusual circumstances produced unusual women, and while some who started their Australian lives as poor convicts changed their status by way of becoming wealthy wives, other women achieved success by adopting a more independent stance:

> Wooloomooloo
> 19th January, 1821

Sir,
 I do myself the Honor to acquaint you that in consequence of being informed that His Excellency the Governor has been in the habit of granting land to Females, and having already some stock by me, and the means of purchasing more, I was induced to request He would be pleased to grant me a portion of land which would enable me to proceed on a larger scale than at present with my view of cultivating and rearing stock, which would not only tend to my own benefit ultimately but must be of considerable advantage to the Colony. I enclose to you a copy of my letter to him, with his answer, and I leave it to yourself sir to take any means in this affair which may appear to you, to be grounded in justice.
 It is however incumbent upon me to state that the Governor lately granted land to Mrs. Ward, Mrs. Gore and to Mrs. Allen, wife of the Deputy Commissary General who was here previous to my landing in the Colony and it does not appear altogether a just measure to exclude ladies from making use of their money for the benefit of the Colony in consequence of their sex, nor can it be deemed a real objection that a Lady should not be able to conduct a Farm as well as a Gentleman.

> I remain, sir,
> (signed) Eliza Walsh

(Source: *Historical Records of Australia*, 1,12, pp. 348–55: quoted in Helen Heney, 1985, p. 68)

Thirty-five years before Barbara Bodichon published her pamphlet on *Women and Work*[11] in England, insisting that women should be allowed the same work opportunities as men, Eliza Walsh was presenting much the same argument to the authorities in Australia. And she was not the only woman to be running her own successful farm: there were many more who were widowed or who – like Elizabeth Macarthur, for example – were solely responsible for managing huge properties while their husbands had extended stays abroad. If these women farmers (often of humble origin or with criminal pasts) have British counterparts, they are among the ruling classes where aristocratic women sometimes took charge of estates when their lords went off to war. From the earliest

days Australian women challenged – and overturned – the established order as they sought new ways to deal with their new world. In their writing they explored some of the possibilities of their new experiences – but their writing also became an expression of their new identity. Even the early letters show how far women had travelled from the conventions of 'home'.

CHAPTER 4

Reflection and remorse

Not all women – whether they were convict or free – found satisfaction or success in Australia. For all those who were tempered and toughened by some of the terrible trials the territory inflicted, there were those who were drained and depleted by their ordeals. The stark facts are that many women were beaten and broken, that many were ruined and raped: while women were killed by the ravages of the climate, by the spears of the Aborigines, by accident, disease and poor diet. It is heart-rending to read the letters and journals which record such cruel fates, but even more moving are the many accounts where the writer reports not only on her own physical privations but on the greater pain of being forced to see her children suffer. This raw experience is the context in which many Australian women were raised and their literary traditions born.

In 1839 Ellen Moger voluntarily sailed for Adelaide: three of her four children died of starvation on the way. It was seven weeks after her arrival before she could bring herself to take up her pen and inform her parents of the dreadful events: so distressing was the task that at times she found it almost impossible to continue: '. . . whilst I write, many thoughts of scenes and past trials enter my mind and frequently I feel as though I must throw away my pen' (quoted in Lucy Frost, 1984, p. 36).

But Ellen Moger forced herself to face the grim realities of her life and in so doing she bequeathed to later generations a valuable historical and literary legacy.

Adelaide, Gouger Street,
28th January, 1840.

My dear Parents,
 I have very melancholy accounts to give, which I cannot do without

great excitement to my feelings. We landed at Holdfast Bay, about 7 miles from Adelaide ... on 10th December, 1839, having been just four months to a day on the Great Deep. We had a safe, and many would say, a delightful voyage: but as regards myself, for the first five weeks I was scarcely able to move my head from my pillow with Sea-sickness, which brought me so low that I could render but very little assistance to the dear children, as I was obliged to be helped on deck by two persons, Edward and another Edward and the children suffered but little from sickness. But as we entered on a warmer climate, the dear children became relaxed (with the exception of Emily) gradually getting weaker and, for want of proper nourishment, became at last sorrowful spectacles to behold. They could eat none of the ship's provisions and our vessel was not like many that are sent out, provided with one or more cows for the accommodation of the sick: and, had I the voyage to take again, I would make that a first consideration as I firmly believe that the dear children would have lived, and much sickness been spared, had we experienced proper attention from our Doctor and been provided with a little natural nourishment.

Poor little Alfred was the first that died on the 30th Oct. and on 5th of Nov., dear Fanny went and three days after, on the 11th the dear babe was taken from me. I scarcely know how I sustained the shock, though I was certain that they could not recover, yet when poor Fanny went it over-powered me and from the weakness of my frame, reduced me to such a low nervous state that, for many weeks, I was not expected to survive. It seems I gave much trouble but knew nothing about it and, though I was quite conscious that the dear baby and Fanny were thrown overboard, I would still persist that the water could not retain them and that they were with me in the berth. . . .

(Quoted in Lucy Frost, 1984, p. 34)

Ellen Moger goes on to describe in greater detail the nature of the 'sea consumption' that took her children and which she fervently believed could readily have been prevented had better nourishment been available. In her highly charged account she is moved not just by the waste of those whom she has lost, but by fear for the one who remains. Emily, the only surviving and now more precious child, still suffers: 'Her health is not as good as formerly, having something Scurvy, the effects of Salt diet. She is also troubled with weak eyes, a complaint exceedingly common in this town, from the great degree of heat, light and dust.' (Lucy Frost, p. 35.)

One question which Ellen Moger asks is how health is to be restored

in such a harsh country which – she states quite flatly – she does not like. In setting sail for Australia she feels that she (and so many others) were miserably misled. It is not beauty, riches, or comforts that she has encountered:

> Bugs and fleas we have by the thousands everywhere. Some nights
> I can get no rest from them. When we first came I was in that
> horrid place, the Square, and caught from 100 to 200 of a night and
> still they were swarming. Ants and mosquitoes are also very
> tiresome, these are a few of the comforts of 'Australia'

(Lucy Frost, 1984, p. 37)

Whether Emily or Ellen Moger survived is not known. Nor is it known in this instance whether the mother found a means of dealing with her despair when she committed her pain to paper: in the 'circling' of her sorrow, in her melding of the horrific and the homely she does show, however, the way in which she is trying to come to terms with the tragedy. And what is known, is that this attempt places her firmly within women's literary traditions. For centuries – and across cultures – women have turned to personal chronicles as a way of recording their anguish and of making their suffering more bearable (see Estelle Jelinek, 1986). For so many women, the ability to express their grief and sorrow in letters and diaries has been both healing and cathartic. And in the early years of colonial Australia, when adversity and affliction were often the constant companions, it is understandable that women should have sought solace in such personal and unburdening chronicles. On occasion, pen and paper were the *only* companions a woman might have. In Australia, separated from other women by physical distance or social constraint, the letter or diary could become much more than a mere source of documentation: it could be a 'conversation' that helped to keep the lonely writer sane.

CHAPTER 5

•

Authoritative woman

Of course, not all letters and journals were used for therapeutic purposes: some of the early chronicles were thoughtful, thought-provoking – and valuable – historical records of the first years. And that such central and colourful chronicles have often not been collected and collated is indicative of the extent to which this heritage has been neglected: in these scattered and unclassified sources lies part of the literary tradition of Australian women – which has yet to be charted.

In contrast, the seventeenth-century record kept by Samuel Pepys of the great (and small) events of his time, has been accorded the status of authoritative British History. His description of the Restoration of the King – of the Great Plague and the Great Fire – have become the definitive documents of the age: his accounts of the way of life, of clothes, housing, food, drink, and physic, of everything from the position of women to the role of the theatre, have been made readily available and not only provide a wealth of fascinating historical detail but make very interesting reading. Yet comparable accounts from women on the early history of the colony have been overlooked and ignored.[12]

Elizabeth Macarthur (1766–1850), for example, wrote countless chronicles which in the Australian context are of no less historical significance or literary interest, but her writing has not been given the prominence, prestige or praise which it plainly deserves. Her continuous, colourful and circumspect account of Colony life from 1789 to 1849[13] is a history of white settlement in Australia and there is no reason why it should not be authoritative. That in many instances it offers a different view – and constructs a very different history from that enshrined in the official records – is simply one more reason why such an account should be in print and accepted as an integral part of the culture's traditions.

Born in Bridgerule, Devon, on 14 August 1766, Elizabeth Neale was

married to John Macarthur in 1788 by a family friend, the Reverend John Kingdon. In 1789 her husband transferred to the New South Wales Corps and the couple, with their baby son Edward, set sail from England with the Second Fleet, landing at Port Jackson in June 1790. The voyage was difficult, but the destination afforded little relief: to put it mildly, Elizabeth Macarthur suffered culture shock when she encountered the poor and primitive Australian conditions in which she was expected to live. But if she ever had feelings of desolation or desperation they do not surface in her journal or letters. In the steady stream of informative and affectionate epistles she sent to her mother and her friend Brigid Kingdon, Elizabeth Macarthur gave a detailed account of settlement life and of her own ingenuity and resourcefulness in adapting to it.

As she explained in a letter to Brigid Kingdon on 7 March 1791, after having dealt with the practical demands of existence, there were but two pressing problems that remained: one was the want of a woman companion and the other the want of an occupation. Although, as she said, it was not within her power to 'produce' a friend, it was well within her power to use her time to extend her education. With this is mind she had started by trying to learn something about the stars from the astronomer, Mr Dawes, but this step had soon proved to be a mistake. Yet as she still had need of a constructive occupation, her scientific study had not been entirely abandoned:

> These considerations made me still anxious to learn some easy
> Science to fill up the vacuum of many a solitary day and at length
> under the auspices of Mr. Dawes I have made small progress in
> Botany. No country can exhibit a more copious field for Botanical
> knowledge than this. I am arrived so far, as to be able to class and
> order all common plants. I have found great pleasure in my study;
> every walk furnished me with subjects to put into practice, that
> Theory I had before gained by reading. But alas, my botanical
> pursuits were most unwelcomely interrupted by Mr. Macarthur's
> being attacked by a severe illness. In December he got better and
> in January we were removed into a more convenient House.

(Source: *The Journal and Letters of Elizabeth Macarthur* 1789–1798, introduced and transcribed by Joy N. Hughes, 1984, p. 24: punctuation modified)

This frankness and lack of fear (what would she have done had her husband died?) is characteristic of Elizabeth Macarthur and her writing: her open and unaffected style simply serves to highlight some of the incongruities of colonial life. As the white settlers tried to establish themselves in the strange and unknown land the old constantly jostled

with the new, and in the midst of describing some of the hardships of
existence – the harshness of the climate and the unfamiliar flora and
fauna that she had found – Elizabeth Macarthur artlessly announces to
her friend: 'I shall now tell you of another resource I had to fill up some
of my vacant hours: our New House is ornamented with a piano-forte
of Mr. Wogan's. He kindly means to leave it with me, and now under
his direction I have begun a new study.' (Elizabeth Macarthur to her
friend Brigid Kingdon, 7 March 1791: in Elizabeth Macarthur, 1984,
p. 24.)

Elizabeth Macarthur's lively letters were long – they read more like
monologues (or short stories) than the letters we are accustomed to today
– and this is not at all surprising: they were written under very different
circumstances and reflect very different needs. As a year or more could
pass from the time letters were written until the time a reply could be
received, very little information was *exchanged*: questions and answers
which are more characteristic of contemporary correspondence assume
a comparatively swift – and sure – post. But when letters could well have
been the only links between families, and such links made but once a
year, the aim was usually to give as full an account of life as possible –
but often only after having explained the arrangements for getting the
letter through. En route to Australia, Elizabeth Macarthur wrote to her
mother from the Cape of Good Hope in 1790 and set out her plans for
the post:

If it please the Almighty that we arrive in safety at Port Jackson, I
shall write you a long letter by Captain Marshall, but that letter you
must not expect till next June, as the Ship is under a Charter to
bring tea home from China for the East India Company. She
therefore will from Port Jackson go on to China, and from thence
return to England which makes the Home Passage very long.
Whether I may meet with a vessel that returns by the nearest way
from Port Jackson to England is very uncertain. Indeed, I believe
it very improbable and therefore you must not expect it. I hope you
will receive this in four months from the date, by which time, and
long before I trust, we shall be comfortably settled in our New World.
If we have a good passage from hence, we hope to be at Port
Jackson in seven or eight weeks from this time. You may be sure
that I shall write to you by every ship that returns, and I pray that
you will punctually write to me.

(Source: Elizabeth Macarthur to her mother, Mrs. Leach, Cape of
Good Hope, 20 April 1790: in Elizabeth Macarthur, 1984, p. 19)

All sorts of plans – and contingency plans – were made in the attempt

to ensure that the letters would get through; but always there was the understanding that there were no guarantees. The sense of isolation and vulnerability of women in Australia was reinforced when they simply did not know if their letters were on – or at the bottom of – the high seas. To Brigid Kingdon, Elizabeth Macarthur wrote with relief in 1791:

> At length we have a prospect of communication once more with our friends by letter. The Gorgon, so long wished for and so long expected, is not yet arrived and by her unaccountable delay, has involved us all in the most mysterious uncertainty, and clouded our minds with gloomy apprehensions for her safety. I hope you will have received my letter dated August, 1790 which I sent by the Scarborough transport, by way of China. I wrote to my mother by the same ship: and a second letter to her dated a few weeks after the first I sent by the Neptune who sailed I think, sometime in August. By those letters I think you will be informed of every material circumstance relative to our voyage and of what happened to us after our arrival till the ship sailed.

> (Source: Elizabeth Macarthur to her friend Brigid Kingdon, 7 March 1791: in Elizabeth Macarthur, 1984, p. 20).

It was a *story* that Elizabeth Macarthur was writing for her family and friends – an adventure story set in a faraway and foreign place and in which she was a star. And if there are any specific origins of the 'Australian Yarn', then some of them must be found in these sagas of colonial life which women wrote for eager audiences back home. Realising the British audience would have trouble visualising such an unfamiliar way of life, letter writers like Elizabeth Macarthur paid great attention to local detail, and it is this which helps to provide not just the interest of the narrative, but the authenticity of the historical record. No work of fiction could offer more than Elizabeth Macarthur does in her letter which recounts the facts of the 'Bennelong incident'. Why this story is not at the centre of Australian literary traditions and why it is not the version of history which is transmitted to the young is – sometimes – beyond comprehension:

> (I do not) think there is any probability of my seeing much of the Inland country, untill it is cleared, as beyond a certain distance around the Colony, there is nothing but Native paths, very narrow and very incommodious. The Natives are certainly not a very Gallant set of people, who take pleasure in escorting their Ladies; No – they suffer them humbly to follow, Indian file like. As I am now speaking of the Natives, I must give you an account how we

stand with them. In order to give you an Idea of this part of our
political Government, it will be necessary to carry the Account back
to a period some months previous to my arrival. In the Winter 1789
(which you will recollect is Summer in England) a dreadful Small
pox was discovered amongst the Natives. How the disorder was
introduced cannot be discovered. They were found lying in a
miserable State, some dead and others dying; nor is it to be
wondered at that this disorder should in general be so fatal to them
when we consider they are not in possession of a single palliative,
nor have any means of procuring nourishment for themselves when
their strength no longer permits them to pursue their usual
avocations of fishing, hunting the Kangaroo, and other little animals,
on which they live. Amongst the unhappy objects that were
discovered was a Boy and a Girl. These were brought in, and from
the humanity of the Clergyman, who took the Girl, and of the
principal Surgeon, Mr. White who took the Boy, they were both
saved. The Girl whom I mentioned to you in my former Letters by
the name of Abaroo or Booroo (for it is difficult to catch their exact
pronunciation, more so, to give you an Idea of it by Letters) appears
to be about Eleven years old. The Boy, (named Nauberry) about
nine. After they began to learn English, and to make us understand
them it was imagined from their communication that if a Man or
two, could be brought to reside with us, that some valuable
information might be obtained, respecting the interior parts of the
country. With this view the Governor left no means untried to effect
an intimacy with them; but every endeavour of that sort as before
proved ineffectual. They accept of his presents as Children do play
things; just to amuse them for a moment, and then throw them away,
disregarded. Despairing to gain their confidence by fair means, the
Governor ordered that two men should be taken by force. This was
done, the poor Fellows, I am told exhibited the Strongest marks of
Terror and Consternation at this proceeding, believing they were
certainly meant to be sacrificed. When they were taken to the
Governor's House and immediately cleaned and Clothed, their
astonishment at everything they saw was amazing. A new World
was unfolded to their view at once; for some days they were much
dejected, but it soon gave way to cheerfulness: they were then
admitted to the Governor's Table and in a little time ate and drank
every thing that was given them; they now walked about the
settlement as they liked, only with a Man who was appointed to
attend them, that they might not escape into the woods; but as they
showed no apparent inclination to do that, the Vigilance of their
keeper by degrees abated, which the oldest of the two (named
Coleby) soon observed: and in a very artful manner one night, made

his escape. The one who remained, and called himself Bannylong, till May 1790, and then took himself off without any known reason, having been treated with the most uniform kindness, and appeared highly pleased with our people and Manners, taking it a great compliment to be called white man. In the time he was here he acquired English enough to make himself understood in common matters, and furnished our people with the Native names for animals, Birds, Fish etc. From this time till after our arrival, nothing was known respecting them, as the Natives whenever they met with any of our people were more shy than ever, and could not be brought to a parley. Nauberry, and Abaroo still remained easy and happy expressing no wish to return to the Woods. On 7th September, Captain Nepean and several other Gentlemen went down to the Harbour in a Boat with an intention of proceeding to Broken Bay to take a view of the Hawkesbury River; in their way they put in at Manly Cove (a place so called from the spirited behaviour of the Natives there at the Governor's first landing). At this time about two Hundred Natives were assembled, feeding on a whale that had been driven on Shore. As they discovered no hostile intentions, our party, having arms, went up to them. Nauberry was in the Boat and was desired to enquire for Bannylong and Coleby, when behold, both Gentlemen appeared, and advancing with the utmost confidence asked in broken English for all their old friends at Sydney. They exchanged several weapons for provisions, and Clothes – and gave some whale bone as a present for the Governor. Captain Nepean, knowing this news would be very pleasing to the Governor, dispatched a Messenger to inform him of it, and proceeded on towards Broken Bay.

The Governor lost no time, but as soon as he was acquainted with the above circumstances ordered a Boat and accompanied by Mr. Collins (The Judge Advocate) and a Lieutenant Waterhouse of the Navy, repaired to Manly Cove; he landed by himself unarmed, in order to show no Violence was intended. Bannylong approached and shook hands with the Governor but Coleby had before left the Spot. No reason was asked why Bannylong had left us; he appeared very happy and thankful for what was given him; requesting a hatchet and some other things which the Governor promised to bring him the next day. Mr. Collins and Mr. Waterhouse now joined them, and several Natives also came forward: they continued to converse with much friendship until they had insensibly wandered some distance from the Boat, and very imprudently, none of the Gentlemen had the precaution to take a Gun in their hand. This the Governor perceiving, deemed it prudent to retreat, and after assuring Bannylong that he would remember his promise, told him

he was going. At that moment an old looking Man advanced, whom Bannylong said was his friend, and wished the Governor to take notice of him. At this he approached the old Man, with his hand extended, when on a sudden the Savage started back and snatched up a spear from the ground, and poised it to throw. The Governor, seeing the danger, told him in their Tongue that it was bad; and still advanced, when with a mixture of horror and intrepidity the native discharged his spear with all his force at the Governor. It entered above his Collar bone, and came out at his back nine inches from the entrance, taking an oblique direction. The Natives from the Rocks now poured in their Spears in abundance so that it was with the utmost difficulty and the greatest good fortune that no other hurt was received in getting the Governor into the Boat. As soon as they returned to this place, you may believe an universal solicitude prevailed as the danger of the Wound could by no means be ascertained untill the spear was extracted and this was not done before his Excellency had caused some papers to be arranged – lest the consequence might prove fatal, which happily it did not, for in drawing out the spear, it was found that no vital part had been touched. The Governor having a good habit of Bodily health – the wound perfectly healed in the course of a few weeks. Since that a Convict game keeper has been killed by a spear; but it seems in some measure to have been owing to his own imprudence.

Bannylong came many times to see the Governor during his confinement, and expressed great sorrow, but the reason why the mischief was done could not be learnt. Since that period, the Natives visit us every day, more or less: Men, Women and Children, they come with great confidence, without spears or any other offensive weapon. A great many have taken up their abode entirely amongst us, and Bannylong and Coleby, with their wives, come in frequently.

Mrs. Coleby, whose name is Daringa, brought in a new born female Infant of hers for me to see, about six weeks since. It was wrapped up in the soft bark of a Tree, a specimen of which I have preserved. It is a kind of Mantle, not much known in England, I fancy. I ordered something for the poor woman to Eat and had her take proper care of for some while: When she first presented herself to me she appeared feeble and faint; she has since been regular in her visits. The Child thrives remarkably well and I discover a softness and gentleness of manners in Daringa, truly interesting.

We do not in general encourage them to come to our houses, as you may conceive there are some offensive circumstances, which makes their company by no means desirable, unless it be those who live wholly with us. A good deal of their Language (if it may be so called) is now understood, but we can learn nothing from them,

respecting the interior part of the Country. It seems they are as much unacquainted with it as ourselves. All their knowledge and pursuits are confined to that of procuring for themselves a bare subsistence. They chiefly abide about the Sea coast: the women appear to be under very great subjection and are employed in the most laborious part of their work. They fish, and also make the Lines and Hooks and indeed seem very little otherways than slaves to their husbands.

(Source: Elizabeth Macarthur to he friend Brigid Kingdon, Sydney, Port Jackson, New South Wales, 7 March 1791: in Elizabeth Macarthur, 1984, pp. 28–30)

Elizabeth Macarthur wanted to make the life she was leading quite clear to her family and friends, for only when they understood something about the conditions under which she was living would they be able to acknowledge and appreciate the sort of person she had become. Australia changed Elizabeth Macarthur and she wanted to communicate that change to absent loved ones so that they would know who she was, and so that she could feel herself part of a community in which her identity was known and respected. This is the way in which relationships are nurtured and sustained.

To women – sometimes from choice, often from necessity – has fallen traditionally the lot of maintaining ties with family and friends: with today's communication technology it is comparatively easy to 'keep in touch' and to make the gestures that help to bind communities together even when they are geographically apart, and the greeting cards and telephone calls that are signs of celebration and grief, marking births, deaths, marriages and anniversaries, are primarily the province of women – and a vital part of the network of family ties. Two centuries ago, it was much more difficult. In general, Australian women were physically far removed from some of the relationships that sustained them and which they desperately sought to preserve, yet the task of keeping alive those links, when there were so many pressures to drift apart, was made much harder. It was in the attempt to protect and affirm these cherished relationships that much powerful, personal letter writing of women was done.

For Elizabeth Macarthur, a new era began when her husband received his first grant of land at Parramatta in 1793. While John Macarthur retained his position as inspector of public works and paymaster to the New South Wales Corps, there were many calls on his time and interest which took him away from the newly established 'Elizabeth Farm'. And from 1801 until 1817 he spent less than four years in Australia, which not only left Elizabeth Macarthur lonely, but left her also with a great

deal of work to do. As within this period the farming (and trading) ventures of the property were dramatically successful it would seem inappropriate to suggest – as some historians have done – that Elizabeth Macarthur managed her husband's business in his absence. 'Elizabeth Farm' was a fitting name for the Macarthur enterprise, for it was Elizabeth rather than John who was responsible for the major family achievements and who made such a significant contribution to the development of the wool industry in Australia. Her letters and journal tell this tantalising tale.

But they tell much more besides. When John Macarthur returned to England, he did not go alone. Elizabeth Macarthur had nine children, of whom four sons and three daughters survived, and all four of her sons – and her eldest beloved daughter – went to England to be educated. For years Elizabeth Macarthur felt disconsolately alone, and wrote movingly of this 'cruel separation' from the younger (as well as the older) members of her family. Two of her sons – Edward and John – remained in England for most of their lives, so again it was through letters that she wove the family ties. The price that she paid – and the joy that the worst part of the ordeal is over – is evident in the letter that she wrote to her god-daughter, on John Macarthur's return:

Parramatta
11th December 1817.

My dear Eliza,

I was favoured with your letter by the Lord Eldon Transport, the very same vessel which restored to me your Godfather and my Husband together with our two youngest sons after a cruel separation of nine years. I am yet scarcely sensible of the extent of my happiness and indeed I can hardly persuade myself that so many of the dear Members of our Family are united again under the same roof. Mr. Macarthur is occasionally afflicted with Gout, otherwise I perceive little change in him during this length of time. James and William, from little boys when they left me, returned fine young men; James, six feet high and stout withal. William more slender, but evidently giving promise of being stout also. They are delighted to return to their native land and breathe not a regret for the gay scenes of the English Metropolis. Nothing they saw in France or Switzerland effaced the strong desire they had to return to their native wild woods in New South Wales. So much for the love of country.

For Elizabeth Macarthur, however, who was torn between love of the country in which she was born and love of the country she had adopted, there was no resolution:

I cannot ever express the ardent desire which I have once more to
see the place of my Birth – so many and so great have been the
obstacles that I have never dared to cherish the hope.

(Source: Elizabeth Macarthur letters, Mitchell Library A 2908,
vol. 12)

From the time she left England in 1790, until her death in 1850,
Elizabeth Macarthur's links with the country of her birth were maintained
by letters alone. And partly because of her talents as nurturer, observer,
interpreter – and writer – her letters embody much more than a record
of one person's life in colonial times: they represent the origin of much
that is characteristic and 'great' in the literary traditions of Australia. It
is little short of scandalous that such a rich repository of historical and
literary sources should remain so obscure: Elizabeth Macarthur was an
authoritative woman who bequeathed an authoritative account of her life
and times to generations of Australians. Her gift should be acknowledged
and appreciated – not neglected or negated.

CHAPTER 6

Novel letters

Were they to be collected and published, Elizabeth Macarthur's letters would be no less a rewarding or riveting read than those of Rachel Henning (1826–1914), which fortunately were published – in the *Bulletin* in 1951–2, almost forty years after the writer's death: although they are a record of a later period, from 1853 until 1882, the events described by Rachel Henning are at least as informative and exciting as – if not more so than – those of earlier times. While Rachel Henning never intended her letters to be read by anyone other than her family, the cultural heritage has been enriched by their publication.

However, the *Letters of Rachel Henning* are not simply a charming period piece (see Norman Lindsay, 1985, p. viii) – nor are they just a nostalgic reminder of a bygone age or a significant historical record. Because they are *real* letters and yet read so much like a *novel*, the *Letters* add a significant dimension to the general literary heritage: they constitute one of the best illustrations in the English language of the unique and close relationship between letters and the novel – one of the best examples of the overlap between fact and fiction. With their unbroken narrative which makes the moves from England to Australia, with their likeable central character who in the course of the letters grows to maturity and attracts our interest and sympathy, with their element of adventure, struggle, suspense and shifting loyalties in the strange new world, Rachel Henning's *Letters* reveal that fact can be the substance of fine fiction.

Seventy-five years before Rachel Henning commenced her literary task another young woman had written a series of letters – but with the intention of publication. In 1778, Fanny Burney's first novel was published in England. Entitled *Evelina: or a History of a Young Lady's Entrance into the World*, it traced a young woman's growing awareness of

the nature of society and its conventions – and the extent to which they
could be challenged and changed. This epistolary novel was hailed as
one of the most important contributions (then and since) to the literary
world.[14] In many respects the *Letters of Rachel Henning* follow a similar
form to those of Fanny Burney with, of course, one crucial difference
being that Rachel's letters were 'true' while those of Fanny were the
product of imaginative experience. But the 'factual' nature of Rachel
Henning's *Letters* does not detract from her literary achievement: the
picture she paints of the world is no less satisfying – or scintillating –
than the one portrayed by that other woman of letters, Fanny Burney.
And both women have also made an inestimable contribution to literary
theory: their *epistolary* achievements – like those of so many other women
writers – oblige literary critics to acknowledge the limitations of the
distinctions between fact and fiction and to take account of the factual
nature of fiction and the fictional nature of fact.[15]

Born in England in 1826, Rachel Henning was the eldest child of
eminently respectable parents who had both died by the time she was
nineteen. As the 'head' of the family, Rachel felt responsible for her
three sisters (Etta (Henrietta), Annie and Amy) and her delicate young
brother, Biddulph, who started it all when, on the grounds of health, he
set sail for Australia with Annie, on 11 August 1853. Rachel missed
them both sorely and started on her saga of immensely entertaining –
and sustaining – letters, the day after the two departed.

> Adington Hall,
> Cheshire
> August 12, 1853.

My Dearest Annie,

I was so rejoiced to see your handwriting again and to get the two
letters from you and Biddulph. How kind it was of you to write
twice to me before the ship sailed, in the midst of all the confusion
there must have been on board!

What a wretched day that Thursday was! After I had watched the
steam-tug you went by, out of sight, I came back to the pier, for I
could not rest anywhere else while I knew the ship was still in the
river, and I saw the last steamer, with Mr. Bright and his friends
and the mail, go off; but they refused to let me go.

After that I went up in the town, shopping. But came down to the
magnetic pier in the afternoon, but the Great Britain had then gone
down the river; so finding it was all over, I betook myself to our
lodgings, where perhaps it was as well that I had my hands full of
work till quite late at night.

I do not know why I am writing you this long account of that
miserable day. Before this reaches you, it will be one of the many

black days we have to look back upon in our lives. It is already a past thing and I suppose we shall not always have such a vivid remembrance of it as I have now.

You left behind your two teaspoons after all. I am so sorry I forgot them. Everything you or Biddulph have had or used seems valuable now, certainly the way to be valued or missed is to go to Australia, I think I shall try it next year, and see if it will arouse my friends to a due sense of my merits, but I am sure nobody could miss me as I do you and darling Biddulph. Even here I am reminded of you by something every hour of the day.

(Rachel Henning, 1985, pp. 1–2)

By the time the *Great Britain* arrived in Australia, Rachel Henning had decided that the pull was too great and that she would go too, even though this meant leaving Etta (who had married Mr Boyce) and embarking on a life in which she would always be separated from some of her loved ones and where – like Elizabeth Macarthur – she would forever be torn between the old country and the new. Almost to the year in which Annie and Biddulph had sailed, Rachel Henning set out with her sister Amy to join Annie and Biddulph on their farm at Appin, New South Wales. By 1855, with all the details diligently reported to Etta back in England, Amy had married Thomas Sloman and moved to Bathurst, and Biddulph had bought magnificently situated land at Bulli, on the south coast. Although the life she led offered much excitement and many rewards, the love of Etta, England (and a little elegance!) once more drew Rachel Henning back to the old country – where she arrived on October 15, 1856, two years after she had left.

Having experienced both the beauties and burdens of the two countries, Rachel Henning found at this stage that she had ruined her chances of contentment by fitting herself for neither. While in Australia she had longed for the green lanes and fields of England, but back in the old country she had chafed under the constraints of consciousness, climate and class, and hankered for the wider horizons of the new land. Difficult though the decision was to make, she resolved to return to Australia and she set sail in February 1861, after an absence of nearly five years.

In her letters which shift between England and Australia, Rachel Henning sketches some of the issues which were to become major preoccupations with various Australian women writers. Like Ada Cambridge (1844–1926), who later explored the tension between the civilised customs of the old country and the harsh necessities of the new – who tried to create an Australian heroine in whom the sophistication of the drawing-room was balanced against the rawness of hard work – Rachel Henning tried to combine and reconcile some of the contradictory

values of the two countries. Just as she had deplored the narrowness of much of her life when she had resided in England and longed for some of the liberating effects (literally and metaphorically) of the open air, when in Australia she found she often hungered for some of the niceties and genteel customs of 'home'. On her own account she was concerned that she should not be coarsened by rough conditions and she was always pleased to note the occasions on which her family retained some of the refinements of their former life-style.

Arriving in Sydney after Annie and Biddulph have left, Rachel writes to Etta (15 May 1861) to inform her of Annie's 'success' – and Biddulph's 'strengths':

> Biddulph too seems to have made quite a sensation here. He was here for two months at the beginning of the year. They say that he is not the least roughened or colonialized by his long residence in the bush, but that his manners and appearance are 'first rate', so very simple and yet so gentlemanly. That he is most polite and attentive to all the young ladies and a great flirt! I do long to see him and Annie again. I am sure we will be very happy together. I fully mean to try.

(Rachel Henning, 1985, p. 63)

By August 1862, Rachel Henning has begun the most invigorating part of her life when she sets sail with Annie for Rockhampton and Biddulph's new pastoral property, Exmoor at Marlborough, Queensland. There she resolves her conflict of loyalty between the old and the new, and in her commitment to Australia she epitomises the shift to self-determination and independence. In making Australia her home, Rachel Henning becomes a different person from the young lady who made her entrance to the new world ten years before, when in England she had said her farewells to her brother and sister: although, understandably, she still retains her affinity for England – and for much that is English – she fully appreciates the opportunity Australia has provided and the identity it affords her.

From Queensland come her letters of the 1860s, which are detailed documentations of the time and place and are replete with references to the contrast between the old and the new; but Rachel Henning does not resort to the self-defeating task of ranking the relative merits of the two. Rather – as many Australian women writers have done – she counts herself fortunate to have had access to both traditions and she uses this advantage to extend and enrich her insights – and her writing.

Exmoor,
Christmas Day, 1864.

My Dearest Etta,

A happy Christmas and New Year to you and yours. It is a time of the year which makes one think of the home country and friends there, and when my thoughts do travel that way there is not much question as to where they go first.

I should like to be with you today to go to church with you (of course 'you' includes Mr. Boyce) in the morning and sit by the Christmas fire with you and the children in the evening.

What a different Christmas yours is from ours! I fancy snow on the ground and a hard frost, yet withal a bright sun as there ought to be on Christmas Day. The children wrapped up very warm going to church with you and having their attention sorely distracted by the holly berries and evergreens with which it is dressed, and saying Christmas hymns and being regaled with figs by the fire when it is getting dusk.

On this side of the world it is rather a hot day, though there is not much sun. Thunderstorms are rolling about the hills, and very beautiful the mountains look appearing and disappearing among the misty clouds. The paddock round the house is emerald-green; the young grass has grown within this week since the rains set in. The gum trees are in flower, and the passion vine over the veranda is in fruit and the seeds are trying to come up in the garden but are nipped off by the fowls as soon as they show above the ground, so I have no hope of a flower garden this year.

The doors and all the windows are open, and I wish a little more wind would come through them. Biddulph is reading on the veranda and Annie ditto, and we three have the house to ourselves. We rather expected two or three of our neighbours to be here for Christmas but the Bowen and Broken rivers are up and that has probably prevented their coming.

All our own people – i.e., those belonging to the house – are either at Lara[16] or on the road there. The Flinders River Station is a sort of Moloch and has swallowed up sheep, horses and men from Exmoor. Five thousand sheep are already there and 3,000 more are on their way. About twenty horses are gone and Mr. Gilliat is out there taking charge of the station. Mr. Taylor[17] set out about six weeks ago with the additional sheep, and Mr. Hedgeland started a week ago with a string of pack horses for the new settlement with the supply of flour, tea and sugar to last them till the drays arrive. Beckford is on the road with the wool drays, and at present, Biddulph is managing Exmoor singlehanded.

I think he rather likes to have plenty to do, on the whole. This is

not a very busy time on the station now that shearing is over, but he has to visit the out-stations every week, count the sheep and send rations to the shepherds. We still talk of going to Sydney some day, but I think, and rather hope, it will not be till after the rainy season, for, of course, Biddulph cannot leave home till either Mr. Taylor or Mr. Hedgeland returns to take charge of the station, and it is hard to say when that will be. . . .

This is the second time I have written to you without any letters to answer. We quite expected an English mail and I believe it was actually in the Port when the postman left, but the letters were not sorted. I was much disappointed at not hearing and at having to wait another fortnight, but for some months the post is sure to be irregular now, for when once the rainy season has begun there is no saying when the rivers may be up.

Sometimes the Broken River which is between us and Port Denison, is impassable for weeks. The postman was nearly drowned on his last trip up. Biddulph met him just at the creek below here, and wondered what dismal object it was riding up, hatless and bootless and trouserless and arrayed only in a Crimean shirt. Biddulph sent some garments down to him, and then he told his sorrowful tale; how in fording the Bowen it was not high enough for swimming, his horse had fallen over in a deep hole and he (the postman) contrived to scramble up in a tree while the horse and mailbags scrambled out, and how, not being able to swim, he stayed half an hour in the tree before he could make up his mind to cross the piece of water that was between him and the shore.

He did cross it at last, and luckily caught his horse, leaving his garments in the tree while his hat floated down the Bowen. He must have been very stupid and lost his nerve altogether to get into such a scrape, because the river is not at all deep yet.

The 'desert lilies' are over and gone. They lasted a short time this year on account of the drought. None of the wild flowers have been very numerous for the same reason. Also the vegetable seeds have hitherto strongly objected to coming up in the garden. We had quantities of cucumbers and lettuces this time last year and now we have none. But we have a wild plant which makes a capital salad and which we very seldom dine without. It rejoices in the name of pigweed, and is a small plant with thick green leaves like the ice-plant and tastes slightly acidic and slightly hot, something like watercress.

We have watercress growing in the creek, but it is not large enough to pick yet. There is another wild plant called fat hen, which is as good as spinach when boiled, so we get along with wild vegetables till the tame ones see fit to flourish.

There will be no lack of moisture for the next three months; the rains began about a week ago, and you can almost see the grass grow. There are thunderstorms nearly every day, and it is setting in for a wet evening at the moment. Christmas Day is almost always wet in Queensland; it comes just at the beginning of the rains. The great floods generally come about the end of January. With love to you and Mr. Boyce and the children. Your affectionate sister,
Rachel Henning.

(Rachel Henning, 1985, pp. 186–9)

Rachel Henning was a writer of lively letters – and good stories. For her sister Etta, who remained in England, and for whom the Australian scene was so unfamiliar, the *Letters* must have been stimulating, satisfying – and informative – on a variety of levels. They would have afforded excellent lessons on the nature of the new land as well as delightful records of daily life: and they would have been such a good read. It is not hard to imagine the eagerness with which Etta Boyce would have awaited their arrival, nor the excitement and pleasure they would have produced within the family circle, when read. Although even at this stage there could still be long intervals between the letters (and lots of 'incidents' which could reduce the reliability of the post), the steady stream from Australia would have seemed very much like a serialised novel – the difference being that the heroine was personally known to the readers and that the narrative related 'true' events.

While Rachel Henning took up her pen in the attempt to document her Queensland way of life to her private British audience far away, closer to her home was another young woman who was 'practising' with her pen – and who would one day take on the task of interpreting the Australian experience to a public audience abroad. At Marroon, near Bromelton, the thirteen-year-old Rosa Murray-Prior (later Rosa Praed) took up writing, partly as a means of combating some of the unnerving isolation of her life. Rachel Henning would have appreciated the young Rosa's need to write: she knew full well that while the bush had its beauties and its rewards, it also had its many forms of deprivation. Writing was one way out.

CHAPTER 7

From the other side

One way of ordering experience – in the attempt to make sense of it and to manage it – is to write about it. Apart from the contribution that 'setting it down' makes to the shaping of reality, it affords the added advantage of providing a record which can be reflected upon – even revised – at a later date. Yet such an activity – however usual or understandable – is one that presents a problem in the world of letters if and when such a composite account is published: for how is such a work to be classified? This is one of the questions which arises in relation to *Annabella Boswell's Journal*, for it comprises some of her adolescent journal entries and her adult revisions.

In the Introduction to the contemporary edition[18] of *Annabella Boswell's Journal*, Morton Herman (1981) states that when the Australian born Annabella Innes (1826–1916) accompanied her husband to Scotland in the 1860s she took her early diary with her and recast it in the form in which it was later published:

> Sometimes she quotes her original girlish writings verbatim;
> sometimes they have obviously been altered and polished since
> there is evident a much more mature judgement than will be found
> in a young girl's observations. At most times it will be clear to the
> reader which is the original diary and which the later commentary;
> but at times the two are inextricably entangled.
>
> (Morton Herman, 1981, p. vi)

Sifting the additions from the original is not the only difficulty presented by the *Journal*: the record it provides is such a pleasant and positive one that it stands in sharp contrast to other accounts of life in

New South Wales at the time, and introduces some doubts about the accuracy of the author's power of description. But it was probably because the writer was in a position to make selections – and able to excise anything that might have been even slightly unseemly – and because the *Journal* was published in Scotland and was designed partly as a source of information on Australia for Annabella Boswell's children, that there is sometimes an 'overwhelming nostalgia' and 'a too-glamorous picture of the places so lovingly recollected' (Morton Herman, 1981, p. vi).

But if Annabella Boswell gives an account of 'the good life' in New South Wales in the 1830s and 1840s it is one which helps to balance some of the many accounts of hardship and brutality that have more generally prevailed. As such it can be said to add to rather than to curtail our understandings of the time. And always there is a double edge to her words, for even as Annabella Boswell documents some of the doings of the fashionable world it is as well to remember the distance separating her from those whom she observes, which allows her a vantage point and affords glimpses of the difficulties predominating just below the debonair surface. True, Annabella Boswell was in a position to enjoy some of the benefits that society then had to offer but they come to her as a *dependent*; with her father dead, she and her mother and sister were the house guests of her wealthy uncle and had no real influence or power. This acknowledgment that the world can look different to women – even when they appear to have a place among the wealthy and influential – commonly characterises women's writing, and is certainly central to Australian women's literary traditions.

Annabella Boswell's Journal sets the scene – literally and metaphorically – for the emergence of these traditions. She provides continuity with the settlement past (*Miss* Elizabeth Macarthur was her mother's bridesmaid) and links with the future: her record stands between that of the early personal chronicles of Elizabeth Macarthur and the later works of Louisa Atkinson, intended for publication.[19] And the account she writes of a young Australian girl's life, and education, gives some idea of the conditions in which women's literary traditions were forged. That education was a problem in the colony is clear from many accounts, but the discussion of the difficulties was usually confined to the education of boys: for example, Georgiana McCrae, writing of her life in Melbourne as a mother of daughters and sons in the early 1840s, indicates that one of her major preoccupations was that of finding a suitable tutor for her boys.[20] But even though records of the problem might not be so readily available there can be no doubt there were many – if not more – difficulties associated with the education of girls: if or when daughters were given access to education it was no easy matter to obtain the services of governesses or schools. In outlining some of the educational

arrangements that were made for girls, Annabella Boswell provides some valuable information on the development of the colony at the time.

I was somewhat surprised to find that at less than eight years of age, Annabella was sent to boarding school in Sydney: I was less surprised by her comments on the educational establishment:

> Early in 1834 I found myself settled at school in Bridge Street, Sydney, under the care of Mrs. Evans, and her friend and partner, Miss Ferris. Mr. Evans had a large bookseller's and stationer's shop, and we occupied the rest of the house, which at that time was thought handsome, and in a fashionable street.

> (Annabella Boswell, 1981, p. 3)

Despite the desirable location, Annabella was not happy at her school (where there was a great deal of bullying) and after a year her father took her home to Capita (Capertee), where the family was fortunate enough to obtain the services of an excellent governess:

> Her name was Miss Willis, and I am sure no children ever had a kinder or more painstaking teacher. My mother, too, found her helpful in many ways, and an acquisition in our isolated home. We children threw ourselves with zeal into our work. I panted for information, and read greedily every book I was allowed to have. We read many times the histories of England, Scotland, Greece and Rome. The story of *Elizabeth, or The Exiles of Siberia* was an especial favourite, and we had many other nice books, considering the time and place.
>
> Miss Willis had a guitar; she was not very proficient, but she taught us to play nicely and to sing some simple songs. For grammar she had a mania. I think I learned every word of a large Murray by heart; her zeal never flagged. We played at spelling lessons; the spelling Bees of recent years would, I am sure, have been a joy to her.

> (Annabella Boswell, 1981, p. 9)

If the education of girls was not always satisfactory neither was the lot of the governess charged with the responsibility of dispensing it. In this instance, the demands made upon Miss Willis appear to have been not so very onerous – though the inference is that she was required to serve as companion to the lady of the house, and it is also likely that her duties extended to certain domestic tasks. But not all governesses were so fortunate, as Patricia Clarke (1985) has shown: in the letters which

governesses wrote from the colonies between 1862 and 1882 the picture which often emerges is that of a hard, impoverished and lonely life.

Trying to make the most of the limited resources available was, however, a typical colonial trait and one that was consistently called upon in an educational context. So many of the basics were in such short supply that improvisation was understandably the order of the day. Yet it is difficult to imagine the form that education took when so much of the established and received wisdom of the old country was so inappropriate – indeed 'wrong' – in the new. What could be done when all the necessary educational materials had to be brought from England: when books vied with agricultural necessities for a place on board? What sort of education could be provided in the absence of good private or public libraries, in the absence of locally written and published geographical, botanical, historical and literary texts? What skills could be cultivated when literary materials were so scarce and communication with the outside world was so expensive?

Apart from indirectly making the case for local and meaningful publications, the entries in *Annabella Boswell's Journal* suggest some of the ways in which educational difficulties could be circumvented. For example, she shows how women's art of letter writing could still be encouraged and practised under adverse conditions:

One of our amusements was that we each wrote a letter every week. I have a few of these compositions beside me now; many were to imaginary people. Those we really wrote and sent had also to be copied into the letter-book. In those days of exorbitant postage very few went beyond it. I have seen a letter for which seven and eightpence postage was paid.[21]

(Annabella Boswell, 1981, p. 9)

So not long after Charlotte Brontë and her sisters and brothers 'practised' their writing in private family novels (see Elizabeth Gaskell, 1985), and not long before Rosa Praed was to 'imitate' them and with her mother write in a private family magazine (see Rosa Praed, 1904), Annabella Innes was practising writing in a private, family letter book. Such family writing has frequently played a crucial part in the formation of women's educational and literary traditions.

For Annabella, however, the pleasant and positive educational experience was of short duration: in a colony where there was an acute shortage of single women, it was but a year before Miss Willis, the governess, succumbed to an offer of marriage. And then the troubles began:

After Christmas we looked forward with anxious interest to the arrival

of our new governess. Papa was to bring her from Sydney, and at
the same time my eldest cousin, Annabella Mcleod, to visit us and
other friends at Bathurst; also to our great delight, another cousin
of our own age, Williamina Macleod, who was to share our studies
under this new governess. Our castles in the air in this particular
soon collapsed. A young lady appeared who I recognised at once as
the girl who mended our clothes and taught us plain sewing at Mrs.
Evans school – a sort of help and quite unfit to be a governess. She
excused herself by saying she expected to find us little children
requiring only a nursery governess. It was very annoying but she was
only too glad to leave at once.

(Annabella Boswell, 1981, pp. 13–14)

After this incident Annabella Boswell makes but one further reference
to attempts to obtain a systematic education: she notes the arrival of Miss
Smith. But here too the limitations of the colony – and the limitations
that were inherent in the attitude to 'young ladies' – imposed severe
restrictions on the type of education that the young Annabella and her
sister were offered. Miss Smith, a trained governess, insisted on
educational activities that could hardly be said to enlarge the mind –
according to Annabella, Miss Smith was:

full of theories, and of her own importance, but we got on very well
with her. She gave us plenty of work to do, and had no peace of
mind till we had learned by rote the whole of Magnell's questions,
and could say 'King's Reign', with dates, without a mistake. At this
time we got a piano. A most laborious business it was conveying it
round The Peak, and scarcely worth the trouble.
 Papa bought us also a pretty guitar, but Miss Smith despised it,
as she also did our efforts at drawing from nature. She gave us stiff
designs to copy, taught us to shade finely with pencil and to draw
from copies, trees rare and wonderful, while our much loved wild
flowers were left unnoticed and our paint boxes set aside.

(Annabella Boswell, 1981, p. 16)

Such a clash of values between the 'formalised' and the 'free' was a
feature of colonial life and a foundation stone of educational and literary
formations. And if Annabella got more than her share of rote and rigid
learning under the well-trained Miss Smith, she was later able to enjoy
the dubious freedom which went with the absence of educational super-
vision. For after Miss Smith, it seems that the educational input was
provided at home and that it was both random and sporadic. When

Annabella's father died her access to educational resources (and to other privileges) was drastically curtailed: like so many other girls in the outback she was obliged to invent her own educational amusements. Writing of her life between 1840 and 1841, when she was fourteen years of age, she conveys a clear impression of the conditions in which she lived:

> We were very much thrown on our own resources. My sister and I had some lessons to do most days, and we drew and practised by fits and starts, albeit much at our own sweet will. I read greedily such books as we possessed, chiefly the *Waverley Novels*, which then and now always interested me. I read most of them aloud as well as to myself. We had Cooper's novels also, which fascinated me then, but somehow I have never read them since, and have no wish to do so. I feel I would not now be in sympathy with them. I regret that some of the books we had were denied to us, among them Shakespeare, which seems strange to me now, but my mother was old fashioned in her ideas and somewhat of a disciplinarian. We spent much of our time out of doors, where our interests were very varied, in the fields and gardens, and among all living creatures from the native blacks, who often came about the place, to the birds and insects we met with on our walks.
>
> (Annabella Boswell, 1981, p. 37)

One could wish that Annabella Boswell's horizons could have been wider, but if she was primarily self-taught she was no different from many other women who became published writers. Because until relatively recently women were excluded from formal education, many of them acquired their learning through their own resources: from the Duchess of Newcastle to Mary Wollstonecraft, from Jane Austen to Rosa Praed, women have taught themselves literary skills – often with spectacular success.

Annabella Boswell was an observant and shrewd reporter with a simple yet effective style who was often conscious of the contrast that her journal entries represented: it was partly because she knew that some of the 'refinements' manifested at certain social gatherings had their element of aberration against the backdrop of rough Australian life that her writing often has a cutting edge. Her style reveals some of the emerging strands which have since become a significant part of Australian women's literary traditions.

Annabella Boswell gives us some illuminating accounts of the morals and manners of her time and in the process she provides commentary on the attitudes and values that helped to influence and shape women's writing. Always, initially, there was the attempt to preserve the practices of the old environment even at the expense of the new – and such efforts

were by no means confined to literary tastes and trimmings, as an account of a wedding in 1837 reveals:

> This was the first marriage at which I was present. It took place, of course, in the house. The Rev. K. Smythe performed the ceremony. Isabella Johnstone and Ann McArthur were bridesmaids. I do not remember who was best man. The bride was dressed in a rich white silk dress, the skirt rather short and full, low bodice, and bell-shaped sleeves.
> Her hair, which was dark and very abundant, was dressed very high on the top of her head, and supported by a high-backed tortoise-shell comb, short curls in front, a tulle veil falling gracefully over her shoulders. The bridesmaids were both tall, and had their hair dressed in much the same style. The bridegroom wore white trousers and vest, and a dress coat of blue cloth, with brass buttons and lined with white silk.
>
> (Annabella Boswell, 1981, p. 13)

Hardly appropriate travelling gear for the rough ride through the bush which the honeymoon journey entailed. But then it seems that one of the signs of refinement in the settlement was the ability to endure uncomfortable clothing in the heat. In describing the attire of the Governor's party on the visit to Port Macquarie in 1847, and aware of some of the absurdities, Annabella Boswell writes that:

> The Governor wore a very light coat, and I had the honour of tying on his veil of blue purse silk (netted by Miss Icely, and the best thing possible for keeping off flies, as it is so cool and light). Mr. Fitzroy appeared with a great green veil, wrapped round a tall white hat. I thought it must be a kind of mourning, a green willow I had heard of, but green crape never. Its size is admirable. . . . He wore long boots with a great piece cut out under the knee, and dark cornered unutterables, a stable jacket and waistcoat of small black and white check, a coloured shirt and neckerchief, and in this behold a bushman's costume of the year 1847!
>
> (Annabella Boswell, 1981, p. 128)

While it may have been permissible for Annabella Boswell to make fun of her fellows, it was an entirely different matter when those 'at home' mocked or maligned the colony and its customs. It seems that as early as 1840 Australians were sensitive about their image abroad and anxious to correct some of the many misconceptions that abounded. Nowhere was this more apparent than in the case of the 'gold-diggers'

who looked upon Australia as a source of quick and easy money and who were only too ready to blame the colonials when their expectations of instant wealth were thwarted – and they found themselves forced to stay in a country that they heartily disliked.

The idea circulating abroad that Australia was a place where golden guineas could be gathered in the street was one which caused consternation and criticism all round: those who arrived in Australia anticipating an easy fortune felt they had been misled and their disappointment and anger served sometimes to anger the colonial population who had little sympathy with their plight – partly because they had troubles enough of their own. For bad times descended upon Australia in the 1840s and the presence of frustrated fortune seekers served to fuel discontent, as Annabella Boswell shows:

We have been much amused at hearing of the golden idea which some people 'at home' entertain of Australia. Two gentlemen who arrived in the Colony early this year said to my aunt the other day, 'It is no wonder we are disgusted with the country. We thought we only had to pick up money, it increased so fast, and without troubles or annoyances.' They explained that their cousin, who came out before they did, was expected to write at once and tell them what he thought of this fine country. As he did not do so, out came his brother to share in his supposed good fortune, but still they sent no word home. 'Come,' thought the other two – 'They shall not keep all those good things to themselves, no doubt they are quietly picking up the guineas, we had better lose no more time.' I wonder if they thought they had found a gold-mine, with mint complete, concealed of course, but sending forth a golden harvest in showers. Well, one left a merchant's office in which he had every prospects (sic) of becoming a partner. The other had just become a W.S. in Edinburgh. Both determined to start off at once to Sydney, and astonish their friends by their brilliant success. But lo, they were met by the cry of 'bad times'. All the guineas had disappeared, if there had ever been any! What was to be done? They could not go back, so, to make the best of a bad job, they have lowered their ideas so far as to become 'settlers' (wretched word) and deferred the pleasures of gathering guineas till they have worked for and deserved them. 'Bad times' is at present the too general subject of conversation; everyone takes an interest in it, and it is melancholy to hear of the number of people who are absolutely in want of the necessaries of life, who lately were in affluence. No one seems to have an idea as to how it will all end.

(Annabella Boswell, 1981, pp. 74–5)

Annabella Boswell tells a good tale and as she does she provides a fascinating account of some of the tensions between the old country and the new, and between the new settlers and the old. Many of the incidents she outlines in her diary reveal the seeds of what later were to become national issues – and literary debates. Her view of the world should be neither discounted nor derided: for while it is fair to say that the position from which she surveys the scene is a semi-privileged one – and that in her uncle's household she was protected from some of the worst forms of privation of the 1840s – there was no individual in Australian society at the time who could be completely cushioned from the cruelties of colonial life.[22] Even the greatest often had to pay the highest price: 'ladies' too died in childbirth, in floods, fires, droughts, and in carriages:

Monday 20th December, 1847

Much to our regret my uncle has confirmed the report of the awfully sudden death of poor Lady Mary Fitzroy. The family had all been staying at Government House, Parramatta, and were going to Sydney to spend Christmas. About ten o'clock on the morning of the 9th, Lady Mary entered the carriage, a heavy travelling chariot. It had been some time at the door and the horses were restless. Sir Charles, who was to drive, was seated on the box with Mr. Chester Master, his A.D.C., beside him. A servant sat behind. Scarcely had the grooms released their hold upon the horses, when the leaders made a bound forward and set off at full speed down the hill to an entrance gate. Had the road been straight possibly the accident might not have happened, but unhappily at the gate there is a sharp turning, and there the carriage which had been swaying from side to side all the way down the hill, upset heavily, throwing all in it out with great violence. Mr. Fitzroy who had watched them from the house rushed down followed by all who were near, but alas before he arrived life had fled, and the fond mother who had but a few short minutes before gaily bade him goodbye, now lay a bleeding and mangled corpse, blood flowing from her mouth and ears, and her chest crushed in by part of the carriage which had fallen upon her. Who can describe the horror of such a moment? Sir Charles, whose fall had been broken by his having kept hold of the reins, although much hurt managed to reach the spot, and there gazed on her in speechless agony[23]. . . . This dreadful event has caused universal sorrow throughout the Colony. Lady Mary had travelled so much in the country and become personally acquainted with so many of its inhabitants that they feel as if a dear friend had been snatched from them . . .

(Annabella Boswell, 1981, pp. 151–2)

While such tragic accidents were not uncommon they were not the main feature of existence by the 1840s: fifty years had wrought changes in the colony so that survival was no longer just a crude matter of conquering the elements. Rather, there was a growing emphasis on the need for cultural activities and, although some of the developments in this direction could now be said to almost defy comprehension, they point to the stark contrasts – and contradictions – that were the substance of the time. For example, in 1838 the first novel was published on mainland Australia – *The Guardian* by Anna Maria Bunn[24] – and it is tempting to see this as a sign that the colony was enjoying a more sophisticated life-style; yet at much the same time as this momentous literary event took place, Annabella Boswell shows the other side of civilised life when, in dramatic detail, she describes some of the highlights and hazards of the 'routine' journey from her home at Capertee to Sydney. She recalls the trip she made in March 1839, a year after the first local fiction publication appeared, and it is no easy task trying to reconcile all these opposing images; she begins by giving details of the preparations.

The day before they set out a dray was sent ahead with a tent and sufficient provisions for the two nights to be spent in the bush; then the family set off in another large dray piled with mattresses and pillows (and drawn by five strong bullocks) as well as a gig in which the parents travelled. At the end of the day – having covered a distance of about five miles – they arrived at the first camp-site where a tent had been pitched and awaited them. Fires were lit, horses were tethered, bullocks watered: a carpet was spread under the tent and trunks were set up as tables. Soon everyone was eating and drinking – with tea from the little brass kettle, and wine for those who wanted it. The plump chickens in the coop – the evening meal for the following night – looked on.

Then it was bed – and very snug the arrangements were – so that the family slept soundly and had to be roused by the men lighting the fires and bringing in the cattle. Bathing was performed in a clear, cool stream, and after breakfast, travelling began again.

They were not on the road very long when they came to a steep hill, 'The First Pitch', where everyone had to dismount and scramble up as best they could, while the men supervised the bullocks. At every step, stones had to be wedged under the wheel and while the dray made slow progress, Annabella walked on and filled her arms with flowers and berries.

It was one hill after another, with going down just as laborious and difficult as going up (small trees were cut and fastened behind the dray to keep it from careering downhill and as Annabella said, 'it was astonishing the number of these trees to be seen lying at the foot of some of these steep hills, which had been brought down in this way and were of

no further use'). As there was no water in the hills and gullies, a careful watch was kept for a water-hole which would provide some refreshment for the hard-worked bullocks. Then part of the harness gave away, and they realised that they were not going to reach a water supply; and then on top of it all the stone jar containing the water for the family was broken.

Deep were the lamentations over the broken jar. Unless one has experienced something similar one can scarcely realize our dismay at the loss of our only sure supply of water. As it was impossible to reach the Flat, our only hope lay in the Reedy Gully, an old camping place about half a mile off. We managed to arrive there before dark, and while some attended to the animals and lit the fires, others set off in quest of water. We were all very thirsty, wine we could not drink, and the beer had been given to the men, who were worse off than we, from being unable to indulge in their usual and most refreshing quart-pots full of tea. We waited for some time hoping for water.

At length the first party returned, their little keg still empty. Then we ate our supper, but would have given it all for a little water. Suddenly we remembered that there was a box of grapes we were taking to a friend on the way. The grapes had been bagged on the vines and so kept fresh after all the others were finished. At first we were delighted with them, but they were so very ripe and sweet we were soon more thirsty than ever. At last, tired and dispirited we went to bed and happily were soon sound asleep.

About midnight we were awakened with the joyful cry of 'Water, Water!' A second party had gone out and now returned in triumph with their keg full. They kindly brought some to us first, and we thankfully took a few mouthfuls. Next morning we rose with the pleasant hope of getting some tea. Great was our surprise on looking into the pannikin in which the water had been brought to us to see nothing but green slime, and that with a very offensive smell. We could not bear to think that we had tasted it, for now all declared we would rather go with faces and hands unwashed than touch such stuff.

Then they were on the road again and were able to reach the place where water was plentiful, and where a carriage was waiting for them. It was a place of entertainment, with many drays taking supplies backwards and forwards, camped around the ponds. After a short break they were off again, with most of the family in the carriage; Annabella's father and his groom travelling behind in the gig. They lunched at Cullen Bullen, and then . . .

We were so late in resuming our journey that the sun had set before
we reached the inn at which we were to stop that night. This was
a large, bare-looking house at the junction of our road with that from
Bathurst, long known and celebrated as Malachi Ryan's, but its
celebrity was not flattering, as, though not haunted by ghosts, it was
so infested with creatures more likely to disturb one's rest that I
wonder now why anyone stopped a night there. One traveller declared
he had been dragged out of bed, another kept up a continual fight
to prevent himself from being devoured alive, and a nervous lady,
being left alone with her invisible tormentors, could think of no
expedient save that of ringing a small hand bell all the weary night
to frighten them off.

 To add to our discomfort on arriving at this wretched place, the
gig had not overtaken us, though we had waited several times in
the hope of it coming up, and mamma was getting very anxious,
though we could not say what was to be apprehended. As time
wore on our anxiety became painful when (it cannot be said to relieve
our fears) dear papa walked in, but so pale and lame, that we saw at
once that he had met with an accident. He had indeed had a most
wonderful escape. A road gang was at that time making in one part
of the road a new piece some feet lower than the old, and had
neglected to put a paling along the side of the upper road. Over
this bank the horse had stepped in the uncertain moonlight, drawing
the gig down after him. It was a miracle that they were not all
killed.

 Poor papa was very much bruised and shaken, which in his weak
state of health was very alarming. The man with him was not very
much hurt, but the horse, a splendid creature, we feared could not
recover. However, with great care and attention, he became in time
as well as ever. The gig was smashed to pieces. Fortunately the place
where the accident happened was quite near the inn. We spent there
a miserable night, but were able to leave the next morning. Miss
Smith had to sit on the box of the carriage to leave more room
inside, and in this way we reached Penrith on the third or fourth
day. We there crossed the Nepean river in a punt, and stopped the
night in a large and comfortable inn. Of the scenery on the road I
cannot remember anything, as we were shut up in a close carriage,
and could only hope at some future time to see it under more
favourable circumstances.

(Annabella Boswell, 1981, pp. 22–9)

When such a routine trip from home to town could turn out to be so
eventful, it can be seen why there was no necessity for Australian women
writers of the early era to rely solely upon imaginative experience as the

basis for their literary efforts. There was just so much to write about in real life – which could indeed prove to be stranger, and more fascinating and exciting – than fiction. And it was the adventurous nature of Australian life, the journey into the physical and often spiritual 'unknown', which helped to give some of the cultural form: it is plausible and explicable that Australian women writers should have been influenced by more down-to-earth concerns, and that they should have expressed them in a more sparse and unadorned style than some of their more cultivated English counterparts 'back home'.

No doubt Annabella Boswell would have been incapable of conceptualising or clarifying the world of Jane Austen, but even as a child she could readily record some of the raw data of her experience on the road. When in the space of a week, and in the company of her sedate family, the young Annabella could banquet in the forest, bathe in the stream and sleep under the stars; when she could struggle against thirst, refuse the wine and resort to drinking green slime; when she could deal with bullocks and drays, injured horses and smashed gigs, and fight off pests and attend to the painful plight of poor papa, there was more than sufficient action to engross the mind and little time or space to devote to nuances of manners and meaning which are more consistent with the concerns of 'polite fiction'.

Of course, Australian women writers would later draw upon both realms of existence, on the possibilities offered by the wide world and the inner mind; they would even explore the relationship between the two. But they would be women for whom writing was a profession, who would seek publication, and who would benefit from some of the earlier endeavours of those who had tried to shape their prose to fit their surroundings.

Much of Annabella Boswell's account was written in the 1830s and 1840s before an Australian 'literary industry' had emerged: originally, she wrote more for herself than for an external audience,[25] and her writing is confined almost exclusively to descriptive accounts of her surroundings. But because it is often a new and remarkable world that she describes we are frequently provided with fresh and remarkable descriptions. And in training herself to be an accurate observer and recorder of the unfamiliar, Annabella Boswell moves towards the shared heritage of Australian women writers.

CHAPTER 8

Sanity and silences

One reason that Annabella Boswell's entries are often so vivid and full of vitality is because the events she describes are being filtered through the eyes of an impressionable child. But to look at the pioneering life from this perspective is to have the emphasis placed more upon the delights than the dangers of existence. What for the young girl could have been the opportunity for pleasurable adventure could be for the adult woman a source of suffering and pain. At much the same time that Annabella Boswell was recording the innocent details of her eventful daily life, other women in far-flung parts of the new colony contemplated comparable events with consternation and many qualms.

Again, writing for herself – and one suspects for the sake of her sanity – Georgiana McCrae comments on some of the primitive conditions in which she was forced to live in Melbourne when she accompanied her husband there in the early 1840s. To think that a 'world of letters' was beginning to take shape in this environment is almost to challenge the limits of comprehension. For, as Georgiana McCrae says, Melbourne then was by no means a civilised place:

9th March, 1841
 Perambulated the town with Agnes, that is to say we went up the north side of Collins Street, without any sign of a pavement; only a rough road with crooked gutters – the shops built of wood and raised on stumps.

(Georgiana McCrae, 1983, p. 53)

In contrast to the life she had left behind, it was not surprising that Georgiana McCrae should have found Melbourne a poor place indeed. And one didn't need to be out in the bush like Annabella Boswell to

know the want of water; Melbourne was so uncivilised that water was
not only scarce, but even where available was difficult to obtain:

March, 1841.
 Water is conveyed from the Yarra in a large barrel mounted on a
dray. These loads cost from seven to fifteen shillings, barely enough
for a week's supply.
 (Georgiana McCrae, 1983, p. 57)

What was a mother to do with a sick child – and with no water? No
search parties would be sent out, there would be no support to be had
when the child cried out and the mother had nothing to give:

3rd December, 1841.
 Sandy crying for a glass of water, and not a drop to be had. . . .
Mr. McCrae tells me he saw the driver of the (water) cart outside
Jimmy Connell's (Hotel) at twelve o'clock and then again between
two and three.
 (Georgiana McCrae, 1983, p. 78)

That *Mr* McCrae was no great help in the circumstances is made
unequivocally clear by *Mrs* McCrae throughout her entries. That when-
ever there was work to be done her husband was not to be found – or
if found, was not to be disturbed on account of his headache – is a point
Georgiana McCrae makes repeatedly and is one which adds 'colour' to
her record. For despite her status as a 'lady' it was an enormously hard
life that she led, and had her descriptions of her husband's 'shortcomings'
been bitter rather than sardonically amusing she could have been
forgiven.
 Her housing went for months unfinished and was for years appalling:
she was responsible for feeding, clothing, educating the family and, it
seems, for providing the funds; she gave birth, she nursed children, she
buried friends. And if in this context she could make time to keep her
journal then presumably so too could other women engage in some form
of literary pursuit when they were leading equally arduous lives. So too
– perhaps – could they make the irreverent remark, the comment that
mocked the patriarch and his authority, a feature which is not atypical
of the Australian women's literary traditions.
 Much of Georgiana McCrae's journal is taken up with considerations
of food: how to get it, how to prepare it, how to pay for it. She provides
some insights into the culinary developments of the time ('Mrs. Bunbury
. . . returned with me to taste the kangaroo soup. We both agreed that,
to our taste, ox-tail is a superior article', p. 61); she provides detailed
information on the market place:

Potatoes at this time cannot be had for less than 6d. per lb.; carrots, turnips, onions etc., are brought across from Van Dieman's land and cabbages, grown here, cost 9d. for a very small one. Bream is the only fish I have yet seen. A fisherman comes round occasionally with a basket of these which he takes in the salt-water river. . . .

Fortune du pot dinners, which were then the vogue, tried my patience and ingenuity. Mutton and beef were to be had at moderate prices, but vegetables and fruit were costly, having to be imported from Launceston. Poultry was exceedingly scarce and at exorbitant prices.

(Georgiana McCrae, 1983, pp. 57–8)

Purchasing the food represented only part of the problem: there was still the cooking to be done. Which is why 'tarts were out of the question' for there was only 'a clumsy fire hole' in which to cook. So the entry on 28 May 1842 presents a stark contrast – and conveys a wealth of meaning:

My Brown's Patent Cooking Stove and a box of books arrived from London (p. 92)

While feeding the family was a major female preoccupation (a factor which is reflected in the amount of space allocated to the activity in letters and journals), a more fundamental issue for many women was that of producing a family – of getting pregnant and giving birth. The prospect of confinement could be distressing enough in general in the nineteenth century but the difficulty – and the dread – could be compounded in the Australian context where the absence of medical assistance – or even of any assistance at all – increased women's vulnerability. This is why women could view marriage as a dangerous occupation and give some thought to other options before deciding to become wives: the prospect of an early death in childbirth – or, alternatively, of repeated pregnancies – was not an attractive one.

Women's real fears about marriage and the stress and strain it could bring (including that of having to deal with a crude or cruel spouse) raised the question of whether women should or should not marry, or indeed of whether they should stay married, and was one which was raised regularly in much of the published literature of Australian women writers in the later part of the nineteenth century. And of course this theme of the problems and perils of marriage distinguishes the writing of women from that of men: as marriage held no comparable risks for men, but rather could offer a range of rewards,[26] there is little in the literature of men that affords insights into this central aspect of the consciousness of women.

Not all women, however, were equally forthcoming in their discussions

of the difficulties of being wife or mother. If in the public sphere women writers pursued a serious path and created characters and contexts which challenged the institution of marriage and all that it implied (as did Rosa Praed, 'Tasma', and Catherine Helen Spence, for example), in their private writing women seem to have been far more reticent. While issues of 'difficult husbands' and 'difficult births' are raised, they are often referred to only obliquely in letters and journals: yet for this noticeable absence of elaboration on such an important dimension of women's lives there are a few obvious explanations. One is that when it came to letters, women did not want to worry family and friends to whom they were writing so they would – understandably – gloss over some of the problems they may have faced with their confinements or their spouses. From the nineteenth-century letters that are available, it is clear that instead of complaining about their lot many women were concerned to reassure their relatives about their well-being and so they would 'make light' of their difficulties and dangers. Such an approach may have had its advantages: for in the process of trying to present the bright and funny side of their harrowing experiences to their family audiences, women may have found a means to deal with some of the hardships of their lives. They certainly helped to forge some of that wry humour which has come to be identified with Australia: while often termed 'gallows humour', and associated with the endurance of men, it should be noted that women too have confronted awful conditions and yet from their anxiety and adversity they have been able to write amusing anecdotes that would both comfort and entertain their loved ones back 'home'.

There were of course women who did not seek to present a glowing or glorious picture of life in the new land. And there were women who dealt with their fear and their pain in emotionally wrought letters and journal entries (see, for example, Ellen Moger, p. 14). But in the main, given the frequency – and the intensity – of the trials of motherhood, the documentation of this experience in women's personal chronicles is surprisingly rare. This could be because the topic was taboo – even in outback Australia: that women had been so well initiated into the polite practices of nineteenth-century society that they were too self-conscious to record the details of birth even in their diaries. Or it could be that women found it too difficult to dwell on the experience: that it was so fraught with fear and overlaid with pain that they preferred to put it out of mind rather than reflect upon it in their writing. Whether it was from choice or necessity what is evident is that many women were reluctant to examine their emotions with regard to childbirth and made but perfunctory reference to it in their diaries and letters. And Georgiana McCrae is not atypical when she mentions this (momentous) event in passing – but inserts a wealth of meaning between the lines:

28th December, 1841.

Thomas Anne and Mr. John Mundy came to our early dinner. Captain Cole to tea, and whether for the sake of prolonging his stay beside his lady love, or from actual thirst, he took no less than *nine* of our small tea-cups full of tea. While pouring out the seventh cup I could hardly conceal the effects of a twinge of pain, but the Captain and Thomas Anne didn't make a move till 10.00p.m. The moment they were gone, I hurried off to my room at Landall's and sent for Jane and Dr. Myer (his house at the end of Great Bourke Street East – Gardner's Cottages). Soon after eleven, Jane and the doctor arrived. At 3a.m. I gave birth to a fine girl. The doctor on his way home, tapped at the window of Mr. McCrae's bedroom and told him what had happened while he had been asleep.

(Georgiana McCrae, 1983, p. 80)

Georgiana McCrae was not writing this record for others – for family or friends back home: she was writing it for herself. This personal chronicle is her 'conversation' with herself and while it reveals some features which are peculiarly 'Australian' it also contains many of the characteristics which place it firmly within the framework of women's traditional writing. Georgiana McCrae used her journal to structure and sustain her reality, to realise her own identity – and to stay sane.

CHAPTER 9

\bullet

Connections and comparisons

In the same year that Georgiana McCrae made the passing entry on her daughter's birth, on the other side of the continent another women gave birth and registered a remarkably similar understatement of the dramatic experience. Eliza Brown (1811–96) left England in 1840 with her husband, two children and seven servants, and when she arrived in the Swan River Colony in 1841, she found that the only available accommodation was a two-roomed hut. With nowhere to house them, the servants – with one exception – had to be 'let go' and in her primitive new abode, in stark contrast to the comforts she had left behind, Eliza Brown ran a home, gave birth – and wrote letters:

Grassdale, July 3, 1841[27]
My dear Papa,
 We have now been four months in the Colony and not received a line from home, the only letter that has come to hand from a relative is one from Mr. Brown's Brother Wm. which communicated the tidings of poor William's death, the circumstance was touched upon more in the way of a passing remark than with any that it would be the source from which we should first hear the melancholy intelligence . . .
July 8th.
 Bedtime arrived before I had concluded my letter on the 3rd. I had therefore put the writing [away] intending to finish on the following morning. Then a little boy arrived during the night, resembling Kenneth for vigour and healthfulness but disabling me for resuming the pen again so early as intended and wholly frustrating my intention of writing to Emma and Matilda at present. Mr. Brown starts for Perth early tomorrow morning and will be the bearer of

this to Miss Crocker one of our late fellow voyagers by the *Sterling* to this Colony. She is leaving by the *Trusty* and has offered to take charge of letters for us to England. I had many enquiries to make respecting Dorchester friends, regards to send etc. but must now only inform you that I am according to general phraseology on such occasions as well as can be expected, and remain,

> Dear Papa
> Yr truly Affectionate Daughter
> E. Brown
> (*Received June 3, 1842*)

(Eliza and Thomas Brown, 1977, pp. 20–4)

While it may not seem possible the announcement of another birth on 8 September 1843 is even less dramatic.

> Mr. Brown has acquainted you of our addition, a boy again, which I believe meet more of your approval than the other sex.

(Eliza and Thomas Brown, 1977, p. 36)

Such a low-key approach is not typical of Eliza Brown's overall letter-writing style. When it comes to farming – to the presence of political intrigue or the absence of currency (a major problem of the time) Eliza Brown presents a lively and lucid account of colony life. And it is not just a 'faithful picture' of her surroundings that she provides but a revelation of some of her personal hopes and fears for the future. However, women's reality is a very different matter: there's little information let alone amusement to be found in Eliza Brown's record of her confinement. Her hopes and fears in relation to childbirth are never mentioned. In this respect her letter-writing style is typical of many women of her time.

In spite of the shocks that they received, Eliza and Thomas Brown were well-prepared emigrants in that they had corresponded with earlier Swan River settlers (and relatives), Dr S. W. Viveash and William Tanner. And in the Viveash-Tanner-Brown letters we have a valuable record of social life and family connections – and a means of making colonial comparisons. That the vast new continent of Australia could sometimes be but a very small world becomes evident in this family correspondence: 'The Browns were relatives by marriage of the Tanners (through the Viveashs)'[28]; and when Hester Viveash and her husband William Tanner landed at Swan River in February 1831, her brother Charles Viveash, who was married to William's sister Ellen Tanner, continued on to Van Diemans Land (Tasmania). The letters from

Tasmania to Swan River (and England) flowed as frequently as postal favours would permit.

From Tasmania Ellen Tanner Viveash writes to her relations at Swan River and to her mother 'back home', and like Eliza Brown, her comments on her confinement are curiously constrained – despite the fact that she had no living children and that pregnancy and birth were not only rare, but exceedingly worrying. But Ellen Viveash has no inhibitions when it comes to her comments on her surroundings: she provides a graphic guide to Tasmanian life of the period and among her descriptions are many details that I found surprising. What I did not know before I read her letters is that until the gold rushes of the mid-nineteenth century the island of Van Dieman's Land (as it was then called) was arguably the cultural centre of the colony. Ellen Viveash kept her mother fully informed about the social life that she led and, even allowing for the fact that she might have wanted to reassure her mother that there was more to her life than hard work, her account of Hobart society is still unexpected. The following extract, dated 28 January 1834, reveals the heights of colonial sophistication, along with Ellen Viveash's apprehensions about the precarious economic situation:

> When I drive in a carriage it always brings forcibly to my recollection the many delightful rides I have had with you my dear mother. The Scotts are always so kind, wishing someone always to partake with them any pleasure. They invited a Dr. Osborne (of the Navy) to go with us. He is a pleasant man but rather sober looking – my dress (new one) is made with a stomacher and white net sleeves, as well as long silk ones to wear as a carriage dress. It is in shot Fujium silk, the handsomest I saw and very becoming. I should have left it at Hobart Town only Mrs. Scott has not enough room for her own dresses without crushing them. She has too many. – I *never* saw anything like the Hobart Town extravagance – one lady walking in the morning with black satin shoes! Carriages kept by everyone, by some we know are always in distress for money and by 2 who are now under obligation to us in changing the time of a bill from 6 months to 3 years. Wilson is mad, I think; he can scarcely go on and no wonder, he has a *service of plate*, one of his sets of parlour curtains cost $40. Charles dined there, he had champagne and English salmon and a larger dinner for six people than we had at Government House when 20 were expected. We shall place no more money in his hands. The ladies, many of them, wear low dresses and only a net Pilerine over to walk in the streets amongst a convict population and where females are in small proportion. In the evening about 8 o'clock when we rode into town we could scarcely get our horses along for the streets being full of people. This proceeds more from

them not making the foot-way than from the number but still the increase is astonishing.

<div align="right">(Ellen Viveash, 1981, pp. 74–5)</div>

This level of cultural sophistication helps to explain the publication of the first Australian novel – in Tasmania. Hobart might not have been able to boast of footpaths in 1834 but it had a literary reputation of which it could be proud: apart from the 1831 publication of Henry Savery's *Quintus Servinton* there was Mary Leman Grimstone's novel *Woman's Love* which although published in England in 1832, reflected the Tasmanian context in which it had been written.[29]

Directly and indirectly in her letters Ellen Viveash reveals the conditions under which women lived – and wrote – in Australia in the first half of the nineteenth century. While she was one of the more fortunate members of society, particularly in comparison to convicts and Aborigines, it is clear that her life was none the less difficult and dangerous and that under the circumstances it would have been incongruous for her to have attempted to pursue any polite literary accomplishments. But it was her aim – even her duty – to convince her family that she was safe and well, and what better way to do this than to transform fears into amusing stories?

In the nineteenth century it was women who were primarily responsible for family links, who wrote the letters and who told wry tales of trepidation and trouble. As early as 1834 some of the danger was taken out of bushrangers when they starred as the rough-diamond characters in the stories women wrote in their epistles home:

February 1, 1834

Four very formidable bushrangers were taken six miles from here just before we got home, which was probably lucky for us; doubtless our house would have been first robbed on account of our absence and *reputed* riches (Captain England said he heard the other day that Charles is the richest man in the Colony!). They were bravely taken and great prudence used by the publican, whose wife soon suspected what they were (they said they were constables going to take the bushrangers). They were fifteen hours in the house before the publican could put his scheme in practice tho' he managed to detain them drinking porter. They had a store of arms they hid in the bush near the public house, together with these well filled knapsacks with plate and valuables they had taken a day or two before near Launceston. The latter place has been too hot to hold them, (very vulgar, but *just in this case* very expressive). Two others have been taken as all are on the alert. They have been most polite and in some instances kind – (no robberies have been committed except

near Launceston, except petty one's off shepherd's) – returning
watches in some instances if requested to do so by ladies, and, in
one instance, on hearing from the master of the house that his wife
had just been confined, and his sister-in-law gone to bed fatigued,
they passed the rooms on tip-toe so that the ladies did not know of
the robbery until the next morning and then the four armed men's
leader said if they had known the case they would have waited a few
days!

(Ellen Viveash, 1981, pp. 76–7)

In a penal colony where there was a constant threat to 'law and order',
where convicts, violence and vice were held to abound, it was quite an
achievement for Ellen Viveash to distance herself from the morals and
manners of her time and to make an amusing anecdote out of prevailing
phobias and fears. But if she could turn the terror of bushrangers to
humorous account, she was much less successful at distancing herself
from the dangers of disease. Her descriptions of sickness, and of its
treatment, make terrible reading and show how difficult and desperate
the struggle was sometimes for survival. However, what does emerge
from Ellen Viveash's description of the dreadful discomfort her husband
endured (from constipation) – and the even more dreadful remedies
administered – is that it was not squeamishness or lack of familiarity with
bodily functions which curtailed her account of her own confinement.

But although there were problems there were also pleasures: Ellen
Viveash reveals that good food and good wine were among her priorities
– regardless of expense:

May 4th, 1834
 We have just gone to the luxury of buying 6 dozen of sherry. The
first good wine we have had, this we shall only produce occasionally
and it will last us more than a year at 35/- per dozen. Tea is now
very high £7–£10 per chest, Sugar higher at £32 per ton, soap low
5d. per lb. Meat 5d. (– how much this is down since we came –
Tho' sheep are of greater value). Flour £36 per ton, very high,
wheat high, 8–10 shillings per bushell, oats scarcely to be got, hay
scarcely procurable at £10 per ton.

(Ellen Viveash, 1981, p. 84)

The cost of living was a popular topic in women's letters of the time:
comparisons were constantly made between Britain and the colonies and
appropriate exclamations were uttered about the cheapness – or the
expense. Before 1840 women would invariably write with details of their
bargains – or burdens – but after this date the style is sometimes modified
and becomes more systematic and serious in its overtones: by 1840 the

new colony was experiencing economic difficulties and many of the itemised lists of expenses that women sent home were not for entertainment value; they were meant to provide a basis for family or friends to decide whether emigration to the colony was worth their while.

When asked by Mr Thorp for her opinion on the opportunities that Australia afforded, Anna Josepha King (a former governor's wife) not only listed all the relevant prices but applauded the efforts of those who were sufficiently sensible to make such inquiries. Writing to the Thorps (14 February 1840), she says:

> We all think Mr. Thorp has made a very *judicious* inquiry & it has been very carefully answered. If every person would take the same steps before they take the trouble & expense of coming with their families to settle here much disappointment, vexation & expense would be saved. We are all of opinion the accounts of this Colony is very *much exaggerated* from what it really is —[30]
>
> In fact the place is so over full with people that in Sydney not a Home is to be got & those small huts which may be got are at such an immense Rent & everything in proportion is double – even since my last return that is quite shocking – but the climate, – the fine climate is beyond everything *good* altho we have more changes than we ever experienced before that it is pure fine air & a delightful change from that of England.
>
> I hope my dear Mrs. Thorp you will not think I have said this to deter [you] & your family from coming out but as you desire a true statement I have considered it right you should have it & not in any way to deceive you.

(Source: Mrs Anna Josepha King to Rev. Mr Thorp and Mrs Thorp, Letter from the Vineyard, AK 1/9, Mitchell Library; quoted in Helen Heney, 1985, p. 139)

When asked to give an honest and accurate assessment of the state of affairs there were many women like Anna Josepha King who found it difficult to make a recommendation one way or the other: aware of the advantages that Australia might possess they were also acutely aware of its limitations. And this 'conflict of interest' between the old and the new which characterised much of their lives was often reflected in women's letters. There is a recognition of the dual reality and an exploration of the tension between the two – which can look like vacillation but which can be an attempt to reconcile the values of the 'civilised' world with those of the raw frontier. This is evident in the advice that Susan Dowling Spencer sends to her brother: on the one hand she recommends emigration but on the other hand she warns him that life in England will

have spoilt him for colonial society – and that he will never find a 'suitable' wife among the Australian born:

> July 1, 1844
> Parsonage
> Raymond Terrace
> My dear James,
> I only received your letter this morning & now hasten to answer it, & by your account of your gains as a Barrister the sooner you reach Sydney the better I should say although I believe there is not much to be Earned here, yet you will always be able to have plenty of Food for it is so very cheap for you can get four *magnificent* Legs of *Mutton for a Shilling* & best Beef for 1 penny a lb & Everything Else proportionately Low) it would be better for Arthur to come out here again as Steerage Passenger than to live in that wretched Manner he must be doing at present but I suppose he would rather starve in England than show his face in Sydney. You will receive this letter by Frank Hodgson a fine young man who will give you the *Picture of our Parsonage* which I hope you will like & I quite long to see you & show you my little Suzy & by that time there will be perhaps a little nephew as I expect to be confined next month. Vincent comes & sees us very often, he wants a Wife very much to make him comfortable & really there is hardly one agreeable girl in the Colony I expect unless you bring a wife with you, you will be an old Bachelor for after seeing the English Ladies you will find a difficulty in meeting one out here for I think they are disingenuous both in manners & appearance . . .

> (Source: J. S. Dowling, Correspondence: Mitchell Library: quoted in Helen Heney 1985, p. 152)

Prices – or the presence or absence of polite society – were not the only factors to be taken into account in deciding on the desirability of colonial life: there were other issues which determined that women's lives could be terrible and tough. Even the most privileged often found themselves forced to endure the most primitive conditions and for the poor – for the servants, the convicts and the Aboriginal women – life could be a dreadful ordeal. Eliza Brown lived in a two-roomed hut and for many months Georgiana McCrae had little more than one room – but as she observes, she was among the more fortunate:

> 5th August, 1841
> Incessant rain. Grievous for the emigrants camped in miserable thin tents exposed to the south-west wind, while the flats are dotted

all over with pools of water. Yesterday, a woman drowned herself from sheer despair.

(Georgiana McCrae, 1983, p. 64)

Few would want to dispute that colonial life could be punishing and painful for all, but life for women – particularly those charged with the responsibilities of being mothers and wives – was peculiarly hard. And yet we know so little about these women and the lives that they led. For unfortunately we have been the inheritors of a distorted tradition: we have been given a false image of our past. While the stories of the difficulties endured by men – and the bonds they forged and the jokes they made – have become the common currency of our culture, the records of women's suffering – of their sardonic strength, their sisterly support, and their survival – have rarely surfaced. But as Helen Thomson (1986) has pointed out, many women were subjected to the most awful conditions and they gave way under the strain: there were women who were driven mad by the bush and we need to know more about their predicament. Their stories need to be 'unearthed' and told, and placed within women's literary traditions.

CHAPTER 10

·

'A difference of view'

While we have access to some of the early writings of women (in published and unpublished form) a rich resource still remains and warrants our attention. So much of what we think we know about the past – and about the patterns of women's writing – will be called into question by the different versions of events that women have encoded. Because women occupy a different position from men they have what Virginia Woolf called 'a difference of view' (see 'Women and Fiction' 1929/1972): they can see much that men cannot see – they can even see men as men cannot see themselves. And it is this 'difference of view' which can be found in the writing of women as far removed as Elizabeth Macarthur and Eliza Dunlop: it is this difference of view which is at the centre of women's literary traditions.

It is probably because of women's different position – because women felt so vulnerable, isolated, even colonised – that they so readily made some of the links between their own situation and that of the Aborigines. Not that their stance here is widely known, either. Again we have been handed a distorted image of our past and one from which women's contribution has been excised. For wherever stories have been passed on about the relationship of black and white they have been mainly the stories of men – which have concentrated on conflict and division. What has been lost is the extent to which women identified with and explained the Aboriginal plight. From the earliest days of white settlement there were women who were concerned about the treatment (or mistreatment) of the Aborigines and who saw in them fellow human beings to whom they wanted to show warmth – and respect. This interest and appreciation – this quest for insights and information – runs right through Australian women's writing and is characteristic of women's literary traditions.

From the poet Eliza Hamilton Dunlop who wrote *The Aboriginal Mother* in 1838 to Catherine Langloh Parker who published the first comprehensive collection of Aboriginal tales and legends (*Australian Legendary Tales*) in 1896, we can trace women's willingness to study and learn from Aboriginal life: from the writers Jeannie Gunn, Daisy Bates and Mary Durack we can recognise women's interest in human dignity and human rights. From the novelists Rosa Praed (who demonstrated the high regard she had for Aborigines in many of her books) to Catherine Martin (who made an Aboriginal woman Iliapa the heroine of her novel *The Incredible Journey*, 1923) to Eleanor Dark (who wrote her superb trilogy on the clash of two cultures – *The Timeless Land*, 1941; *Storm of Time*, 1948; *No Barrier*, 1953), we have evidence that the empathetic portrayal of Aborigines has been a major preoccupation in women's writing.

Even before women took up their pens as professional writers, their concern for the colonised victims of another culture was apparent: it is to be found in the letters of Elizabeth Macarthur and Rachel Henning; it is also to be found in the first published pieces of women's writing. Eliza Hamilton Dunlop provides a worthy example.

Eliza Dunlop travelled to India to join her father and brothers before she ventured to Australia. In India she found her father dead and discovered that she had two Indian half-sisters whom her brothers refused to acknowledge. Helen Heney (1985) suggests that it could have been this experience which set Eliza Dunlop thinking about 'racism' and the suffering and injustice that it generated. But whatever the cause, the consequences are clear: in Australia, Eliza Dunlop publicly identified with Aboriginal women.

In 1841 her poem *The Aboriginal Mother* was published and it attracted considerable criticism in the *Sydney Herald*: so Eliza Dunlop wrote a letter to the editor defending her position and that of the Aboriginal woman:

November 29, 1841.
The author of the Aboriginal Mother takes leave to notice the favor bestowed on that poem by the learned correspondent of the
Herald. . . . But however much the idea is to be deprecated (it) had its origin in the hope of awakening the sympathies of the English nation for a people rendered desperate and revengeful by continued acts of outrage. (I am) Painfully sensible of great literary demerit and of a deficiency in poetical imagery, but above all in having such *mal – a – propos* taste as to select so inexpedient a subject.

The author did hope that even in Australia the time was past when the Press would lend its countenance to debase the native character or support an attempt to shade with ridicule ties stronger

than death, which bind the heart of woman, be she Christian or
savage.

(Source: Margaret de Salis, 1967. Two Early Colonials by a Great
 Granddaughter, p. 103: quoted in Helen Heney, 1985, p. 141)

All these women – and their writing – helped to shape the traditions
of Australian women writers. They found themselves in a new land where
old responses could not be relied upon and in their writing they reflected
upon their experience and found new forms of expression for their
pioneering ways. Necessity was the mother of their literary inventions: it
was necessity that dictated the importance of *letters*, and necessity often
determined the form those letters should take. It was necessity that
induced women to overcome their isolation and to 'converse' with jour-
nals and diaries.

From these 'private' origins, the public and professional writing of
Australian women emerged in the later part of the nineteenth century.
But if this public writing was quantitatively different from the 'private'
writing which preceded it, there were still many links between the two
forms. There is a continuum of women's writing which not only extends
back to the letters of Elizabeth Macarthur but which can be found even
further in the epistolary novels of Fanny Burney, the correspondence
of Dorothy Osborne, and the public letters of Margaret Cavendish.
Contemporary women writers in Australia constitute a strong branch of
this well-rooted dual tradition of private and public writing.

PART II

Professional Pioneers

Louisa Atkinson 1834–72
Annie Baxter 1816–1905
Mary Anne Broome 1831–1911
Anna Maria Bunn 1808–89
Ellen Clacy
Matilda Jane Evans 'Maud
 Franc' 1827–86
Mary Hannay Foott 1846–1918
Mary Leman Grimstone c.
 1800–??

Agnes Grant Hay 1838–1910
Fidelia Hill 1790–1854
Louisa Lawson 1848–1920
Caroline Leakey 1827–81
Jessie Lloyd 1843–85
Laura Luffman 1846–1919
Louisa Anne Meredith 1812–95
Elizabeth Murray 1820–77
Mary Therese Vidal 1815–69
Eliza Winstanley 1818–82

The transition from the private to the public realm marks the second stage in the development of the literary tradition. From the mid-nineteenth century, women overcame some of the psychological barriers (which were meant to discourage women from seeking publication) and some of the material barriers, and from choice and/or necessity embarked upon professional literary lives.

At this time there are many 'firsts': the first novel with an Australian setting; the first piece of professional writing; the first novel published in Australia; the first native-born novelist; the first book of poems; the first women's magazine – and many more. The range of woman writers during this period is quite extraordinary. Their pioneering strengths and professional achievements helped to set the scene for a later generation of women writers who were to gain great acceptance – and popularity – abroad.

CHAPTER 1

·

Facts from the frontier

With the exception of Eliza Hamilton Dunlop's 'Letter to the Editor' most letters written by women during the first fifty years of the colony were of a private nature: even if it had been considered seemly for women to write for a public audience, such an activity (and the necessary machinery it demanded) was not high on the list of priorities of the first settlers and convicts of either sex – who faced the much more fundamental problems of finding and ensuring sufficient food and shelter. Given these difficult circumstances it is not surprising that there was so little opportunity for literary 'indulgences': what is surprising is that in such dire and discouraging conditions, women should have *made* the time (and taken 'the liberty') to write at all. One can only assume that their psychological needs to restate their 'self' and to stay in touch with the world they left behind, far outweighed the arduous physical demands of their days. And this *emotional* quality, often apparent in women's private letter writing, helped to shape the form and substance of women's literary traditions.

Women's determination to write is evidence that neither woman – nor man – can live by bread alone. This is clear in the case of individuals like Georgiana McCrae, for example: it is also clear in relation to colonial development in general. Even when living conditions had progressed little further than the most basic, the need for the printed word began to be felt in the fledgling society: for official information, for unofficial information, for newspapers, periodicals and books[31] – and for audiences 'at home and abroad'.

For fifty years private letters had been flowing slowly but steadily across the ocean providing a wealth of factual (and false) detail on the fascinating Australian frontier. But far from satisfying the craving for knowledge about such a strange place, many of these letters had helped

to whet the appetites – to increase the interest – of the British, not a few of whom were prospective settlers and fortune seekers.

What was life in Australia really like? So many stories emanated from the colony that it was almost impossible to sort the facts from the fictions. And family letters were sometimes the starting points for stories which were passed on – which 'grew', which were dramatically elaborated – until women like Annabella Boswell and Anna Josepha King could ridicule the wildly exaggerated rumours of riches and deplore the outrageous expectations that were held by many who emigrated to Australia.

The publication of a book such as Mary Leman Grimstone's novel, *Woman's Love*, in England in 1832, simply served to add to the speculation about life in the new land. Mary Leman Grimstone was born around 1800 and in more ways than one she was a most unusual woman for her time: by the age of twenty-one she had published some poems (under the unusual pseudonym of 'Oscar') and in her twenties she set sail for Tasmania. On 4 March 1826, for reasons not entirely known, Mary Grimstone arrived in Hobart with her sister, Lucy Adey and her husband. In Van Dieman's Land she continued to cultivate her poetic predilections and soon had some of her verses published in the *Colonial Times*. But while in Van Dieman's Land, Mary Grimstone also worked on her novel (from 1826 until 1829) and was influenced by the local setting – which to the British reader, of course, would have been exciting and exotic.

Back in London, Mary Grimstone became a member of the circle that formed around the 'arts' journal, *La Belle Assemblie*, which was edited by the clever and courageous Caroline Norton.[32] When *Woman's Love* – the first of her novels – was published,[33] it was well received by many periodicals (including *The New Monthly Magazine*, 1832) and well reviewed in *La Belle Assemblie*. The novel reveals some of the advanced views and values of the author in that it is a plea for the recognition of women's intellectual qualities and for women to have the opportunity to be able to contribute to public life. But it was not the 'feminist' nature of the book that attracted the most attention: that it was the *first* novel to be set in the new colony was the cause for far more comment:

> (*Woman's Love*) . . . comes recommended to us by a novel
> circumstance; it was written in Van Dieman's Land, and it has
> something of the warmth and freshness of the scene amidst which it
> was composed.
>
> (*La Belle Assemblie*, June, 1832, vol. 15, p. 135)

It is understandable that such emphasis should be placed upon the 'freshness' and 'novelty' of the setting. To the British audience this could well have been the book's most striking feature. To the Australian writer it could well have been an effect most easily obtained. A creative imagin-

ation was not always called for in order to arouse the curiosity of a British reader: all that was required was detailed description of the amazing Australian flora and fauna – of the bizarre social arrangements of the penal colony in the southern hemisphere – and to the British audience it would be sufficiently 'fresh' and 'novel' to qualify as science fiction!

In the 1830s and the 1840s the desire in Britain to know more about the strange new land continued to grow and to be fuelled by the many private letters and the few published sources that were available. For not even the most accurate, or understated, accounts – of koalas or kangaroos, of sky, space, fire or drought, of gold or graves, of convict, emancipist or free settler, of bushranger or Aborigine – could make colonial existence appear monotonous or mundane. But there was a real need for extensive and reliable information – and explanations – and it was a *professional* woman writer who came forward and helped to provide it.

CHAPTER 2

Professional writer

By any standards, Louisa Anne Twamley was a remarkable woman. Born in Birmingham in 1812, she soon professed to be very ambitious and showed every intention of achieving her many literary and artistic aims. An only child of elderly (but not wealthy) parents, she was supported and encouraged in all her endeavours with the result that she became a talented portrait painter, a skilful sketcher and writer, and a lover, protecter, illustrator and recorder of nature. Totally immersed and at ease in the intellectual and creative life of Birmingham in the 1830s, Louisa Anne Twamley was astonished – and not a little affronted – when she received a letter from her uncle, George Meredith, in Van Dieman's Land, offering her employment as a governess to her young cousins. Aware that the Twamleys were under financial pressure – and that the situation would become more serious with the death of the aging Mr Twamley – George Meredith had presumed that his offer of £100 per year to his niece would be attractive. His proposal was not appreciated by Louisa Anne Twamley: to her, the very idea of leaving her highly civilised and cultured life for the wilds of Van Dieman's Land was unthinkable. On 18 May 1833, she wrote and told her uncle so:

Can you imagine that anyone of my habits and pursuits could bear the estrangement from all the many delights afforded them by living in a civilized (pardon the word) country among friends whom, did I choose or could I afford it, I might speedily extend to a much larger circle.

(Quoted in Vivienne Rae Ellis, 1979, *Louise Anne Meredith: A tigress in exile*, p. 37)

Miss Twamley was not being unrealistic in her assessment of the artistic advantages of Birmingham in comparison with the privations of colonial cultural life: nor was she overestimating her own abilities and prospects for success on the English intellectual scene. She was actually awaiting the publication of her first book – *Poems* – when she received her uncle's offer of employment as a lowly governess in a convict community. Not that Louisa Twamley adopted the conventions of her time and objected to 'a lady' working, to being paid, or to publishing in her own right and earning 'a name' as well as her bread. It is a measure of her independence (and her determination and defiance) that when increasing pressure was being placed on young middle-class women to conform to the rules of 'refined retirement', Louisa Twamley was averse to neither work nor pay. And while when young she had published some of her progressive political articles (she was a supporter of the Chartists) in the radical *Birmingham Journal* under a pseudonym, she proudly had her first book printed under her own name. This is in itself indicative of her spirited (and pioneering) nature, but the Preface to her first book – *Poems* – reveals more than her level of confidence and her commitment to being a writer: it also displays a playful side – an ability for satirical self-deprecation. She writes of her own motives as an author that –

> The preceding [argument] she offers as a reason for *writing* the poems: if she should be called on to give one for *publishing* them, she would feel honestly inclined at once to plead vanity, which though a species of vice, is far more excusable in anyone than the deprecatory and fashionable style of fibbing, so frequently adopted in prefaces to the first productions of authors, whether in verse or prose.
>
> (Quoted in Vivienne Rae Ellis, 1979, p. 42)

Unusually for her time, Louisa Anne Twamley was serious in her commitment to her intellectual pursuits: she was no amateur who looked on her art and her writing as mere accomplishments. The forty poems – and six plates – which comprised her first book earned her considerable praise (from such persons as Leigh Hunt, for example[34]), and after it she continued to devote her days to the study of nature and to its representation. That she was an extraordinarily gifted woman is a point made by her biographer, Vivienne Rae Ellis, who assesses her subject's achievements at the age of twenty-six:

> She had five published books to her credit, was the author of many articles, poems and literary critiques, and an accomplished painter of miniature portraits. Hr published flower paintings and sketches, some engraved by herself, had been well received. She was a member

of the Royal Birmingham Society of Artists and had exhibited a total
of twenty six pictures in its galleries in the period 1829 to 1838.
She was also an accomplished pianist and gifted at recitations.

(Vivienne Rae Ellis, 1979, pp. 47–8)

Add to this the fact that Louisa Anne Twamley became the Corn
Inspector of Birmingham on her father's death and it is obvious that she
was a most remarkable woman – and a serious writer.

But what Miss Twamley would not do for money, she did for love.
When she was twenty-six, with a well-earned place in intellectual circles,
her cousin Charles Meredith arrived from Van Dieman's Land and made
her an offer – which was attractive. Although it meant leaving the cultural
life that was so important to her (and an elderly mother who was very
dear to her and whom she rightly assumed she would never see again)
when faced with what she saw as a choice between marriage and a literary
career, difficult though the decision was to make, Louisa Anne Twamley
chose the husband. In the first week of June 1839, Louisa Anne Meredith
left behind the rewarding life that she had made for herself in England,
and set sail for a sojourn in Australia.

This did not however mark the end of her literary career: she simply
entered another – albeit unplanned for – stage. Louisa Meredith had
been a writer from an early age and she continued to write even when
she moved from the English scene that had stimulated and sustained
her. She found as much to note – and sketch – on board ship as she
had found in the countryside and the details of her journey to the new
land are recorded, in typically lively and lightly satirical style, in her first
colonial publication – *Notes and Sketches of New South Wales during a
residence in that Colony from 1839–1844*.

England's loss was Australia's gain: Louisa Meredith went on to write
more than a dozen books (including two novels) and numerous articles
and pamphlets. And, if not the first, she was certainly among the first
professional women writers in Australia:[35] Like Margaret Cavendish,
Duchess of Newcastle, she was a committed writer who was intent on
being taken seriously, and who wanted to be paid for her work. For
although Louisa Meredith had believed that life with attractive and
relatively wealthy Charles Meredith would be comfortable (and of short
colonial duration), he soon showed himself to be financially incompetent[36]
and money was often in short supply in the Meredith household: Louisa
Meredith was prompted to write and to publish in part from economic
necessity.

Louisa Meredith made a major contribution to the development of
Australian women's world of letters. Because she was a woman of 'repu-
tation' back home, the way had been prepared for her Australian writings

to be well received: with the reputation she had gained for detailed and accurate observation in her study of nature, the way was also open for her reports to be seen as trustworthy and reliable. And because this woman of well-established English literary credentials found that there was so much in Australia that was worthy of attention, Louisa Meredith helped to legitimate interest in Australian flora and fauna, and social customs. By setting out the reality of the Australian scene – in much the same engrossing way that she had documented the English scene – she shifted the focus from the strange, exotic and inexplicable to the ordered and comprehensible. When she described the natural surrounds or the colonial people she did so with the aim of showing that while different – even intriguing – they were no aberration, but an integral part of the pattern of world order. In treating the colony in this way, Louisa Meredith took the element of the 'fantastic' out of Australia and set it firmly in the understandable world.

Had she been a man, no doubt she would have been called an incisive philosopher of natural history as well as a perceptive writer: clearly her accounts of the botany, zoology – and sociology – of the colony made a contribution to the scientific understandings of her time. The only precedent for this form of writing was provided by that other devastatingly shrewd observer and seriously disciplined writer, Harriet Martineau (1802–76), who in 1837 published *Society in America*, which was a survey (and interpretation) of American morals and manners for a British audience. But while to some extent Harriet Martineau has retained her reputation as philosopher, political theorist and scientific writer,[37] the intellectual and scholarly dimension that characterises Louisa Meredith's comparable contribution has been overlooked, particularly in her adopted homeland.

That Louisa Meredith wrote authoritative accounts of people and places does not mean that she wrote dry, dull – suitably detached – prose. On the contrary, it is the wit and the entertainment value of her writing which help to capture some of the (often incongruous) elements of early colonial days. So consistently good were her reports on everything, from the hedonistic life in Sydney to the need for conservation in Tasmania, that it is almost impossible to select extracts which illustrate the range of her interests and do her justice.

On her approach to Sydney, Louisa Meredith recorded her impressions of the harbour in a manner that is both objectively accurate and emotionally moving: so successful is her style in promoting interest and evoking appreciation for beauty that her prose would still provide unsurpassed 'copy' for tourist brochures. It is this attention to detail along with her ability to convey the fascinating ethos of the whole which was responsible in part for Louisa Meredith's popularity as a 'reliable witness' back home: it was her ability to see below the surface, to register

and record some of the interweavings of relationships and the nuances
of life, that mark Louisa Meredith as one of the originators of Australian
women's literary traditions. Her accounts of the Sydney markets, for
example – from a distinctly female perspective – afford one example of
her literary achievements:

> The market in Sydney is well supplied and is held in a large
> commodious building, superior to most provincial market-houses
> back home. The display of fruit in the grape season is very beautiful.
> Peaches also are most abundant, and very cheap; apples, very dear,
> being chiefly imported from Van Dieman's Land, and frequently
> selling at sixpence each. The smaller English fruits, such as
> strawberries, etc., only succeed in a few situations in the colony and
> are far from plentiful. Cucumbers and all descriptions of melon
> abound. The large green water-melon, rose-coloured within, is a
> very favourite fruit, but I thought it insipid. One approved method
> of eating it is, after cutting a sufficiently large hole, to pour in a
> bottle of madeira or sherry and mix it with the cold watery pulp.
> These melons grow to an enormous size (an ordinary one is from
> twelve to eighteen inches in diameter), and may be seen piled up
> like huge cannon balls at the fruit shop door, being universally
> admired in this hot, thirsty climate.

(Louisa Meredith, 1844, p. 43)

This delightful blend of fact and fancy was the very thing that British
audiences were looking for, and Louisa Meredith soon found that in
leaving England she had not lost her following. She continued to write
and to be read and, while her first colonial publications reveal her
identification with British values, a survey of her writing shows her shift
to the adoption of Australian life and loyalties. Not that this is surprising:
from the outset she was concerned that Australians should cease to 'ape'
British ways and should develop habits that were more appropriate to
their environment:

> There are some excellent fish to be procured here, but I know them
> only by the common Colonial names, which are frequently
> misnomers. The snapper, or schnapper, is the largest with which I
> am acquainted, and is very nice, though not esteemed a proper dish
> for a dinner party – why, I am at a loss to guess; but I never saw
> any native fish at a Sydney dinner-table – the preserved or cured
> cod and salmon from England being served instead, at a considerable
> expense, and, to my taste, it is not comparable with the cheap fresh
> fish, but being expensive it has become 'fashionable' and that

circumstance reconciles all things. The whiting, much larger than its English namesake, is perhaps the best of all; but I pretend to no great judgement as a gastronome. I thought the rock oysters particularly nice, and they are plentiful and cheap; so are the crayfish, which are very similar to lobsters, when small, but the large ones rather coarse. I must not end my list of fish that we eat without mentioning one that is always ready to return the compliment when an opportunity offers, namely, the shark, many of whom are the habitants of the bright tempting waters of Port Jackson. Provisions vary much in price from many circumstances. Everything was very dear when we landed in New South Wales, and at the present time prices are much too low to pay the producers.

(Louisa Meredith, 1844, pp. 43–4)

Some of Australia's problems have, it seems, always been present. Louisa Meredith was quick to identify them, and to make recommendations when a solution was possible – and to counsel resignation when one was not. Dust, for example, was one of the local attributes that she found most distressing and about which little could be done: dust, and the wind – particularly the 'brick-fielders', winds so named because of the direction from which they had come. But of course there were other equally discomforting local factors with which one had to contend:

Flies are another nuisance; they swarm in every room in tens of thousands and blacken the breakfast or dinner table as soon as the viands appear, tumbling into the cream, tea, wine and gravy with the most disgusting familiarity. But worse than these are the mosquitoes, nearly as numerous and infinitely more detestable to those for whose luckless bodies they form an attachment, as they do to most newcomers; a kind of initiatory compliment which I would gladly dispense with, for most intolerable is the torment they cause in the violent irritation of their mountainous bites. All houses are furnished with a due attention to these indefatigable gentry, and the beds have consequently a curious aspect to an English eye accustomed to solid four posters, with voluminous hangings of chintz or damask, and a pile of feather beds which would annihilate a sleeper in this climate. Here you have usually a neat thin skeleton-looking frame of brass or iron, over which is thrown a gauze garment, consisting of curtains, head and tester, all sewn together; the former full, and resting on the floor when let down, but during the day tied up in festoons. Some of these materials are very pretty, being silk, with satin stripes of white or other delicate tints on the green gauze ground. At night, after the curtains are lowered, a grand hunt takes

place, to kill or drive out the mosquitoes from within; having effected
which somewhat wearisome task, you tuck the net in all round, leaving
one small bit you carefully raise, and nimbly pop through the aperture
into bed, closing the curtain after you. This certainly postpones the
ingress of the enemy, but no precaution that my often tasked
ingenuity could invent would prevent it effectually. They are terrible
pests and frequently aided in their nocturnal invasions of one's rest
by the still worse and thrice disgusting creatures familiar to most
dwellers in London lodgings or seaport inns, to say nothing of fleas,
which seem to pervade this colony in one universal swarm. The thickest
part of a town, or the most secluded spot in the wild bush, is alike
replete with these small but active annoyances.

(Louisa Meredith, 1844, pp. 44–5)

It would have to be conceded that there were some contexts in which
the colonials abandoned British ways and developed their own peculiar
means of dealing with their own peculiar pests and problems. And in
reporting on the sleeping arrangements (of the more fortunate members
of society) Louisa Meredith provides a valuable social document, an
amusing read, and a testimony to the adaptive qualities of Australians.
But if she is prepared to give praise where she thinks it is due, so too
is she quick to criticise when she thinks it is called for. Ever conscious
of the rich intellectual resources she had relinquished in her move from
English society, Louisa Meredith reports on her own case of culture
shock which – while it may have catered to some of the pride and
prejudices of her British audience, could be calculated to arouse the
resentment of many Australians:

I heard that there was a Museum of Natural History; and the
'Australian Library' contains an excellent selection of books for so
young an institution. The circulating libraries are very poor affairs,
but, I fear, quite sufficient for the demand, reading not being a
favourite pursuit. The gentlemen are too busy, or find a cigar more
agreeable than a book; and the ladies, to quote the remark of a witty
friend, 'pay more attention to the adornment of their heads *without*
than *within*.' That there are many most happy exceptions to this
rule, I gladly acknowledge; but in the majority of instances, a
comparison between the intellect and conversation of
Englishwomen, and those of an equal grade here, would be highly
unfavourable to the latter. An apathetic indifference seems the
besetting fault; an utter absence of interest or inquiry beyond the
merest gossip, – the cut of a new sleeve, or the guests at a late
party. 'Do you play?' and 'Do you draw?' are invariable queries to a

new lady-arrival. 'Do you dance?' is thought superfluous for
everybody dances; but not a question is heard relative to English
literature or art; far less a remark on any political event, of however
an important a nature: – not a syllable that betrays *thought*, unless
some very inquiring belle ask, 'if you have seen the Queen, and
whether she is *pretty*?' But all are dressed in the latest known fashion,
and in the best materials, though not always with that tasteful
attention to the accordance of contrast of colour which an elegant
English-woman would observe.

(Louisa Meredith, 1844, pp. 49–50)

In Louisa Meredith's account of early Australian mores we can see
not just the traditions, but some of the *myths* – in the making. To what
extent these descriptions were accurate – and to what extent they have
played a part as self-fulfilling prophecies – it is impossible to determine,
but it is interesting to note her descriptions in the 1840s of some of
those traits which have since been proclaimed as typical of the population.
If Louisa Meredith was the first she was by no means the last popular
writer to deplore Australians' ostensible lack of interest in intellectual
and creative aspects of life: that the gentlemen were too busy to read,
the ladies too distracted, and *all* too apathetic to pursue political or
literary questions with verve or vigour, are allegations that have frequently
been levelled at the members of Australian society, and while they might
have 'been true', it is also the case that they might have 'come true' after
such constant reiteration. For even when she outlines Australian reading
habits, Louisa Meredith's account contains some inherent contradictions.
To my mind, the remarkable feature of her report lies not in her reference
to the colonial reluctance to read but in her acknowledgment of the
existence and relative excellence of the Australian Library and Museum:
that such institutions should have been established in the space of
fifty years, and in the face of so many pressing opposing practical
needs, seems not only more memorable, but could be quoted as evid-
ence of the importance attached to intellectual pursuits in the young
colony.

However, the fact that the perspective through which Louisa Mere-
dith's experience is first filtered is essentially British – and provides a
none too positive picture of Australia – does not detract from her contri-
bution to literary history. Rather, in her well-documented shift from
British values to those of her adopted country, Louisa Meredith gives
us some graphic illustrations of the way individuals – and the society –
can be changed by their environment. By the end of her writing career,
her commitment to Australian customs is quite clear: had she returned
to England to write, it is likely that she would have evinced impatience

with nineteenth-century Victorian values when viewed from her recently acquired Australian perspective. But in 1844 it was still the peculiar morals and manners of the colony that were giving her cause for concern.

Some of her accounts are refreshing, and amusing: one illustration is her anxiety about Australian language habits. She does comment on the capacity of Australians to coin a colourful idiomatic style – as for example the case of the native born (not Aboriginal) who are referred to as 'the currency' . . . in distinction from '"the sterling" or British born residents' (1844, p. 50). But she also reveals her distaste for the Australian accent and professes her curiosity as to its causes:

> what puzzles me exceedingly to account for, a very large portion of both male and female natives *snuffle* dreadfully: just the same nasal twang as many Americans have. In some cases English parents have come out here with English-born children; these all speak clearly and well, and continue to do so, whilst those born after the parents arrive in the colony have the detestable snuffle. This is an enigma which passes my sagacity to solve.
>
> (Louisa Meredith, 1844, p. 50)

That the nasal Australian accent was attracting complaints as early as 1844 is an interesting item of linguistic history. And while in some instances Louisa Meredith was highly critical of Australian snobbery – and the colonial tendency to strive to out-British the British – language was one area where she held it was preferable to preserve the British practices. In other matters she was much more open to local adaptations: she was full of praise for Australian ingenuity in the bush and, on a later journey through the wilds of Tasmania, made a notable contribution to Australian recorded history when she presented one of the first accounts of that quaint Australian custom, the *barbeque*, known then by the more evocative label, 'the sticker-up cookery':

> The orthodox material here is of course kangaroo, a piece of which is divided nicely into cutlets two or three inches broad and a third of an inch thick. The next requisite is a straight clean stick about four feet long, sharpened on both ends. On the narrow part of this, for the space of a foot or more, the cutlets are spitted at intervals, and on the end is placed a piece of delicately rosy fat bacon. The strong end of the stick spit is now stuck fast and erect in the ground, close by the fire to leeward; care being taken that it does not burn. Then the bacon on the summit . . . drops a lubricating shower of rich and savoury tears on the leaner kangaroo cutlets below, which

forthwith frizzle and steam and sputter with as much ado as if they were illustrious Christmas beef grilling in some London chophouse.

(Louisa Meredith, 1852, *My Home in Tasmania during a residence of nine years*, vol. II, pp. 54–5)

The appeal of such accounts to a British audience can be fully appreciated and for Louisa Meredith it was fortunate that there was a demand for her 'documentaries' of colonial life. In more ways than one her Australian adventure was proving to be much less comfortable than she had assumed it would be. Though a woman of virtually indomitable spirit she struggled against depression in her first year in New South Wales: this is not surprising given that she felt so cut off from all her intellectual sources, that she was homesick, pregnant, and her husband's business had failed. And it was with some trepidation (but little alternative) that she left her home in 'Homebush' on the outskirts of Sydney, and set off for her uncle's (now father-in-law's) residence in Tasmania.

In 1840, when she set foot on that island fortress 'there were 41,000 people in Van Dieman's Land and Hobart Town as a busy, bustling place with prices rising in both land and trade' (Vivienne Rae Ellis, 1979, p. 93), and there was still a steady influx of convicts who provided most of the labour. But Louisa Meredith did not linger – not to study the peculiarities and problems of a penal colony, nor to enjoy some of the relatively civilised comforts afforded to the more privileged in Hobart Town: her destination was the isolated Great Swan Port, 120 miles overland, and her description of the trials and terrors that the trip entailed makes Annabella Boswell's journey from Capertee to Liverpool look like a pleasure picnic. Louisa Meredith's ordeal – with a young baby – was truly horrendous. And for Louisa Meredith so too was it horrendous to find herself in such an isolated situation – in the very place she had disdained to serve as a governess but a few years before.

Once more however – despite the odds – she revealed her determination to create for herself a literary life: she took up her pen and described and dissected the people – and the place – of her times. And although she may have arrived in the colony with the advantage of having learnt her craft in a more conducive climate, her conditions were soon indistinguishable from those which prevailed for many other aspiring Australian women writers: she was on her own, without benefit of the exchange or support of a literary community, and with little or no encouragement in the private or the public sphere.

Louisa Meredith looked to her surrounds for her sources of literary inspirations, always with an eye to its attractions for her audience 'back home'. In this sense she was a professional writer who could distance herself from her material. Unlike Annie Baxter[38] – who in much the

same place and much the same period – was obtaining a form of emotional satisfaction from confiding her doubts and despair to her diary, Louisa Meredith was obtaining her satisfaction from the literary task of polishing her prose for publication.

In choosing her topics, Louisa Meredith provides some illuminating insights into the processes of a woman writer, and some salutary accounts of the pressures on women of her time. Her treatment of 'the servant problem', for example, shows how far removed the colony was from some of the Victorian values of Britain – and how far removed the servants (and convict women) were from the lady whom they served. Descriptions such as the following may have been extremely useful in the nineteenth-century British context, where accurate and current information was needed, but they are also very useful in the twentieth-century Australian context where an exploration of women's literary history is being undertaken:

> My first prisoner nurse girl was taken at random by our agent in Hobarton, from among the herd of incorrigibles in the female house of correction, or 'Factory' as it is termed; and was indeed a notable example: – *dirty* beyond all imagining! She drank rum, smoked tobacco, swore awfully, and was in all respects the lowest specimen of woman-kind I ever had the sorrow to behold. Before I had time to procure another, she drank herself into violent fits, so that four men could not hold her from knocking herself against the walls and the floor, then went to hospital, and finally, got married!

> (Louisa Meredith, 1852, vol. 1, pp. 153–4)

'Getting married' was seen as a readily available option for women of all walks of life in the colony: whereas in Britain the proportion of women to men had led to the pronouncement that there were thousands of 'surplus' women, in Australia the situation was just the reverse – not that this led to the labelling of men as 'surplus' of course.

So many women spent so little time in the single state that marriage was generally viewed as a contributory cause to 'the servant problem' in the colony: this was certainly how it was seen on occasion in the Meredith household. And if he had no capacity to handle money, Louisa Meredith's husband showed he had a capacity for humour when he placed the following advertisement in the newspaper:

> How to Get Married!
> Engage with the undersigned
> as cook or housemaid.
> Sg. Charles Meredith

> (Quoted in Vivienne Rae Ellis, 1979, p. 109)

These are the gems which provide some of the delights of literary history – and many of them are to be found among Louisa Meredith's accounts of early colonial life. Often ahead of her time much of her counsel for the colony remains exemplary: her pioneering campaign against cruelty to animals, her protest against the needless destruction of flora and fauna, and her advocacy of conservation, all give her writing relevance today: the manner in which she conducted her own life – with her insistence on the necessity of creative and intellectual resources and the right of women to lead their own (rewarding) lives – all mark her as a 'modern'.

If Louisa Meredith had her strengths, unfortunately she also had her weaknesses. Although she showed nothing other than some of the prejudices of her time, her attitude to Aborigines was indefensible. True, she was instrumental in having the last remnants of the Tasmanian Aboriginals photographed for the purposes of science (Vivienne Rae Ellis, 1979, p. 207), but this was basically because she saw the Aborigines – like plant and animal life – as something apart from herself and a fit object for study. To Louisa Meredith they were 'the very lowest creatures in human form', for whom she had little or no sympathy.

That she had limitations, however, should not allow us to lose sight of some of her undeniable and extraordinary achievements. In an age before technological communication, her documentaries on colonial life helped to provide factual and fascinating information on Australia: in an age before it was acceptable for women to be professional writers her literary commitment, creativity and competence all helped to lay the foundation stones for future generations.

The pressures that were applied – both directly and indirectly – to prevent Louisa Meredith from writing should not be underestimated. There were the pressures of being a wife and mother in the 'unserviced' Australian environment – and the pressure of having to prove that she was a woman, of having to put womanly things first, in order to reassure all that her role as a woman was not being undermined by her regard for her writing.

This contradiction between being a woman and a writer was a terrible source of conflict for so many nineteenth-century women with literary aspirations: it is a conflict which the critic Margaret Swann makes clear continued into the twentieth century. And it is further evidence of the sexual double standard that operates in the world of letters. For while no man's literary reputation has ever been risked by his propensity to engage in husbandly tasks, Margaret Swann tries to persuade her readers that even though *Mrs* Meredith was a professional writer it was not at the expense of her womanly duties:

> Mrs. Meredith was a woman of such wide interests, varied
> capabilities, and unbounded energy that it is practically impossible

to give a complete account of all that she encompassed in her long and active life. In discussing her accomplishments in Literature and Art, it should be born in mind that she was first of all a capable housekeeper, looking well to the ways of her household, and besides attending to the ordinary household duties, she made all the clothing worn by herself and her three sons; and, as her grand daughter Mrs. Norvill remarks – 'those were the days before sewing machines'.

(Margaret Swann, 1929, p. 11)

Certainly Australia was the land where – as the novelist Elizabeth Murray said in 1864 – *all* must work (see p. 122), but when it came to women the adage was prone to have more practical than intellectual applications. That without benefit of models – or a conducive literary climate – Louisa Meredith insisted on being a professional woman writer, says a great deal about her commitment and her contribution to the Australian cultural heritage.

But it would be remiss to omit any reference to Louisa Meredith's fiction: apart from the excellent children's stories she wrote – set in the new colony and invested with educational overtones – Louisa Meredith also wrote 'theatricals' and novels. In her first novel, *Ebba* she returned (somewhat nostalgically) to 'home' for her setting – Castle Bromwich: initially serialised in the *Australasian* in 1866, it was published in London (by the reputable Tinsley Brothers) as *Phoebe's Mother* in 1869. I have not had the pleasure of reading this novel, nor have I read Louisa Meredith's second novel, *Nellie, or Seeking Goodly Pearls*, partly because of its unavailability: as Vivienne Rae Ellis has pointed out 'The only copy of this book is located in the British Museum' (1979, p. 196). Given the unobtainability of her books, one must rely heavily on Louisa Meredith's biographer's assessment, which is that the literary style of the novels 'is stilted and lifeless and in no way compares with the excellent writing of her personally-based descriptive travel books' (Vivienne Rae Ellis, 1979, p. 196).

While I have no wish to challenge this opinion of her work, I would rather readers were in a position to make decisions for themselves about the relative merits of this remarkable woman writer. In her own time, Louisa Meredith enjoyed considerable esteem and acclaim: in 1867 the *Illustrated Melbourne Post* gave some idea of her local success with its statement that:

Mrs. Meredith – whose political writings and botanical drawings have a place on every drawing room table throughout the colony – has been giving dramatic readings in Hobart Town with much success.

(*Illustrated Melbourne Post*, 20 June 1867)

That she should now be out of print, and so ignominiously ignored, casts aspersions on the learning and legitimacy of the Australian literary establishment. It would be preferable to have her books in print and to promote criticism and debate on her contribution and its limitations: as the first professional Australian woman writer she deserves no less.

CHAPTER 3

Personal chronicles and present problems

The emergence of the first professional woman writer did not herald the end of the desire – or the necessity – for women's personal chronicles. While Louisa Meredith may have extended the range of possibilities and shown that publication was an option for women, there were still many who kept records of their lives and their travels for purely private reasons. One such woman was Annie Baxter (1816–1905) who was the author of the first known major autobiography.[39] At much the same time that Louisa Meredith was making the most of some very meagre resources to sustain herself as a published writer, Annie Baxter was writing her impressive thirty-six volumes of autobiography to sustain herself as a human being:

> My journal: I always come to you to enumerate my grievances. No one shares the secrets of my heart as you do – and why? Because your pages, like my little troubles, will never be *seen*!

> (Annie Baxter, 1984, p. 87)

In fact, as Lucy Frost points out, Annie Baxter's claim was not strictly true: she did show her diary to select friends. But only those to whom on occasion she wanted to reveal her secrets and her troubles: one wonders how she would have reacted to the now public exposure of her problems – for she assuredly had plenty of them.

Married at seventeen to the somewhat insensitive Andrew Baxter, Annie accompanied the penniless lieutenant to Van Dieman's Land, where she started to keep her journal in 1834. For more than twenty years she wrote her powerful and perceptive personal chronicle of the folly of impulsive marriage ('I was only bent on pique') and registered

her emotionally evocative record of regret ('No one can half conceive the horrors of an unhappy marriage – but those who experience it –', see Lucy Frost, 1984, p. 87). Not that Annie Baxter's account is bitter or twisted: on the contrary, her positive determination to survive and her spirited attempt to subvert and resist some of the pressures placed upon her as woman, wife – and pioneer in the bush – ensure that her autobiography makes unforgettable reading. The fact that the only part of her more than 800,000 words which is readily available is to be found in a few extracts in Lucy Frost's excellent anthology of *Voices from the Australian Bush* is not only lamentable, but inexplicable. For Annie Baxter's personal chronicle encompasses some of the low points of women's experience as well as some of the high points of women's literary achievements, and as such it deserves recognition as part of the national heritage.

In the most appalling circumstances, when she could well have been forgiven for abandoning all in despair, Annie Baxter shows her mettle and her merit when she takes up her pen. She also shows the way in which the published word is linked to the personal chronicle when she 'polishes' her accounts of experience and transforms some of the dreadful conditions of existence into an amusing anecdote for an acquaintance. Letters written in 1840 to her friend Henrietta, in England, were copied into a sketchbook (and were accompanied by pencil drawings): they reveal much about the bush-woman's plight – and Australian literary traditions:

Yesabba
January, 1840.

And so you really and truly wish to know what a bush life is! I'm not very au fait at such descriptions, but I'll try –

A bush life! Oh! 'tis the most rustic thing you can possibly imagine – almost approaching barbarism – but to commence –

The time at which Mr. Baxter took it into his head to settle, was August '39 – We had no house or hut of any kind of our own, nor had we even fixed on one particular spot to erect any – a friend of our's and a Bachelor, (what excellent persons this poor, neglected, despised race are!) offered us his cottage until we should have our own – so to it we went – very soon after, we pitched our slab hut on a pretty flat, close to a nice creek of fresh water –

I entered my hut, when only half the bark roof was on – and to add to our discomfort it rained almost incessantly for the first three weeks – It certainly was most ludicrous to see the oposum skin rug nailed up to a rafter, to keep out the rain – we had two rooms – separated by a large Meg Merrilies shawl – The one was our bedroom – the other sitting room and kitchen and all – we might almost have done without the kitchen – as you will say when I tell you what we had to cook –

Everything was most exorbitantly high when we 'squatted' (i.e. settling on Government land and not purchasing it –) and we determined not to get into debt – so we commenced feeding ourselves on corn-meal – Now this is most excellent food for young chickens, but unfortunately we are not of this denomination; therefore we all began to look uncommonly thin – Baxter, not being very strong could stand it but a short time – and flour being 75 per ton, the next was to be considered *what* we could eat – 'Rice is low,' said my spouse, 'we will send for some rice; we can mix that with corn-meal, and I dare say it will be very wholesome'! We tried to fancy this wholesome food, and had nearly done so, when one day a friend came in we of course asked him if there were any news – 'None of any consequence,' said he, '*only* rice is high!' Now this to us was very important, and I shall never forget the look of utter dismay that Baxter put on at this intelligence – enough to say 'We're done for!'

The rice came – we eat it with coarse sugar, and no milk – and altho' we do not find it improve our condition, 'twas pleasing to know that it agreed with others – to witness – the mice, cats etc. – I really cannot tell you the millions that fed on our *Rice*!

At last our cows began to increase – and the dairy was made – but we had no person to make the butter and cheese . . . but oh! the labour! Often whilst busy in my dairy, have I cried, and wished I had been born a dairy-maid!

'Perhaps,' thought I to myself, 'I might have grown too stout in this very healthy district, unless I had some severe exercise!'

AMB.

(Annie Baxter, 1984, pp. 48–91)

Apart from the fact that I find it reassuring to come across a writer who uses dashes with much the same frequency that I have been accused of doing, I am conscious of the art that is needed to turn such terrible ordeals in the bush into such good yarns: the absence of food, shelter and friends – and the presence of danger and drudgery – is no laughing matter, and yet Annie Baxter is able to polish her prose to the extent that the very real hardships of her life are camouflaged under a cover of sophisticated humour. This is a commendable achievement.

When Annie Baxter declared that she had seen better days, she was not exaggerating. Not only had she experienced many more comforts in England, she had enjoyed a much greater social life in Van Dieman's Land before her venture north, into the bush. It is interesting to trace her journey from 1834 where, in Launceston, she was entertained by the social and flirtatious whirl of concerts, dinners, events, visits and

balls, on to the less fashionable but more expensive (and far more gauche!) Sydney: then in 1839 to the privations and primitive conditions of bush-life at Yesabba, near Port Macquarie. In her experience of contrast, even of incongruity, Annie Baxter encountered some of the contradictions that were commonplace in the colony.

Although she may have travelled a long way in this vast new continent, Annie Baxter also shows that she was a member of a very small community: at Yesabba, her neighbours were Annabella Boswell's relatives at Lake Innes and Annie Baxter refers to them as the 'aristocrats of the district' (1984, p. 93). Among her other neighbours were of course the blacks, and it is interesting to note the qualitative difference in her attitude towards them from that of her contemporary, Louisa Meredith. Again, writing to Henrietta in April, 1840, Annie Baxter says –

> The Blacks have been a source of considerable entertainment to us
> – I like them – and think, if properly managed, they may be of
> much service to settlers – They assisted us in many things – even in
> eating our *Rice*! They never intrude either – and so prove themselves
> much more mannerly than I am – having taken up your time with
> this scrall.
>
> (Annie Baxter, 1984, p. 94)

Despite the literary skill and social insight that is inherent in her letters, it is Annie Baxter's journal which is of primary interest: as a documentary of one woman's experience of the problems which are part of the commonalities of so many women's lives, Annie Baxter's journal makes a substantial contribution to women's heritage – to the understandings of how and why women wrote – and to that continuum of women's recorded reality which reveals the time-enduring patterns of women's consciousness.

While the best course would be to allow Annie Baxter to present the story of her life in her own inimitable words, the constraints of space preclude this possibility: a summary of some of the major events in her life – accompanied by some illustrative extracts – will have to suffice instead. Although in Launceston Annie Baxter had been surrounded by some of the amenities of the civilised world and although her life may have been full of diverting activities, she was by no means fulfilled! In contrast, despite her protestations about the arduous work, the frustration and the veritable lack of appreciation, Annie Baxter found compensations, even contentment, in the bush. But if bush-life itself represented a form of improvement and provided her with a sense of achievement and satisfaction, the same certainly cannot be said of her marriage. And her difficulties were compounded by hardship, miscarriage, ill health – and Andrew Baxter's ill humour:

15th March, 1840. Sunday. What a sabbath has been passed in this
house! I can almost affirm that not an hour has gone by, without
Baxter's horrible blasphemy! – he struck Supple and Scotchy – and
swore at me – I care about as much for that as I do for him – not
one straw – Nothing in this world will ever make me even esteem
him! I positively hate him – his presence is loathsome to me – and
as soon as ever I *can* get away, I will – and never return to him again!

(Annie Baxter, 1984, p. 98)

Strong words! A strong woman.

The relationship between husband and wife was further estranged by
an incident which would probably not have been all that unusual in the
outback. Although historically the topic has virtually been taboo, because
Annie Baxter had few inhibitions about the entries she made in her
journal we know that Andrew Baxter had an Aboriginal mistress and that
his wife was distressed about it. Whether she felt that the Aboriginal
woman was being exploited or whether this event served Annie Baxter as
an excuse it is not possible to determine: what Annie Baxter determined,
however, is unequivocally clear; she insisted, 'with a registered oath, that
he must consent to take *for ever*, one bed, and I another; or else I would
go to my Uncle' (1984, p. 100).

Unlike some of the other women of her generation, Annie Baxter
seems to have been able to write – and to talk – about her personal
repudiation of the doctrine of conjugal rights (which even now in most
states still holds that a wife must be available to her husband and cannot
therefore be raped by him). In her journal Annie Baxter makes numerous
references to her refusal to sleep with her husband and to the fact that
her rejection of him is widely known:

Friday 16 February, 1843.
 Mrs. McLeod was talking to me the other day, and amongst other
things she said 'Do you still continue separated from Mr. Baxter
at Night?' Strange thing that people cannot fancy my doing so! I only
answered 'I slept with Mr. Baxter for the last time in this World, next
May, will be 4 years'.

(Annie Baxter, 1984, p. 146)

After her four miscarriages and her resolve 'to refuse' she had no chil-
dren. Nor was she to be seduced into making a 'mistake': writing of her
planned trip to England in July 1843, Annie Baxter states –

And now he is continually annoying me to sleep with him again
before I leave – Now this is a most knavish idea – He knows very

well that after having had four miscarriages and not having for so
long a time been in the way of having more – that I should naturally
be *enceinte* immediately – He would then lay it to my conduct on
board a ship going home – But I had the advice from one older
party than myself – on no account to humour him in this – there
was no occasion for giving in – for I am not of a prostitute
disposition – and this would be mere prostitution.

(Annie Baxter, 1984, p. 103)

Annie Baxter does not mince words: her attitude towards women's
rights, and sexuality, is forthright and curiously contemporary. When it
comes to the issue of birth control – for herself and others – she
reveals a frank and humorous approach which is testimony both to her
independent spirit and the quality of her writing:

15th Friday . . . I was settling Mrs. Johnson's account yesterday, and
she was telling me that Mrs. Rudder had told her make haste back,
as she expected her accouchement immediately! This is only the
13th! And the poor children have positively scarcely a mouthful to
eat – this is tempting Providence indeed! *Why* do they have any
more? I remember telling my pretty little friend Mrs. C.F. that she
must not have any more children – She answered quaintly, 'But how
is it possible for married persons to avoid it?' Just as if the bare
ceremony of matrimony was to be the cause of myriads starving!

(Annie Baxter, 1984, p. 109)

It is these glimpses of the perennial problems of women – and the range
of explanations and solutions – which give Annie Baxter's journal the
status of an authoritative document of social history – and should grant
it a permanent place in the records which map women's consciousness
and illuminate women's reality.

Unfortunately not all of the volumes of the journal could be published,
partly because Annie Baxter's frank confessions about her hostility
towards her husband – along with some of her own transgressions –
were not always safe from her husband's prying eye. There would not,
of course, have been much scope for secrets or privacy in a bush hut.
When Andrew Baxter did get to read some of the mocking and
maddening charges that his wife made against him, not to mention her
admission of her own previous love affair, he was enraged. As Lucy
Frost comments, 'Not surprisingly, he destroyed the journal and the love
affair' (1984, p. 101): the volumes from July 1841 to July 1843 cannot
now be found.

But even these actions could not intimidate Annie Baxter:

Yesabba, July, 1843.
I think I had written about thirty pages at the other end of this book,
when one day my amiable consort tore them all out! Nothing could
have much more annoyed me altho' if he had asked me to read it, I
would (not withstanding a few pieces of abuse of him) have shown
it him – not so! He went while I was in the settlement and made a
second key to my drawer, read my journal – and replaced it – in
the meanest manner possible – This, he may see with all my heart
– and I trust he will like it – . . .
 (Annie Baxter, 1984, p. 101)

And she goes on to list further grievances against him; some of his habits
were hardly endearing:

Upon going to my trunk yesterday, I found that the lock was spoiled
– Some person, and I presume that to be Baxter, had been opening
my box to see what it contained, and injured the lock in so doing –
Strange thing being so fond of prying! I recollect now, that men
have a superlative share of curiosity – for I once gave three books to
an old friend of mine, *two* of which he might read – The *third* he
could not help opening – and yet I consider him one of the élite of
mankind –
 (Annie Baxter, 1984, p. 126)

In some ways these snippets from Annie Baxter's journal are misrep-
resentations of her priorities and her processes, for it was not the daily
jotting she was inclined to. Often her accounts are very long and for
pages she reflects upon her personal experience and then, 'aided by
philosophy', on the meaning of life. Clearly in the enforced isolation of
the outback, her journal filled the role of intellectual companion and
confidante. She used it not only to find some emotional release from the
pressure of living with someone whom she neither liked nor respected,
but also to find her 'self' and her place in the wider world. The entries
sometimes go on for many pages and cover topics as varied as the
excursion of the chickens into the dairy to eat the cheeses, to the details
of Mrs Horne's audacious affair, and the destructive effects of drink,
and they reveal Annie Baxter's way of ordering the world – of organising,
reflecting upon, expanding and changing her own reality. She takes the
everyday individual experience and elaborates it to generalise upon the
human condition:

Drink! What does it not cause a man to do? It unfits him for society

either at his own home or abroad – It puts him on a level with the
brutes – And in this Colony, whoever *once* gives way to it, will never
(unless by a most superhuman force) get the better of it – It is
painful to fancy all this – and yet, are there not so many instances
of it! Talented young men – the very élite of any society, we see
giving way to this odious dissipation! Many is the heartache their
friends at home are spared by not being eye-witness of this – They
become perfectly maddened by intoxication – Even the lowest of men
lose all respect for them – and indeed in some instances it is 'Hail
fellow! Well met!' with the commonest persons – of what use has
been their education – and their abilities! All to be buried in drink!

(Annie Baxter, 1984, p. 116)

Were Annie Baxter's journals to be readily available today – and to
comprise some of our cultural understandings – perhaps we would be
able to see some of the similarities between the nineteenth-century
attitude to the problem of drink and the twentieth-century attitude
towards the problem of drugs: at times, the very same words and phrases
are used to describe these dreadful 'evils'. Annie Baxter was simply
expressing the 'wisdom' of her generation when she railed against alcohol
and remonstrated that the first drink was the worst drink and would
lead directly to rack and ruin. It is her emphasis on prohibition which
distinguishes her stance from the one prevailing today and, were we to
have the benefit of her insights, no doubt we could develop a more
informed and rational perspective on the contemporary problem of drugs.

Just as we could learn from history if we had some of the views and
values of Annie Baxter for reference, so too would we have something
to think about if we were to study the novels of Matilda Jane Evans
(1827–86), who wrote under the name of 'Maud Jeanne Franc'. Settling
in Australia in 1852, she devoted herself to writing from 1868, and
published fourteen novels (several of them in England) and many short
stories. A devoutly religious woman she used her fiction – as did many
other women writers – for educational purposes,[40] and was particularly
concerned to provide moral guidance for the young. In her 'temperance
novels', such as *John's Wife* (1874), she reveals an uncompromising
attitude to drink and delineates the decline of a woman (as well as a
man) who destroys her own life and the lives of those around her when
she takes a drink. There is no notion that the impulse to drink could be
contained, that not all who have a drink automatically descend to the
depths of alcoholism: there is no conceptualisation of 'safe drinking'
among some of these nineteenth-century women, just as there is no
conceptualisation of safe drug-taking among some twentieth-century
commentators and writers.

Professional Pioneers

Of course, this is not to advocate the adoption of a safe drug-taking policy. It is not even to suggest that Annie Baxter or Maud Franc would have modified their attitude to drink in the light of more information or greater experience; nor is it to suggest that the present policy on drink is to be preferred. But it *is* to suggest that in order to make sensible decisions now we need to know more about the practices then. In some ways, this is what literature is for – to serve as a repository of meanings and explanations which can be drawn on to extend our present interpretations and to support our future projections. And while every women's meanings are missing from this continuum, while ever we encounter only silence and interruptions when we seek the explanations of women,[41] we are denied the full evidence of human experience and can be condemned to forming partial and unbalanced views.

But it is not just because of the direct and indirect detail of the past provided by their work that the omission of Annie Baxter and Maud Franc from our literary heritage is to be deplored. It is because Annie Baxter's diary is a delight to read – because it possesses all the best qualities of women's traditional writing – that it should be in print: for while Annie Baxter's message is marvellous her medium has merit too.

CHAPTER 4

●

Confounding conventions

While Annie Baxter was making an appraisal of her own world primarily for her own personal purposes, another intrepid young traveller was keeping account of her highly eventful life – but with the definite aim of publication. In surveying the literary scene during the mid-nineteenth century it would be negligent to leave out the contribution of Ellen Clacy, for even though she may not really qualify as Australian, her material is undeniably colonial and her style unmistakably typical of the women writers of her time.[42]

Not a great deal is known about Ellen Clacy – who in her own writing is not particularly self-revealing – but in London in 1853 she published *A Lady's Visit to the Gold Diggings of Australia, 1852–1853, Written on the pot by Mrs. Charles Clacy,* and it is clear that the young author was astutely aware of the nature of the market that she was appealing to:

> It may be deemed presumptuous that one of my age should venture to give the public an account of personal adventure in a land which has so often been descanted upon by other and abler pens; but when I reflect upon the many mothers, wives, sisters in England, whose hearts are ever longing for information respecting the dangers and privations to which their relatives at the antipodes are exposed, I cannot but hope that the presumption of my undertaking may be pardoned in consideration of the pleasure which an accurate description of some of the Australian Gold Fields may perhaps afford to many. . . .
>
> (Ellen Clacy, 1963, p. 9)

Apart from the fact that the book raises interesting qustions about the definition of 'an Australian writer', and the reality of the health, habits

and inhibitions of Victorian 'young ladies', Ellen Clacy's account provides some of the most action-packed and amusing anecdotes to have been written on the antipodean scene. As Patricia Thompson (the editor of the 1963 edition) comments, her British audience were highly appreciative: for although her homeward voyage was her honeymoon and she did not arrive back in England until February 1853, she published the book at once. It was well received and soon sold out (Patricia Thompson, 1963, p. 7).

To those who stayed at home there was an attractive escapist element in such exciting and exotic accounts, and a young woman being at the centre of the adventure added yet another dimension. Whether or not it was intentional, Ellen Clacy cast herself in the role of heroine when she recounted her experience of colonial life: in a manner far removed from that of her English contemporaries she –

> turned her hand to cooking, camping, washing for gold, as occasion demanded. She also wrote busily in her diary, collected facts and figures, involved herself in various adventures with abandoned wives and orphaned children, fell in love and got married – and naturally found some gold.
>
> (Patricia Thompson, 1963, p. 7)

But if she was unlike some of the women of her day in the way that she set out (unchaperoned) for the harsh life of the gold-field and the bush, in terms of what attracted her attention – and how she recorded it – she was very like some of the women writers of her period, and she shows some traits that are now considered typical of Australian authors. First of all, like so many women writers she breaks many of the boundaries of literary conventions. While a unified and authentic account of her experience, the book contains a mixture of writing styles: there are diary entries and shrewd observations on people and places; and there are straight 'travel reports', documentaries, itemised lists, including a copy of a mining licence; and amid all this there are complete short stories – 'good yarns' – of the outback life.

This raises the question of just how far the nature of the material has determined some of the features of Australian literature. Ellen Clacy's visit was hardly long enough for her to have acquired the attributes of the Australian character, and yet some of the incidents she describes in her non-fiction account would rival the story-telling prowess – and wry humour – of Henry Lawson, for example.

Some of the real events of the gold-fields needed no adornment to become very funny stories, which revealed some of the follies and foibles of human kind: and some of Ellen Clacy's observations of Australians at

work and play were pointed, profound and – some might go so far as to say – prophetic:

> The colonists (I speak of the old established ones) are naturally very hospitable and disposed to receive strangers with great kindness; but the present ferment has made them forget everything in the glitter of their own mines, and all comfort is laid aside; money is the idol and making it is the one mania which absorbs every other thought.
>
> (Ellen Clacy, 1963, p. 22)

And Ellen Clacy's comments on Australian chivalry have not lost their relevance:

> Another day, when passing the Post-Office a regular tropical shower of rain came on rather suddenly, and I hastened up to the platform for shelter. As I stood there, looking out into Great Bourke Street, a man, and I suppose, his wife passed by. He had a letter in his hand for the post; but as the pathway to the receiving box looked very muddy, he made his companion take it to the box, while he himself from beneath his umbrella, complacently watched her getting wet through. 'Colonial politeness' thought I as the happy couple walked on.
>
> (Ellen Clacy, 1963, p. 23)

Because of the eclipsing of women writers one of the elements which is often absent from the literary history of Australia is the woman's view of the world – and women's view of men. For women have often seen men very differently from the way that men have seen themselves, and to the extent that Ellen Clacy provides a female reference point for male behaviour, she stands firmly with many other Australian literary women.

But women writers have also frequently looked upon the plight of women from an entirely different perspective and it is in this respect that Ellen Clacy's account of gold-fields' life is qualitatively different from most of those which have been handed down as part of the heritage. It is how women and children fare on the gold-fields that becomes a matter of concern to Ellen Clacy: in the primitive canvas townships where dirt and disease prevail – and where men go mad with gold-fever – Ellen Clacy witnesses the dreadful existence of deserted wives and the privations and pain of orphans.

Among the short stories which are scattered through Ellen Clacy's factual account is the one of Jessie, the orphan; there is the one of the tragic end of the young woman twice abandoned by her unscrupulous lover and left to bear her illegitimate child; and the one of Harriette

Walters who, alone, follows her husband to Australia and, until she finds
him, dresses as a man to protect her against harassment. Commenting
on the writers who have by no means given 'unqualified support to the
idea of "mateship among the diggers"', H. M. Green states that 'Mrs.
Charles (Ellen) Tracy's [sic] record of her visit to the gold fields, "written
on the spot" is of unusual interest because of its point of view' (1984,
p. 349). One can only assume that this is a reference to her portrayal of
the otherwise often 'invisible' experience of women and to her penchant
for seeing men in anything but a permanently positive light. Not that
Ellen Clacy always thought that the behaviour of women was exemplary:
she describes women whom she sees as having been degraded by some
of the conditions of colonial life:

> Meanwhile we were seriously debating about again changing our
> quarters. We found it almost impossible to sleep. Never before
> could I have imagined that a woman's voice could utter sounds
> sufficiently discordant to drive repose from us, yet so it was.
> The gentlemen christened her 'The amiable female'.
> The tent of this 'amiable' personage was situated at right angles
> with ours and our shipmates so that the annoyance was equally felt.
> Whilst her husband was at work farther down the gully, she kept a
> sort of sly grog-shop, and passed the day in selling and drinking
> spirits, swearing, and smoking a short tobacco-pipe at the door of
> her tent. She was a most repulsive looking object. A dirty gaudy-
> coloured dress hung unfastened about her shoulders, coarse black
> hair unbrushed, uncombed, dangled about her face, over which her
> evil habits had spread a genuine baachanalian glow whilst in a loud
> masculine voice she uttered the most awful words that ever
> disgraced the mouth of man – ten thousand times more awful when
> proceeding from a woman's lips.
> But night was the dreadful time; then if her husband had been
> unlucky or herself made fewer profits during the day, it was misery
> to be within earshot; so much so, that we decided to leave so
> uncomfortable a neighbourhood without loss of time, and carrying
> our tents etc., higher up the gully, we finally pitched them not far
> from the Portland stores.
>
> (Ellen Clacy, 1963, pp. 62–3)

But if the 'locals' displayed some depraved habits, Ellen Clacy's
compatriots also provided plenty of ammunition for her poised pen. In
a style which shows just how successfully she could blend objective
reporting with some of the features of good story-telling she tells of a
meeting with a young man with whom she sailed from England:

One day during our stay in Melbourne he came to me and said laughing:

'Well, I've got rid of one of the bad *habits* I had on board the –'

'Where?' was my reply.

'That old frock-coat I used to wear in the cold weather whilst we rounded the Cape. A fellow down at Liandet's admired the cut, asked me to sell it. I charged him four guineas and walked into town in my shirt sleeves; soon colonized eh?'

(Ellen Clacy 1963, pp. 60–1)

Such lively first-hand descriptions ensure that *A Lady's Visit to the Gold Diggings 1852–1853* continues to be as entertaining – and informative – now as it was when it appeared upon the British scene. Because of the quality of its observations and commentary – and the talented writing style – Ellen Clacy makes a contribution to Australian history and to Australian literature.[43] If still in print her accounts of women's experience of the gold-fields would help to fill what is all too often a gap in the records of the social history of women: it would also help to show the extent to which the reality of Australia has in itself helped to shape the forms in which this experience is expressed. For while she was only a temporary Australian, Ellen Clacy's work should have a permanent place in the development of Australian women's literary traditions.

Another woman who should be valued is Lady Mary Anne Broome (1831–1911), who also wrote widely acclaimed reports of colonial life for those back in Britain, who also confounded literary conventions and wove her accounts from fact and fiction and who, like Ellen Clacy, had one of her books reprinted in 1963.

Born in Jamaica, Lady Broome was educated in England and became Lady Barker on her first marriage: widowed at the age of thirty (and with two children to support), she could have been excused had she believed the eventful part of her life to have been over. But at the age of thirty-six she married a young New Zealander, and set off with him to reap the rewards of his country's pastoral life. An account of this period (1865–68) is contained in her first book, *Station Life in New Zealand* (1870).[44] Lady Mary Anne Broome went on to travel extensively with her husband and to write many entertaining books about her experiences, including *A Year's Housekeeping in South Africa* (1880). As Alexandra Hasluck has said, Lady Broome

was one of the small number of women who during the nineteenth century sailed, pen in hand, to the less frequented parts of the world and set down their impressions for the stay-at-homes, who delighted to buy the gilt-edged books that resulted, profusely

illustrated with engravings. There is an attention to detail in the works of these women travellers that makes them invaluable to the historian.

(Alexandra Hasluck, 1963, p. 1)

Clearly Lady Broome made a contribution to the nineteenth-century women travellers' literature: she also made a contribution to the record of social history when, with books such as *A Years Housekeeping in South Africa*, she documented some of the experiences of colonial life that were common to women. And in *Letters to Guy* (1885) she made a contribution to Australian literature. Ostensibly written to her son who stayed in school in London when she accompanied her husband to Western Australia, these letters serve to show how women blurred some of the distinctions between fact and fiction and how Lady Broome – like Ellen Clacy – adopted an adventurous, open, wryly amusing style that was consistent with her material.

While the reports of Ellen Clacy and Lady Broome – and on occasion, Louisa Anne Meredith – have much in common with the chronicles of other Australian writers like Elizabeth Macarthur, Rachel Henning and Annie Baxter, there is one crucial difference: Ellen Clacy, Lady Broome and Louisa Anne Meredith wrote with the specific aim of publication – and without the 'protection' of pseudonyms. They were among the Australian professional pioneers.

CHAPTER 5

First fictions

By the mid-nineteenth century, women were also writing fiction and their novels were being published at home and abroad. However, unlike the travel accounts which shared some common features and were essentially 'Australian' in detail and tone, the early novels of the colony had no uniform focus; they ranged across the spectrum from the intrigues of upper-class English society to the troubles of convict women transported to Tasmania.

The Guardian, by 'An Australian' (Anna Maria Bunn 1808–89) was the mainland claim to cultural fame in that it broke the Van Dieman's Land monopoly on literary achievement – being the first novel to be published on Mainland Australia in Sydney in 1838. But except for the occasional humorous reference to Botany Bay – and the 'joys' of life in New South Wales – the novel has little to mark it as 'Australian'.

Born in Ireland in 1808, Anna Maria Murray embarked for Australia in 1827 and there married Captain George Bunn. While little is known about her, it seems that her novel of English/Irish manners was her only published literary work.[45] This is in some ways surprising for *The Guardian* is a well-crafted novel and although it has its limitations it could still be ranked with some of the good 'supporting' British novels of the day – so it could not have been the fruits of incompetence or failure that discouraged the author from writing more. Nor would it necessarily have been a shortage of material for the concerns of the novel are sufficiently 'fanciful' and far removed from the Australian reality to permit further – perhaps even infinite – possibilities.

The style of the novel is interesting: it is clearly a product of its time in that 'letters' play a central though not exclusive role in the structure. With its blend of letters (which demand first-person author involvement) and its narrated episodes (in which the author is outside the story as a

third-person observer), it serves as a good example of the transition between earlier and later forms of fiction.

None the less, *The Guardian* is a curious novel, and somewhat difficult to account for. It is about incest – but where incest is almost a random happening. For it is not a denunciation of deliberate incest nor a condemnation of those who stray from the straight and narrow and who, in the absence of certainty about fatherhood, are liable to be 'caught'. While the end is tragic – in that the husband and wife discover they have the same father (and they have a young child) – there is no specific acknowledgment that they are being punished for their own, or anyone else's, 'sin': rather we are left with the impression that incest is just one of those things that can eventuate every now and then in the world. No doubt such a conclusion could have been as unsatisfactory then as it is now.

However, even if a sharper focus should be desired this does not negate some of the novel's merits. As the first novel by a woman to be published in Australia, it reveals many of women's characteristic insights and concerns: even the *possibility* of incest – or bigamy – has been at the forefront of women's consciousness as distinct from that of men, with the very earliest novelists such as Aphra Behn (1640–80) and Delarivière Manley (1672–1724) giving this priority in their writing.

Like many women writers before her – and like most nineteenth-century Australian women writers who published after her – Anna Maria Bunn asked some of the fundamental questions about women's existence: when women were no longer legal entities upon marriage – when they were obliged to pledge obedience to the authority of their spouse – should women marry, and if so, on what grounds? Was love the rationale – and the reward: and if love ended, then should the marriage be terminated? These are questions which have been central to women over the centuries, and although they are questions which have often been mercilessly mocked within the male frame of reference, they represent the real crux of women's lives as they have been structured. While men have not been required to yield their psychological or physical person to the will or whim of their spouse, it is predictable that on this awesome issue they should show so little understanding. But for women, for whom the *choice* of husband, marriage (and childbirth) has held the balance of their fate, the predicament has been even more problematic – and binding! – than any equivalent male choice of a *career*. So consuming and overwhelming have some of these considerations been, that it could be said women invented the novel precisely for the purpose of exploring their consciousness – and conscience – in the area.

How far Anna Maria Bunn's exploration of love and marriage is a product of her personal circumstances – and how far it is a reflection of women's concerns of her time – it is difficult to tell. But she certainly

comments on the vagaries of love in an illuminating and often most amusing manner. One of her characters, Clara Dean, puts the case for and against love, declaring in a letter to her friend Jessie (dated 28 May 1826):

> He is gone now, gone to resume his avocations in Vienna, so you cannot say from this acknowledgement that I am in love with him. Heaven forbid I should be so vulgar as to be in love! It is too common a concern of life: even my laundress's daughter is in love. I hate all locks of hair, miniatures, etc. etc. etc., even the beautiful curl you wear round your neck; and would almost as soon become that dreadfully common thing, a corpse, as fall in love.

(Anna Maria Bunn, 1838, p. 8)

And later, in assessing the basis for decision-making, Clara continues cynically with –

> People speak of the simplicity of the cottage; but believe me, if you seek for purity of thought and feeling, the higher you go, the nearer you will be to its attainment.

(Anna Maria Bunn, 1838, p. 11)

Such sentiments are supported by Mrs Trafford who seeks security for her daughters and checks her own husband with the statement –

> I did not care whether he fell in love with her or not; I wanted him to marry her. As to love it takes as short a time going as coming.

(Anna Maria Bunn, 1838, p. 100)

One young woman does marry for love, and lives to repent it, as Clara Dean reports:

> Julia Jedd is here, and with her she has brought the gentleman she was in love with while at school, her cousin Colin Jedd. . . . I cannot imagine how a person who displays good taste in every thing else, could be wholly so destitute of anything like it in this one instance, but she married for love, and of course did not see his faults, however clearly they now shine forth. She has been three months Mrs. Jedd, and believes herself the most miserable being under the sun, because Mr. Jedd never offers her his arm going into dinner when they are alone, never asks her to take wine with him, says 'umph' when he

meets her in the morning, does not thank her for anything she
does, does not listen when she speaks.

(Anne Maria Bunn, 1838, p. 175)

Some problems, it seems, are perennial. Julia Jedd goes on to lament
her own ill fortune throughout the narrative:

> 'Who could be more unfortunate,' resumed Julia 'than the person
> who finds with all the accomplishments she has passed years in
> acquiring, that she is to end her career with an individual who will
> not reply if she addresses him?'
>
> (Anna Maria Bunn, 1838, pp. 231–2)

But in the interest of character development – and the overall
complexity and quality of the novel – not even the minor figure of Julia
Jedd is allowed to stand as the one-dimensional disconsolate. She too is
granted an element of humour:

> I really never thought of Eve, but I could fancy Adam handsome,
> and feel interested about him, did I not think a tailor absolutely
> necessary to a gentleman.
>
> (Anna Maria Bunn, 1838, p. 247)

Such satirical touches show some of the strong points of Anna Maria
Bunn's style: she is generally in control of her material and capable of
crafting some elegant vignettes as distinct from melodrama. But where
she pursues her concerns in more serious vein, the result is sometimes
less than satisfactory. For example, when Jessie declares to her guardian
Sir Charles Vereker that she really loves him and married Francis
Gambier only for consolation, the fundamental question on the nature
and permanence of marriage is addressed in the following fashion:

> Jessie caught his hand in both hers, and pressed it to her lips, saying,
> 'I will not look round this garden and think that you are gone; no,
> I never will. You have told me that you loved me, and I will not
> separate from you again. Where you go, I will go; I will be your
> slave, be what you will, only let me live with you as I once did. I do
> not care for the world; I could – I would forget everything in the
> world for you.'
>
> 'Remember Francis.'
>
> 'I could leave a thousand Francises for you, and will do so; I will,
> I must! The marriage ceremony is but a human tie. My heart and soul

are united to you; they have vowed themselves to you in spite of me; such are the marriages which heaven sanctions!'

'If so, I am already married.'

Jessie became deadly pale, attempted to speak, but gave a loud piercing scream.

'I spoke of your mother, Jessie', cried Sir Charles.

(Anna Maria Bunn: 1838, pp. 264–5)

Pretty shocking stuff for the nineteenth century: in part, the precursor of the contemporary television 'soap'. And a long way removed from some of the realities confronting such women as Annie Baxter in outback Australia. In fact, if it were not for the few references to Australia which suggest some familiarity with the land there would be nothing to link *The Guardian* with Australian literary traditions. But comments such as those of the prospective governor of New South Wales (whom Clara reports as trying to win her hand) add to the interest of the novel and give it some association with Australia:

(I) was much amused with the intended Governor's efforts, as I then thought they were. He said he hated going to a country, where the Governor would be like the old man with his ass, trying to please everyone and sure to please no-one. I recommended him to leave the care of the ass to someone else, as he had a precedent for doing so. He said he became sick when he thought of going to a country where society was divided into parties, dust blown as well as thrown in your eyes, children ran under your horses' feet, dogs lay about the streets, ladies talked of wool, and dressed like antediluvians; and one beautiful spot of land is styled Pinchgut and another Longbottom. . . .

(Anna Maria Bunn, 1838, p. 14)

A sentence for rulers as well as for criminals, it would seem. And clearly a place without cultural advantages as the following exchange reveals:

'He purposes writing a novel when he goes to Australia. It seems quite correct that things should be done at the antipodes, the *reverse* of what is done in England, therefore a bad novel will be quite *apropos* to the colony.'

'Nothing good could come from such a place' said Frederick Turk, smiling.

'Their wool is very fine,' remarked Mr. Barnwall.

'Have the natives wool?' cried Adamina.

'They live on it,' said Frederick, still smiling.

'How can they?' asked Adamina, 'only think of eating wool!'

'They write on it too,' continued Frederick smiling.

(Anna Maria Bunn, 1838, p. 224)

If Australian customs are being criticised here so too are English manners being mocked; this is no simple swipe at the crudities of colonial life but an indication of the author's dual reality, poised as she is between the values of the old country and the new. And it is this which helps to stamp some of Anna Maria Bunn's writing with the imprint of Australia.

CHAPTER 6

Australian native

Louisa Atkinson (1834–72), self-consciously Australian, was a talented writer of fiction, journalism and science who – like that other remarkable writer of the same first name, Louisa Meredith – was a natural scientist of some stature, providing accurate and intricate illustrations of a wide range of new and interesting species to an appreciative scientific community.

The first native-born novelist – who had but a very short life – Louisa Atkinson was a woman of extraordinary achievement. The author of five Australian novels, her work marks the point where fiction and non-fiction can meet, for she combined her scientific observations of her surroundings with speculations regarding their influence on fictional lives. When so many who were accustomed to the British sense of scenic beauty found the Australian landscape deficient and dreadful in comparison, Louisa Atkinson revelled in the stark yet subtle beauty of the Australian bush: where others complained of its monotonous 'sameness' she saw its almost infinite variety. Never apologising for the rawness or 'lack of refinement' in the colonial context, Louisa Atkinson was well able to draw inspiration – and material – from the Australian bush, and it is as much her attention to the natural detail as to her narrative which is responsible for the realistic element of her accounts of colonial life.

Louisa Atkinson could not separate living creatures from their environment and, for her, poetry was to be found in the pastoral life of the outback. But trying to extract some of the scenic descriptions from her narrative to serve as illustrations of her affinity with the natural world proves to be a difficult task – partly because she so successfully integrates her setting and her characters. Rarely does she 'add on' an observation about the natural world but rather weaves together the place and the plot, and in terms of the development of fiction in general, this represents

quite an achievement: in terms of the development of Australian fiction
such a feat is even more memorable.

No one paragraph could do justice to Louisa Atkinson's skill as a
scenic sketcher but the following helps to show the ease with which she
describes the setting, when two women go for a walk in the bush:

> The day was beautiful; a clear brilliant sun shone with intense rays
> upon the sparkling water, still flowing cheerfully after the winter's
> rain: myriads of gnats and ephemera danced, and fluttered above its
> surface: the Magpies taking their midday rest in the trees, rehearsed
> their songs and indulged in a good deal of social gossip; and on a
> white dead limb overhanging the sheep pen, an old crow sat with
> a business-like eye, watching the sheep and evidently counting on a
> death among them. The swallows skimmed through the air with
> nimble wing, and all things seemed to echo the words of the poet –
> 'the gift of life is good'.
>
> (Louisa Atkinson, 1857, p. 66)

This is but one of the accomplishments of Louisa Atkinson, whose
achievements were not only laudable but astonishing. And much of what
she did served as a model for what women *could* do for generations to
come: in so many areas Louisa Atkinson was 'the first'.

Her mother wrote the first children's teaching text in Australia (*A
Mother's Offering to Her Children* by a Lady Long Resident in New South
Wales, 1841), which might not be something for which Louisa Atkinson
should be given the credit but does give some idea of the conditions in
which she was raised: and it does help in part to explain some of her
very considerable successes, for which she should rightly receive full
credit.

Louisa Atkinson was not only the first native-born novelist, it seems
that she was also the author of the first illustrated novel in Australia –
and she was definitely the first writer to provide her own illustrations for
her own fiction (see Elizabeth Lawson, forthcoming). Part of her skill as
an artist came from her 'apprenticeship' in the natural sciences where,
in the days before photography (and other technological developments),
the ability to execute accurate drawings was an integral component of
scientific competency and was highly valued.

While Louisa Meredith and Louisa Atkinson shared much in common
(see, for example, Margaret Swann, 1929 'Mrs. Meredith and Miss
Atkinson, writers and naturalists') it appears that greater weight was
attached to Louisa Atkinson's scientific contribution, for she is generally
referred to as the first active Australian female botanist. During the
1860s she had numerous articles on natural science (accompanied by
her own illustrations) published in the Sydney press, and on the basis of

the value of her work she was not only accorded the acclaim of the scientific community but was honoured by having a variety of native plants named after her as well.

That she was also a talented sketcher and water colourist who provided the many excellent and evocative illustrations appearing throughout her first novel, *Gertrude The Emigrant*, testifies to her talent as an artist of great diversification. That she has been described as Australia's 'first expert female taxidermist and amateur female zoologist and geologist' and 'a professional collector' (see Elizabeth Lawson, forthcoming, p. 1) is evidence of her energy and her wide range of interests.

Louisa Atkinson was born in Berrima in 1834 to parents who placed great emphasis on education. Her father died shortly after her birth with the result that the responsibility for teaching the youngest and frailest child in the family fell solely to the mother – who clearly deserves to be congratulated on her competence as an educator! Plagued by ill health, Louisa Atkinson was not one to allow her heart complaint to incapacitate her and she constantly indulged her craving for the great outdoors: she explored the bush around her south-coast home and later, when she moved to the Blue Mountains for the sake of her health, she continued her 'scientific' walks.

With such a serious interest in study – and such an abandoned love of nature and the outdoors – Louisa Atkinson could hardly be said to have qualified as a nineteenth-century lady according to British norms: at best she would have been a 'blue stocking', an eccentric, and at worst, a womanly failure. But Louisa Atkinson was not troubled by such questions of taste and refinement. She saw herself first and foremost as an Australian and lived – as well as wrote about – the experiences of the young woman who seeks an intellectual identity in the colonial community. She was in *fact* the forerunner of many of the later heroines of Australian fiction: she could have been a model for Miles Franklin's creatively thirsty heroine Sybylla in *My Brilliant Career* (1901).

Louisa Atkinson was an Australian who conveyed her deep and enduring commitment to her country and who experienced no conflict of loyalties between the old and the new. She was all for the new – and for its development. She saw in Australia the possibility for the creation of a new egalitarian society, based not on exploitation but upon the mutual respect of human beings who had regard for their environment. And it is this ecological approach to existence which helps to give Louisa Atkinson's writing a curiously contemporary appeal.

In her fiction she provides a realistic appraisal of colonial life but always within the context of what Australia *could* be. The corner-stone of her philosophy was her belief that people and the planet were part of the same whole and must coexist amicably. It was this 'conservation attitude' which oriented her towards finding the worth in all human

beings and in fitting them into the scheme of things, in much the same way as she found place and purpose for all the flora and fauna of her native land; it was this which also determined her respect for Aborigines. And while she was by no means overly devout or religious for her day, the moral assurance that pervades her style – and is responsible for many of her intellectual and creative strengths – can sometimes appear slightly laboured in the twentieth-century context.

What should be kept in mind is that nearly all the novels of the mid-nineteenth century were marked by moral and religious justifications. In a period when women were pressured to stay out of the public realm, one excuse that they could advance for their entry into the world of print was that their purpose was perfectly proper and this – along with their attempts at anonymity – explains some of their preoccupation with Christian precepts and practices. Pioneer though she may have been, Louisa Atkinson was not devoid of due regard for some forms of decorum and her novels are invested with high moral tone: but this does not mean they are without their many redeeming features.

Louisa Atkinson's first novel *Gertrude The Emigrant: A Tale of Colonial Life* by An Australian Lady (with numerous engravings) was first published in parts in 1857 by J. R. Clarke, 205 George Street, Sydney. Six months later (in a new edition) the author showed some of her social concerns and her style when in the preface to the collected edition she unapologetically defended the ordinary nature of her story – and its heroine. 'A common impression appears to be that a Colonial Tale must necessarily involve the history of prominent persons and infringe the privacy of personal affairs', wrote Louisa Atkinson, and continued, 'let them dismiss such an idea utterly' in this case. In her own words, the novel is an endeavour 'to portray the incidents of everyday life', and in choosing the unfortunate and unprivileged Gertrude as her heroine, Louisa Atkinson strikes a blow for egalitarianism and argues for the inherent value of the lives of the unimportant and oppressed. And she begins her novel in the manner in which she intends to proceed, with the difficulties faced by an impoverished and unprotected – but 'respectable' – young woman:

'I want an honest decent girl if you have such a thing,' said a lady, to the Immigration Agent, on board a newly arrived ship in Port Jackson. After musing and biting the end of his pen for a few moments he enquired,
'As a house-servant?'
'Yes. Rather beyond that, as a responsible person, a sort of housekeeper; one that will not be above putting her hand into the cheese vat, or the beef cask, you understand.'
'Perfectly Madam.' and he mused again. 'Yes I think we have.

Here Gertrude Gonthier.' A young girl stepped forward with a modest air, feeling like a slave put up at an auction mart. He ran over the requirements of the lady. She searched the young immigrant with her keen black eyes; she was a small woman with a brown careworn countenance, the index of generous emotions, strong passions, and acute griefs, which had worn her straight features into sharp outlines, and given a restless keenness to her small dark eyes, which now turned quickly from one to the other of her companions, and seemed like burning coals; her voice was quick and commanding; she was evidently a woman accustomed to rule.

Gertrude did not attempt to conceal her ignorance of any things required, but she could and would be a faithful housekeeper; and would be thankful to receive instruction in what she did not already know.

'That is right; you will do child; we shall get along well together I see' uttered the quick voice; and the keen eyes flashed full upon her. 'Draw up the agreement, sir,' she added.

(Louisa Atkinson, 1857, p. 2)

And so began the tale of colonial life in which we learn of the experiences that befell the sixteen-year-old orphaned emigrant – and of the resilience and independence of her first mistress, the mature Mrs Doherty. So realistic – even commonplace but by no means uneventful – is the account, that apart from the opportunity that it provided for Australians to reflect upon the nature of their own experience, the novel could also serve as a source of accurate information for the benefit of those in England. To any women who were contemplating the idea of journeying to Australia to fortune and independence, *Gertrude The Emigrant* – and later *Ella Norman or a Woman's Perils* (1864) by Elizabeth Murray – were sensible and sensitive documentations of the recompenses – and the dangers.

In her attempt to cover the range of typical Australian ordeals, Louisa Atkinson introduces a series of bush short stories into her novel: there is the episode of the drought, the new chum, the dead child – and the fire – where her effective and evocative prose taps some of the patterns of Australian consciousness and sets some of the precedents for Australian fiction:

Morning came, still hot and oppressive, while the smoke obscured every distant object. Mrs. Doherty looked out of the window often and wished Tudor was at home. Gertrude watched the countenances of her companions to ascertain their danger.

'Where is the fire, Nanny?'

The black woman scanned the smoky horizon, and shook her head.

'Where is the camp,' pursued Gertrude.

'Blackfeller move camp down along ob river misses; fire come up gullie him bin say burra berri, to fire down along ob scrub, then blackfellow move camp, murry quick.'

'Yes?'

'Yes.'

'I am afraid that fire burra berri now.'

'I belibe so, Missus.'

Both women looked sorrowfully at each other, and turned an apprehensive glance at the high dull forest, between them and the flames; the grass was white and parched with the hot sun, it was an unusually sultry season, and very dry; there had been no rain for many weeks.

'I wish Tudor was here,' said a voice behind them, and Gertrude turned, as Mrs. Doherty's hand was layed upon her shoulder. . . .

Towards noon, the roar of the flames could be distinguished, and the leaves of the orchard tree quivered at the breath of the hot smoke. The ripe wheat lay between the bush and the garden; a spark falling there, and the whole twenty acres would be in a blaze.

As night approached, the sun was shut out from their view, and a thick darkness veiled the earth; the wind rose and carried up columns of sparks and blazes; then died down to a perfect calm: again arose each time driving the flames before it with frightful rapidity, till a wall of fire shut in the farm.

Mrs. Doherty and Gertrude stood in silent anguish in the side verandah, and Nanny squatted in the yard: all eagerly attentive to the progress of the fire. The families from the huts formed groups, weeping and awe-struck; here was a mother, with her babe in her arms, and half a dozen sobbing children clinging around her skirts, and hiding their heads from the choking smoke; there, another stood sentinel over her household treasures: some were praying, some weeping, some silent: the men were hurrying here and there in uncertainty, with no one to take the lead; here a few, kept together by a master spirit, vigorously swept back the flames with green boughs; and there, others ran with pails of water, half emptied by their speed, and dashed it upon some building, or on the devouring flames, which illuminated the whole scene.

Presently a horseman came speeding up the path, leaning forward over the horse's neck, as if his impatience overlept its reckless speed. The females shrieked, 'Tudor', and ran into the yard as he sprang from the saddle, he threw an arm round each, pressing them

to him for an instant: then he dashed into the stable, saddled two horses and returned to them.

(Louisa Atkinson, 1857, pp. 74–5)

While Louisa Atkinson endorsed the ideal of female strength and independence she clearly felt that there were some things only a man was masterful enough to do. But of course she was a product of her time and it is not really fair of me to mock what are now melodramatic representations. That she directly and indirectly reveals some of the tensions between her aims for the strength of women and the constraints of society was not only part of her achievement but also her intention. For her fiction was not just a pretext for describing the pleasures and plagues of the Australian bush, and her characters were neither 'inserted', nor incidental. She was critically interested in the relationship between people and place and while in her novel she may have succumbed to some of the 'Victorian values', sentimentality was assuredly not one of them. She saw in the bush both the friend and the foe that it could be, and she showed no hesitation when it came to conveying some of the hardship and horror it harboured. In one of the conventional attacks on the dangers of tobacco and drink, Louisa Atkinson presents the following exchange between Tudor and Gertrude:

'What a sad waste of money,' exclaimed Gertrude.
 'So it is: but yet think of the poor fellows without any of the comforts of life, perhaps shepherding, or stockkeeping, away all day with their flock of sheep or mob of cattle, not a soul to speak to, not a white face to break the solitude of the cheerless bush, or the sun-burnt plain; many of them have led lives of crime, and they dare not think on the past, it would send them mad as many a one has told me; then to come home of an evening to the pot of milkless tea, and lump of damper and beef, or mutton. Think at such a time what a solace the pipe must be.'
 'You are an able advocate for smoking and smokers,' remarked Gertrude smiling.
 'Yet I do not smoke. I am aware of the baneful effects of imbibing a narcotic poison into the system. But I wished you to do full justice to those lonely men.'

(Louisa Atkinson, 1857, p. 23)

While today there would be some smokers who no doubt would be appreciative of Louisa Atkinson's recognition of the 'comfort' that smoking can provide, her stance should not necessarily be interpreted as tolerance, or balanced. Rather, it is because she is aware of the intense pressure of isolation in the outback that she is prepared to go so far as

to admit the need for a narcotic poison to blunt the pain. And while on occasion she explicitly describes what happens to the *men* who go mad in the bush, part of the purpose which pervades her novel is to show the way women must *adapt* to their environment – or else go mad!

The novel is filtered through the experience of women and in so far as women's world is called 'domestic', it is a domestic novel.[46] It is the plight of women in the Australian outback that primarily interests Louisa Atkinson. Through the eyes of Mrs Doherty we see some of the issues that were later to emerge as fundamental in Australian fiction as a *woman* struggles to come to terms with a criminal past, and tries to earn a respectable living and reputation. And through the eyes of Gertrude, the emigrant, we see the Australian bush in all its novelty. We come to appreciate some of the ravages that can be wrought by physical and emotional isolation and we come to admire some of Gertrude's attempts to acquire the resources that she needs to contend with the privations and deprivations of her life. We are introduced to the first young Australian heroine.

Gertrude begins to ask questions about love and marriage, about who is deserving of her love and whether, through love, fulfilment can be found: and the author warns of some of the pitfalls that can await – 'How is it that the best and most lovely ever become the wife or loving devotée of the most unworthy?' (p. 56). As Gertrude weighs the evidence and thinks to some extent of her own self-development, she starts to tread the path which so many later Australian heroines were to follow. All the major Australian women writers of the nineteenth century[47] – and for that matter into the twentieth century, for Miles Franklin and Christina Stead cannot be omitted – looked towards greater self-realisation for women, and then asked whether it was compatible with marriage. Of these increasingly independent women Gertrude was (a somewhat timid in comparison) *first*. And Louisa Atkinson followed her up with a series of women characters whom she sympathetically portrayed as having to adapt and become 'strong' in order to survive in their Australian surroundings.

Her second novel was *Cowanda or The Veteran's Daughter*. Then on 1 March 1861, the *Sydney Mail* began publication of her serial 'Debatable Ground of the Carillawara Claimants' and this was followed on 2 February 1864 by 'Myrna'. Then came 'Tom Hellicar's Children' (4 March 1871), and 'Bush Home', and posthumously (31 August 1872), 'Tessa's Resolve'. However, the only works of Louisa Atkinson currently in print are some of her nature notes and her novel *Tom Hellicar's Children* (1983).

All these works were written before Louisa Atkinson reached thirty-eight years of age, when her literary career was abruptly ended. Who knows what further fine contributions she might have made to the forma-

tion of the Australian tradition, had she lived? But in death too she becomes a central part of women's literary traditions: like Mary Wollstonecraft, Mary Brunton and Charlotte Brontë she died a few days after giving birth.

CHAPTER 7

Forerunner and forgotten

Two years after the publication of *Gertrude the Emigrant* there was another 'first' in the Australian world of letters: it was one, however, which has since been persistently passed over (in preference for a male) in most literary circles. Yet when Caroline Leakey (1827–81) published her novel *The Broad Arrow* in 1859 she presented her audience with the first authentic account of convict life – and the main character was a woman.

Traditionally, the honours for the first convict novel have gone to Marcus Clarke for *His Natural Life* (not published in book form until 1874). Yet fifteen years before this highly acclaimed exposé of convict life appeared upon the scene, Caroline Leakey had published her 'critique' which has been called the 'forerunner' for Marcus Clarke's achievement (see Anna Rutherford, 1976), with the only crucial difference being that *The Broad Arrow* is by, and about, a woman. That Caroline Leakey's contribution should have been cast aside – that she should not have been given due credit for her original work, and that there should not have been detailed commentary on the extent to which Marcus Clarke was in her debt – is but evidence of the double standard that operates in the evaluation of literary endeavours. And this was not the only instance where Caroline Leakey was a victim of the literary double standard which decreed one rule for women and another for men. Like Elizabeth Gaskell and Charlotte Brontë who had encountered the double standards of the critics who had claimed that if *Mary Barton* and *Jane Eyre* were written by men the efforts were commendable, but if written by women they were disgraceful,[49] so too did Caroline Leakey find that her sex rather than her writing was used to determine the quality of her work. Whereas Marcus Clarke was praised for his powerful exposé of the horrors of the convict system, Caroline Leakey was censured for knowing too much about a subject so unseemly!

But Caroline Leakey was far from being a 'vulgar' woman. Born in Exeter in England, into a devout family, there were two major influences in Caroline Leakey's life: one was religion and the other was ill health, and both were responsible for the cultivation of her literary interest and its pervasive moral bent. It was because she was so often confined to bed that she took such comfort in her writing – and her religion.

The way in which Caroline Leakey dealt with her difficulties was held to be exemplary. A sentimental memoir of her was written by her sister Emily (*Clear Shining Light*, 1882) and Anna Rutherford (1976) sums it up – aptly – as one in which the impression is conveyed that not only did Caroline Leakey come 'from a family whose virtue put the Angels in Heaven to shame', but that 'In this family renowned for its goodness, Caroline was a star' (p. 245). Whatever else may be deduced from Emily Leakey's description of Caroline and her family, what is clear is that it was conscience and not salacious concerns which prompted the author's interest in the convict system.

Caroline Leakey learnt about the convict system first-hand when in 1847 she joined her sister, Eliza, in Van Dieman's Land. Although the purpose of her visit had been to provide some assistance to her sister and clergyman husband, not long after her arrival, Caroline Leakey's health deteriorated and she was confined to bed. At first she found solace in writing poetry: further evidence of the literary ascendancy of Hobart is the publication in 1854 of Caroline Leakey's poems – *Lyra Australis or Attempts to Sing in a Strange Land* – which came out under her own name and was also published in London.

It was, however, her conviction that she had been called by God to help the lowest in society that led her to an awareness of some of the suffering caused by the convict system. Not that Caroline Leakey sought to overthrow the system: she was no revolutionary. What she wanted to do was to *reform* it – partly so that it could help reform those who were its victims. She was convinced that convicts could be rehabilitated if given the opportunity (and she created characters in her novel precisely to show this), but her real complaint was that such opportunities were all too rare. Moreover, she maintained that the vicious system operating in the 1850s in Tasmania corrupted both convict and 'free' society.

The first attempt Caroline Leakey made to give her moral purpose literary form was in her poem 'Dora', in which the heroine is an upper-class woman who 'falls', and 'pays'. In some ways the poem was a first draft for her novel in which the main character, Maida Gwynnham, is another upper-class lady who falls into sin. And the punishment is awful: Caroline Leakey provides realistic and authentic descriptions of the convict system which still have the power to horrify.

Because of the accuracy of the accounts of convict life – and because of some of the presumptions about good and evil that reside in the mind

of the author – *The Broad Arrow* stands as a significant social document. And the conflict that the author faces when her characters threaten to assume lives of their own (and thereby challenge the absolute nature of the moral code she is enforcing) adds considerable literary interest to this work above and beyond that of being the first novel of convict life, and the horrors it held for women.

There can be no doubt that Caroline Leakey wanted to write a moral tract stipulating the straight and narrow path that all should follow: one encompassing the 'correct code' on everything from the treatment of Aborigines to the reform of prison life, from the attitude to fallen women, and to drink. One device that the author adopted in order to have an 'inside' view of convict life without being 'contaminated' by it was to have a convict heroine who was 'not really one of them'. So Maida Gwynnham comes from the upper echelons of society and is tricked by her lover so that she is convicted for crimes she did not really commit. And while such a character may provide the author with a convenient 'pair of eyes' to observe the brutalising atrocities of convict life, it is a bit hard on the heroine whose sole crime was to have been seduced. Still, the novel does make the point that those women who 'do it all for love' can find themselves in a great deal of trouble, and though it may not have been Caroline Leakey's intention to query the sacrifices made in the name of love, her portrayal of women's vulnerability and subordinate position places her with some of the later, less moralising Australian women writers.

To classify Caroline Leakey as an 'uplifting' writer is not to detract from her achievement, no matter how unpopular such a position may be today. It is to place her in the context of her time, for during the nineteenth century the majority of women writers used fiction as a means of informing, educating – and cautioning – their women readers about the pitfalls of society. For where else could women learn? Where else could women learn to gauge, assess – judge – the worth of their fellows (a vital quality when it came to the choice of marriage partners)? Where else could women learn about the wider world which was outside their own direct experience?

Denied education and access to so many sources of information, the novel was often women's curriculum in the school of life. And Caroline Leakey was a significant contributor to the resource material available. She attempted to open women's eyes, to show just how easily the most advantaged woman could become the victim of the most awful system – and she urged women (and men) to 'do something' to ensure that the system reformed rather than ruined those who were subjected to it. Caroline Leakey stands well within women's traditions in terms of her moral treatise and tone; and in terms of her topic she made a unique contribution to Australian literary history.

The Broad Arrow, Being Passages from the History of Maida Gwynnham, a Lifer (London 1859, Hobart 1860) was published under the name Oliné Reese, after Caroline Leakey returned to England in 1853. There, she continued to write articles for the Religious Tract Society and the *Girls Own Paper* as well as working for the Exeter Home for Fallen Women. Her commitment to her religion – and to improving the plight of women – should never be doubted: and if *The Broad Arrow* were now in print as a permanent part of the Australian literary heritage there could be no doubts about the fact that many convicts were *women*, and that they endured additional forms of brutalisation – from many men.

CHAPTER 8

Ideal and reality

Much less moralistic, but no less serious, was Elizabeth Murray's novel, *Ella Norman or A Woman's Perils*. Published in London in 1864, it is probably the first Victorian novel, and while it is indubitably 'a fiction' it has more than its share of 'facts'. For it too was written with the purpose of exposing a dreadful system – that of exporting young Englishwomen to the Australian colonies where they invariably met their 'downfall'. But if the author showed her displeasure with the misguided practices of the English Women's Emigration societies, she did so in a most popular and palatable form. *Ella Norman* is even now a most entertaining – and informative – read.

Born in Jamaica in 1820, Elizabeth Poiter later moved to Ireland, where in 1844 she married Virginius Murray; in 1852 he set sail for Australia and when in 1855 he had not returned to England, Elizabeth Murray (with her five sons) followed him. For almost five years she resided in Victoria and kept strict and shrewd account of the strange Australian scene, but so many shortcomings did she find (particularly educational ones) that in 1859 she decided to return to England. She left behind her husband (who died shortly afterwards) and her eldest son, and made her home in Harrow, where she turned to novel writing.

Obviously, Elizabeth Murray was quite used to a certain degree of independence, and even when married spent much time on her own: and her sense of confidence and competence comes through clearly in her novel. It was partly because she believed that women could, and should, assume some responsibility for their own actions that she put pen to paper to pronounce judgment on the 'marriage stakes' and to warn young English ladies against the folly of going to Australia to make their fortunes as governess or wife. The novel is subtitled *A Woman's*

Perils and while Ella Norman is fortunate enough to triumph, many of the other ladies (and some of the gentlemen!) have no such luck.

Elizabeth Murray was concerned to write an exciting and popular tale but she did not see this as pre-empting her serious purpose: she made no attempt to disguise the didactic element of her story but rather insisted that such a dimension added to the value of her work. So she explicitly stated her educational aims in her preface, where she declared that she wanted to accurately describe the Australian scene to a poorly informed British audience, for it was 'a state of society of which few of the most intelligent of the British public can realize even a faint idea, when its private and domestic influences are considered'. And she wanted to expose and to end some of the hardships that were being endured by deceived emigrant women: 'My own personal sympathies are, and have long been, strongly excited by the sufferings of members of my own sex, exposed too often to a heart rending fate, by the mistaken kindness of "friends at home".' To Elizabeth Murray, too many 'friends' counselled too often and too ignorantly on the opportunities to be found in the colony, and it is this theme which makes her novel unequivocally a woman's novel.

In order to provide the context for her account, Elizabeth Murray was obliged to set her novel in two countries: she was then able to contrast the ideals of the philanthropists in Britain with the reality for the 'young ladies' in the colonies. While the distance creates some difficulties with the structure (with the supernatural resorted to at one stage in order to get a message from one continent to another), the novel had the distinct advantage of being able to appeal to (or antagonise!) both the British and Australian societies whose characters and customs were reflected within it. All this makes the novel sound more like a sermon than a scintillating story and to give such a sober impression would be completely misleading. For the novel careers along in action-packed, lively – and humorous – style, so that even Lady Duckworth, one of the philanthropic 'villains' who helps to send young ladies to Australia and their often frightful fate, is portrayed with satirical ease:

> statistics were her forté, and principally in connection with female emigration. Among the half-dozen money boxes on her table, was one for funds in aid of female emigration.
>
> After severe work she had come to the most satisfactory conclusion, that in Victoria (Australia) there were four and three seventeenths of males to one female! Appalling! She had the last census of that flourishing colony, but it was necessary to be *exact*. She had monthly returns of the passengers going into and leaving the ports, and returns of emigrants leaving for those inviting shores, and the deaths, and the births. What a dreadful sum to work! But she went to it bravely, and

came out triumphantly. There were four and three seventeenths males to one female, and the sexes *must be balanced forthwith*! These men must have wives at once! Three and three seventeenths of a whole population bachelors!

<div align="right">(Elizabeth Murray, 1985, pp. 369–70)</div>

It was efforts such as these that Elizabeth Murray condemned: Jock – a banished gentleman who through a series of deaths becomes a Lord – has in Australia, 'seen it all', and is adamant that he shall help end some of the mischievous meddlings of the emigration societies when he returns to England:

There are some of the most influential women in England – and, I firmly believe, the most well-intentioned – who are leagued in all these Colonization and Emigration Societies; and the effect of what they have worked out has been, that they have actually decoyed and sent out more unfortunate and innocent girls to irretrievable ruin than any similar number of the most depraved women in England could possibly have destroyed. It is a harsh fact for them to digest, but the statistics of this colony will show its truth . . .

<div align="right">(Elizabeth Murray, 1955, pp. 316–17)</div>

Jock's stand was not based on abstract arguments: it is because he has witnessed the downfall of 'Bella' that he is so intent to end the inter-ference of individuals and societies who condemn and transport free but unfortunate young ladies who are desperate to find 'a living'. The tale of 'Bella Dyce' is a cautionary one indeed: it is central to the structure of the novel (providing a unifying theme) and, of course, significantly central in the author's scale of values.

With but a few hundred pounds left to her in England, 'Bella Dyce' went to live with a half-aunt on the death of her parents and it was presumed that her stay would be short because she would soon make 'a good match'. And then came the stories of Australia – 'of the wealth of the men and the splendid matches people made' (p. 137) – with the result that Bella's opportunistic aunt determined that Bella should be off to the colony, where she 'should marry a squatter of enormous wealth, in a few days, and induce him to return home' (p. 137).

Now Bella did not want to undertake such a course of action – but neither did she put up much resistance. And Elizabeth Murray makes it quite plain that it was partly Bella's own fault that she started on the road to ruin. The author wants her readers to know that it is desirable and necessary for women to have integrity – and the courage of their

pure convictions – else they may find themselves in a dreadful 'fix': for it is Bella's lack of moral fibre which leads to her awful fate. Because, as Bella confesses, 'I did not care much whom I married if I had a comfortable home and my husband was kind to me' (p. 137), she was easily persuaded to take passage to the 'promised land' where the reality proved to be far removed from her expectations. And after that – owing to some unfortunate incidents – it was virtually downhill all the way, aided by the 'comfort' of the demon drink.

In contrast, Ella Norman, despite the pressure from her mother, resists the offer of a rich but not respectable man and takes a position as a governess in the bush. En route to her destination she comes across 'Bella' in the most debased circumstances: obliged to stop at a low public house, Ella was contemplating her past, present and future

when the door opened and a woman entered with her tea. Following the thread of her speculations she did not at first turn round, and therefore her face was not visible to her attendant. When she did, she could scarcely believe the evidence of her senses. A young woman with a profusion of light brown hair, tossed in a dishevelled state into a net, all awry; a dowdy, dirty, flaring skirt, hitched up in front, showed unlaced boots and hanging stockings; her figure was in some measure screened in a loose grey jacket trimmed with tarnished gilt lace and buttons. Her face! How for months Ella dwelt on that face! She had evidently been drinking, and the swollen, bloated state of her features showed that the vice was habitual; but all this could not efface the traces of remarkable beauty. They looked at each other as strangers would at first, when Ella, to her intense grief and astonishment, recognized in her changed form, an old and much loved schoolfellow, the daughter of a clergyman, while the other screamed out hysterically at first, and then as suddenly rushing up and putting her dirty hands on Ella's mouth, hissed out rather than whispered,

'Ella Norman, for God's sake don't mention my father's honoured name! For God's sake don't say you know me in this place. I am a lost, lost creature, not worthy to wait on you, and you have no business here. Don't call my name, for God's sake.'

Ella, greatly excited and distressed, tried to calm her.

'Stop, I entreat you, and tell me how you came here. I may help you, I may do something for you Mary.'

'I am not Mary. I am Bella. Bella Dyce. It is the only name known here. . . .

The wretched creature was by this time sobbing hysterically and hearing a step she flew through an opposite door and escaped.

Ella's tea stood untouched; a violent flood of tears came to her
relief.

<div align="right">(Elizabeth Murray, 1985, pp. 64–5)</div>

Ella Norman had a lot to contend with. This was not the only woman
in her life who had succumbed to the temptation of stimulants: Ella's
mother too was 'weak' and had sought comfort in drink in her colonial
life. Later she was to become a source of acute embarrassment to Ella,
who had to be informed by her 'rough diamond' Scottish employer that
her mother was the worse for drink. In Melbourne, motivated by kind-
ness, Mr McLaren had visited Mrs Norman at her boarding house to
see if she had any messages for her daughter, but as he explains to Ella –

 '. . . when I went in – but lassie' (and he took her hand) 'it's a
great pity of ye! – but she was that gone she cudna speak. She was
crying, and trying to say you didna send the siller.'*
 Ella was by this time crying violently herself.
 'Never do you mind, lass; it will make no difference with me,' but
its richt ye sud know. Its an aufu' habit, and the weemen in this
country tak it up, and there's no curing them. Don't ye send her the
siller. She wanted me to give her an advance, but I told her I would
expec ye to spend it in my house'; and the benevolent but rough
creature laughed at the idea. 'I widna gie her a baubee.'
 It was nothing new to Ella to be made aware of this habit; but to
hear that her mother had thus exposed herself to a stranger! – that
she had so far exceeded as to openly disgrace herself! – there, in a
boarding house, where it would be talked of, and known! She
thanked Mr. McLaren for his kindness in warning her, and said
something by way of excuse for her miserable parent, and then took
refuge in her 'skillion' to weep herself into a headache.

<div align="right">(Elizabeth Murray, 1985, p. 213)</div>

It was enough to drive a woman to drink!
 While by no means advocating such a solution, Elizabeth Murray
shows that she is more than aware of some of the constraints that
convention places upon women when they confront such problems.
Having allowed Ella to deal with her fears and her frustration by means
of a solitary weep, the author provides her own passionate plea:

What could she do? Do as it is woman's fate too often to do – *wait
and endure*. That passive fortitude men can seldom even understand,

*'Siller' – money

is that quality most frequently exercised in cases like here. Oh! To be able to *act*, to *do* something. Who has not felt the relief of even abortive efforts to escape from some impending evil? Yet how often is it not still the only thing a woman can do well – the only way in which she can conquer circumstances, to wait and endure.

(Elizabeth Murray, 1985, p. 213)

For Ella Norman it was not just what could she do about her mother's problem, but what could she do about Bella's predicament? In both cases the author spares no details when she describes the desperate lives of those who are driven by drink – and yet such scenes are not ordinarily the subject of good Victorian novels. For while 'polite fiction' may have permitted the occasional and oblique reference to the gentleman who over-indulged (and of whom disapproval was invariably shown) rarely was it extended to encompass the ladies. No matter how anti-alcohol or pro-temperance writers may have been they generally didn't describe at length the coarse condition of the inebriated women.[50] And yet in this Victorian novel, Elizabeth Murray presents us with not just one but two women whose lives have been eroded by drink. Perhaps if the setting had been any place other than Australia, the departure from decorum would not have been tolerated. But for many British readers such accounts of 'depravity' simply served to confirm their worst suspicions about the barbaric practices of the colony.

Elizabeth Murray's exposé of the lack of refinement in the colony was not confined to her denunciation of drink. Nor was it criticism of the carping kind. Rather, much of the humour of the novel is provided by accounts of the incongruity which is part and parcel of the Australian way of life. For example, there is the maid, Jane, who not only leaves her mistress Mrs Townshend and rises rapidly in the world when she marries, but who later generously offers her patronage to her former mistress – and Miss Norman:

One day while Ella was walking to the hospital, accompanied by Mrs. Cooper, a very dashing dog-cart passed her. An unmistakeable Milesian was driving it, and by his side was a lady, whose white bonnet was literally covered with flowers. A white veil was not sufficient to conceal the face beneath, and, surely, Ella knew that face! Who was it? At first she could not tell. Her acquaintance evidently had the advantage of her in this respect, for the dog-cart was stopped, and a plump little figure descended from it; the veil was raised, and our old friend Jane, all smiles and self complacency, rushed up to shake hands with her.

'Sure, Miss Norman, it's me that is deloighted to see ye up in this woild place'

Ella could scarcely control her countenance at the easily assumed equality of the *ci-devant* housemaid, but she congratulated her on her marriage and good looks.

'Me name is Mrs. O'Connor now. Mr. O'Connor has got a beautiful place at Castlemaine, and druv me over here to see the counthry. He is making his fortin in the contracts for the railway, him and his pardner. I've got two servants, and me garding, and me cow, and all – beautiful! If you are going far we shall be happy to give you a lift, and inthrojuce ye to Mr. O'Connor.'

Ella thanked her, and said she was too near her journey's end to trouble her.

'Well, Miss Norman, if I can do anything for you – if you should want a place, and require references, or anything of that sort – I shall be happy to do you a kind turn. We have a large connexion and acquaintance, very ginteel indeed, I assure you, and maybe I may help you. I shall be deloighted!' – and Jane, after sunning her many-shaded *glacé* on the pavement of Maryborough, and feeling no small price in doing so beside two such truly elegant-looking women as Ella and her friend, clambered up to her perch beside her husband . . .

(Elizabeth Murray, 1985, pp. 262–3)

Not that Elizabeth Murray disapproved of Jane: quite the contrary. She appreciated that the motto for living in Australia was necessarily 'Here we must all work' (p. 139), and there was no doubt that Jane worked – and deserved some reward. And Elizabeth Murray was not against women engaging in honourable work. What she was against was people who arrived in the colony badly misinformed: she tried through her novel to warn those in England who were looking for an easy fortune, or a life of ordered class distinctions and refinement, that they would find little satisfaction in the rough conditions and social upheaval that characterised colonial life: 'In this country people were so often out of their proper places, that it did not signify so much.' (p. 215)

And for any who wished to uphold some of the social distinctions of 'home', the water carters of Melbourne had their own method of bringing them down a peg or two. In her range of characters who all respond differently to the demands of Australia, Elizabeth Murray shows how one – Francis Pierrepont – could never be acclimatised:

We must trouble our readers to return to Melbourne, and follow, for a short time, the fortunes of our 'new chum'. Turning down Russell Street, towards the Yarra, he escaped from the Collins Street

throng, whose glances at his drenched condition were far from pleasant
to his unseasoned sensibilities. On the first turning again to the right,
however, he entered a narrow street, called Flinder's Lane, which ran
behind the scene of his late catastrophe.

The whisperings of small oaths might have been heard by the
passers by, as he thus doubled back to an hotel which stood in from
this lane, and which was at the time one of the quietest and most
select in Melbourne, frequented principally by the better class of
squatters, and government officers from the country. The equanimity
of a polite waiter was visibly disturbed, when the figure, which, in
faultless perfection of costume, had departed a few minutes before,
returned in this dismal plight.

'Accident, sir?'

'I understand shower-baths are the only gratuitous luxuries which
Melbourne offers to visitors. Tell those fellows, will you, if you
know them – with my compliments – I shall meet them next time in
bathing costume.'

'Aha! Sir! It is a way they have. If one of them watermen only see
a – what they call a swell, as sure as they can do it, they make a
mistake with their hose. Lor, sir! it is nothing new. But they *have* wet
you, to be sure!'

<div align="right">(Elizabeth Murray, 1985, p. 73)</div>

Accounts such as this help to place the novel firmly within the Austra-
lian literary tradition where the distinct nature of the material gives rise
to a distinctive style: throughout *Ella Norman* there are anecdotes which
reveal the early and easy emergence of the redoubtable 'ripping yarn':

Jock took the lead. 'Please follow me, miss, and leave the mare to
herself, and she will take care of you.'

'Is not this a very dangerous road?'

'Oh, not when you are sober, and have a good nag; not very bad.
Digger lost in that hole though' – pointing to one – 'going home
from that very public house to his tent; a fortnight after, they seen
flies over the hole, and there he was dead. He was walking, and had
taken too much, so fell in.'

<div align="right">(Elizabeth Murray, 1985, p. 66)</div>

Another blow struck against the demon drink!

While she resided in Victoria for less than five years – and definitely
writes her novel as an 'outsider' – Elizabeth Murray took great pains to
get her material right and to account for the country and its customs to
those who were 'at home' and would have such difficulty in compre-
hending some of the realities of colonial life. She cleverly introduces

advertisements for servants and governesses into the text in order to provide precise information on the conditions which prevail – and she even inserts a glossary of colourful Australian terms. But, ever ready to reveal the even-handed nature of her approach, Elizabeth Murray does not confine her indictment to the vulgarisms of Australians:

> Had Lord Tiptree landed as his cousin [Francis Pierrepont] had done, he would have been at home at once. His slang would at once have endeared him to ninety-nine out of a hundred of those who met him in the motley society of the *table d'hôte*, or smoking room – men from whom Francis shrunk instinctively. He would have been a 'brick', 'a fellow of the right sort,' and 'trump,' while Francis was a 'conceited ass', a 'proud aristocrat' and one who 'wanted to be taken down a peg,' etc. etc.
>
> (Elizabeth Murray, 1985, p. 103)

Language was not the only index of Australian vulgarity: Elizabeth Murray was even more critical of the vulgar obsession with money – which she saw originating in England and able to find ready expression in Australia. She was critical of the mendacious and mercenary English aristocrats (such as Lady Merrivale and her brother) and critical too of the greed in the middle classes which prompted people (like 'Bella Dyce's' aunt, for example) to send young women on 'gold-digging' expeditions to Australia. And she consistently condemned the Englishmen who ventured to Australia with the sole purpose of amassing a quick fortune – and of beating a hasty retreat. As far as Elizabeth Murray was concerned, such an over-riding interest in money blunted civilised growth and a sense of appreciation, and only encouraged the development of coarseness: her cutting comment on the crudeness that soon appeared in English emigrants – clergyman included – was that as they all 'came here to make money, so about money alone did any one think of quarrelling' (p. 292).

If she does not excuse, she certainly helps to explain why Australians should set up *money* as their criterion for success and social standing: introducing a theme that not much later would repeatedly be explored by Australian women writers, Elizabeth Murray attempts to account for the Australian reserve about antecedents – and the Australian enthusiasm for 'measuring a man by his money'.

> Few would like to say *where* and how the money was earned which erected some of those neat little dwellings. One of the most palatial was the home of a *ci-devant* convict. Few would like to have their antecedents investigated. A good name – a family tree: these are things not to be named either in the 'mob' or indeed in any society

in Victoria, without an offence to someone present, to be treasured up and revenged on a future occasion. It is not who you are, or what you are, but *what you have* (never mind how you have got it) which is *the* question, from the vice-regal salon to the labourer's wooden box, yclept a house at the Antipodes.

(Elizabeth Murray, 1985, p. 244)

While Elizabeth Murray is keen to describe and analyse some of the peculiar practices of the Australians, as she states in the preface to her novel, this is only part of her purpose: she also identifies strongly with those members of her sex who are so often exploited by men (and their systems), with the result that she recounts numerous incidents – in feminist overtones. Although she does not significantly challenge some of the stereotypes of her time, Elizabeth Murray suggests that women can be morally strong within the sphere to which they have been assigned, and she gives this argument substance by contrasting Ella with her mother and her friend 'Bella', when faced with a choice between conviction and convention, Ella has the courage to make the difficult decision. One example is when Ella urges Bella to leave her dreadful life and to repent and reform; finally Bella finds the strength to start to make a move. As she has put her money (and her energies) into the profitable public house, she furnishes herself with ten pounds from the till. Bob Parsons ('proprietor') misses the money and accuses a groom of stealing it. Unable to stand by in silence while the groom is attacked, Bella admits to taking the money but refuses to return it on the grounds that it is hers. Bob Parsons creates a stir:

'Give me that note, or I will break every bone in your skin;' and he flourished a stick.
'Oh, for God's sake, don't! Hear me, Bob. I am tired of this sort of life; I want to go. Let me go in peace. I will leave you half my money, if you will let me have the other. You can do it, I know.'
'And who will take such a drab in, I should like to know?'
'I will manage that; only let me go in peace – do, Bob!'
She turned to plead, but she was felled to the earth. Blow after blow followed, and she was then kicked out on the front verandah. She did not scream, because she was insensible, and therefore the man, to save whom she had prematurely divulged her plans, was not aware till too late of what had taken place. He had often saved her before, from a portion of the ill-usage to which she had become accustomed; he now stood in the bar aghast at the scene before him.
'And you call yourself a man, I suppose?' said he sneeringly to Parsons. 'That looks like it!' and he pointed to the prostrate and

insensible figure of Bella. 'Do you mean to leave her there, or must
I take her up?'

(Elizabeth Murray, 1985, p. 221)

Here Elizabeth Murray makes the links between drink and male violence:
she depicts a scene which must have been shocking to her British
audience. In showing the brutality of a man towards a woman, Elizabeth
Murray also embarked on a course which would be followed by promi-
nent Australian women writers. Twenty years later Rosa Praed would
write about the violence of men to women – the difference being that as
an Australian she would write about the British – and her couple would
be married and come from the upper stratum of society (see *Bond of
Wedlock*).

Sometimes it may seem that the awful problem of violence against
women is a relatively new phenomenon: one reason for this is that so
much documentation of its occurrence in the past has disappeared from
literary history. For it was a major preoccupation with many women
writers in the nineteenth century. Because female writers of both fiction
and non-fiction were frequently concerned with violence against women,
their literature contains extensive discussion of the problem – and poss-
ible solutions. It is this particular concern which often distinguishes the
writing of women: it is this particular awareness and understanding which
is lost when these women writers are out of print. So Elizabeth Murray
was doing nothing so very different from many other women writers of
her time when she tackled the issue of violence – and drink. But she
did present the problem in unusually graphic detail – and she did invest
it with her own artistic purposes.

After 'Bella' is beaten insensible, she is taken to hospital, where she
is critically ill and desperately alone. Ella elects to go to her bedside,
even though the acknowledgment of her fallen friend could well mean
that she must endure the ostracism of those who are clearly her moral
(and social) 'inferiors'. And apart from showing how Ella rises above her
mother and her friend when she takes the honourable but uncomfortable
path, Elizabeth Murray also makes it clear that women have an obligation
to stand by their fallen sisters. In tracing the plausible circumstances
whereby the beautiful 'Bella' was tricked and seduced, Elizabeth Murray
emphasises the vulnerability of all women – and the need for sisterhood.

Another feature of her novel which characterises her as a part of the
tradition of women writers is the way in which she sends 'signals' specifi-
cally to women. Just as women may use eye contact – facial expressions
(or grimaces) – to communicate privately with each other in a public
setting, and to signal that they share another wholly different frame of
reference subverting the meanings that are being conveyed, so too do
women writers often make statements that are intended to be significantly

meaningful to women. And Elizabeth Murray spikes her novel with this female shorthand which can speak volumes to the woman reader. Describing one ostensibly 'fortunate' lady, the author alerts her audience to the less fortunate reality of existence when she says –

> She was simply a machine to do the female branch of her husband's trade. To order his dinners and his luncheons when she had a cook, and to cook them herself when she had no one capable of doing it; to say civil things to the gentlemen and the ladies, or rather the men and women, whom day by day he brought in to be regaled at his board, without respect to anything but their eligibility as tools in the business of his life – making money.

> (Elizabeth Murray, 1985, pp. 30–1)

Sometimes Elizabeth Murray's reference to the shared but silent meanings of women, is even more explicit:

> 'Mr. Touchet requested me to introduce Mrs. McLaren to you,' (this meant, she is no friend of mine). 'Mr. Touchet thinks, perhaps your friend Miss Norman could be induced to go to the Bush as governess to Mrs. McLaren's brother's family (meaning, no doubt, she may go if she likes, but I have no share in recommending it), and Mrs. Townshend understood her.

> (Elizabeth Murray, 1985, p. 32)

Quite a few of Elizabeth Murray's insights about the relationship between the sexes have now become the substance of feminist research: for example, some of the contemporary findings in language study simply restate what the perceptive author knew then:[51] says Agnes Townshend to her husband –

> 'So you agree with me after all, though you choose to put my ideas into your own words. So like men – they never admit that a woman can originate a rational idea.'

> (Elizabeth Murray, 1985, p. 304)

All these intentional features of her style now help to place Elizabeth Murray within women's literary traditions, and when she wrote they helped her to forge a bond with her women readers. It was her own sense of sisterhood – of allegiance to members of her own sex – that prompted her to write her words of warning and induced her to be so insistent in informing women of the dangers of colonial life. She is just

as concerned to show how difficult it was for servants and governesses
as she is to draw her conclusions on the downfall of disappointed women:
in page after page the realities are portrayed as the author gives enter-
taining accounts of the 'agencies' that provide servants (and take a
percentage of their pay); of the (harassing) pitfalls awaiting poor unsus-
pecting waitresses in cafes; of the hardship encountered by the govern-
esses in the bush – and of the distress and despair when they lose their
jobs and are destitute and friendless.

Although the Female Middle Class Emigration Society was, at the
time of writing, just beginning to play its role in removing young women
to the colonies, it seems that many of the emigrant young ladies found
themselves in the unfortunate circumstances that Elizabeth Murray so
forcefully described. In her anthology of letters written by the emigrant
governesses to the Society organisers 'back home', Patricia Clarke (1985)
reveals that there were those who could have profited from Elizabeth
Murray's cautions and counsel.

Such sentiments were also reflected in some of the reviews that the
novel received at the time: 'a popular novel will go into many places
where a serious and sterling work' will not, commented the critic in the
London *Saturday Review* (26 March 1864: reprinted Elizabeth Murray,
1985, p. 405). And he clearly thought that there was a great need for the
populace to be forearmed and forewarned against the startling 'exposure of
the gross vulgarity and immorality of the social state which prevails in
the colony of Victoria' (p. 401).

Because the author could claim that her accounts of colonial life were
completely authentic, her novel held considerable sway: to the British
who were prepared to believe in the grossly uncivilised state of Australia,
the representations in *Ella Norman* must have realised their worst fears.
But to see *Ella Norman* as an anti-Australian novel is to over-react and
to mis-read it. Even at the time of publication there were those who
could see the value of her work, albeit with reservations. As the reviewer
in *The Age* observed:

It is not a bad thing for social health at times to see ourselves as
others see us, even though the reflection should involve some
exaggeration of the proportions of our noble selves. The fair author
of the Victorian novel and sketch book before us is a plain speaker
and no mistake; and if the absence of malice prepense cannot
certainly be predicated in the revelations of what she has at some
time or other of our history seen with her own eyes, she extenuates
nothing.

(*The Age*: 20 May 1864: Elizabeth Murray, 1985, p. 406)

Having sketched an outline of the story (quite an achievement given the complications of the plot) the reviewer concludes:

> Finally, to sum up, Mrs. Murray has the making in her of a literary artist. She has first rate perception, but wants judgement. Let her wit (we speak in the old sense, though there are nice specimens of modern) be subordinate to a dire sense of the novelists's vocation in our age – to speak and advise the truth and the whole truth, and she will yet be a writer of mark in our generation.

> (Elizabeth Murray, 1985, p. 420)

Not a bad definition of the purpose of fiction: not a bad assessment of Elizabeth Murray's achievement.

It was Virginia Woolf who – in *Three Guineas* (1938) – described women as 'outsiders' and extolled the virtues of that position, particularly in the literary world. And one of the most salient features of Elizabeth Murray's writing is the extent to which she uses to advantage her position as 'outsider' to observe and analyse Australian and male society. But ironically, it is because of her Australian experience – and the vantage point it provided her with for an evaluation of the British – that Elizabeth Murray also becomes an outsider/observer on 'home'. Like so many writers who experienced the old and the new – who lived in Britain and Australia – Elizabeth Murray could not only explore the tensions between the two, but identify the strengths and weaknesses of both. In this sense she is part of the Australian tradition: she displays many of the views and values characterising those with experience of the colony, who tried to categorise and interpret, to describe and explain its ways. But Elizabeth Murray is also quite definitely part of women's literary traditions in the English-speaking world. *Ella Norman* is, as the author states, a novel about women's perils. It is a novel in which the author is critical of the social practices of the old and the new: it is a novel in which the basic premise is that all societies could benefit from the greater influence of good women.

CHAPTER 9

●

Links in the chain

In the period from 1838, when Anna Maria Bunn's *The Guardian* was published, until Elizabeth Murray's *Ella Norman* in 1864, the pioneers of women's professional writing had forged the beginnings of a distinct and distinguished Australian literary tradition. During this time there were many 'firsts' and, while some of the more significant achievements have been given attention, the coverage has by no means been exhaustive: there were many more women who made original contributions, whose work forms what Elaine Showalter (1978) has called the links in the chain of the tradition of women writers. For example, it is probable that the first book of woman's poems – *Poems and Recollections of the Past* – was published (by subscription) in 1840: little information is available on the poet, Fidelia Hill (1790–1854), except for the fact that she was born in Yorkshire and she seems to have no rivals to the claim of being the first published Australian woman poet.

Then there was Mary Therese Vidal (1815–69) who, like Elizabeth Murray, spent five years in Australia (1840–5). While an Australian resident – and when she returned to England – she was an acclaimed and successful writer of fiction. In 1845 her book *Tales for the Bush* was published in Sydney, and it had more to do with directing British morals to those who lived in the bush than it did with describing the experience of those in the outback for an audience far away! But when Mary Theresa Vidal set sail for England she took with her her experience of Australian life, and some of her later fiction had a decided Australian setting: for example, 'The Cabramatta Store' (1850) and *Bengala or Some Time Ago* (1860) both exploit the adventurous and exotic element of the strange colony for a British audience.

But during the mid-nineteenth century when the two-way flow of traffic (and information) between Britain and Australia became regular

and was increased, there was less romance and more realism in the growing number of publications concerned with the portrayal of colonial life. There is a noticeable shift from description to interpretation, from the 'travel accounts' of Louisa Meredith which capitalised on all that was strange and unknown, to the more philosophical considerations of the later nineteenth-century writers – such as Rosa Praed, Catherine Spence and Ada Cambridge.

One woman who crossed the ocean on quite a few occasions, who took British habits to the Australians and Australian achievements to the British, was Eliza Winstanley (1818–82), and because the research that I undertook on this remarkable woman is something of a tale in itself, I think it worth recounting here.[52]

Before I went to the Mitchell Library in Sydney to follow the trail, all that I knew about Eliza Winstanley was to be found in the *Oxford Companion to Australian Literature* (1985, edited by William Wilde, Joy Hooton and Barry Andrews – note the unusual alphabetically reversed order!): it was – namely – that she had been born in England in 1818, arrived in Australia in 1833 and made her first appearance on the Australian stage at the Theatre Royal in 1834. A versatile and talented tragic actress, she married H. C. O'Flaherty in 1841 and in 1846 she set sail with him for England where she continued to enjoy a highly successful acting career – joining the company of Charles Kean and going on tour in the United States.

Then in the 1850s she turned to writing as a means of support and, according to the *Oxford Companion to Australian Literature* (1985), *Shifting Scenes in Theatrical Life* (1859) is thought to be her first novel in book form ... 'although she could also be the author of "Lucy Cooper" a short novel published anonymously in the *Illustrated Sydney News* (1854)'. And – the entry continues – 'Other novels, stories and articles followed in quick succession, often drawing on her Australian experiences. ... Her Australian novels, which include *Margaret Falconer* (1860), *Twenty Straws* (1864), *What Is to Be Will Be* (1867) and *For Her Natural Life*[53] (1876) have more historical than literary value.' (p. 752)

There is not a great deal to go on here: the comment that her writing is of more historical than literary value is hardly going to prompt a rush for her books by interested and eager readers – and this is the sort of comment that is too frequently made of women's writing, and without sufficient cause. Who is to say that her many and once hugely popular books now have no great literary value? To pronounce such judgment is to aid and abet in a writer's 'disappearance': better to make such books available and allow audiences to decide for themselves. It is salutary to note that most of the titles on Virago's[54] classics' list were only recently judged by mainstream publishers to have insufficient literary merit or popular appeal to warrant reprinting. But no doubt if women were to be

the arbiters on the contributions of men, and were to dismiss those which they felt to have little literary interest, the contemporary canon would look very different.

Still, all criticisms aside, I was not to be 'put off' by the 'put down' of Eliza Winstanley's writing: I decided to pursue my interest in this literary and thespian woman. To my delight I found that the Mitchell Library held some relevant newspaper cuttings on her career and contribution.

When the newspaper cuttings arrived – on microfilm – and almost defied my ability to locate them, read them, and take notes! (and they call this progress, an information and technological revolution, oh for an old newspaper and pages that you peruse and turn), I seriously thought of abandoning my search. I am very pleased that I did not, for on the reel I found some cuttings from the *Truth*, a newspaper that had a section on 'Old Sydney' and which was edited by 'Old Chum'. The following – copied laboriously and with the greatest of difficulty – is taken from the edition of the paper on 9 November 1919, and begins with a letter to 'Dear Old Chum':

> In one of your articles in the inter-state 'Truths' (I cannot just now remember which) but believe it to be under the heading 'Mummer's Memoirs' in Melbourne 'Truth' a few years ago, you therein wrote of Mrs. Elizabeth Winstanley, the notable Bow Bells (London) authoress of 'Twenty Straws,' 'Desmoro of the Red Hand', and some forty or fifty other novels. John Dicks, publisher, London, issued thousands of them at 6d. each. This famous woman, later, became an actress of repute at the old Victoria Theatre in Pitt Street, Sydney and you wrote of her under the second marriage name, which I have quite forgotten. I have been told that this lady came to Sydney as the governess to the daughters of Governor Sir Richard Bourke, one of whom became wife of (Sir) Edward Deas Thomson, Colonial Secretary. During the early thirties of the last century is the period of the story of the book, 'Twenty Straws', which most intimately deals with the 'life' as it then was in Sydney.

This is followed by a reply:

> My object is to verify as to this lady being a one-time governess in the household of Governor Bourke and to find out if any of your good correspondents can give the readers of 'Truth' this worthy woman's life story and history. It must not be forgotten that at one time Mrs. Winstanley was the editress of 'Bow Bells'. I am given to understand that there are descendants living in Sydney, one well positioned as a dental surgeon.

Without comment on the relevance of dental references, the correspondence continues:

> I would be pleased 'Dear Old Chum' if you can tell me where Mrs.
> Winstanley is buried, and if there is any tombstone over her grave,
> and the section of the cemetery. From a boy I have been greatly
> interested in her stories of early Australian conditions, as was my
> mother also. All Mrs. Winstanley's books are out of print, but it is
> sometimes possible to get some old volumes of 'Bow Bells' in
> second hand bookshops. Please if at all possible give a history of this
> remarkably able woman, as I know many are anxious to read same.
> Perhaps some of your readers can say where she was born.

Well, 'Old Chum' cannot answer all the queries on Eliza Winstanley,
but 'he' does his best. After going through a list of possible descendants
(and dead ends – even among dental surgeons) 'he' continues:

> Let us now turn to some other sources of information. Frank Brewer
> in 'The Drama and Music in New South Wales' published in 1892
> by the New South Wales Government Printer says, 'Knowles staged
> Henry IV (at the old Theatre Royal attached to the Royal Hotel,
> George Street, in 1833) From time to time at short intervals
> the company was augmented by the accession of other actors and
> actresseees, those most worthy of remark being Mrs. Taylor, Miss
> Douglass, Miss Winstanley, Miss A. Winstanley etc. etc.' Again,
> says Brewer 'Miss Winstanley exhibited early traits of talent for the
> profession, and soon escaped from the drudgery which is the lot of
> mediocrity, to a more congenial representation of leading parts, all
> of which were well acted, and on her leaving the colonial stage for
> a new sphere in the old world, it may be said that she had acquired
> here a position that had not been reached by any other actress up
> to that time and endorsed by the critical public of some of the largest
> audiences in the United Kingdom. At the close of her theatrical career
> in England some years ago, Mrs. O'Flaherty though past the ordinary
> length of even a long life, is still in possession of all her faculties
> and remembrance of the old days. Miss Ann Winstanley (sister of
> Mrs. O'Flaherty) was a pleasing actress and also a good vocalist.
> She was not however, long on the stage having married Senor
> Ximenes.

Then comes another item to add to the knowledge on Eliza Winstanley:

> In the Australasian, June 27, 1867, appeared the following among
> the obituary notices:– 'Winstanley – on the 19th instant, at No. 2

Webb Street, Fitzroy, Mrs. Elizabeth Winstanley, mother of Mrs.
O'Flaherty and Mrs. Ximenes of London. Aged 72. Sydney and
Home papers please copy.'

And there is more: more about the acting ability of Eliza Winstanley
(she was the actress most often selected by Queen Victoria for holiday
performances at Windsor Castle): and more about some of her literary
achievements, particularly in relation to the widely popular periodical
Bow Bells and to her novel, *Twenty Straws*, which was about women
convicts in Sydney, Norfolk Island and the South Seas in the 1830s.

I don't know what place this extraordinary woman should be given in
the literary canon: but I do know that she was one of the first Australian
actresses and one of its most popular and prolific early authors – and
that her career is sufficiently colourful for her to rate a place among the
characters of Australian history. I would certainly like to know more
about this woman – and to become more familiar with her writing – then
perhaps I could make a more accurate assessment of her contribution to
Australian women's literary traditions.

In comparison to Eliza Winstanley the information I was able to obtain
on another professional pioneer – Agnes Grant Hay (1838–1910) – was
not nearly so fascinating. She too stood between the old and the new,
acknowledged her dual reality and allegiance, and even adopted the
pseudonym 'Anglo-Australian'. Born in London, she did not enter the
publishing arena until late in her life when she wrote memoirs and a few
pieces of fiction (e.g. *After-Glow Memories* (1905) and *Malcolm Canmore's
Pearl* (1907)), and the question arises as to whether her name has found
its way into the literary records on the grounds that her most significant
achievement was to give birth to a novelist son.

Jessie Lloyd (1843–85) is another writer of this mid-century period,
whose name and work was to me unfamiliar, and yet, when I found a
copy of her novel *The Wheel of Life* (1880), I was soon laughing out loud.
Born near Launceston (another 'plus' for Tasmanian cultural life) and
later living in Gunnedah and Coonamble, Jessie Lloyd wrote many pieces
for the Sydney press during the 1870s and early 1880s, usually under
the name 'Silverleaf': before her early death she also wrote two other
novels – 'All Aboard' which was serialised in the *Echo* in 1879 and
'Retribution' serialised in the *Illustrated Sydney News* 1884–5.

Much of her writing was about the pleasures and pains of bush-life,
and in *The Wheel of Life* there are some excellent descriptions of the
outback housekeeping of a young and inexperienced bride: there are also
some horrendous accounts of the treatment of Aborigines. However,
there was one incident which amused me immensely – and which is not
the usual form of humour to be found in domestic tales of the bush: it
was about the strategy used by the young John Hazelwood who wants to

marry Agnes and realises that he must first obtain the consent of her cantankerous and possessive old aunt. So he spends time and energy in trying to win the goodwill of the querulous creature – and then proceeds to state his case:

> 'I am thinking very seriously of getting married. It is time I was settled,' (says John). 'I have sufficient means to maintain a wife – what is your opinion?'
> 'Really Mr. Hazelwood your question is so unexpected. I scarcely know how to answer you. I think your resolution to marry a wise one, provided the choice is a suitable one.'
> 'There can be no doubt about that', (he replied), 'The lady I love is everything that is gentle and good, and oh! dear madam! and here John seized the old lady's hands in the excesses of his emotion, 'Can I dare to hope for your consent?'
>
> (Jessie Lloyd, 1880, p. 58)

And hereafter are pages of hilarity as Aunt Patty assumes that *she* is being asked to be the bride – while Agnes becomes at first confused and then distressed, and John tries to extricate himself from his awkward predicament. But it all turns out well in the end. It is partly because Aunt Patty has been flattered – because she has had the opportunity to refuse a suitor and is gratified to think of her niece having to settle for her 'reject' – that she finally gives her consent to the marriage. Such conventions, however, involving misinterpretation and misidentification, were more often the substance of the British 'novel of manners' than part of the plot in stories of Australian bush-life. This makes Jessie Lloyd's work even more interesting, for while she was born in Australia and almost exclusively concerned with describing the vagaries of the 'new' life she makes use of some of the literary conventions of the 'old' world in her writing.

Much more central to the new scene is her commentary on the way the British are misinformed about the reality of Australian life. A common theme which runs through much of the literature of this period (and which sometimes can still be found) is the protest against British misrepresentation of Australia. It doesn't seem to matter whether the false image is good or bad; it is the fact that it is false which seems to incense many writers.

In *The Wheel of Life*, John Hazelwood is out in the bush – seeking suitable land on which to squat – when Jessie Lloyd inserts the following authenticated wisdom:

To rise, take a plunge in the creek, dress and get his breakfast was

a work of short time. A bushman's breakfast is not a very elaborate affair. A quart of tea, boiled in what is commonly called a jack-shay, and a slice of damper, another of salt beef, form a sumptuous repast; and there is no grand breakfast equipage, a pint to fit into the jack-shay, and a large pocket knife formed it all. John was greatly amused some time previously, in looking through an English magazine, to see the illustrations to an Australian bush story. A man was camped out and dressed something like an Italian Brigand (except he hadn't striped legs), his horse was tethered and over a neat fire three upright sticks were placed, joined together at the top, from the middle of which dangled a slender chain, on which there hung a pretty little kettle, and on a grassy bank were arranged a cup and saucer and spoon, plate, knife and fork, and a nice little cottage loaf. They forgot to put in a cream jug and sugar basin, but if the traveller had all the other things he surely had these. This picture was given as a correct one of an Australian bushman's camping out.

(Jessie Lloyd, 1880, pp. 25–6)

While neither Jessie Lloyd – nor any of these other pioneer women writers who have been mentioned – may have been great, all of them are of interest, and all have a contribution to make. For when they are placed alongside each other, then can we see the continuum of women's writing – then can we see the connections, the patterns, the formation of a tradition.

Men writers have invariably been able to trace their own 'line': they have retained so many of their minor links – with five times as many men as women anthologised in the *Oxford Anthology of Australian Literature* (1985), for example. With their genealogy so well-documented, men writers have been able to recognise their antecedents, acknowledge their relations, and claim their inheritance. But it has been qualitatively different for women: so many of the links in the chain have been lost that it is difficult, often impossible, to trace the 'family history' or find the heritage.

These 'minor' (but not necessarily mundane) women writers are the missing links, the ones who help us to reconstruct the continuity – and the community – of women writers. Without them, the tradition is distorted: as it stands the 'lineage' is just one of unaccountable, random and isolated eruptions, which suggests that there was little or nothing which linked these literary women – and such an impression is a long way removed from the truth.

Mary Hannay Foott (1846–1918), for example, is part of the network of women's writing. Born in Glasgow, she arrived in Australia in 1853, opened a school in Brisbane in 1884, and became the literary editor of

the *Queenslander* in 1887. From this central position she communicated with – encouraged and influenced – many writers, while continuing to write her own verse and stories, sometimes under the name of 'La Quenouille'. While no mention is made of Mary Hannay Foott in the *Oxford History of Australian Literature* (1981), after Rachel Henning (and Ada Cambridge who will be discussed later, see pp. 151–54), she is the first woman to be included in the *Oxford Anthology of Australian Literature* (1985).

Two of Mary Hannay Foott's poems are reprinted in the *Oxford Anthology of Australian Literature* (1985): with their emphasis on the outback – and their sense of personal loss – these poems can be readily placed within the Australian women's tradition. Mary Hannay Foott made a valuable – and 'linkable' – literary contribution to the cultural heritage.

Another professional pioneer was Laura Luffman (1846–1919) who, as Laura Lane, wrote children's books, biographies, and novels (*Gentleman Verschoyle* (1875); *A Question of Latitude* (1909)). With her firm commitment to the women's movement (and her communication with other women) she paved the way for women to be seen and heard: she used the press as part of her literary forum, and her journalism was extensive, varied – and empowering. As editor of *Woman's Voice*, and as 'Una' in the *Sydney Daily Telegraph*, her words informed and helped shape the experience of many women.

Journalism is not generally included in the repository of great literature in English-speaking societies – although of course there are always some exceptions: the *Spectator* and the *Tatler*, for example, were two British periodicals (or magazines) which, with their celebrated essays and non-fiction pieces, made their way into the annals of English letters: the *Bulletin*, too, was for many years a leading literary magazine in Australia.

But women's magazines have rarely figured among the exceptions, and few attempts have been made in the literary mainstream to justify or explain this exclusion. Yet in tracing the patterns of Australian literary traditions there has been no great rush to find and assess the essays, verse and fiction that have been a prominent part of woman's magazines and the women's pages of newspapers. This, however, is the context in which writers as varied as Laura Luffman and Mary Gilmore (see p.241), for example, frequently published their literary efforts. And while women's periodicals and women's journalism may not enjoy the same status or prestige as that of the magazines of men, no survey of women's traditions could be conducted without reference to women's periodicals – and no coverage of women's periodicals could be complete without reference to the outstanding contribution made by Louisa Lawson, whose life story is given in the next chapter.

CHAPTER 10

Woman to woman

Louisa Lawson (1848–1920) is more infamous than famous, having been given a 'bad press' by her prominent son: a 'bad press' which Louisa Lawson's biographer Lorna Ollif claims was completely unjustified – but characteristic of Henry's 'sex bias':

> Henry Lawson always spoke well of his grandfather, saying he was a fine bushman, big in heart, and gentle to a fault with children.
> In fact, he was always enthusiastic about his grandfather and father, but showed little or no gratitude to his grandmother, his mother, his sister, or later, even his wife.
>
> (Lorna Ollif, 1978, p. 9)

It is partly because she has been damned as the dreadful dominating mother that so little attention has been focused on Louisa Lawson's literary life – yet she assuredly warrants consideration in her own right. If she experienced some literary success, it was not because she enjoyed any particular privileges: she attended the public school in Mudgee where she received a little encouragement to write,[55] but such elementary provision hardly qualifies as a rich and rewarding education or preparation for serious literary commitment. Had the choice of spinsterhood (and a possible literary career) been a viable one, perhaps we would now possess an even greater contribution from this pioneering woman, and mention of the great Australian writer 'Lawson' would refer to a very different body of work from the one that we have come to associate with that name. But no one opened a literary door for Louisa Lawson: she did not enjoy the opportunities that she struggled so hard to provide for her son.

She married early, and from the outset life was a bitter battle with

poverty and privation. It would be absurd – and cruel – in the circumstances to suggest that she had any thoughts of a literary life. At the age of nineteen, on the gold-fields of Grenfell, during a wild and stormy night, her first child was born 'to the sound of rain beating against the canvas or calico of the tents' (Lorna Ollif, 1978, p. 14). Of this ordeal, Louisa Lawson's biographer has said:

> Imagine this girl, only nineteen herself, giving birth to her first child, while the tiny, flimsy tent swayed and creaked and billowed above her in the wild Australian storm that swept the rough goldfield that night. It was winter, too, and the area could be extremely cold. Louisa's mother, and anybody else who could have made her lot a little easier, were a long way away, and she was left to the mercies of an awkward husband and a neighbour who acted as midwife.
>
> Under the weight of wind and water, the tent finally collapsed, and mother and baby, protected by heavy coats, were rushed some distance to the nearest farmhouse for more substantial shelter.
>
> (Lorna Ollif, 1978, p. 16)

Louisa Lawson knew about the harrowing hardship women endured on the gold-fields – and in the bush. She knew about poverty, pain – and pregnancy. For years she tried to feed, clothe (and educate!) her family on the means that her husband provided but the time came when – in desperation – she left him. She set out for Sydney to try and earn sufficient to support the children that she had with her, but for this she has been castigated, rather than given credit. As Lorna Ollif states, most of what we know about Louisa Lawson has been filtered through her son's fictions – and interpreted by his critics and commentators: 'Most of Henry Lawson's biographers have been men, and whenever a difficulty arose in the family, Louisa has been airily and summarily recorded as being to blame.' (p. 17).

In Sydney, the opportunities for Louisa Lawson might not have been great but life was certainly better than the back-breaking existence she had previously endured. And it was not long before she was trying to make the most of her opportunities by putting her pen to professional use: Louisa Lawson attempted to earn her living by writing, and – more unusually – by printing. One of her first ventures was with *The Republican*, 'a propagandist sheet that Louisa Lawson bought in 1888 and which she trained Henry to edit' (p. 49). But *The Republican* soon gave way to *The Dawn* – Australia's first feminist periodical – which represented an extraordinary achievement.

Louisa Lawson was a woman of great spirit who had every intention of practising what she preached. And because she preached loudly,

clearly – and repeatedly – the doctrine of sex equality and the belief that women could do anything, she insisted that women should be the ones to produce this women's magazine. Such a stance antagonised many, among them the members of the Typographical Association (and other trade societies), who objected to the employment of women and who made every effort to obstruct the publication of the journal. But Louisa Lawson would not yield to the pressure they applied: the first issue of the magazine appeared in May 1888, and by 5 October 1889 *The Dawn* carried the information that it provided whole or partial employment for ten women. It also provided extensive opportunity for the expression of women's experience – and for literary and artistic contributions.

'Dora Falconer' was the pseudonym that Louisa Lawson published under: the first issue of *The Dawn* contained one of her poems, and the last issue (July 1905), 'An Explanation' as to why publication was to cease. In the issues in between there are countless contributions from this talented woman – and many are worthy of historical and literary attention.

The whole spirit of *The Dawn* was one where woman talked to woman. It was one which validated women's experience, asserted women's independence, and insisted on the legitimacy of women's work – and women's writing. *The Dawn* helped to pave the way for women's magazines in Australia, in part by demonstrating that women had need of a printed space of their own; in that printed space Louisa Lawson created a context for the exchange of ideas – and for the encouragement of women's writing.

But she did not write much else beside her (many and varied) contributions to *The Dawn*: during its eighteen years of publication there was one short novel, *Dert and Do* (c. 1890), which was aimed more at young people, and one book of poems, *The Last Crossing* (1905).

We cannot know what Louisa Lawson might have done had she enjoyed more time for writing and assumed less arduous responsibilities than those of supporting, educating, and feeding a family – as well as managing a monthly magazine. But what we do know is that her contribution warrants recognition. She is currently one of the minor links in the chain of women's writing but a more thorough review of her editorial role on *The Dawn*, and a more systematic assessment of her literary work, could well suggest that a reclassification of her status is in order.

PART III

Popular Prose

Marjorie Barnard 1897–
Daisy Bates 1863–1951
Barbara Baynton 1857–1929
Ruth Bedford 1882–1963
Inez Bensusan n.d.
Marie Bjelke-Petersen
 1874–1969
Hilda Bridges 1881–1971
Mary Grant Bruce 1878–1958
Kathleen Caffyn ('Iota')
 1853–1926
Ada Cambridge 1844–1926
Grace Jennings Carmichael
 ????–1904
Evelyn Mary Clowes ('Elinor
 Mordaunt') 1872–1942
Emily Congeau 1860–1936
Jessie Couvreur ('Tasma')
 1848–97
Charlotte Dick n.d.
Flora Eldershaw 1897–1956
Helena Sumner Locke Elliott
 ('Sumner Locke')
 1881–1917
Lala Fisher 1872–1929
Mabel Forrest 1872–1935
Mary Fullerton 1868–1946
Mary Gaunt 1861–1942

Mary Gibbs 1876–1967
Beatrice Grimshaw 1870–1953
Jeannie Gunn 1870–1961
Gertrude Hart n.d.
Alice Henry 1857–1943
Ada Holman 1869–1949
Inez Hyland 1864–92
Marion Knowles 1865–1949
Julia Levy n.d.
Agnes Littlejohn n.d.
Nancy Lloyd-Tayler n.d.
Edith Joan Lyttleton (G. B.
 Lancaster) 1874–1945
Amy Mack 1877–1939
Louise Mack 1874–1935
Dorothea Mackellar 1885–1968
Catherine Martin 1847–1937
Harriette Anne Martin ('Mrs.
 Patchett Martin') n.d.
Nannie O'Ferrall n.d.
Laura Palmer-Archer
 1864–1929
Catherine Langloh Parker
 1855–1940
Marie Pitt 1869–1948
Rosa Praed 1851–1935
Elizabeth P. Ramsay-Laye ('Isabel
 Massaray') n.d.

Annie Rattray Rentoul
1846–1926
Cecil Raworth ('Cecil Warren')
n.d.
Mary Simpson ('Weerona') n.d.
Mollie Skinner ('R. E. Leake')
1876–1955

Catherine Helen Spence
1825–1910
Kate Margaret Stone ('Sydney
Partrige') 1871–1953
Ethel Turner 1872–1958
Lilian Turner 1870–1956

CHAPTER 1

Setting the scene

Towards the end of the nineteenth century – and in to the twentieth – three women writers made their entry to the international world of letters, and in the process they made an unprecedented contribution to the establishment of Australian literary credentials. Ada Cambridge (1844–1926), Jessie Couvreur – 'Tasma' – (1848–97) and Rosa Praed (1851–1935) became best-selling novelists in Australia, Britain, (and the United States) and, were the image of Australia to be drawn from their writings rather than those of a few men, the representation of Australia, past and present, would be very different. The concerns and conceptual-isations of the women were far removed from those which were the preoccupations of men, and every area from birth to death, from the treatment of Aborigines to sickness, survival, and support in the bush, appears in a very different light when it is women who show the way.

Ada Cambridge, 'Tasma', and Rosa Praed were very consciously *women* writers, and very unapologetically Australian[56] writers – and they were highly acclaimed and widely popular at home and abroad. But this was by no means all that they had in common. As women who inhabited both worlds (with Ada Cambridge being reared in England and then voyaging to Australia, while 'Tasma' and Rosa Praed were reared in Australia and then set sail for Europe and England), they were in a position to see both sides and to present balanced pictures of the old country and the new, and the relationship between the two. Although often critical of Australia, their comments were consistently constructive, and none of them needed any encouragement to extol the colony's many and varied advantages.

Interestingly, these women display no traces of 'cultural cringe' but look upon Australia as young, a little raw – and yet possessing enormous potential. From her refined British background, and after thirty years in

Australia – most of it spent in the bush – the careful Ada Cambridge
can declare that Australia

> is indeed a good country. I can say with truth and gratitude,
> homesickness notwithstanding, that nowhere could I have been
> better off. And I am as sure as I am of anything that sooner or later
> – this year, or next year, or after my time – the day of emancipation
> and enlightenment will come, to inevitably make it as great as it is
> good.
>
> (Ada Cambridge, 1903, pp. 303–4)

'Homesickness' was another area where these women writers shared
a common bond: while valuing their dual perspective, all three felt the
wrench from their roots and, in attempting to reconcile themselves to
that psychological split which they experienced when family ties were
divided between continents, they added to and affirmed this fundamental
issue in Australian women's literary traditions. Ada Cambridge could
have spoken for the scores of women who have crossed (and still do
cross) the ocean and are pulled between 'home' and 'abroad', when she
weighs the pros and cons of her own divided loyalties:

> Doubtless, if we had settled in an English parish, we should have
> bewailed our narrow lot, should have had everlasting regrets for
> missing the chance of breaking away into the wide world; but since
> we did exile ourselves and could not help it, we have been homesick
> practically all the time – good as Australia has been to us. At any
> moment of these thirty odd years we would have made for our
> native land like homing pigeons, could we have found the means; it
> was only the lack of the necessary 'sinews' that prevented us. Such
> a severe form of nostalgia is, however, uncommon here, and would
> be cured, I am told by a twelve months' trip. Certainly, in nine
> cases out of ten, where I have known the remedy tried it has seemed
> infallible. The home-goers come back perfectly satisfied to come
> back . . .
>
> (Ada Cambridge, 1903, pp. 2–3)

Not wanting to put complete faith in Ada Cambridge's 'infallible
remedy', it is none the less understandable that women who have
migrated should always feel there is something missing from their lives.
Women's socialisation emphasises relationships and attunes women to
the desirability (and demands) of maintaining them, and the separation
from family and friends – and the women's wisdom that goes with them
– has been decidedly difficult for women and a poignant theme in

Australian literature. So many of the writers had first-hand experience of this separation and sense of loss that it is predictable that it should find its way into their work – and be portrayed painfully and powerfully in their writing. Thirty years after leaving her family and friends, Ada Cambridge recalls them, and reflects on her feelings of bereavement:

I was marrid on the 25th April, 1870. On the same date of the following month I left them all, never – as now seems only too probable – to return. We buoyed ourselves up through the anguish of the last farewells with a promise, made in all good faith, that I should come back in five years. My husband promised to bring me. 'We must save up' we said to each other, 'and have a holiday then'. It was an easy thing to plan, but proved too difficult to carry out. After we became a family, going anywhere meant going as a family, and taking all the roots of its support and livelihood with it. Theoretically I could have run home alone, if not in five years, in eight or ten – we could have afforded that – but practically it was as impossible as that we should all go, which we could never afford. So here we are still and my poor mother, who lived to the last on the hope that we had given her, has long been in her grave. There is no trace of an English home to go back to now . . .

(Ada Cambridge, 1903, p. 5)

There is pain too in remembering those friends and relatives as you once knew them – knowing now that they have changed: of her old friends Ada Cambridge says –

They were the last hours we spent together – all young things then but now grey and elderly, though I cannot realise it; three of them widows, most of them grandmothers, but never old to me; nor I to them. For more than thirty years we have not met and there have been long gaps in our correspondence; but friendship has survived all unchanged. They still write to ask when they are to see me, and I still write back to make provisional appointments which I can by no effort contrive to keep.

(Ada Cambridge, 1903, p. 5)

This realm of enriching yet wrenching experience had no counterpart among the women writers who stayed 'at home': while Charlotte Brontë endured almost overwhelming breavement, while George Eliot felt an acute sense of isolation and Margaret Oliphant[57] watched her family ties disintegrate around her, none had direct experience of that split which

characterises the emotional framework of migrant women – and the
traditions of Australian women's literature.

This feeling of being tugged and stretched between the relations of
two worlds should not necessarily be seen as detrimental to the develop-
ment of women's writing: on the contrary, it could even be said to have
had a positive outcome. It was partly to heal the split – to provide the
balm – that Australian women so often turned to private and public
writing. Like Rachel Henning, and so many more, Ada Cambridge had
not even boarded the ship to sail for Australia before she began to forge
her links with loved ones – through letter writing:

> Most of the night as we travelled down to Plymouth, I talked with
> paper and pencil to my beloved ones at home. For change of
> position and to get better light, I knelt on the carriage seat for a time,
> spreading my sheet on the leather of the back. Our one fellow-
> traveller, a stout clergyman, dozing since we started in his distant
> corner, woke up to see what I was doing and remonstrated with
> me. 'Don't you think,' said he, 'that you had better try to sleep a
> little now, and write your letters in the morning?' In the fulness of
> my heart, I told him that I did not know how much of the morning
> might be left me, and the pressing reasons that there were for
> making the most of my time.
>
> (Ada Cambridge, 1903, p. 7)

Letter writing was vital to many Australian women: it has been central
to their literary tradition. Not just as a 'genre' but in the influence it has
exerted over all the other forms of writing. Even the focus on personal
accounts in Australian women's fiction owes much to the habit of letter
writing. Just how many women served their apprenticeships as writers in
their many letters home[58] and then shifted to public pieces, it is impos-
sible to tell: but what can be claimed with confidence is that among
colonial women a burning need to write letters was created, and this has
been a contributory factor in the development of the cultural forms. This
is not to suggest for a moment that all the women writers have been
much the same: on the contrary, they are often extremely individualistic.
But it is to suggest that Australian women writers have shared a common
framework and this has helped to shape the substance as well as the
style of their writing.

For example, as writers who identified with Australia, Ada Cambridge,
'Tasma', and Rosa Praed were continually concerned to explain the
colony to those 'at home'. They were upset – sometimes incensed – at
what were often the wilful misrepresentations of Australia that all too
frequently flourished abroad, and these three popular novelists unapolo-
getically and explicitly stated that they would use their fiction to help set

the record straight. Introducing one of her earliest novels to her British audience, Rosa Praed made the following statement:

> In placing before the English public a novel dealing exclusively with Australian life, a few prefatory remarks may not be inapplicable.
> That the mother country should be comparatively unacquainted with the features and characteristics, the inner workings, the social interests, and great and petty political aspirations of this most promising of her offspring, is a fact principally to be attributed to the one-sidedness of the intellectual intercourse which at present connects Great Britain with the antipodes.

And Rosa Praed is determined to remedy the situation and to use her fiction for informative purposes:

> It has been my wish to depict in these pages certain phases of Australian life, in which the main interests and dominant passions of the personages concerned are identical with those which might readily present themselves upon an European stage, but which directly and indirectly are influenced by striking natural surroundings, and by the conditions of being inseparable from the youth of a vigorous and impulsive nation.

(Rosa Praed, *Policy and Passion: A Novel of Australian Life*, 1881, pp. iii–iv)

Sometimes the aims were specific, sometimes general: often they were simply to correct false information. In both her fiction and her autobiography, Ada Cambridge raises the issue of why the British wanted to believe reports of 'barbarous' Australia – and why Australians were sometimes happy to lend them a helping hand:

> I lately read in some English magazine the statement that tree-stumps – likewise if I mistake not, Kangaroos – were features of Collins Street 'twenty five years ago.' I can answer for it that in 1870 it was excellently paved and macadamised, thronged with its wagonette-cabs, omnibuses and private carriages – a perfectly good and proper street, except for its open drainage gutters. The nearest kangaroo hopped in the Zoological Gardens at Royal Park. In 1870 also, although the theatrical proceedings of the Kelly gang took place later – bushranging was virtually a thing of the past. So was the Bret-Harte mining-camp. We are credited still, I believe, with these romantic institutions, and our local story writers love to pander to the delusion of some folks that Australia is made up of them; I can only say –

and I ought to know – that in Victoria, at any rate, they have not
existed in my time.

(Ada Cambridge, 1903, p. 19)

Despite their many efforts, it could be said that these novelists, who
wanted to ensure the accuracy of the information available on Australia,
were not all that successful: there are still many who believe that kanga-
roos and bushrangers roam the streets and that the country remains
uncivilised. Myths continue, long after they have been factually or philo-
sophically repudiated.

But more central and significant than the remedying of false reports
on the basics of Australian life was the concern of women writers to
reconcile the values of the old world with the new. Moving from Britain
to Australia, Ada Cambridge was intent on preserving the best of British
values in her new home, yet to do this she had first to identify and then
to assess the significance of those values: moving from Australia to
England, 'Tasma' and Rosa Praed took their sense of possibilities and
their enthusiasm for change into the old world and confronted the issue
of what was worth preserving – as well as changing. And it is this
philosophical and ethical dimension which helps to distinguish the *Austra-
lian* woman writer.

People who know but one reality can come to believe that it is the
only reality and from this they can draw their certainties, their truths.
But people who cross cultures – who have access to more than one
reality – have gained more than just two ways of looking at the world:
the very fact that they know *two* worlds removes the certainty and the
security that can go with knowing only one, and the result is that the
entire spectrum of human understandings is open to negotiation.

In contrast to some of the popular male writers of the period who made
a virtue of staying at home and asserting their chauvinistic certainties,
Ada Cambridge, 'Tasma' and Rosa Praed consolidated the practice of
presenting the dual reality – the two sides of the story – and because in
their fiction they insisted that there was more than a monodimensional
view, they raised provocative philosophical questions about the nature of
truth, the meaning of life – the purpose of existence. It is this particular
and pervasive intellectual quality which helps to give their writing wide-
spread and enduring appeal.

It is vital that it should be established that the work of these women
had intellectual strengths because it is this dimension of their work which
is frequently denied in any discussion of their achievement as *women*
writers. Too often their contribution has been decried as light, frothy,
romantic – more of the same old love story suitable only for sentimental
adolescents[59] – and their efforts have then been undeservedly dismissed.

Apart from the fact that there is no good reason for disallowing the positive value of emotion, love, or relationships, in any account of human existence, there is also the issue that the allocation of such disparaging labels has frequently been false. When the novels of women, from Ada Cambridge to Mary Grant Bruce,[60] are reclaimed and re-examined in a fresh light, then will the extent of their unjustified devaluation be perceived.

One reason that has been regularly advanced to explain the disappearance of these popular nineteenth-century women writers from the shelves, is that their writing was without merit – that it lacked depth, that the writers proferred no lasting insights and presented no universal understandings. 'Just another love story', as the ritual dismissal goes. Now while not wanting to fall into the trap of denying the importance of love in human emotions – and its appropriateness as a subject for exploration in fiction – I do want to insist that the so-called 'love stories' of Ada Cambridge, 'Tasma', Rosa Praed (and Catherine Spence, Catherine Martin, Mary Gaunt, 'Iota', etc., etc.) contain as many, if not more, understandings and speculations on the human condition as the contributions of many men that are currently acclaimed and awarded a place in the canon.

In her novel *The Marriage Ceremony* (1894), for example, Ada Cambridge does use 'love and marriage' as a means of scrutinising human nature. The story begins with the wealthy bachelor, John Thomas Ochiltree, who wants to ensure the wise management of his fortune after his death – but the question is who should he leave his money to? He has a niece, Betty (but she is only a girl!), and a young male relative acquired by marriage, in the form of Rutherford Hope, but neither seems really suitable and he is in a quandary as to what to do. Then inspiration strikes: he makes his will and in the excitement of finding a solution, John Thomas has an attack of apoplexy and within twenty-four hours is found dead.

Then the will is read. The terms are that nearly all is to go to Betty and Rutherford – on the condition that they marry within three months: if they do not the fortune is forfeited. And then the story of love and marriage really begins. The author points out that in the ordinary course of events, without the element of coercion, Betty and Rutherford could well have found their way into each other's arms: but given that they have been instructed to marry – and for money! – little love and a great deal of suspicion surfaces. With this rupture in the usual ritual of love and marriage, Ada Cambridge opens up the possibilities for a perceptive analysis of human motives.

Of course there is some 'froth', but this is all the more cause for commendation. For Ada Cambridge was able to blend the entertaining and the serious: one might laugh out loud at some of her comic situations

and sardonic observations but her novels also provoke some thoughtful reassessment of the individual and society. It is because Ada Cambridge, 'Tasma', and Rosa Praed were able to educate *and* to entertain that they were the popular novelists of their day. To now see only the supposed 'froth' – and to ignore the significant substance of their writing – is to be worse than short-sighted; it is to be wilfully blind.

All three were responsible, thoughtful – and talented – women writers who wanted to earn a living by their pens. They saw in fiction the opportunity to explore important issues in society – to challenge and inform the public – and it was no coincidence that they were concerned with *the position* of women in the world. In the terms of their time, and in terms of their own personal experience, they were well acquainted with 'the woman question' which overtly and covertly makes its presence felt in their writing. In the late nineteenth and early twentieth centuries in Britain,[6] the pressure for women's suffrage increased and few women writers walked away from the implications of 'sex equality'.

All three questioned the importance of love and marriage in a woman's life. Like their English counterparts, all three challenged the institution of marriage and the permanence of marriage vows: and as each was their own primary means of support they all asked whether women should serve men – or learn to please themselves. All three were quick to point to the limitations of a male-dominated society (and to the limitations of individual men), and they used their fiction to structure a new reality in which women enjoyed greater intellectual and material independence. This is why they are central in the tradition of women's writing: the scandal is that for so long their contribution has been ignored.

CHAPTER 2

•

Ada Cambridge 1844–1926

Ada Cambridge had led a sheltered life in Norfolk, England, and then in 1870, in the space of three months she was engaged and married to a clergyman – and on her way to Australia. While she had written some 'idealistic' poems prior to her marriage it was not until after she arrived in Australia – until after she had written volumes of letters, learnt to contend with the loneliness of her new life, and felt mounting financial pressure – that she began to think seriously about writing:

> It was about this year (1873) that I began to write for the *Australasian*
> – trifling little papers at long intervals – not because I found any
> fascination in such work to dispute the claims of the house and
> family, but to add something to the family resources when they
> threatened to give out. I had no time for more, until one day the
> editor of the *Australasian* wrote to enquire what had become of me
> and my contributions, when it occurred to me that it might be
> worthwhile to make time.
>
> (Ada Cambridge, 1903, p. 86)

While I think that Ada Cambridge could well be bowing to convention and playing coy with her comment that it was family necessity rather than personal desire that sent her to her desk to write (for there is ample evidence that she was a dedicated writer), these first 'trifling' pieces for the *Australasian* mark the start of her long – and laudable – literary life. In 1875 came *The Manor House and Other Poems* and from 1875 to 1886 she published no less than nine novels in serial form in the *Australasian*.[62]

One could – of course – ask how this clergyman's wife, who was constantly on the move (she had eight homes in thirty years) and who

was ostensibly 'on call' to her family and the parish, could have found the time to write so much. Her own explanation is quite revealing:

> Only the other day I attended a gathering of the friends of a lady to whose loved memory it was desired to raise some public monument. She, lately dead, had been our bishop's wife, and so the meeting was appropriately presided over by dignitaries of the Church. They stood up, one after another, to air their views. 'I propose,' said a worthy canon, with the most matter-of-fact air in the world, 'that every clergyman's wife be a collector for the fund' – of course. I heard a sigh and a *sotto-voce* ejaculation behind me – 'the poor clergyman's wives!' – and the incident exactly shows how their male belongings treat them.
>
> I, however, have not been a victim. Before I was willing myself to lighten the double strain, I was compelled to do so, and the parish – as well as all succeeding parishes – had to put up with it. But very early in the day I evolved opinions of my own as to the right of parishes to exact tributes of service from private individuals in no way bound to give them. And I came to a conclusion, which I have never since seen reason to alter, that the less a clergyman's wife meddles with her husband's business (except between themselves) the better, not only for her but for all parties. After I could plead the claims for a profession of my own, my position in the scheme of things was finally and comfortably defined.

<div align="right">(Ada Cambridge, 1903, p. 89)</div>

That Ada Cambridge did not often attend Church was duly noted. To refuse to play 'the female-curate' (her term), to fail to attend Church, and to offer by way of excuse a claim to a profession of her own, was quite a courageous stand for a woman to take at the time. It says much about Ada Cambridge and her convictions: more about her heroines and the issues explored in her writing. What her non-compliance meant to her clergyman husband can only be guessed at, but reading between the lines of her autobiography – and her verse – it seems that she had personal grounds for questioning the rewards of love and marriage. True, she never speaks of her husband in disparaging terms: in fact, she virtually never mentions him at all and it is partly because he appears as a presence rather than a person that one presumes that their union was not one in which Ada Cambridge found fulfilment.

In 1887 her volume of poetry, *Unspoken Thoughts*, briefly appeared. Aptly named, these poems show that at the age of forty-three Ada Cambridge was prepared to break some of the prevailing taboos and to ask what life was all about. Was marriage all there was for women – and

was the hollow reassurance of religion all that could be expected? After more than fifteen years of residence (in the Australian bush) and with no prospect of a passage 'home', Ada Cambridge was more than resigned to making Australia her place of permanent residence, but as these poems reveal it was not just her allegiance to a country that had shifted in her scheme of values. Clearly she experienced what would no doubt now be called a 'mid-life crisis', and all was exposed in her poems. This could have proved to be embarrassing in clerical circles and could well explain the volume's abrupt withdrawal.

It was Ada Cambridge's experience that the life of a woman could be sufficient in itself to drive a person mad: there were times when she felt this about her own life; when she observed it in others; when she portrayed it in her fiction. She knew what it was that women had to contend with and this fuels much of her writing:

Amongst my colleagues of those days was a lady of exceptional culture and refinement. Her husband, a Bush clergyman like my own, was poor, of course, and they averaged a baby a year until the baker's dozen was reached, if not passed. The way she 'kept' this family was such that I never saw a dirty child or a soiled tablecloth or a slatternly touch of any sort in her house. She taught the children as they grew old enough; I know that she did scrubbing and washing with her own hands. In addition, she did 'the parish work.'

One day she was run down and worn out, her husband told her that the organist, from some cause, was not forthcoming, and there was no time to procure a substitute. 'So my dear you will have to play for us.' He knew that she could do it, for she had often done it before; it was the merest trifle of a task, compared with those she hourly struggled with; but it was the one straw too many that breaks the overloaded back. She looked at him in silence for a moment, flung out her arms wildly, and exclaiming 'I can do no more!' went mad upon the spot. She had to be put into an asylum and the parish and the husband and the growing young ones had to do the best they could without her. The husband, I may say, was – apart from being the inadvertent accomplice of the parish in her destruction – one of the very best of husbands and of men.

(Ada Cambridge, 1903, pp. 88–9)

The way in which Ada Cambridge describes this awful event raises some fundamental questions about her style: I see her last comment – this particular clergyman was 'one of the very best of husbands and of men' – as an absolute indictment of the male sex. If he is the best, what hope do women have? But to take this as her meaning is to cast Ada Cambridge

in the role of satirist and she has rarely been given the credit for being satirical (see Raymond Beilby and Cecil Hadgraft, 1979, for example).

Few are the women writers who have been granted the gift of irony in the male-dominated world of letters. Like Jane Austen before her (and Miles Franklin after her), Ada Cambridge has her comments on men taken at face value – and it is almost as if male critics cannot conceive that criticism of their sex is intended. While I do not seek to place Ada Cambridge on the same plane as Jane Austen there is another area where I would like to make a link between these two women writers. Both confined themselves to an analysis of the social strata which they knew and for this 'limitation' they have both been condemned. Yet I would contend that both women present in microcosm the fundamental problems of the 'bigger' world, as distinct from creating a rarefied world apart. Furthermore, I think it absurd to be critical of Jane Austen for failing to cover the Napoleonic Wars – and of Ada Cambridge for failing to explore the issue of class. Of course her attitude to servants is far from exemplary: of course she has blind spots in her assessment of people and events, and of course the passing of time affords a different perspective from which she might be judged, just as the passing of time will expose some of our prejudices in the present. However, this is no reason to minimise or mock her achievement (as Raymond Beilby and Cecil Hadgraft do) – unless the purpose is to find a plausible excuse for keeping her out of the literary canon. While she may appear inconsistent – even shallow – to many men, her exploration of women's fate and fortunes can still speak powerfully to many contemporary women.

In 1890 *A Marked Man* was published in London[63] and it was for Ada Cambridge a considerable critical and financial success: it helped to establish her international reputation as a popular writer. Fourteen more works of fiction followed, the last one being *The Making of Rachel Rowe* in 1914, and there is no question that all should profitably be in print and allowed to make a contribution to the discussion of Australian women writers' literary tradition. Space does not permit even a summary of the contents of these many and varied novels:[64] suffice it to say that it is partly because her range of characters and contexts is so great – so fluid – that Raymond Beilby and Cecil Hadgraft (1979) have accused her of inconsistency! But while she deals with a diversity of issues they can all be traced back to her concerns as an Australian woman writer.

CHAPTER 3

'Tasma' (Jessie Couvreur) 1848–97

If Ada Cambridge had asked what women were to do when they found that marriage did not afford fulfilment, 'Tasma' certainly provided one answer: they could always get a divorce. Startling as it may seem – given the time and place and the pressure on young women to be proper and prudent – this remarkable woman writer obtained a divorce in Australia in 1883.

Born in Highgate, London, in 1848, Jessie Catherine Huybers arrived in Hobart at the age of six: at the age of eighteen she married the attractive and reasonably affluent Charles Fraser. In between she seems to have been educated – provided with her marital and literary preparation – by her dynamic mother who continually encouraged her children to 'make something' of themselves in the world. Presumably this was to be done without benefit of extensive financial resources, for the family were never free from economic pressures. Perhaps this is why Jessie married so early, and so 'well'!

But (as so many heroines have shown) the 'good' marriage was far from being a success. For six years Jessie evidently tried to come to terms with her unsatisfying life, but to no avail. And in 1873 she sailed with her mother and other members of her family – without her husband – for greener pastures. For two years she supported herself by journalism and travel writing, while she immersed herself in the cultural and intellectual life of Europe.

In 1875 she returned to Australia and her husband, but neither it seems wished the marriage to continue, and in July 1883 Jessie sued Charles Fraser for adultery and desertion: the divorce was granted and almost immediately Jessie set sail to join her mother in Florence.

Jessie married again in 1885. This time her husband was an urbane Belgian – Auguste Couvreur, a former politician, political editor of *l'Inde-*

pendance Belge, the Brussels correspondent of the *Times*, and a journalist of considerable distinction. And this time Jessie Couvreur found her social and intellectual milieu conducive to her writing.

From 1877, when Charles Fraser had technically 'refused to make a home for her', 'Tasma' had been writing short stories and travel pieces for publication. Her work had appeared in the *Vagabond Annual*, the *Australasian*, the *Australian Ladies Journal*, and the *Melbourne Review*. Then from January to May 1888, the *Australasian* serialised 'The Pipers of Piper's Hill', and so successful was it that it launched 'Tasma' on the road to literary fame. In 1889 it was published as *Uncle Piper of Piper's Hill*[65] by Trubner, London, and it was received with enthusiasm and acclaim.

It is important to recognise the significance that was attached to 'Tasma's' novel at the time of publication. It was rated as one of the best books to have come out of Australia. The author was presumed to be male – and the contribution to Australian literature to be considerable, and unique. According to the *Spectator*:

> *Uncle Piper of Piper's Hill* is, to the best of our knowledge only the third work of fiction possessing remarkable merit that has come to us from the Antipodes. The first of this trio is Marcus Clarke's powerful and painful story, *For the Term of His Natural Life*, which can never be forgotten by anybody who has read it. . . . The second is the stirring story called *Robbery Under Arms*, by the gentleman who wishes to be known as 'Ralph Bolderwood'.[66] . . . The third is a work totally different from either Marcus Clarke's or Ralph Bolderwood's in matter, manner, character, and purpose, the very last kind of book we expect from the intimation that is an Australian novel, and one such as we rarely have the chance of welcoming from any quarter.

> (*The Spectator*, quoted in Raymond Beilby and Cecil Hadgraft, 1979, p. 21)

So in some of the earliest assessments of the Australian tradition we find the writing of 'Tasma' being given pride of place. And we find that this writing is considered very different in 'matter, manner, character and purpose' from the other contributions of the time. For *Uncle Piper* is not about the endurance of brave men in brutal bondage or the blistering outback: quite the contrary. It is a woman's view of urban Australia – of the clash of values between the old and the new as they are worked out in the psychological conflict within one family. What is interesting about this is that for as long as Australians have written fiction there have been novels that would not fit into the framework of the great

male tradition. That these novels – like *Ella Norman*, *The Three Miss Kings*, *Uncle Piper of Piper's Hill* and Rosa Praed's *Policy and Passion* – should since have been eclipsed so that prominence can be given to the glorious and conquering experience of men says more about who is making the selection than it does about the range and scope of the writing from which the selection is made.

The Australian tradition which is now familiar represents but one strand of the literature that was written and it is – and will remain – a distorted tradition until the writing of women such as 'Tasma' is reinstated within it. Then the views, values, and voices of many men will be perceived as but a part of the cultural heritage, rather than the whole.

Uncle Piper deserves a permanent place in the Australian literary canon. It is a highly sophisticated and humorous novel: it is well-crafted, elegant, substantive and amusing. With its commentary on manners and the significance of the gaucheries of the 'nouveau riche' it could clearly sit comfortably within the category of polite fiction. But it is a great deal more than a description of a self-made man and his quest for acceptance: partly because 'Tasma' (like Ada Cambridge and Rosa Praed) consistently presents two perspectives, the novel has provocative and profound psychological and philosophical dimensions.

Uncle Piper does not make his money out of bushranging or gold, out of wheat, wool, or a clever business venture. He is a butcher who works long and hard and gets his hands very dirty with trade. In England he has a sister who is married to the poor and pretentious Mr Cavendish, and Uncle Piper sends them their fare to Australia to rescue them from their impoverished predicament. And then the clash of values begins. Uncle Piper has money but no breeding: Mr Cavendish has class but no cash. A struggle for ascendancy ensues. Not just between Mr Cavendish and Uncle Piper – although this is dramatic in itself – but between two opposing world views.

Always 'Tasma' maintains the balance between the old and the new: she exposes the strengths and weaknesses inherent in both. But if her purpose is serious, her touch is often satirical and light, and this novel still qualifies as a riveting good read. That it does not still stand among the first ranks on the list of significant contributions to Australian literature is inexcusable.

That 'Tasma' should have chosen such a subject as the contradictions between the old and the new is, of course, not at all surprising: in some ways she was telling the story of her own life. She experienced the pull of two worlds and in Europe she repeatedly encountered the resistance and resentment that was often the patronising response to supposedly coarse colonial ways.

The publication of *Uncle Piper* was soon followed by an anthology of short stories – *A Sydney Sovereign and Other Tales* (1890, Trubner,

London) – most of which had appeared previously, the majority in the *Australasian*. But after this 'Tasma' once more drew on her own personal experience and, before her early death from a heart attack in 1897, she wrote five more fascinating novels.

'Tasma' had been unhappily married and she had been divorced: clearly these were significant events in her life and she wanted to reflect upon them in her writing. She was not the only one who wanted to ask questions about the importance – and permanence – of marriage for women. For most women writers of the late nineteenth century the issues of love, marriage – and sex – were of central concern, so when 'Tasma' began to explore these problems in her fiction she showed her affinity with other women writers of her time.

Only a man for whom such issues were peripheral could ever think that 'the woman question' in general – and 'Tasma's' version of it in particular – could have been a passing phase, open to popular exploitation. It is a matter for some regret then that in one of the few articles available on 'Tasma' she should be criticised for jumping on the bandwagon, ostensibly with the aim of increasing her sales! Such an assessment denies the details of her life. In their article on 'Tasma', Raymond Beilby and Cecil Hadgraft (1979) make 'popularity' seem a dirty word: they charge 'Tasma' with writing five 'rather pedestrian examples of the "problem" novel of the "nineties"' (p. 22) and then proceed to provide their own profound and perceptive analysis of her work:

> Her 'problem' matter was very much up-to-date but her manner was more a reversion to the styles of the 'seventies and eighties'. Three were written in two – or three – volume form, and to fill these and to make up for the general lack of inspiration, Tasma enclosed the little inspiration that did come her way in a complex autobiographical web. It is no exaggeration to say that the more one discovers about Tasma's personal experiences, the greater the autobiographical content of these later novels appears to be. Nor is it too rash to assert that in most instances Tasma was her own model for her heroines, that Charles Fraser was her model for unsatisfactory husbands, and that, in one novel at least, members of her family make up the bulk of the characters involved.

> (Raymond Beilby and Cecil Hadgraft, 1979, p. 23)

Perhaps these commentators should be congratulated on their own inspiration and intellectual achievement in finding the autobiographical elements in the novels that have been transformed into fiction: perhaps they should also be criticised for the limitation of their view. For I find 'Tasma's' rogues' gallery of unsatisfactory husbands an understandable

– and useful – addition to women's literature. For where else were women to learn about the realities of marriage? Where else to find how badly it could turn out? In *Not Counting the Cost* (1895), for example, 'Tasma' introduces a young wife, Eila, who not long after her marriage is confronted with a violent and mad husband who must be confined to an institution, and in this way 'Tasma' provides a safe place for women to reflect upon the possibility of violent husbands – and on the permanent nature of marriage vows, and when and where they might not apply. If this was the source of her popularity it was not because she was engaged in any shoddy or shady tricks to ensnare an audience: it was because she discussed – sensibly and sensitively – many of the problems that women sought to understand and which they often could not explore anywhere else.

According to these critics, however, 'Tasma' also dealt with a subject ripe for commercial exploitation – namely, the sex problem. Raymond Beilby and Cecil Hadgraft (1979) comment condescendingly that 'It should have been clear to anyone with an eye to the market that here was a subject which could well be profitably exploited [and] Tasma was not slow to grasp the idea that success lay in giving the public what it wanted.' (pp. 24–5). Such subjective and silly 'padding' in an article that purports to be serious criticism undermines the entire exercise of literary evaluation – and points to some of the prevalent practices used to prevent women writers from becoming prominent within the tradition. It shows how male critics can have their cake and eat it too: if women writers do not sell then clearly their exclusion from the canon is justified, but if they do sell then too can their omission be explained on the grounds that they were simply producing pot-boilers and giving the public what they wanted. Either way, the literary worth of women can be denied and their work can be rationalised out of the revered tradition.

Because 'Tasma' writes so consistently about the reality of women – and because she wrote at a time when there was general interest in the reality of women's lives – her critics seem to feel justified in dismissing her contribution as both personal and commercial. It is as if she is being penalised for having private experience which coincides with public concern. Perhaps her reception now would be more positive if it were possible to place her within the tradition of the male mainstream – if she had written more about the image of the Australian supposedly subduing the forces of the outback.

Regardless of the reason for her devaluation, the contributions of 'Tasma' have been cast aside: her novels about marriage failure and their impact upon women have been dropped from the literary canon. Yet even now these novels continue to offer insights and explanations on the breakdown of relationships – and the repercussions for wives.

After the 'non-conformist' *Uncle Piper* came *In Her Earliest Youth*

(1890, Heinemann, London), which continued in the vein of exploring the psychological tensions within a family, only on this occasion it is not the opposing values of the old and the new that are the source of the conflict: it is the different frames of reference of husband and wife which cause the clash of interest. This 'drama' was followed by *The Penance of Portia James* (1891, Heinemann, London), a complex and unconventional tale with a surprising and salutary ending – and of course marriage *is* Portia's penance!

A Knight of the White Feather (1892, Heinemann, London), *Not Counting the Cost* (1895) and *A Fiery Ordeal* (1897, Bentley, London) complete the sequence examining the flaws in men that render them inappropriate as partners in marriage. All of these novels have something to contribute to women's literary heritage and it is both frustrating and distressing that they should all be out of print.

Jessie Couvreur was a remarkable woman and a talented and versatile writer. On her husband's death in 1894 she took over his post as Belgian correspondent for *The Times* and continued to support herself by her writing. Her knowledge of Australia and her familiarity with the European traditions – her experience of love, marriage, disillusionment, divorce and widowhood – all helped to provide her with ample and diverse resources for her novels and short stories: her skill translated them into fine fiction.

Margaret Harris, in her introduction to the reprint of *Uncle Piper* in 1988, recognises the considerable achievement of 'Tasma' and the loss that her disappearance from the literary records represents. She offers an explanation:

> How then did Tasma's fiction come to be relegated to museum status in literary histories? For a start she died relatively young, at the age of 49; and she was an expatriate. More potent in effecting her eclipse, however has been the version of Australian literary history which sees the emergence in the 1890s, especially in the Sydney Weekly *Bulletin*, of a tradition of authentically Australian writing. This male-oriented bush realism claimed to offer unadorned presentation of themes like mateship, the pioneering spirit and epic adventure in the bush as against the pernicious mannered conventions of Anglo-Australian romance.

> (Margaret Harris, 1988, p. viii)

Because 'Tasma' did not write the 'bush realism' that was valued by males she is of no great interest to those who retain and reinforce that tradition.

The image of Australia being structured during the 1890s was one which cultivated male views and values as they were being forged in the

bush. But of course, even by this stage, such a proud and self-congratu-latory image was more of an ideal than a reality. By the end of the nineteenth century it was but the few who were braving their way through frontier existence, while the many embarked on urban life. And it is probably because from the outset the image was so fragile that firm steps were taken to keep it in place. Unfortunately, any writer who did not make a contribution to this particular representation of hardship – and mateship – was all too often deemed to have no contribution to make.

When the ideas and understandings of women writers such as 'Tasma' – and Ada Cambridge and Rosa Praed to name but a few – could not be accommodated within this malestream/mainstream tradition they were by-passed, ignored and lost. And this is why Australians are the inheritors of a predominantly male literary tradition: not because women have not written nor because what they have written has been without merit, but because men in the main have handed out the prizes and they have judged their own sex to be the best and to have been the makers of a glorious tradition.

This is how the experience and expression of women has come to be excluded from the available cultural heritage: this is how women's view of the world – past and present – has been eclipsed. And this is why the image of Australia – of its people and its culture – would be substantially different if it were to be based upon the reclaimed writings of its women rather than its men.

CHAPTER 4

Rosa Praed 1851–1935

While the contributions of 'Tasma' and Ada Cambridge are impressive, that of Rosa Praed strains the limit of credibility. For she was born and raised in outback Australia and yet found for herself an esteemed place on the London literary scene, without the benefit of 'contacts', money or mentor.

Rosa Caroline Murray-Prior spent the first twenty-five years of her life in Queensland[67] and the next fifty years in London and Europe drawing on that experience in her writing. It was a rich and varied existence, providing the resources for a steady stream of diverse short stories and novels; an existence which ranged across people and places, encompassing everything from extreme isolation to the heights of social life, from acquaintance with suave political figures to uninhibited black playmates, from comedy to tragedy and from boredom to passion. It was a distinctly 'young Australian' – and self consciously female – existence, which was to find expression in her more than forty volumes of best-selling fiction.

Rosa was born on her father's property at Bromelton on the Lower Logan (in the area now referred to as the 'Gold Coast') and from her earliest days she was aware of some of the back-breaking – and heart-breaking – hardships of outback life, and of the terrible toll they could take on women. Her mother, Matilda Harpur, had been reared in more civilised circumstances and was far more at home with books than in the bush but for her – as for so many other outback women – there could be no respite from the dreadful and deadening demands of daily life: often sick, often inflicted with the blight which blinded her, often pregnant and very often frightened, Matilda Harpur Murray-Prior was caught in the struggle for survival and had no choice but to keep going, regard-

less of the cost. And her eldest daughter watched, and 'filed' her observations.

But this was only part of her informal education. As an Australian woman writer Rosa Praed was educated by her natural surrounds as well as by the 'model' of her mother. She learnt from the bush: as a child her only 'playmates' outside the family were the Aborigines and from them she learnt a language, a lore, and a lasting respect for their persons and culture. From them too she learnt about fear: the young Rosa lived through some of the massacres in the Burnett district and as a mature writer was intent to account for the conflict in terms that neither now nor then have gained great currency in the white community.

In her own words, however, it was the 'Marroon Magazine'[68] that provided her with her literary education, and in acknowledging its influence Rosa Praed reveals how close – and yet how far removed – she was from the British woman writer, Charlotte Brontë. For it was after reading Elizabeth Gaskell's biography of Charlotte Brontë's life – after discovering how Charlotte Brontë and her sisters (and brother) served their literary apprenticeships through family scribblings and a magazine – that Rosa and her mother and brother started the 'Marroon Magazine' of their own. Here too her mother provided a model, perhaps a more positive one in this instance, for her handwritten contributions to the family periodical display a quite considerable talent: here too Rosa Praed had her first audience and critical feedback as the magazine was circulated.

In contrast to some of the literary and intellectual provisions that were available at the time to potential writers in England, the education of Rosa Praed can appear impoverished in the extreme. But in comparison to the education received by Charlotte Brontë, Rosa Praed's preparation for a literary life does not look quite so bad. Women had much in common – even though oceans divided them – and this shared experience of exclusion, of isolation and self-education can be traced through women's literary traditions. And this helps to explain why women have invested so much in novels, which have often been their only avenue of communication and learning, their only access to 'worlds' other than those experienced directly.

To Rosa Praed the reading of novels (and the reading of what novelists had to say about other novelists) was a crucial element in her literary education: novel reading was probably as central to her sense of literary appreciation as was an Oxbridge degree in classics to her male British peers. Yet she counted herself as fortunate because she did have access to books and to novels – for example, to Elizabeth Gaskell's biography of Charlotte Brontë in a relatively short time after publication (it was first published in 1857). And she knew there were many other Australian women who enjoyed no such advantages and who – without the benefit

of books and novels – were provided with an education that must be classified as genuinely deprived.

Reduced resources Rosa Praed might have had when it came to formal education, but she was well schooled within the women's tradition which had developed outside the institutional framework: in keeping with women's literary tradition, she read women's novels, and she wrote. Like Charlotte Brontë, Rosa Praed compensated for the isolation of her life through her writing: like Charlotte Brontë she created her own context and conversations for her exploration of the world; like Charlotte Brontë she allowed her emotional life to be given shape and substance in her writing, and made a major contribution to women's literary heritage.

In June 1866 the 'Marroon Magazine' was started; in 1931, Rosa Praed's last novel, *Soul of Nyria*, was published in London. In the period in between we witness the growth, development and achievement of an Australian writer of great distinction. Here is a woman who wrote about the outback, and about political intrigue, about squatters, bushrangers, criminals, governors, knaves and knights: a woman who wrote about oppression, who wrote about the victimisation of women and of blacks. And despite this abundance of 'bush realism', here is a woman writer who cannot be comfortably placed within the Australian male tradition, for her view is that of women, and it is very different. And it is this 'woman's view' which has been eclipsed.

Rosa Praed's writing was informed by a wealth of women's experience: she watched her mother suffer and die early, and she was determined to avoid a similarly harsh fate. There was cruel irony in the fact that it was the death of her beloved mother which provided Rosa with a better 'quality of life'. For in 1867 when Queensland became a colony, Rosa's father, Thomas Murray-Prior, became a Member of Parliament and the family spent much of their life in the relative comfort of Brisbane. Here Rosa served as her father's hostess and so from a very young age had an unusual place at the centre of a lively social and political scene. She entertained, and she listened to some of the most influential figures of her time and place: she attended sittings at the House and official receptions and was privy to some of the great political plots and intrigues of her period. In this she enjoyed much more access to the affairs of state – and the ways of the world – than some of her British counterparts, Charlotte Brontë included. And as Rosa Praed attended to the life around her, she stored up her experiences to be drawn on later in her writing.

Whether or not she seriously practised her craft at this time it is difficult to tell: once she became famous she jealously guarded many of the details of her private life, and by providing her own version of her past (as she did in *Australian Life: Black and White*, 1885 and *My Australian Girlhood*, 1902) she controlled much of the information that is available about her and constructed the identity that she wanted known.[69]

What is known, however, is that she enjoyed her Brisbane life and had no great urge to marry. But as with so many other young women in fact and fiction – including Mary Gaunt's heroine, Phoebe, in *Kirkham's Find* – parental pressure was applied. Her father was about to marry again and –

Papa was somewhat impatient of Rosa's steady rejection of the various suitors who asked her hand in marriage, and bluntly said one day, after a scene of tears and angry words, 'Young woman, you'll marry the next man that asks for you.'

(Colin Roderick, 1948, pp. 63–4)

Whether Rosa really wanted to marry, whether she was worn down by her father's insistence or simply found it easier to start on her own rather than to see someone step into her mother's shoes, is not clear: but the coercion left its impression on her and was more grist for the literary mill. In October 1872 she entered a hasty marriage with Campbell Praed. After their marriage they were to live on Curtis Island, which in retrospect Rosa Praed admitted that she thought would be romantic. But the reality was very different. It was a nightmare and one which was to surface in much of her writing at a later date. This was where incredible demands were made upon her endurance, and it is more than regrettable that such experience of privation and fear, of trials, tests, and courage, should have been omitted from the cultural understandings. For Rosa Praed, the detail of these two years on the island were indelibly printed on her memory. In *My Australian Girlhood* she describes the amazing journey across the dangerous waterway to the island and the desolation of the scene that greeted them when the bride and groom arrived at their new home:

And then it came in sight – after a painful progress of three miles or so – in which the pillar of mosquitoes led the way through barren gum-country, where ill nourished trees shred tatters of white bark and drooped, limp boughs scantily clad with thin, metal-like leaves. The hill on which the head station stood had been cleared of all growth except for blady-grass tussocks – the nursery of myriads of mosquitoes and a few upspringing gum saplings pushing new life out of the stumps of felled trees. Gaunt and erect, near the house, rose that one skeleton gum, whose naked boughs, when they swayed in a south-easter gave the suggestion of bones rattling on a gibbet. The full force of ocean gusts shook them, for there was nothing between that bald station hill and the Pacific, seven miles distant.
Now, as our dray approached, a band of dogs and an angora goat – a pet which lived in the pantry and couched in the best bedroom

– ran down the hill, and a few wild hens flew cackling out of the
grass-tussocks and from beneath the piles supporting the cottage. The
dust below the house flooring, which was mostly uncovered, so that
light and air – and worse – rose through the wide cracks between
the boards, held a new Egyptian plague awaiting island-dwellers.
Here was a gigantic nest of fleas – worse evil than mosquitoes, for
curtains would keep out – poorly enough! the flying pest but not the
closest mesh mosquito netting was proof against fleas, which made
night hideous for many weeks, till they were finally routed by boiling
water poured continually through crevices in the boarding.

Beneath was space high enough for a calf to stand upright and to
furnish a dormitory for a flock of goats. A bullock was killed only
once in six weeks, and in the interval, occasionally, like the patriarchs,
we fed on flesh of kid. Often of nights, the goats horns knocking
up against the bare floor would make an odd chorus in one's dreams.
So it will be seen that till some of these difficulties were overcome,
sleep was a blessing not wholly at command.

At the back of the house a covered passage open at the sides led
to the kitchen, beyond which, lay the store and meathouse, all
enclosed by a fence of spiked saplings on which pieces of salt beef
would be hung till they became almost as hard as the section of an
iron-bark log. One living gum-tree grew close by the meat house –
a sad, lanky thing that looked lonely.

(Rosa Praed, 1904, pp. 260–1)

And Rosa Praed too was lonely, desperately lonely, on this desolate
island where there was not even any likelihood that pioneers – or travel-
ling bushmen – would ever pass by. From the beginning she had a
feeling of foreboding:

To a foolishly expectant bride on the occasion of her first
homecoming, there seemed something fiendishly ironical in the
hoarse mirth of a laughing jackass – the demoniac-sounding bird of
the bush – which greeted her from the dead gum tree. Of other
welcome there was none. The only other woman on the station . . .
announced on the moment she was going away for a holiday. It was
Christmas time, and the island staff, stockman, stockwoman and two
black boys, had chartered the boat which brought us hither. They
set hastily forth to catch the ebbing tidé that would bear them to the
mainland, leaving a dejected young woman face to face with Destiny.

A mean, sordid, grubby destiny. There was no food in the place
but a wedge of salt junk and a three cornered loaf of camp-oven
bread, to be washed down with black tea, for milk and butter
represented a stage of civilisation that the island had not then

reached. The unappetising meal was laid, with a tin teapot, two iron cups and saucers, enamelled plates, and three pronged forks, minor trials that would be remedied when the schooner came along, bringing stores and luggage. But the house had not been cleaned for months, the boards in the best bedroom were inch deep in mire, and a plank across two chairs served as a washstand, while the incongruity between lace-frilled cambric and the duties of maid-of-all work was deeply distressing.

(Rosa Praed, 1904, pp. 262–3)

Within a decade, however, all this would change dramatically: by Christmas 1880 Rosa Praed would be in England, noting with interest the critical reception of her first novel, *An Australian Heroine* – which drew on her experience of Curtis Island. By Christmas 1881 she would be a highly praised novelist with the publication of *Policy and Passion* – which drew on her experience of political life in Brisbane, and by Christmas 1882 she would be a well-established writer with the release of her third novel *Nadine* – which drew on the experience of women who were victims of men. And she would achieve all this without privilege or patronage.

But in 1872 that journey from Curtis Island to England – which figuratively and literally speaking represented so great a distance – was a long way hence. The young bride on Curtis Island had to cope with every conceivable form of privation. Sometimes when I hear the spurious assertion that Rosa Praed was a leisured lady and a middle-class writer – and such 'accusations' are made in the ostensible attempt to explain her omission from the literary canon – I am tempted to produce some of the reports of her terribly difficult early life and to make them publicly available in very large print. For perhaps such accounts could then put to rest the myth that Rosa Praed was a refined and languid, bourgeois lady-writer of polite fiction.

Rosa Praed was *never* a leisured woman: she worked first as a bush-wife and then as a professional writer. She endured a primitive and materially impoverished (and psychologically disturbing) existence on Curtis Island – and she shows her affinity with the Australian tradition when she distances herself from such horrendous and harassing conditions, when she masks them with humour and transforms them in fact and in fiction, into a gripping and good yarn.

For life on Curtis Island was unbearable: the desolation, the heat, the flies, the fleas, the mosquitoes, the loneliness, the diet – the fear. It was when Rosa Praed was pregnant, when she felt at her most vulnerable and most in need of support, that she had a spiritual experience of deep significance: *Sister Sorrow* (1916) is the novel which gives resonance to this particular period of her life.

Rosa Praed's biographer, Colin Roderick (1948), provides some of the background detail of her 'terrifying loneliness':

> With the onset of clammy heat in December, 1873 and the birth of her child not far off, Rosa's nervous fears increased to such a pitch that she used to bar the doors at nights and lie awake in wakeful dread of attack, despite the certain knowledge that she and Saint Helena (a black woman) were the only people on the island other than the pilot colony.
>
> As the intensity of her terror increased she felt herself unable to bear the coming months of torture. Loneliness magnified the wretchedness of mosquitoes, the heat, and the torment of confinement in the box-like furnace that represented home. Despair wrapped its tentacles about her heart. She thought she must give up. She determined to contact the spirit of her mother for guidance.
>
> (Colin Roderick, 1948, p. 67)

Her method was to take pen and paper and to concentrate on receiving a message through automatic writing. Rosa Praed maintained that through this medium her mother spoke to her, and provided her with invaluable comfort and consolation. Later, Rosa Praed was to write more extensively about the spiritual and the occult in her sequence on 'Nyria'.

Rosa Praed left Curtis Island for the birth of her first child, Matilda: she later returned to the island but not for long. Her second child, Humphrey, was born in England in May 1877. And by that time Rosa Praed had begun to write: not just messages from her mother but novels which were designed to make money – and to support the family.

The reason for her husband's return to England was that his pastoral venture had failed – and he knew of nowhere else to go. But he failed to sustain his wife on more matters than financial ones. It was partly because of his extramarital affairs that the Praed marriage was such a torturingly unhappy one. And while Rosa Praed's novels contain a long line of sometimes mean, shiftless, unfaithful and violent men there is no way of knowing just how far they are a representation of her own personal experience. It was obvious that she was separated from her husband (and that she had a close relationship with a woman friend, Nancy Harward) but so reticent was Rosa Praed about the intimate details of her life that it is not always possible to make direct links between her reality and her 'romances'.

In England there were no family finances to fall back on and, with four children to support, Rosa Praed in typical egalitarian working style took up her pen and assumed responsibility for her family. She worked with characteristic energy and commitment: she wrote with characteristic

frankness and forthrightness about Australian problems – and women's plight. In the process she challenged many polite conventions and ventured into areas where English lady-novelists were not supposed to go. From George Meredith – the first publisher's reader to offer her advice – to Fred Chapman of Chapman and Hall, she received the constant counsel that she should 'tone down' her novels, that she should remove the 'raciness' from them and reduce them to the realm of refined fiction.

If Rosa Praed did 'tone down' her fiction this is not apparent in most of her novels, which are often serious and courageous explorations of some of the moral and social issues of her time: if a study could be made of her original manuscripts in comparison with the edited versions perhaps efforts aimed at 'genteelness' would be revealed and the originals could be judged better – or worse.

Colin Roderick certainly seems to think that she 'toned down' not only her writing, but her *self*: commenting on the contribution of two literary men who proffered their counsel to Rosa Praed, he states –

If George Bentley and Fred Sartoris had not forced her into the mould of public Victorian respectability, we should have had novels from her hand that would have disguised less thinly the passion that wracked her. The novel they bowdlerized would have been a story of red blooded conflict, for was not Rosa Praed's whole life one of deep inner stress and strain?

(Colin Roderick, 1948, p. 208)

Personally I think Colin Roderick is looking for something in Rosa Praed's writing that simply isn't there: because she draws heavily on her own experience in fiction he assumes that she will beat her breast about her own personal involvements and tragedies. Particularly when it comes to her relationship with Nancy Harward. But Rosa Praed is not the sort of writer to expose herself in her fiction: she doesn't take her raw experience and insert it in her novels – she transforms it in the process and this is one reason why she is such a good writer. While she uses her own reality to generalise about Australia – and the position of women – she does it with great artistic control and detachment. She does not write intimately about the death of her mother, the violent deaths of all her four children, the difficulties with her husband or her relationship with Nancy Harward, though it is clear that these tragedies and traumas left their imprint on her emotional life. What she does do is draw on the painful insights that she has gained from these experiences and permit them to permeate her provocative novels.

When she turned to writing Rosa Praed did so with the aim of making money – which she did not see as interfering with her aim of being a

good writer. From the outset she took her work seriously and believed that she had a part to play in developing, shaping – and legitimating – the literature of Australia. This is why in the prefatory note to her first written (but second published) novel, *Policy and Passion* (1881), she not only declares that she intends to use her fiction as a means of remedying English ignorance about the antipodes, she also insists that the English should take note of the emerging – and distinctive – literature of Australia with which she identifies:

> It can be no matter of conjecture that when in the course of years Australia shall have appropriated to herself an independent position among those occupied by more ancient nations, and shall have formulated a social and political system adapted to the conditions of her development and growth, she will possess *a literature of her own*[70] as powerful and as original as might be prognosticated, from the influence of nature and civilisation brought to bear on the formation of a distinct national type.
>
> (Rosa Praed, 1881, p. iv)

No 'cultural cringe' here: Rosa Praed certainly thinks that Australian literature is in its early stages – but she sees it as young and healthy and she likes the direction in which it is to go. She wants to be a link between the old and the new:

> But it is to the British public that I, an Australian, address myself with the hope that I may in some slight degree aid in bridging over the gulf which divides the old world from the young.
>
> (Rosa Praed, 1881, p. iv)

What is interesting to note is that Rosa Praed considers her own contribution to be well within that emerging Australian tradition. She sees her own novels about politics, passion, and oppression as part of a peculiarly Australian scene. Such a position would have been difficult to maintain by the end of the nineteenth century when Australian chauvinism made its presence felt to such an extent that anything that was not about mateship, or boys in the bush, could be regarded as *non*-Australian.

But in 1880, Rosa Praed looked on her first novel *An Australian Heroine* as indisputably Australian: drawing as it does on her experience of isolation on Curtis Island – and her initial unease in English society – it reflects some of the conflicts of her life. But even here there is an exploration of some of the ethical, popular (and Australian) issues of the day. How far are the sins of the fathers to be visited on the next

generation? In the wake of the controversy caused by Charles Darwin – what is the relationship between heredity and environment?

In Australia, where the leading citizen could have convict origins, the question had more practical applications. And in *Policy and Passion* (1881) Rosa Praed took up the issue of when a convict, criminal, law-breaker, was to be trusted: when were the crimes to be pardoned and ex-convicts allowed to take their place in decent society? For her purposes she created Leichardt's Land – a place that would feature in much of her fiction: 'The scenery described here is drawn directly from nature, and the name of Leichardt's Land – a tribute to the memory of a daring but ill fated explorer – is but a transparent mask covering features that will be familiar to many of my Australian readers' (1881, p. iv). Thomas Longleat is the Premier of Leichardt's Land: the heroine, his daughter Honoria, is his hostess who has access to all the political debate of the day. It is a mark of how selective and distorted the literary tradition has become that it now strains the bounds of credibility to realise that one of the earliest and best (and most popular) Australian novels was concerned with the political intrigues of the nineteenth-century colony of Queensland – and that it was a woman providing the perspective and the information.

The similarities between Rosa Praed and her heroine do not end with their political involvement: like Rosa Praed, Honoria Longleat is reluctant to marry and her situation is complicated by the requirement to choose between the old and the new. *Policy and Passion* goes straight to the heart of much social hypocrisy and it is not surprising that on the basis of it the author should have been regarded as quite risqué.

Rosa Praed's reputation received another boost (or blow, depending on which way you look at it) with the publication of *Nadine* in 1882. An exposé of the injustice of the sexual double standard and a moving study of the implications of illegitimacy, this novel placed Rosa Praed among the women writers who were prepared to use their fiction to protest on behalf of their sex. In reference to *Nadine*, Edward, Prince of Wales, was to comment at a dinner with William Gladstone that the book was worth reading – but should be kept out of the reach of children. That Rosa Praed should have been present at such a gathering – purely on the basis of her literary work – gives some idea of her meteoric rise, and the significance that was accorded her writing.

She went on to become a part of the intellectual and literary milieu of her day – and she did it as an Australian woman writer – in her own right. She became the friend of another famous (equally talented and under-rated) English novelist, Eliza Lynn Linton: she knew Ouida, Ellen Terry and Oscar Wilde. And she retained her prominent position among the literati well into the twentieth century.

Nadine was followed by a steady stream of novels and in 1886 came

Miss Jacobsen's Chance. While to some extent all Rosa Praed's heroines were not moved to seek marriage (albeit, it frequently falls upon them!), *Miss Jacobsen's Chance* is the one in which the issue of coercion is most carefully and crudely detailed. Set again in Leichardt's Land, the despicable and dypsomanic Mr Jacobsen knows that there will be no more opportunities for him in the political world and he determines that his daughter should make a match (and relieve him of his duties) before his dreadful doings catch up with him. No father could be plausibly worse than Mr Jacobsen: no predicament more desperate or humiliating for a daughter.

Being pressured into marriage is a theme that has made its presence felt from the very beginnings of women's modern literature. When Frances Sheridan wrote *Memoirs of Miss Sidney Bidulph*[71] in 1761 she asked whether a woman should marry to please her mother or to provide finances for her brother: and she asked whether a woman should stay married if and when her husband proved to be a brute. One hundred and twenty-five years later Rosa Praed asked much the same questions and contributed to women's distinct literary tradition.

The Bond of Wedlock[72] was published in 1887 and so popular (and controversial) was it that it was soon dramatised as *Ariana* and presented on the London stage. In graphic and horrific detail it depicts the disintegration of a marriage to the point where the drunken Harvey Lomax beats Ariana, his proud and beautiful wife: deeply in debt Harvey has no aversion to Ariana accepting money from her wealthy (and admiring) friend, but this Ariana will not do:

'I'll have no man coming to my house and pretending honest and disinterested friendship' [Harvey says] 'who doesn't choose to act the friend to me and help to pull me out of a fix. If D'Acosta is your friend and my friend, we need have no scruple in asking him for the loan of a thousand or so, to get us out of our difficulties.'

Ariana stood perfectly rigid and silent.

'Well, have you nothing to say?'

'I have already said that I would rather starve than take money from Sir Leopold, as a loan or as a gift. It is the same thing.'

'You meant that, did you?'

'I meant it so thoroughly that, this very afternoon, when he offered me a loan, I refused it – in those very words.'

'You did, did you? By God! I'll punish you for this!'

He came close to her. For a moment she seemed to see only the flash of fury from his reddened eyes. His heavy arm was raised and fell in a cruel blow – once, twice, thrice, upon her shoulder and half bared neck. He was blind with drink and with passion, and scarcely realised what he was doing. Her unflinching courage maddened him.

She uttered no sound; her large clear eyes met his steadily; she did not attempt to evade the blow. Her face was as though it had been cut out of stone; every drop of blood seemed to have gone out of it. She staggered beneath the weight of his clenched hand, but reared herself again and stood erect. The pain made her dizzy; for a few moments everything was dark.

There was a silence between them – a strange tragic silence. The shock of what he had done, and the look in her eyes sobered Harvey.

'Damn you!' he said. 'Go away from me; I can't answer for myself. If I've hurt you, it's your own fault.'

(Rosa Praed, 1987, p. 49)

One hundred years later the scene is just as relevant – and symptomatic.

After this the issue that is raised is whether Ariana is obliged to stay with her husband or whether she is morally free to walk away and start again. And surprising though it may seem to some there is a long tradition in women's (suppressed and subversive) literary history whereby heroines not only leave their husbands, but go on to live full and happy lives. Eliza Haywood, one of the first writers of fiction,[73] introduced *Betsy Thoughtless* in 1751: Betsy leaves her husband because he is boring and instead of being punished is allowed to reap a great reward. And Ariana could – at a pinch – be part of this women's liberation literature. Rosa Praed, however, provides an ending with a subtle but stinging twist and creates even more contradictions for her audience to resolve.

The Bond of Wedlock is no sensational 'soap': it is a serious examination of the relationship between the sexes – of privilege, politeness, power – and the permanence of love and marriage. It makes a critical contribution to the history of women's consciousness and can help to provide women with a past which allows them to make sense of conditions in the present. The novel also shows sensitivity when it comes to the Australian image, and the relationship between the supposedly civilised home country and her raw colonial offspring. Quite deliberately, defiantly and deftly, Rosa Praed sets her drama among the upper classes of British society: it would have been so much easier for the British to dismiss the implications of 'wife-beating' had the rough and violent man been Australian.

Rosa Praed was a clever artist: she was a superb story teller who wanted her fiction to clarify some of the perplexing questions on the human condition. She tried to use her writing to enhance understanding, to promote debate, to inform individual and social actions. It is interesting to note that at the turn of the century when some of her Australian male counterparts were extolling the virtue of brute force (in 'taming' their environment), Rosa Praed was actually questioning its use and abuse. At a time when the literature of men was moving towards a sense of national-

istic confrontation and conquest, Rosa Praed (along with other women writers such as Catherine Martin and Catherine Helen Spence) was giving her attention to the victims of such values and adopting a cross-cultural rather than a nationalistic point of view. No wonder there was no room for her within the male-dominated tradition.

She continued to write her 'non conformist'[74] novels in the twentieth century. *Fugitive Anne* was published in 1903 and is a novel of considerable distinction. An unusual blend of fact and fantasy it combines Rosa Praed's intimate knowledge of – and respect for – Aboriginal life with a form of science fiction and, in a manner later emulated by D. H. Lawrence, the heroine (and hero) discover a 'lost tribe'. (I hasten to add that this is where the similarity ends: the 'fugitive Anne' is actually fleeing from a fiendish husband who can of course claim his conjugal rights, and this novel is not just an informative and appreciative account of Aboriginal customs but an indictment of the legal position of wives in the supposedly civilised societies.)

To list all Rosa Praed's novels – to give an evaluation of her complete works – is a most tempting exercise but, unfortunately, it is not one which can be undertaken here. She wrote so much – and so well – and there is such a lot which could be said about her, that a fair coverage would necessitate a complete volume (or volumes) being devoted to an assessment of this woman and her work. There is also much which could be said about her collaborative ventures, for she wrote three novels with Justin McCarthy[75] and some with Nancy Harward who, apart from being Rosa Praed's companion, was also her psychic medium. It was Nancy Harward who recounted the details of an earlier life in ancient Rome and who provided the material for the 'Nyria' series.

But what has happened to this prolific, popular and – in her own period – prestigious woman writer? She is not even included in the *Oxford Anthology of Australian Literature* and in the *Oxford History of Australian Literature* the only novel referred to is *Policy and Passion* where, as the entire discussion revolves around *Thomas* Longleat, one could be forgiven for concluding that such a person as the main character – Honoria – does not even exist (1981, pp. 64–5).

John Barnes (in *The Literature of Australia*, 1982, edited by Geoffrey Dutton) provides a more accurate coverage of the contents of *Policy and Passion*, but with his assertion that Rosa Praed 'was potentially though not in fact, a major Australian novelist' (p. 170) he doesn't exactly promote a rush of enthusiasm for her work. While all these judgments about 'quality' are subjective (and reveal a political bias) I suspect that his poor evaluation of Rosa Praed's contribution is associated with his inability to appreciate the value of a woman's view.[76] I find myself in complete opposition to his assessment of her 'defects' and the reasons for them:

The reasons for Mrs. Praed's failure to develop as an artist are plain in this early novel (*Policy and Passion*): In the first place she was a victim of . . . 'the cultural cringe' . . .

(John Barnes, 1982, p. 171)

He then goes on to say that it is because Rosa Praed 'adopts the values of the English novel-reading public' that she fails to attain the literary heights. In one sense such a statement is absurd – for if English novelists were to be considered failures because they adopted the values of the English novel-reading public then of course we would be left without any good novelists at all! More to the point, I think, is John Barnes' statement that it was because Rosa Praed was 'committed to the values of the popular romantic novel' (l. 172) that she was unable to achieve her potential. Which is really just another way of saying that she wrote in the tradition of women and not that of men and therefore she is not up to scratch.

This is how women writers have been put aside, neglected, some would say subtly suppressed. They have been judged deficient and then dismissed and, sadly, Rosa Praed is still being penalised for not conforming to the male standard. Yet it is precisely those views and values which are different from men's and which are often absent from the male perspective, that provide the full complement of human values and demand and deserve a place in the literary canon: it is only when women's literary tradition co-exists with men's that there will be a human heritage. This is why Rosa Praed's novels should be in print.

CHAPTER 5

Catherine Helen Spence and Catherine Martin

Catherine Helen Spence 1825–1910

Another great woman writer who failed to fit in and who consequently has been eclipsed is Catherine Helen Spence: while she did not write as many novels as Rosa Praed (six in all), she was more overtly feminist in her fiction. Even in her own lifetime her challenging novels were considered subversive and dangerous, which is one reason why *Gathered In* (which Catherine Spence considered her best work) was until 1977 confined to the newspaper files in which it had been originally serialised, while for another novel, *Handfasted*, no publisher could be found at all until sixty-five years after her death. And all because Catherine Spence looked at the world from the perspective of woman and found the social and political arrangements decidedly wanting.

Born in Scotland, Catherine Spence came from comfortable circumstances and a secure – if somewhat fanatical – family background. She was a serious young woman with a well-developed social conscience (and what now seem to be unbelievable religious doubts), who determined to do her duty in the world. When – owing to her father's unfortunate speculations – her immediate family experienced financial collapse and so took passage to South Australia, the contrast served more to promote good deeds than to plunge Catherine Spence into depression. Yet the circumstances must have been terribly trying for the fourteen-year-old: for seven months the entire family lived in a tent at Brownhill Creek.

By the age of seventeen, however, Catherine Spence was a governess and then later, in 1846, a teacher in a school with her sister, and she was soon using her pen to write frequent pointedly political articles for the Adelaide *Register*. Still deeply disturbed by religious doubts (by her own admission she was 'thirty years old before the dark veil of religious

despondency was completely lifted from my soul'; see *Autobiography*, 1910, p. 19), she rejected offers of marriage and chose to remain a spinster. She did not see single life as second-rate but rather as an opportunity to enjoy a full intellectual and political existence.

There are two major strands to Catherine Spence's writing: her novels and her journalism. And the two are closely linked for, in some ways, she uses her journalism to outline her social vision while in her fiction she shows the means by which such a possibility can be practically achieved.

At the centre of her conceptualisation of a fair and just society was a drastic transformation in the position of women, and while this commitment may have made her a radical in her own time it is also one which makes her work extraordinarily relevant today. She wrote and she campaigned for women's rights – for votes for women and proportional representation. And she shows her affinity with that outstanding American feminist economist, Charlotte Perkins Gilman,[77] when she argues for better, more communally-based housing which ends the isolation and domestic servitude of women: 'A Week in the Future', written in 1889, depicting the social and political arrangements of 1989, presents such a utopia where all human beings are made equal. Catherine Spence's economic philosophy encompassed women's work as well as men's.

Not that she was unaware of what men were doing – or of the detail and drama of Australian 'economic' life. Her first novel was entitled *Clara Morison: A Tale of South Australia during the Gold Fever* (1854), and from this work (and some of her other writings) it is apparent that she identifies strongly with Australia and its development. But her novel is also well within the framework of women's literary traditions for not only does she use it to correct any false British impressions, she also emphasises all the domestic implications. As she wrote in the letter which accompanied the manuscript to the publishing house of Smith Elder and Co.:

I have grown up in this colony of South Australia and love it – the domestic life represented in my tale is the sort of life I have led – the people are such as I have come in contact with – the politics are what I hear talked of – the letters from the diggings are like those I have seen – the opinions I give are what are floating about among Australian society – so that it may be considered a faithful transcript of life in the Colony. Of course the plot is fictitious but the anecdotes I intersperse are true, or at least believed to be true, in Adelaide which is more than can be said of half the tales current in England about diggings and diggers.

(Letter of 1 August 1853, Mitchell Library: quoted in B. L. Waters and G. A. Wilkes, 1977, p. vi)

There can be no doubt of Catherine Spence's allegiance to Australia, but if she embraced some of its values she did not automatically reject the British ones with which she had been reared. Rather – like Ada Cambridge, 'Tasma', and Rosa Praed – she saw herself as privileged in that she was the inheritor of a dual tradition. She was able to be critical of both – and to draw on both – and she saw this as an advantage, not the limitation that it is often perceived to be within the dominant tradition.

Similarly Catherine Spence wanted to draw upon the dual traditions of women and men: which is why she objected – systematically and strenuously – to the one-sided representation of Australia as a bush society preoccupied with bush values. To her, the establishment of an intellectual life and the realisation of equitable political goals were equally important and worthy of recognition.

In 1865 Smith and Elder published *Tender and True: A Colonial Tale* which – unfortunately – I have not read: but I *have* read *Mr Hogarth's Will*[78] published in 1865 and I can vouch for it as one of the best novels on my shelves. By now one would think that I should be a seasoned feminist novel reader – accustomed to finding fantastic women's novels which go back as far as the seventeenth century and the work of the Duchess of Newcastle and Aphra Behn[79] – but I must confess that *Mr Hogarth's Will* astonished me with the power of the writing and the force of its feminist perception. I don't propose to give away the story, to ruin such a 'riveting good read'. Suffice it to say that Mr Hogarth educates his nieces as he would have educated his nephews – for work and independence: on his death, his will stipulates that the young women are to have no part of his fortune for this would undermine their autonomy – rather, they are to go out into the world and make their mark, like any man. Well, of course, they almost starve. But not before they provide a dramatic illustration of the sexual double standard. From this novel it can readily be seen why Catherine Spence was regarded as a disconcerting radical.

Comparable concerns characterised her next novel, *The Author's Daughter*[80], which marked the end of her early fiction-writing period. During the next decade it was her journalism (she wrote leading articles for the Adelaide *Register* among other things) and her social work which predominated. In 1878 *Some Social Aspects of South Australian Life* was published and in 1880, *The Laws We Live Under*, the first social studies text in Australia.

But in 1879, in response to the *Sydney Mail* offer of £100 prize, Catherine Spence forwarded her manuscript, *Handfasted*: it was rejected. The reason given was that 'it was calculated to loosen the marriage tie – it was too socialistic, and consequently dangerous' (see Helen Thomson, 1984, p. viii). Catherine Spence went too far: while *Handfasted* is in every sense a love story which would qualify it for inclusion in the

genre of romantic fiction, the fact that Catherine Spence explicitly queries the social arrangements and asserts a greater degree of autonomy for women, puts her novel beyond the pale – and makes her meaning blatantly subversive. She was doing what Ada Cambridge, 'Tasma' and Rosa Praed had done: she was questioning the price and the permanency of marriage for women. But she was doing more than pointing to the limitations of the institution. She was showing ways in which these limitations could be overcome – ways which would improve the position of women but demand greater accountability of men! And for the very same reasons that the *Sydney Mail* rejected this manuscript, I would insist that it should be in print: on the grounds that it shows women what an equal marriage could be – if of course they wanted to try one.

While all the Australian women writers of the nineteenth century challenged the nature (and nurture) of marriage, Catherine Spence went further than her fellows in revealing the discrepancy between the deal that women got and the improved arrangements that there could be. This is why *Handfasted* still makes a considerable contribution to women's consciousness – and why, despite its publication in 1984,[81] it has virtually been ignored within mainstream literary circles.

Understandably, Catherine Spence was disappointed when the manuscript of *Handfasted* was rejected but she showed no inclination to modify her views and continued to take her bold (and brave) stand. Between 1881 and 1882, *Gathered In* was serialised in the Adelaide *Observer* and in it the sexual double standard is again exposed and the issues of legitimacy and divorce are questioned. In writing to a prospective publisher, Catherine Spence demonstrates her own intellectual capabilities when she explains her particular treatment of the problem in her novel:

It takes up new ground and is differently treated from the manner in which kindred subjects are handled in fiction.

In all cases of supposed illegitimacy on the part of hero or heroine, the novelist always contrives to prove the birth legal even at the expense of greater villainy on the part of the father than is pleasant for his child. It is the law of inheritance working directly on public opinion that makes it less honorable to be descended from parents both weak but not wicked than from one who is a thorough scoundrel and the other a wronged but innocent victim. No doubt the extravagant appreciation of female purity and the indifference as to masculine virtue is fostered by other influences but I think the law of inheritance has greater power in the matter.

(Letter (with manuscript) 4 March 1878, Mitchell Library: quoted in B. L. Waters and G. A. Wilkes, 1977, p. viii)

Catherine Spence was an intellectual, literary, and feminist pioneer, but such is not the sort of pioneer favoured in the mainstream Australian literary tradition.[82] Despite her efforts to find a publisher for *Gathered In*, it did not appear in book form until 1977, and then it was as a scholarly edition published by the University of Sydney. The fact that it was printed is of course to be applauded, but in so far as *Gathered In* (and *Handfasted*) have not made their way to the centre of the Australian literary tradition – nor to the popular market place – is an omission to be deplored. For few writers would have more to offer than Catherine Spence.

With her admiration for George Eliot and her respect for John Stuart Mill,[83] with her social conscience, political commitment and literary skill, she is one of the leading intellectual lights of Australian history and were her contribution to be appropriately appreciated, the knowledge of her existence alone would help to dispel the image of Australia as a cultural and intellectual desert. It is because women of the creative calibre of Catherine Spence have been excised from the heritage that the tradition which is customarily transmitted from one generation to the next is so lop-sided and distorted.

Catherine Spence would have been saddened to see just how far her achievements had been eclipsed: not because she was vain or egocentric, but because she thought she was lighting a path which would make it easier for other women to follow:

> I am a new woman, and I know it. I mean an awakened woman . . .
> awakened to a sense of capacity and responsibility, not merely to
> the family and the household, but to the State; to be wise not for
> her own selfish interests, but that the world may be glad that she
> had been born.

> (Catherine Helen Spence, 1825–1905): pamphlet reprinted from the
> *Register*, Adelaide, 1905, p. 33; the *Advertiser*, 10 October 1969: quoted
> in Susan Magarey, 1985, p. 2)

This statement of hers reflects the essence of feminist philosophy as it has been expressed in English-speaking societies from the time of Aphra Behn. But while such understandings are not passed on, women – and men – can be led to believe that their society has no women's heritage – no tradition of responsible, resourceful, admirable and intellectual women.

The views – and the visions – of Catherine Spence are to be found in both her novels and her non-fiction, and for so many reasons her work should now be in print, and given popular promotion. For in her writing can be found a valuable documentary of life as it was in Australia,

and an invaluable representation of what it could be in the future – when a woman was accorded the same worth as a man.

Catherine Martin ('Mrs Alick McLeod') 1847–1937

Catherine Martin, although somewhat younger than Catherine Spence, had a great deal in common with her apart from first names. Born Catherine Macaulay Mackay on the Isle of Skye, she arrived with her parents in Adelaide in 1855. Later she became a journalist and novelist and in 1923, Catherine Spence said of her that she had attained 'the highest level ever reached in Australian fiction' (see Catherine Spence's *Autobiography*, 1910, p. 55). That her contribution should since have been so fully eclipsed is a sad but all too often standard practice in literary circles in Australia: while she rates a paragraph mention in H. M. Green's *History of Australian Literature* (1984), no reference is made to Catherine Martin in Geoffrey Dutton's *Literature of Australia* or the *Oxford History of Australian Literature*, and she is not included in the Oxford *Anthology*.

It has been suggested that her best novel was the remarkable *The Incredible Journey* (1923) but this was preceded by *An Australian Girl*; it was first published anonymously in London in 1890 and soon a second edition was required (1891), and then in 1894 an Australian edition was issued. While this novel was a considerable achievement in its own right, it is also extremely interesting in the way it links different facets of the Australian women's literary tradition.[84]

It almost goes without saying that Stella Courtland – the Australian girl – asks a lot of questions about the advantages and disadvantages of marriage and doesn't automatically assume that with wedding bells comes happiness or fulfilment. When the right man comes along, Stella is prepared to take the step but to the extent that *she* must first acquire judgment, and *he* must then pass the test, Catherine Martin takes her place in the long line of women who have written in such a vein, from Jane Austen to Rosa Praed. And this is not the only way in which her work illustrates the continuity of the tradition: Stella Courtland – like Emma Woodhouse – is comfortable, cultivated and attractive, and the source of many of her own misfortunes, but she is also like Sybylla, in Miles Franklin's *My Brilliant Career* (1901), in that she is a distinctly Australian heroine who must reconcile her own aspirations with the realities of her own culture.

And again – as an Australian woman writer – it is almost superfluous to add that Catherine Martin had little interest in mateship, or in the taming of the outback: but her characters are inextricably linked with their Australian setting and the author has a healthy respect for the psychological price that the country can exact from both women and

men. In this, her work prefigures that of 'Henry Handel Richardson' and Barbara Baynton.

Again, too, she draws on the dual tradition of the 'home country' and the 'colony', and criticises the poor products of both with a fairly even hand. While she makes some scathing comments about the British aristocracy she is equally caustic about some of the pretentious people and practices of Melbourne, and it is clear that Catherine Martin has little or no patience with anyone who is motivated solely by money or show.

Nor can there be any doubts about the sort of woman she thinks the Australian heroine should be: she should be intelligent, informed and strong – not shallow, simpering and weak – as is Dora in the following extract:

> If anyone sang or played, Dora always begged for one more song or a little more music. . . . When anyone spoke, she always listened with the most reverential attention. When Cuthbert spoke, she would often murmur one of his sentences over to herself, as if better to impress it on her memory. She was, in fact, what is known in England as a very sweet girl. In Australia, unfortunately, the species is so rare that no specific name has had to be invented.
>
> (Catherine Martin, *An Australian Girl*, 1988, p. ix)

But if *An Australian Girl* places Catherine Martin within the mainstream of the Australian women's literary tradition, her novel *The Incredible Journey* provides evidence of the new forms that this tradition could extend to. And it is a novel which is uniquely Australian and assertively female in its perspective.

In 1896 Catherine Langloh Parker (1855–1940) published the first substantive collection of Aboriginal tales and legends – *Australian Legendary Tales*: in 1905 Jeannie Gunn (1870–1961) published *The Little Black Princess* and, in 1908, *We of the Never-Never*; and these volumes (which are by no means an exhaustive list) help to show the extent to which women's literary tradition has encompassed concern for black Australians. Yet even in these publications – all very worthy but predictable products of their period – the events were filtered through a white persona who was merely an *observer* of Aboriginal ways, albeit a sympathetic one. In her contribution to Australian literature, Catherine Martin did something entirely new. She identifies with her black heroine.

The Incredible Journey is the story of Iliapa whose son is kidnapped by a white man. With another woman – Polde – who knows how to survive harsh and barren conditions, Iliapa makes her incredible journey across the desert in search of her son. And as she moves through a landscape invested with Aboriginal meanings, Iliapa becomes the 'story-teller' who

explains the significance of black culture – from the 'inside'. The link between black women and white women is dramatically made: not just by means of the symbolism of shared motherhood, although Catherine Martin said of her novel that she wrote it 'in order to put on record as faithfully as possible, the heroic love and devotion of a black woman when robbed of her child' (1987, pp. 11–12). The bond between women is also reinforced when Iliapa fears for her safety after challenging the authority and territory of black men.

Of course, on numerous grounds, the politics of Catherine Martin's presentation can now be questioned: the limit of her reality was one where the theories of Charles Darwin prevailed, and she was among the most progressive of her time when she expressed the tenets of the survival of the fittest and expected the Aborigines to 'die out'. But even as she subscribes to this position she subverts it with her assumption that women – black and white – share a common experience. It is because she pushes at the limits of her reality – because she exposes and explores the discrepancy between 'theory' and 'practice' – that Catherine Martin is such a sure, subtle and successful writer. And, whatever shortcomings her work may have, there can be no doubt that she was an advocate of human rights and that she used her fiction as a force for social change.

Along with Harriet Beecher Stowe, for example, who shifted the debate about slavery with *Uncle Tom's Cabin*, Catherine Martin took the issue of depriving black women of their children into another realm: and while the representations of both women can now be challenged, what cannot be disputed is the powerful effect their novels exerted in their own time.

But where is Catherine Martin now? As well as *An Australian Girl* and *The Incredible Journey*, Catherine Martin wrote the novels *The Silent Sea* (1892) and *The Old Roof Tree: Letters of Ishbel to her Half brother, Mark Latimer* (1906), and the serial 'Bohemian Born', as well as a volume of verse, *The Explorers and Other Poems*, published in 1874 under the initials 'M.C.'. The fact that she published anonymously or under the pseudoynm 'Mrs Alick McLeod' could also mean that she wrote even more but that it has not – as yet – been attributed to her. Certainly she was a very private person – to the point where it would be difficult to provide a biographical study of her – as not much can be made out of the few facts that from 1875 she tried to support herself from her writing, that she failed in this, became a clerk in the Education Department in Adelaide in 1877, and that –

Here she was discriminated against financially and failed to gain a permanent position. She was dismissed in 1885. In Adelaide she appears to have found a circle of friends with similar intellectual interests. She met the writer, Catherine Helen Spence and became

a friend of the Unitarian Martin family. In 1882 she married
Frederick Martin, an accountant.

(Margaret Allen, 1987, p. viii)

Like her heroine, Stella Courtland, Catherine Martin too took her time
to marry.

The fact that she left no known autobiographical writing makes it
difficult to document the details of her life, but even her reticence
cannot begin to explain the reasons why she has been omitted from the
Australian literary tradition. She is one of the major links in the chain
of women writers and warrants a prominent and permanent place in the
Australian world of letters. But as Elizabeth Webby has so succinctly
said of Catherine Martin –

Like other women writers of her period, she has been dismissed as
second-hand and second-rate, a derivative colonial rather than a
truly Australian Writer. In her case this seems particularly unfair and
can be explained only by the long identification of the 'truly Australian'
with the masculine.

(Elizabeth Webby, 1988, p. xii)

CHAPTER 6

The supporting cast

Among the popular prose writers who published primarily abroad – and about whom I would like to know a great deal more – is one, Kathleen Caffyn, who wrote under the pen-name, 'Iota'. In his entry on her, H. M. Green (1984) says that Mrs *Mannington* Caffyn, 'The author of the once famous *Yellow Aster* (London, 1894) lived for several years in Sydney and Melbourne and one or two of her novels are more or less Australian: the most interesting of these, *A Comedy in Spasms* (London, 1895) was written in something of the easy satirical manner that Wilde had made fashionable.' (p. 733). Such an assessment sparks my interest, but without the expenditure of even further time and energy there is little I can do to satisfy my curiosity about this once famous writer. What I have been able to determine is that she lived for almost twenty years in Australia, that she was the author of seventeen novels, and that despite the patronising reference to her as Mrs Mannington Caffyn, her literary reputation was really only established after the death of her husband in 1896, when she took to writing as a means of making some money.

A Yellow Aster was written in Australia, and I have been fortunate enough to obtain a copy of this unusual novel which presents one of the most fascinating accounts of child-rearing practices to be found in literature – and which questions the sexual nature of women. Of this novel and its author, Sue Martin (1987) has said, 'I like the way she takes the Victorian ideal of the passionless woman one step further to show it up. Of course it would have been nice if she had thrown it out altogether.'[85] But then we can't have everything and 'Iota' does seem to have challenged fundamentally the conventions of her time. And to have been congratulated on her efforts. In the copy that I have of *A Yellow Aster* (1894, second edition) are reprinted some of the reviews that the book initially received, and not only do they make intriguing reading, but they arouse

enormous interest in both the work and the identity of this talented woman:

SPEAKER
We do not pretend to be able to do justice to *A Yellow Aster* in the space at our command. It is no ordinary novel, either in conception or treatment, and we feel no surprise at the gossip which has attributed it to at least one woman of well-recognised genius. Altogether a notable book.

DAILY TELEGRAPH
A Saul has arisen among the fictional prophets. *A Yellow Aster* is distinctly a work of genius remarkable for novelty of plot, force of diction, grace of literary style, and subtlety of psychical analysis. In short, *A Yellow Aster* is one of those rare novels of superb quality which compel the iciest criticism to thaw and resolve itself into warm admiration and unqualified praise.

WESTMINSTER GAZETTE
A first impression is that *A Yellow Aster* is one of the very best novels we have read for many months; a second, that, in saying this, we do it rather less than justice. For it is a novel apart, with a strikingly original subject, which is worked out with a skill which is altogether unusual. This is a strong and excellent story, which will with all its pathos and tragedy, have the refreshment of a tonic ...

And so they go on. I have no reason to quarrel with any of these assessments: what I do quarrel with is the place that Kathleen Caffyn has been accorded in the Australian literary tradition. I suspect that she had been dismissed without a hearing, that she is a victim of the premise that predominates among men of letters – namely that you don't have to read women's novels to know they are no good![86] Which is why I would like to have access to her novels, particularly her Australian ones, so that I could decide for myself on the contribution she could or should make to the women's literary tradition.

Mary Gaunt 1861–1942[87]

Another immensely popular novelist who has suffered from the system of rejecting women writers without a reading is Mary Gaunt, commonly called 'a cosmopolitan Australian' (see H. M. Green, 1984, p. 709; and Ian McLaren, 1986). Her novel, *Kirkham's Find* (1897), is one which I think should be compulsory reading for all Australian young women – not that you would suspect this from the descriptions of it that are to be

found in the standard sources. It is classified as 'a story of prospecting in the Northern Territory' (*Oxford Companion to Australian Literature*, 1985, p. 290) and as 'a goldfields story' (Ian McLaren, 1986, p. xv), and such comments make it quite clear that the novel has not been read. For it is a wonderful story about the independent life of Phoebe Marsden – and an outspoken critique of men, their manners and the arrangements they make for women. Phoebe may be 'pure gold' and 'Kirkham's find' but it is reasonable to assume that Mary Gaunt would turn in her grave if she knew that her strong feminist novel had been classified as a story of the gold-fields and appropriated by the male value system.

Judging from the way that she lived her own life, Mary Gaunt did not have to invent a great deal about the determination – and the liberation – of her character, Phoebe Marsden. Born at Indigo, Chiltern, Victoria, Mary Gaunt moved to Ballarat with her family in 1869 and at a very early age perceived and protested at the sexual double standard. Of this period of her life she later wrote –

> Our world was bounded by our father's lawns and the young men who came to see us and made up picnic parties to the wildest bush round Ballarat for our amusement. It was not bad. Even now I acknowledge to something of delight to be found in a box seat of a four-in-hand, a glorious, moonlight night, and four horses going at full speed; something delightful in scrambles over the ranges and a luncheon in the shade by a waterhole, with romantic stories for a seasoning, and the right man with a certain admiration in his eyes to listen. It was not bad, but it was not as good a life as the boys of the family were having.
>
> (Mary Gaunt, 1912, pp. 3–4)

Mary Gaunt would have liked to have been a sailor – like her two brothers – but of course such a career was not (and maybe still would not be) open to her: but she did push convention to the limit when in 1881 she was among the first women to enter Melbourne University. Not that she stayed for long. Like her heroine Phoebe Marsden she wanted to be independent, she wanted to lead her own life, and she soon started on her literary career: she had a variety of short stories and articles published (earning the grand sum of £50 in 1888), and in 1890 her story 'The riots at the Packhorse' appeared in the first twelve issues of the *Australasian* (see Ian McLaren, 1986, p. xiii).

From her writing, Mary Gaunt saved sufficient money to indulge her love of adventure and travel and in 1890 she set sail for India, England and Aden. In London she joined the Society of Authors, took up her pen and proceeded to write a most 'creative' account entitled 'Across the Atlantic in a Torpedo Boat by an Officer on Board'.[88] The story was

accepted by the *English Illustrated Magazine* and the editor was later somewhat disconcerted to find that the 'author/officer' was a female Australian.

But Mary Gaunt went on to reap even better literary rewards. In 1894 she had two novels published: 'The Other Man' which was serialised in the Melbourne *Argus* and *Dave's Sweetheart*, which was published in London to considerable acclaim. Then, however, Mary Gaunt returned to Australia, married a doctor and went to live in the little town of Warrnambool in Victoria. No wonder she questioned the sacrifice of women required on marriage in much of her work: in 1898 in an interview with the *Sydney Mail* she said 'I got married and have not finished any big piece of work since: at present I am writing something about Warrnambool, but it doesn't get on very fast.'

In 1900 Mary Gaunt's husband died: during her married life she had written some short stories, an expansion of her 'Packhorse' tale which was published as *Deadman's* in 1898 – and of course her fiesty feminist fiction, *Kirkham's Find*. It cannot be coincidence that the great struggle confronting her main character, Phoebe Marsden, is that of finding a way out of the crippling constraints that convention placed upon young women at the time.

Left 'penniless, homeless and alone' on the death of her husband (1912, pp. 4–5), Mary Gaunt determined to earn her living once more by her pen: she returned to London and in many respects it was like starting all over again. In 1915 she confessed that had she not left it would not have been so difficult to further her literary career (Ian McLaren, 1986, p. xiv) and the picture she paints of this period is bleak indeed:

> I took a hundred pounds out of my capital and came to London determined to make money by my pen in the heart of the world.
>
> Oh the hopes for the aspirant for literary fame, and oh, the dreariness and the weariness of life for a woman poor and unknown in London! I lodged in two rooms in a dull and stony street. I had no one to speak to from morning to night, and I wrote and wrote and wrote stories that all came back to me, and I am bound to say that the editors who sent them back were quite right. They were poor stuff, but how could anyone do good work who was sick and miserable, cold and lonely, with all the life crushed out of her by the grey skies and the drizzling rain? I found London a terrible place in those days: I longed with all my heart for my own country, my own little home in Warrnambool where the sun shone always, the roses yellow and pink climbed over the wall, the white pittosporum blossoms filled the air with their fragrance, and the great trees stood up tall and straight against the dark blue sky. I did not go back to my

father because my pride would not allow me to own myself a failure, and because all the traditions of my family were against giving in. But I was very near it, very near it indeed.

(Mary Gaunt, 1912, pp. 5–6)

Mary Gaunt certainly saw herself as an Australian writer, even if her exclusion from the canon has been explained in terms of her 'cosmopolitan' rather than Australian values: but assuming that such an assessment has been based on a study of her work, one can only ask whether it is because much of her writing makes no mention of the mateship myth – or the outback – that her Australian identity has been disparaged.

But for ten years Mary Gaunt persevered with her writing efforts and by 1910 some of her hard work was beginning to pay off. *The Mummy Moves* (a great thriller) and *The Uncounted Cost* were published in 1910, and both attracted a great deal of attention, although it was *The Uncounted Cost* that was at the centre of the controversy that helped to establish Mary Gaunt's reputation as a well-known writer again. The Circulating Libraries Association in London took exception to a heroine who was bent on achieving her own independence: as Sue Martin has said, it was partly because the heroine in *The Uncounted Cost* was a 'fallen woman who failed to fall' (1987)[89] that The Times Book Club, Mudies, and Smith and Sons banned the book from their shelves. While in women's literature there has been a long line of 'less-than-pure-or-perfect-women' who have not been penalised, and who have even gone on to lead happy lives,[90] this was a tradition that the circulating library authorities clearly did not want to endorse – although of course their attempts to censor the book simply served to increase its sales and to promote the name of the author (see Ian McLaren, 1986, p. xvii).

Not that the disapproval of *The Uncounted Cost* was universal: some of the critics were quite impressed by the work. According to the *Athenaeum*, 'The writer's powers of narrative are considerable, as is her knowledge of the Mahogany Coast and its people', and the *Westminster Gazette* went even further with its declaration that 'when we say that we have read every word of "*The Uncounted Cost*" we have almost praised it without reserve'. The *Daily Graphic* took the stand that the book was 'A perfectly clean and sincere attempt to deal with certain fundamental truths from the woman's point of view', while, at least in 1910, the *Melbourne Argus* was delighted to claim Mary Gaunt as one of its own: 'Mary Gaunt has written a new book. It is a book of which she may well be proud, of which every friend she possesses in Australia will be proud. It is the sort of book that we read from beginning to end with the absorbed interest that forbids us to lay it down.'[91]

Mary Gaunt could spin gripping yarns – and from the woman's point

of view! She could create marvellously inspiring and independent
heroines who challenged social conventions and who, like the author
herself, can still serve as valuable role models today. Mary Gaunt made
a unique contribution to Australian women's literature – even if it was
not always in the officially preferred form. After the publication of *The
Uncounted Cost* her literary future was assured. From 1910 to 1934 she
published more than twenty books, some of them in collaboration with
John Ridgwell in Essex. And many of them were about her travels for,
in part, Mary Gaunt achieved her long cherished aim to be a sailor when
she set out for all sorts of unusual places and wrote accounts of her
adventures. *Alone in West Africa* (1912), *A Woman in China* (1914), and
Reflections – in Jamaica (1932) say much about the nature of the woman
and the scope of her work.

But while Mary Gaunt enjoyed travelling and turning her experience
into tantalising tales it was not always *her* choice to be an Australian
writer in exile: believing the opportunities in her native land to be limited,
she decided that there was no alternative but life in London. She would
have liked to have spent more time in Australia and to have written more
about Australia but she did not think it was possible to earn her living
in that way. Speaking to the editor of *The Girl's Own Paper and Woman's
Magazine*, E. O. Hoppe, she said:

> I came to England, because for literature there is no opening in my
> native land. Life was very, very, very hard for a beginner in London.
> I was practically a foreigner, I had no introductions, and I knew no
> one; you can have no conception of how lonely I was, the more so
> because I did not understand how to write for the English point of
> view, and so my mss. came quickly back to me through the letter-
> box again! However, I slowly got on, sold a thing here and there, got
> to know a few people and made enough money to again go wandering,
> this time in more civilised countries, France, Brittany, Italy, Corsica,
> Sicily, which I know very well, also Spain.

> (See Ian McLaren, 1986, p. xvlll)

Mary Gaunt earned for herself a considerable reputation as a writer in
England: that she has been ignored by Australians is incomprehensible.

Barbara Baynton 1857–1929

One of Mary Gaunt's great achievements was her refinement of the short
story form: of her book of short stories (*The Moving Finger*, 1895), the
distinguished critic Desmond Byrne stated in 1896 that in it she had
'raised the short story to an artistic level hardly approached by any other

Australian writer' (see Ian McLaren, 1986, p. xvi). But if Mary Gaunt added something extra to the short story – from the woman's point of view – Barbara Baynton took the form one step further. Their talent as short story writers is not, however, all that these two remarkable women had in common. Barbara Baynton, too, experienced difficulties when it came to getting published in Britain: and there have since been problems with her literary 'reception'.

Trying to explain the reasons why Barbara Baynton's work remained for so long unknown and unread, Sally Krimmer and Alan Lawson (1980) resort to the usual rationale which rates women in relation to the achievements of men. It is, they suggest, because 'nowhere in her stories can be found the characteristics often attributed to Australian literature in the 1890s' (p. ix) that her work has been overlooked. But if her writing does not reflect the characteristics of the eulogised literary men, it reveals a range of features that have come to be considered typical in the writing of Australian women. If there is 'no nationalistic pride, no love of the bush and no feeling of mateship or affinity between the bush and its inhabitants' (p. ix) as expressed by men, there is a realisation of the grim nature of the Australian setting and a harrowing understanding of the way it – and men – can inflict cruelty upon women.

Barbara Baynton's portrayal of the harshness of life for bush women has its own autobiographical element. While there is some confusion about the circumstances of her birth,[92] it has been established that she grew up in rural Scone (New South Wales), where her father was a carpenter. From there she took a position as a governess and at the age of twenty-three she married her first husband, Andrew Frater. But the marriage did not endure: Andrew Frater deserted her (for her cousin) and Barbara Baynton was left with children to provide for – and a great deal of anger to overcome.

She moved to Sydney where for a while she led a desperate life, selling bibles door to door in the attempt to support her children. Then she met the wealthy – and elderly – Dr Thomas Baynton, whom she married on 4 March 1890, the day after she obtained her divorce. From this time forth her life was decidedly easier. In true Australian fashion Barbara Baynton could be said to have reversed her fortunes overnight. Perhaps it is because this transformation occurs in a woman that this very 'Australian' feature of her life has been ignored.

In her new comfortable and highly-cultivated circumstances, however, Barbara Baynton had ample opportunity to reflect on the horrors of her harsh life as a woman and her earlier experience in the bush. This is the area on which she draws as a writer and, in so far as her stories are a savage exposé of the exploitation of women, one assumes that the 'writing out' of these emotions provided the author with a cathartic release from some of the pressures and pain that pervaded her past.

The stories are bitter, often biting, without a single softening feature. 'Squeaker's Mate', for example, is one of the most shocking short stories that I have ever read. In it a woman is able to deny the constraints on her sex while she can work as a man; but when her back is broken and she can no longer *claim* consideration she is left alone, isolated, despised and taunted.

Bitterly brilliant as these stories are, however, Barbara Baynton had difficulty getting them published. No Sydney publisher was forthcoming so she took her *Bush Studies* to London; but the path to publication was still by no means an easy one.

When the Society of Authors could provide her with little assistance she sought letters of introduction from the Agent-General of New South Wales (Mr Henry Copeland) to some of the major publishers. But short stories were not in vogue and so often was her work rejected that she informed Vance Palmer (about 1905) that she had thought of throwing her manuscript in the fire, for 'English readers are only interested in a background they know ... and Australia to them is more remote than Abyssinia' (Sally Krimmer and Alan Lawson, 1980, pp. xiv–xv).

But when by accident she met the critic and publishers' reader Edward Garnett and he read her work, he was able to persuade Duckworth to publish it; *Bush Studies* appeared in 1902 and Duckworth also brought out *Human Toll* (1907) and *Cobbers* (1917).

If Barbara Baynton's assessment of British literary appetites were accurate, then some of the burning interest in Australia that had fuelled the demand for Louisa Meredith's work, for example, had clearly passed. But as other Australian women writers continued to enjoy success with Australiana offerings well into the twentieth century (Ada Cambridge, Rosa Praed, Catherine Martin, 'Henry Handel Richardson', Miles Franklin – to name but a few) it could be that it was the brutal nature of Barbara Baynton's stories and her uncompromising assertion of female exploitation that contributed to the absence of enthusiasm for her work. Even today her fiction is still extraordinarily discomfiting.

That Barbara Baynton – despite her later relative status and wealth – was against all forms of tyranny and exploitation is apparent from the variety of public stands that she took: she abhorred the exploitation of women, of domestic servants – and the exploitation of writers. I appreciate and endorse the efforts she made to improve conditions in the literary profession: in her address to the Writers' and Artists' Union she commented on writers' need for unionism and declared that in the effort 'to make the rich papers pay decent rates for writers' brains ... you can claim the last ounce of my strength in support of your union here' (see Sally Krimmer and Alan Lawson, 1980, p. xvii).

With her experience of life, to dismiss Barbara Baynton as un-Australian is to be absurd: to classify her as 'upper class'[93] is to do her a grave

disservice. She was a woman who suffered – often as a *woman* – and who wrote about it. That her male characters are devoid of compassion and constancy, that they are crude and cruel, says something about Barbara Baynton's experience of the world. That her positive reference point is nurture, and that she symbolises this in her representations of motherhood, says something about her as a woman writer. That her short stories have been eclipsed so that the culture is much more familiar with 'The Drover's Wife'[94] than 'Squeaker's Mate' says something about the selections – and the selectors – of the Australian literary tradition.

Evelyn Mary Clowes ('Elinor Mordaunt') 1872–1942
Mollie Skinner ('R. E. Leake') 1876–1955

Among some of the other popular writers who drew upon Australian experience but who published primarily overseas was Evelyn Mary Clowes who used the pseudonym 'Elinor Mardaunt'. Born in Nottingham, she landed in Australia in 1902, and was soon contributing to such periodicals as the *Bulletin* and *Lone Hand*. For nine years Evelyn Clowes lived in Australia and wrote a number of semi-travel accounts, including *On The Wallaby Through Victoria* (1911).

During the first quarter of the twentieth century, 'Elinor Mordaunt' became a prolific and popular fiction and travel writer, with more than forty volumes to her credit. Many of them display distinct Australian affinities (such as *The Ship of Solace*, 1911) and it would be helpful if her work were to be more thoroughly examined for the possible place it might provide the author in women's literary history.

So, too, would it be worthwhile to sift and study the contribution made by Mollie Skinner, whose efforts have not only been eclipsed by a predominantly male tradition but by a preoccupation with one man. Despite the fact that Millie Skinner is one of the few women to have been 'honoured' by having her work used as the basis for a contemporary television series, this has not prevented her achievement from being lost in the enthusiasm to accredit her work to a literary man – D. H. Lawrence.

Born in Perth, Western Australia, Mollie Skinner enjoyed the benefits of a 'good' education in England, where she early displayed an interest in writing and a capacity for 'nursing'. A Quaker, she performed many good works in the slums of London and in India during the First World War. Much of her experience among those in adverse circumstances was drawn on later as the substance of her work, one example being *Letters of a V.A.D.* which was her first published book, in 1918.

In 1922 she met D. H. Lawrence who, for better or worse, looked over her literary efforts, with the result that in 1924 *The Boy in the Bush* appeared. Although frequently attributed to D. H. Lawrence, Mollie

Skinner was the creative force behind the work: Lawrence provided the 'polish' as many males are wont to do,[95] together with an ending which Mollie Skinner was not at all comfortable with. And in the way that Mollie Skinner has been edged out of due acknowledgment of her work, there is a parallel with the way that women in general have been edged out of the literary tradition.

But Mollie Skinner was persuaded once again to collaborate with D. H. Lawrence, this time on her novel *Eve in the Land of Nod*. On this occasion she did not accept his changes and recommendations – which help to highlight the different perspectives and the discrepancy between the view of female and male – but then neither was this novel published.

However, *The Boy in the Bush* was not the only book to see the printed light of day: *Black Swans* was published in 1925 and *Men Are We* in 1927. These were followed by *Tucker Sees India* (1937), *WX – Corporal Smith* (1941), *Where Skies are Blue* (1946), and Mollie Skinner's autobiography, *The Fifth Sparrow*, which was published (posthumously) in 1972 with an introduction by Mary Durack. Such an association between these two women writers is most fitting, not just because both have their roots in Western Australia, but because they were passionately concerned with the issue of justice – as it applied to black Australians. *Men Are We* is a collection of Aboriginal stories which constitute another example of the extent to which women's literary traditions are interwoven with understandings of oppression as they apply to black and white Australians.

Portrayal of 'local' problems, identification with (or appropriation by – depending on your view) a literary hero, and adoption by the media have not been enough, however, to ensure the popularity or the permanency of this highly gifted writer in the Australian literary tradition. It is an indictment of literary history as it has been constructed and taught that most Australians who have ever heard of (or seen) *The Boy in the Bush* would not know the name of Mollie Skinner.

CHAPTER 7

Black and white issues

By the turn of the century there was a well-developed Australian literary tradition which allowed women to experience some of the satisfaction arising from past achievement and which helped to foster their confidence for the future. But not only did women's world of letters have continuity – it also had breadth: the scope of Australian women's writing in the early twentieth century is quite extraordinary. It encompasses the entire range of literary forms (from novels to non-fiction, from personal chronicles to drama and to verse) and it crosses the entire range of styles. There is everything from the fierce feminist tract to the lilting lyrical lament, from provocative politics to pure escapism, from travel literature to social protest and children's fiction. And there is a strong strand which includes recognition of the reality of black Australians.

Were the literature of Australian women to provide some of the signposts to past and present social concerns there could be no dispute about the empathy that has been expressed with the Aboriginal plight: and no question about the culpable role that white Australians have played in the destruction of Aboriginal culture. And among the women who led the way in the recognition of the tragedy was one, Catherine Langloh Parker, whose *Australian Legendary Tales* was published in 1896. It has since been reprinted – on more than one occasion – with a 1953 edition appropriately selected by Henrietta Drake-Brockman and illustrated by Elizabeth Durack, and a 1978 Bodley Head edition which drew on the original volume as well as the later (1898) *More Australian Legendary Tales*.

These *Australian Legendary Tales* constituted the first attempt to document the lore of Aborigines and in undertaking the task, Catherine Parker was motivated by a sincere desire to preserve some of the myths and legends before – as she put it – the blacks should all die out. She

was years ahead of her time in her appreciation of the significance of oral history and her sensitivity to some of the problems of anthropology. Of course, some of her dated assumptions can now lead to hackles being raised but the limitations that she shows on the present scale of values should not be allowed to nullify the radical insights that she generated in her own time. And some of her understandings are still applicable today: it was a genuine multiculturalism that she helped to foster when she urged whites to know, appreciate and respect, the lore and language of the blacks.

In order to compile *Australian Legendary Tales*, Catherine Parker went to the Aborigines themselves and asked them to relate the wisdom of their tribe. And she believed that there was some urgency about the task, for as she noted in her preface, 'The time is coming when it will be impossible to make even such a collection as this, for the old blacks are quickly dying out and the young ones will think it beneath their dignity' to recount such simple tales (1978, p. 11).

While she could be accused of 'interference' it is clear that Catherine Parker did not seek to exploit the Aborigines: her stated intention was simply to try to record the nature of a lore and language which she thought would otherwise be lost. Given her aim, there is every indication that she did succeed. And she was quick to thank her collaborators for all the assistance they provided:

> I must also acknowledge my great indebtedness to the blacks, who when once they understood what I wanted to know were most ready to repeat to me the legends – repeating with the utmost patience, time after time, not only the legends but the names, that I might manage to spell them so as to be understood when repeated. In particular I should like to mention my indebtedness to Peter Hippi, 'King' of the Noongahkumas and to Hippitha, Matah, Barahgurrie and Beemumny.
>
> (Catherine Parker, 1978, p. 12)

While Catherine Parker has been denied a place in many of the standard literary histories of Australia, H. M. Green (1984) acknowledges the significance of her achievement, and declares that her documentation of Aboriginal lore 'stands far above the rest' (p. 629): he also accords her account authoritative status –

> [She] played with Aboriginal children on her father's station on the Darling, and was for ten years in close contact with the aborigines on her first husband's stations in Northern New South Wales and Queensland.
>
> (H. M. Green, 1984, p. 629)

And that is not the end of his praise for her contribution. Later, he says of Catherine Parker's anthropological Study, *Evahlayi Tribe* (1905) that it 'deals with the customs of Aborigines who had been her neighbours for twenty years, during which she became intimate with their women and children as no man could ...' (pp. 894–5).

Here, H. M. Green reveals some of his own bias when he assumes that the world is male (he uses the word 'Aborigines' to mean men when he states that Aborigines have wives and children): this is a bias which also runs through much of the literature of anthropology – when a male world results as a consequence of male anthropologists' habit of talking only to men. Such a distortion would not have developed, however, had the contribution of 'women talking to women' been included.

Nor would women's contribution have been confined to anthropological literature: Catherine Parker – like Catherine Martin and so many more – used some of the insights that she gleaned from communication with black Australians to weave additional versions of Aboriginal tales and legends: both *The Walkabouts of Warrunah* (1919) and *Woggheeguy* (1930) are in this category.

Less productive in literary terms, but more committed to actively improving the conditions of Aboriginal life, was Daisy Bates, who rates little or no mention in the literary histories. A colourful character, Daisy Bates found her life's work in Western Australia when she arrived there in 1901. She was unrelenting in her efforts to ensure better treatment of Aborigines (and she was a constant contributor to newspapers and periodicals to this end), and although criticisms can now be made of her when she is judged by current standards, her integrity cannot be questioned. The book that she wrote with Ernestine Hill, *The Passing of the Aborigines* (1938), was a powerful protest and plea, and was particularly influential. Along with her 300 journalist articles, Daisy Bates also wrote her autobiography *My Natives and I*, again published in newspaper serial form. That her records should not be entered in the records of Australian literary history is a matter for regret.

Another contributor to this strand of the Australian literary tradition who has been more fortunate in terms of posterity is Jeannie Gunn. On her marriage in 1901 she spent one year on her husband's property on the Roper River in the Northern Territory: when he died, and she returned to 'civilisation', she wrote two books, both of which encapsulate her affection and respect for black Australians and the land they inhabited.

The Little Black Princess (1905) is among the first in a host of healthy children's 'fiction'[96] that was assertively Australian. A lively and amusing account, H. M. Green acknowledges that it puts the portrayal of black Australians on a new plane:

the Aborigines at the station homestead are real and likeable
individuals, presented with humour and sympathy: the story is
mainly about Bett-Bett, an eight year old Aborigine, niece of Old
Goggle Eye, 'King' of the tribes of that part of the Territory.

(H. M. Green, 1984, p. 699)

While The *Little Black Princess* may still enjoy a modicum of 'success'
it is Jeannie Gunn's other book, *We of the Never-Never* (1908), which is
better known. Often assumed to be the Australian classic by a woman
writer,[97] it is a dramatic documentary of her experience at Roper River
and suffers from some of the classic problems that accompany the evalu-
ation of women's literature. If such an account had been written by a
man it is probable that the emphasis would have been placed on the
factual detail and the whole labelled as non-fiction – or, in more recent
times, 'faction': but because it is written by a woman it is the emotional
element that is emphasised and which determines its classification:

We of the Never-Never (London, 1908) is actually a piece of
autobiography, but the events and people are recreated rather than
described, so that it reads like a novel, a romantic novel, and as such
it seems best treated here.

(H. M. Green, 1984, p. 697)

Clearly a careful evaluation of women's writing can confront men with
a double-bind – and cause a great deal of confusion in the process. On
the one hand Jeannie Gunn writes an autobiographical account – but on
the other it is sufficiently 'creative' to warrant the label 'romantic fiction',
according to H. M. Green: and on the one hand it is emotional – but
on the other it is journalistic:

We of the Never Never is likely to remain an Australian classic; quite
a minor classic however, because it belongs to journalism as much
as to literature, and is a record, an emotionalized description, without
any real attempt at an evocation of the spirit of time and place.

(H. M. Green, 1984, p. 699)

By such means are women writers acknowledged – and then denied,
relegated to the minor ranks in the literary tradition. Yes, Jeannie Gunn
is given a place, her achievement allowed and her popularity permitted:
but then the qualifications are introduced and her status made question-
able. So systematic is the treatment of women writers that one is obliged
to conclude that it is the sex and not the writing that is at the source of
such disparagement.

However, if Jeannie Gunn has contributed but a minor classic to the overall Australian literary tradition she has made a major contribution to women's heritage. *We of the Never-Never* is a characteristic and highly commendable work which draws extensively on the personal experience of women, which explores a variety of relationships, which spins scintillating and sobering yarns from the substance of disaster – and which pays tribute to the humanity of many culturally diverse Australians.

Today the writing of Jeannie Gunn – and Catherine Parker – would be placed in a political context, even though it would probably have been perceived as apolitical in its own time. But no such shift in perspective has occurred with some other Australian women who were – and still are – highly politicised writers: Alice Henry and Inez Bensusan are two such examples, and their role is discussed in the following chapter.

CHAPTER 8

•

The major role of the minor writers

While some women continued to document the problems, practices and peculiarities of their native land, other Australian born writers set off to see the world and invariably found a variety of 'causes' that caught their attention and called on their skill as writers. Alice Henry, for example, was one of the many 'minor' writers who found her political vocation in the United States, who used her pen to further women's fight for equal rights, and whose contribution helped to establish the diversity and depth of women's literary heritage.

Born in Victoria, Alice Henry served her literary apprenticeship as a journalist, before going overseas. A fervent feminist, she took her quest for equality to the workplace where she used her skills to help secure better conditions for women. In Chicago she became the editor of the journal of the National Women's Trade Union League from 1910 to 1919: among her publications are the politically uncompromising *The Trade Union Woman* (1915) and *Women and the Labour Movement* (1923).[98]

That Alice Henry was interested in the literary traditions of Australian women is evident from her compilation of an (unpublished) 'Bibliography on the Work of Australian Women Writers', currently held in the Mitchell Library, in which she states that her aim has been 'to furnish a record, as representative as may be, of what women in Australia have accomplished, from Colonial days onward, under what must often have been rather discouraging circumstances'.

I have made use of Alice Henry's 'Bibliography': it has the names of more than ninety women writers in it, some of whom I cannot now find. And I deeply regret the fact that neither the 'Bibliography' nor its compiler has a place in Australian literary history. This is one of the sobering aspects of studying women's traditions: again and again can be found women who tried to trace their heritage, only for their own

contributions to be 'lost' in much the same way as the very sources they were trying to reclaim.

Inez Bensusan is another woman who made a remarkable political contribution overseas but who remained invisible in her own land. I came across her in London when I was in the throes of reconstructing an area of women's dramatic heritage.[99] During the first decades of the twentieth century there was a thriving political theatre in England, which was part of the campaign for 'Votes for Women'. In the pre-radio and television age a great deal of propagandising and educating could be accomplished through street theatre and the Actresses Franchise League was committed to the development of a repertory of plays and pieces that put the case for women, and for which there was a constant demand.

Inez Bensusan was in charge of this dynamic department of the League: she ran it, she recruited actresses, she produced plays and she persuaded women writers (who had not always tried their hand at drama before) to write plays, monologues, pageants and other appropriate pieces.

In between times, she did her own writing. Among her work is her political one-act-play, *The Apple* (see Dale Spender and Carole Hayman, 1985). 'The Apple' is a reference to Cyril, brother of Ann and Helen Payson and 'The apple of his father's eye', the one to whom all privileges (and monies) must go. With its coverage of sexual harassment, *The Apple* would certainly have made the audience aware of the dimensions of the sexual double standard: it puts a most convincing case for the empowerment of women which goes far beyond the provision of a vote!

But Inez Bensusan has not been included in Australian literary history: that I could find so little information on her in London did not seem to me so surprising but that there is even less documentation on her in Australia is something that I did not expect. And it cannot be because she wrote abroad that her contribution has disappeared: women who 'stayed at home' and wrote apolitical pieces – even about the Australian bush – frequently fared no better.

Laura Palmer-Archer, for example, was a 'true' Australian who wrote about her native country under the pseudonym, 'Bushwoman'. Her short stories about the outback appeared in the *Australasian* and other periodicals, and she published two works of fiction – *Racing in the Never-Never* (1899) and *A Bush Honeymoon and Other Stories* (1904). Her sparkling and sporting yarns were well within the framework of the dominant *bush* literary tradition and earned her a considerable reputation in her own time. Her efforts were praised in an article entitled 'Women Writers of Australasia', in *Cassells Magazine*[100] in 1909, where the eminent 'Rolf Boldrewood' was called on for his support. When it came to the writing of Laura Palmer-Archer it was 'his opinion that work of such genuine merit should find a permanent place in literature'[101] (p. 191). *His* work

has of course enjoyed a permanent place in the literary tradition, but that of Laura Palmer-Archer has disappeared. As has that of 'A younger sister, Nannie O'Ferral ('Bohemienne') whose successful short stories appeared in the Australasian and other weeklies' (see C. Hay Thomson, 1909, p. 191).

Two Victorian women – Mary Simpson and Marion Knowles – also made substantial contributions to the popular 'bush-genre'. While their lively sketches were often written in a style which was very similar to the men's, the version of experience that they presented was dramatically different. Mary Simpson – who used the pseudonum 'Weerona' – wrote humorous stories, many of which were published in the *Bulletin*. She also wrote for the *Woman's Mirror* which, along with other women's periodicals of the past, remains an untapped source of women's literary wealth. For while the *Bulletin* itself has retained a central place in the cultural heritage (with a steady stream of reprints and discussion documents still flowing from it), the women's magazines, which also assisted literary growth and development and which primarily carried contributions from women, have, like Mary Simpson herself, virtually faded into oblivion. A selection of her short stories were published in 1926: *Tell Tale Stories from the Bulletin*. No such collection or presentation has been made of the work she had published in women's magazines.

A little more prolific, decidedly more poetic, and definitely more 'pure' was the work of Victorian schoolteacher Marion Knowles, who wrote numerous works of fiction about bush-life. 'Good stories' which were sometimes couched in religious overtones were her 'hallmark', and are to be found in her many publications – among them, *Country Tales and Sketches*, 1896; *Barbara Halliday*, 1896; *Shamrock and Wattlebloom*, 1900; *The Little Doctor*, 1919; *Meg of Minadong*, 1926; and *Pretty Nan*, 1928. Despite the fact that Marion Knowles had seven volumes of verse published from 1898 to 1935, she does not appear in the *Penguin Book of Australian Women Poets* (1986). Nor does Emily Congeau, who wrote verse drama (*Princess Mona*, 1916) and numerous volumes of 'nature' poetry, including *Rustling Leaves*, 1920; *Palm Fronds*, 1927; and *Fern Leaves*, 1934.

No anthology can ever be all-inclusive and my comments on the absence of these women from the volume of *Australian Women Poets* should not be construed as adverse criticism. On the contrary, one reality that the anthology has helped to establish is that Australia has a rich tradition of women poets of whom some are great and many are good. But because the anthology is the first in its field it is feasible that not *all* women poets should have been reclaimed, and that some superb women poets should have slipped through the net. While it is reassuring to see Mary Fullerton among the contributors to the book of *Australian Women*

Poets, it is regrettable that, as yet, Marie Pitt remains unrepresented and still awaits deserved acclaim.

Given that Mary Eliza Fullerton is acknowledged in H. M. Green's *History of Australian Literature*, it could almost be said that here was one woman poet who had 'made it' into the literary canon – except of course that she rates no mention in the *Oxford History of Australian Literature*, or in Geoffrey Dutton's *Literature of Australia*, and she is not included in the *Oxford Anthology of Australian Literature*. Why she should have been omitted from these later surveys and selections is a matter for speculation, for it cannot be because she was unknown or that her work was without merit. Using a variety of pseudonyms, Mary Fullerton wrote poetry, documentaries and fiction: as 'Alpenstock' she wrote pieces for newspapers and magazines, and under her own name she published novels (*Two Women*, 1923; *The People of the Timber*, 1925; *A Juno in the Bush*, 1930) and volumes of poetry (*Moods and Melodies*, 1908; *The Breaking Furrow*, 1921; *Bark House Days*, 1921).

Determined feminist and dedicated socialist, firm friend of Miles Franklin and political peer of Marie Pitt, Mary Fullerton wrote provocative polemic poetry which still makes its point today. In a contemporary context of violence against women her indictment of the English puppets 'Punch and Judy' strikes a stark note:

> Puppets
> Why bring *him* here?
> To this foul lane,
> Where husbands know beer,
> and wives know pain.
>
> They've nothing to learn
> From a puppet's knack:
> Who drink half they earn,
> Know how to thwack.
>
> Old as old oak
> Punch beating his mate
> And – heart breaking joke –
> Quite up-to-date.
> (*Australian Women Poets*, 1986, pp. 29–30)

Even more heart-breaking: *still*, quite up-to-date!

One of the themes running through Australian women's literary traditions is that of the feminist protest – against oppression, against violence, against drink. Mary Fullerton's poetry comes well within this feminist framework and her writing constitutes a valuable contribution

to women's cultural heritage. Even her comments on the advisability of pseudonyms for females provide insights on the role of women and the ranking accorded to their writing.

With the assistance of Miles Franklin, Mary Fullerton published two volumes of verse under the pen-name 'E' (*Moles Do So Little With Their Privacy*, 1942; *The Wonder and the Apple*, 1946). The reason she gave for this ruse was that the work would get a better reception if it were not known to be by a woman. And it seems that many women writers then (as would some now) agreed. Whereas modesty had previously prompted anonymity, by the mid-nineteenth and twentieth century it was the hope of fair play that often persuaded women of the value of non-female pseudonyms – Currer Bell and George Eliot among them.

Among the Australian women who chose to discard their female literary identity were Catherine Martin ('CEM'), Mollie Skinner ('R. E. Leake'), Kathleen Caffyn ('Iota'), Ethel Florence Lindesay Robertson ('Henry Handel Richardson'), Kate Margaret Stone ('Sydney Partrige'), Edith Joan Lyttleton ('G. B. Lancaster'), and Helen Sumner Locke ('Sumner Locke'). Marie Pitt too wrote under the name 'M. E. J. Pitt', and allowed her reading public to think she was a man, in order that her political journalism would be taken more seriously:

> The amusing part was that until shortly before I left Tasmania no one knew that those articles in support of Labor principles were written by a woman. Prejudice against women in politics is very strong. In fact I had to fight almost as hard to gain recognition from my own party as against my political opponents.

> ('Marie Pitt: Socialist and Poet', *Adelaide Advocate*, 2 April 1927: quoted in Colleen Burke, 1985, pp. 20–1)

How I have for so long managed to miss this remarkable feminist/socialist poet, Marie Pitt, continues to remain something of a mystery to me. When I now read of the way she revealed and rejected the operation of the sexual double standard – in work, politics, the family, literature – I can only marvel at her commitment and energy: when I realise the extent to which she dedicated her life to ending oppression, I can only offer my respect and admiration for her effort and tenacity. And when I read some of her many moving articles and poems I can only emphasise the desirability and the necessity of including women's contributions in the cultural heritage.

Born in Boggy Creek, Gippsland, Marie McKeown was not provided with a propitious start in life. Like so many women writers, she was primarily self-taught although she did have varying stints at the local Catholic and public schools, depending on which authorities her father

was at odds with at the time. But within her family circle she was given no encouragement to pursue her education at all: in an article in the *Bulletin* in 1910 the harsh circumstances of her early life were described:

Born on a miserable little outback farm. Father regarded the Compulsory Education Act as an interference with the liberty of the subject. At five years she was herding pigs. At seven she was promoted to weeding and crops. At eight she had a hoe put in her hands, and was given the job of planting potatoes. She nominally began school attendance at seven but as her labour was worth more than her fines cost him, her father mostly paid them. Kept her at home. From eight to eleven she worked in the fields, milked cows, fed a corn-stripper every night for a couple of hours till the crop was threshed, picked and bagged potatoes, drove horses, sat up nights to feed the horses, according to the rule of the house. At eleven, in spite of these little interferences with her scholastic work, she gained her standard certificate with credit. She decided to be a teacher. Her father decided otherwise. So from eleven to sixteen she worked like a man, hoed row for row of maize or potatoes with the hired man, with casual spells of education, here and there as she went along. At eighteen she was still struggling, grubbing tussocks with a mattock in the daytime and studying nights, handicapped badly at times with neuralgia and incipient anaemia. At nineteen she was completely broken down in health, a victim of neuralgia, insomnia, etc.

(Quoted in Colleen Burke, 1985, p. 11)

If ever there was a woman who had reason to question the right or the wisdom of patriarchal authority, it was Marie Pitt. No doubt much of her anger against exploitation and much of her ardour for an end to oppression can be traced to the awful conditions she was forced to endure in her youth.

In 1893, however, Marie Pitt made a partial escape when she married William Pitt and went to live in a series of mining towns in Tasmania: her escape was only partial, for while her efforts may have been more fully appreciated, life round the mines (and with young children) was back-breakingly hard. But it was in this context that Marie Pitt became even more politically astute and outspoken – and where she found some solace in her writing of finely honed verse. As she later wrote to the flamboyant poet, Zora Cross, she had:

Scribbled verse in young girlhood but didn't get much encouragement from surroundings. Took it up again in the loneliness of the West Coast Mountains in the intervals of house and

baby tendings. Sent my first verse to the *Bulletin* in 1900 – some
Boer War verse and it was accepted.

(Letter to Zora Cross, 16 December 1921, La Trobe Collection, Ms
 6107: quoted in Colleen Burke, 1985, p. 15)

More pressing than political problems far away, however, were the
ones at home, and Marie Pitt not only fought for equality for women as
mothers and wives – she fought for the rights of men who went down
the mines. She wrote evocatively, empathetically – and embitteredly –
about the dangers and diseases that were death to the miners. Her articles
and poems deploring the disregard, and advocating better conditions
for mine workers, appeared regularly in newspapers and periodicals in
Tasmania. But protest was no protection even for her own family: in
1905 her husband contracted the miners' lung disease phthisis and the
family finally returned to Melbourne.

Life for Marie Pitt was extraordinarily difficult. Her own health was not
good, she had no formal qualifications and to her fell the responsibility for
supporting a family – and caring for a sick husband for whom there had
been no worker's compensation. She tried all manner of poorly-paid
occupations, from writer to clerical worker and census collector. She also
wrote a powerful, plaintive and protesting poem entitled *The Keening*.[102]
And she joined the Victorian Socialist Party where Mary Fullerton was
also a member!

Marie Pitt's prose and poetry were forged from the raw material of
grim personal experience; the sense of injustice and the urge to promote
change pervade most of her writing. While she produced the occasional
lyrical ode most of her poems show the sharp edge of deep discontent.[103]
And they are just as damning of the system now as they were when first
written. The same can be said of Marie Pitt's articles. She was not
content to simply question the fairness of the deal that women received on
marriage (as many of her literary predecessors had done): she completely
condemned the conditions under which wives and mothers were required
to work.

In her article, 'Woman her Duty to her Race' (*Socialist*, 15 March 1912,
p. 2), she stripped away some of the sentimentality generally surrounding
motherhood to expose the realities of women's labour:

What a damnable piece of impudence to deny to a woman that which
the poorest navvy takes as his right, but which his wife, if she has
a few children never dares to hope for – an eight hour day, a paper
or book and a couch when the eight hours are done.

(Quoted in Colleen Burke, 1985, p. 34)

According to Marie Pitt, there was only one way women would improve their position – and that was by withdrawing their labour. Such a strategy was also suggested in the 1970s when the revitalised Women's Movement confronted the very same problem that Marie Pitt had addressed. But whereas the tactic of the 1970s was to withdraw *domestic* labour (with each adult to be responsible for their own 'shitwork') what most of its adherents did not know was that in 1912 their foremother, Marie Pitt, had gone one step further. For she had advocated 'The Greatest Strike in World History' (*Socialist*, 8 March 1912, p. 2) and called on women to withdraw their *reproductive* labour. It was her contention that if women were to refuse to do the necessary work that went with bringing children into the world they would soon be in a position to determine their own work load – and to claim their independence. Perhaps she was right. Certainly what is wrong is that such a powerful and persuasive contributor to women's consciousness and cultural heritage should be eclipsed to the extent that her existence and her intellect have virtually passed from view.

Not that Marie Pitt would have been surprised at the way her efforts have been treated by literary history. In the insights she provides on the process of women's writing – and on its reception – in a male-dominated society, she also makes a substantial contribution to the formulation of women's literary traditions. In her highly illuminating and harrowingly incisive article 'Women in Art and Literature' (*Socialist*, 11 August 1911, p. 2) she states:

> Wifehood and motherhood combined as they are under capitalism, with overwork and over-anxiety are a bigger handicap than the average male genius would successfully essay to carry to success.

> (Quoted in Colleen Burke, 1985, p. 62)

And, again in a letter to Zora Cross, Marie Pitt explores some of the conflict between being a woman – and a writer – in a male-controlled society:

> My output of verse has not been a large one – but I sometimes wonder that there has been any output at all. Housekeeping and writing are incompatibles – and the woman who tries to combine them usually finds tragedy very close – either she sacrifices ART to the house or the house to ART – or herself to both – which is also a tragedy – so my verse has all been written in snatched hours.
> I am seriously considering the kicking off of my domestic harness and taking a little office in town where I shall not see the common tasks that cry to be done – then I hope to write one or two things

that have been crying to be written for years, and will perhaps cease
to feel as lopsided as I do today, with regard to my duty to others,
and to oneself, that is not always possible on the treadmill track.

(Letter from M. E. J. Pitt to Zora Cross, 16 October 1921, State
Library of Victoria, Ms 6107: quoted in Colleen Burke, 1985, p. 62).

Marie Pitt's biographer, Colleen Burke – along with many others –
has tried to explain how such a valuable and viable writer should have
been omitted from the literary canon: the consensus has been that it was
because Marie Pitt was such a powerful political writer that her work
has been left out of the transmitted literary tradition (see Colleen Burke,
1985, p. 40). But while her ability to discomfit and discredit may well
have been responsible for a negative reaction within the establishment,
it cannot fully account for the fact that Marie Pitt (along with countless
other good women writers) has been removed from the literary record.
 Were it her politics that had precluded her inclusion, one could
surmise that the writing of more sweet and sentimental pieces would
facilitate her entry to the hallowed halls of literary fame: yet had she
written only lilting lyrics no doubt she would still have been damned for
her failure to meet 'the required standard'. There is no reason to suspect
that the reputation of Marie Pitt would have fared any better, whatever
she had written. She is a woman and as such her work has been dropped
from the male-stream: this is women's literary tradition.
 While there is clearly no comparison between the two, Inez Hyland
was a woman of much the same period as Marie Pitt but one who wrote
much 'softer' verse, and she too has been excised from the literary
canon. Commenting on her contribution – and that of Grace Jennings
Carmichael – C. Hay Thomson says in the article 'Women Writers of
Australasia' in 1909 that:

Two of Australia's most prominent singers early passed 'beyond these
voices' – Inez Hyland, in 1892 at twenty eight years of age, and
Grace Jennings Carmichael (Mrs. Mullis), in 1904, when well under
forty. Miss Hyland's collected verse, 'In Sunshine and in Shadow'
was published in 1893. It shows a very graceful fancy.

(C. Hay Thomson, 1909, p. 190)

Had Inez Hyland lived longer her literary reputation might have been
somewhat different: hopefully, however, the circumstances of her death
were not as distressing as those of fellow poet, Grace Jennings
Carmichael:

Miss Carmichael's book of 'Poems' with an introduction by Mr. J. F. Hogan, M.P., came out in London in 1895, and was very favourably reviewed. Most of its content had been contributed to newspapers during the early 'nineties, when the author was in training as a nurse at the Melbourne Children's Hospital. She was understood to be a Gippslander. . . . A very beautiful girl with her great dark eyes and pale, clear skin, she needed only a chaplet of wattle bloom to be the personification of the 'Spirit of the Bush'. Her poem, 'The Old Bush Road' has passed into currency.

She married and sailed for England in 1897 and from then her harp was silent. A recent endeavour to obtain a photograph of her brought to light the fact that she died with the love and esteem of those near her, but in circumstances of extreme poverty, and that her three children (boys), the eldest born in Adelaide, are inmates of an English workhouse.

(C. Hay Thomson, 1909, p. 190)

Verse making has not been a lucrative profession.

Some women who went to England, however, had happier tales to tell. Lala Fisher, for example, who was born in Rockhampton, Queensland, lived in England for four years from 1897, and her published poetry (*Twilight Teaching*, 1898) enjoyed a favourable reception there. She added to her reputation (and possibly to her income) when in 1899 she edited a book of short stories of Australian writers who were then residing in London: *By Creek and Gully* included a contribution from 'Iota'. Back in Australia – and in Charters Towers – Lala Fisher continued with her poetry (*Grass Flowering*, 1915 and *Earth Spiritual*, 1918) and was a regular contributor to periodicals and, later, editor of *Theatre Magazine*.

Another woman who edited volumes of Australian short stories which enjoyed success on the English scene was Harriette Anne Martin (often referred to as 'Mrs Arthur Patchett Martin'), whose *Under the Gum Tree* (1890) includes an excellent contribution from Rosa Praed. *Coo-ee: Tales of Australian Life by Australian Ladies* (1891) is a veritable 'Who's Who' of women on the literary stage, and the story by 'Tasma' in this collection makes impressive reading.

Beatrice Grimshaw was another woman who travelled and enjoyed spectacular popular success. Born in Ireland, she voyaged through the South Pacific, lived in New Guinea, and spent some time in Australia. The author of more than forty books, many of her volumes encompass antipodean settings and values.

By the twentieth century there were quite a few Australian women for whom writing was a profession and, although no doubt there were more unhappy endings than the one which befell Grace Carmichael, there were still those who were earning a reasonable living by their pens.

Ada Holman, for example, was a sufficiently popular journalist to have earned a tidy sum from her writing – assuming that she was always paid for it of course. It comes as something of a surprise to find that this committed feminist should have let her husband take the credit for some of her work. But in using her literary skills to enhance the reputation of her husband, Ada Holman was conforming to one of the persistent (and pernicious) patterns of women's literary history – as women from Sonia Tolstoy to Zelda Fitzgerald, Mollie Skinner, and the contemporary 'research wife' could testify.[104]

However, this was not the only area where Ada Holman encountered some of the problems which are part of the male-dominant literary tradition – and which continue to this very day. Ada Holman wrote enough and had experience enough to know that a sexual double standard operated in the world of letters and that it was a standard according women low status. Clearly she wanted to see an end to this practice of presuming that women writers were second-rate and it seemed to her that the way to do this was to insist on sex neutrality: Ada Holman argued that there should be no *women* writers or *men* writers only *writers* who were all judged by the same standard!

Few would want to quarrel with this literary ideal. But while most would agree that in a perfect world there should be a single literary standard, there is still considerable controversy as to how this perfect world can be achieved. And there were feminists then as there are now who were firmly convinced that it would be no perfect solution for women writers to deny that they are women.[105] So that when Ada Holman adopted the stance that women writers should simply be writers, she soon found herself on the opposite side of the fence from many of her sisters – Miles Franklin being no exception.

In Sydney, in September 1933, women's influence in literature was the topic of the meeting of the Fellowship of Australian Writers. Ada Holman, along with Dora Wilcox and Nora Kelly, declared that it made her 'see red to think that works are to be judged as written by a man or a woman'.[106] Miles Franklin, together with Flora Eldershaw and Alice Henry, who took the opposing side of the debate, also affirmed that it made them see red that women writers were viewed first and foremost as women, and were therefore assumed to be second-rate. But they protested against the *system* that endorsed – even encouraged – this practice, rather than quibble over the nature of women or resort to the rationalisation that writers were exempt from the gender constraints that applied to the rest of the population. They warned that women writers who tried to walk away from the implications, and the responsibilities, which went with the unfair treatment of the entire female sex (writers included!) would not necessarily find a favoured or firm place in the literary traditions of men.

Another example of the old double-bind; to be damned as a woman or damned as a writer? To Miles Franklin, Flora Eldershaw and Alice Henry, neither was a satisfactory solution. They wanted a society, and a system, that was based on equality and allowed all artists a 'fair hearing' without regard to sex.

Flora Eldershaw, Alice Henry and Miles Franklin wanted to assert the autonomy of women and to celebrate women's traditions, which they believed should *co-exist* with the traditions of men. And the stand which they took is one which is still central in the formation of women's literary traditions. It is also one which still promotes some controversy.

Whether Ada Holman thought it expedient to state the advisability of women joining men's ranks – rather than insisting on the viability and validity of their own – it is difficult to tell. Certainly Ada Holman moved in political circles and was extremely astute. She was married to the politician William Arthur Holman and displayed her own interest in the political arena with her novel, *Sport of the Gods* (1921) and her auto-biography, *Memoirs of a Premier's Wife* (1947). Using the pen names 'Myee', 'Nardoo' and 'Marcus Malcolm' (all of which are sexually neutral or male) she contributed extensively to the *Melbourne Punch*, the *Sydney Morning Herald*, the *Daily Telegraph* and the *Sydney Mail*. Under her own name she wrote children's fiction and numerous plays.

Then there was Mabel Forrest (1872–1935), who was a determined and dedicated writer. Unfortunately, I have not been able to read any of her work but Elizabeth Webby[107] believes that Mabel Forrest's writing has been terribly under-rated and that some of her novels – particularly *The Wild Moth* (1924) – deserve to be much better known. From 1924 a steady stream of novels issued from Mable Forrest's pen – *The Wild Moth* was followed by *Gaming Gods* (1926), *Hibiscus Heart* (1927), *Reaping Roses* (1928) and *White Witches* (1929): she had her first book published in 1904 (*The Rose of Forgiveness and other Stories*) and her *Poems* in 1927. In between there was *The Green Harper* (1915, a collection of prose and verse) and *Streets and Gardens* (1922, verse). Whatever happened to Mabel Forrest? Would she have fared better if there were a single rather than a double standard in the literary tradition?

That the name Marie Bjelke-Petersen should not be better known, however, is perhaps more surprising – and not just because of the quantity and quality of her literary output. Born in Denmark in 1874, she was seventeen when she arrived in Tasmania to make yet another contribution to that state's literary heritage. Not that she embarked on a writing career straight away: she began her working life by teaching the then current version of 'aerobics' until deteriorating health prevented her from continuing. It was then that she turned to a literary career and produced a steady stream of novels – where the titles give the clue to the nature of her substance and style: (*The Mysterious Stranger*, 1913;

Before an Eastern Court, 1914; *Muffled Drums*, 1914; *The Captive Singer*, 1917; *Dusk*, 1921; *Jewelled Nights*, 1924; *The Moon Minstrel*, 1927; *Monsoon Music*, 1930; *The Rainbow Lute*, 1932; *The Silver Knight*, 1934; *Jungle Night*, 1937 – and this list is by no means exhaustive).

With their blend of (some might say predictable) religiosity and romance, Marie Bjelke-Petersen's novels had widespread appeal and she soon enjoyed an international reputation. Her work was appreciated in the United States and England, and she was the recipient of many awards – including the King's Jubilee Medal for Literature in 1935.

Then there was another Tasmanian, Edith Joan Lyttleton (1874–1945) – more commonly known as 'G. B. Lancaster' – who was probably no less acclaimed abroad than Marie Bjelke-Petersen but who enjoyed greater favour in her native land. 'G. B. Lancaster' won the Australian Literary Society Gold Medal for her novel, *Pageant* (1933), which is a family saga that runs for a century, and which is a 'factional' account of the fate of the author's own family from the early pioneering days of Tasmania.

But 'G. B. Lancaster' did not continue the family tradition and stay in the state where she was born. She travelled widely and wrote extensively, and not a great deal of her work was identified with Australia. While her short stories appeared in the *Bulletin* and *Lone Hand*, her novels were much more cosmopolitan in flavour and only three of the thirteen (*A Spur to Smite*, 1905, *Jim of the Ranges*, 1910 and *Pageant*) could be said to be directly associated with Australia. In this respect Edith Lyttleton shares some features with her fellow Tasmanian, Louise Mack (1874–1935), who also drew on her experience of Europe in her many novels.

So many of these popular and internationally renowned Australian writers were such intrepid travellers, and Louise Mack was no exception. Hobart, Adelaide, Sydney, England, Italy, Florence, Belgium – these were just the starting points in her itinerant literary life. And it wasn't just people and places which served as a prompt to her writing: like quite a few other women writers (her sister Amy, and Ethel Turner included), Louise Mack was provided with sound preparation and considerable encouragement to lead a literary life at Sydney Girls' High – where she edited the school magazine.

Clearly the editor of the *Bulletin* counted this as valuable experience, for from a relatively young age and until she left for London in 1901, Louise Mack was on the *Bulletin* staff and 'declared her interest' in her regular contribution, 'A Woman's Letter'. During this period she also wrote two of her best received volumes of adolescent fiction – *Teens* (1897) and *Girls Together* (1898): *Teens Triumphant* followed much later in 1933.

Louise Mack was a versatile writer: she was a published poet, novelist,

and a skilled writer of non-fiction – her book *An Australian Girl in London* (1902) is a classic which has lost neither its power to entertain nor to inform. And during the First World War, Louise Mack was in Europe, and she quickly switched from the popular fiction that she had been writing to a more serious and sobering literary exercise: *A Woman's Experience of the Great War* was published in 1915.

While she produced a series of popular novels prior to the war (*The Red Rose of Summer*, 1909; *Theodora's Husband*, 1909; *In a White Palace*, 1910; *The Romance of a Woman of Thirty*, 1911; *Wife to Peter*, 1911; *The Marriage of Edward*, 1913; *Attraction*, 1913; *The Music Makers*, 1914; *The House of Daffodils*, 1915) there is little fiction forthcoming thereafter. I have often wondered what happened to this talented woman writer in the years between 1915 and 1933 after she published a few volumes of adolescent fiction – including in 1934, *The Maiden's Prayer*.

There are so many gaps in women's literary history and no one survey could even begin to comprehensively chart the breadth and the depth of this great Australian tradition. Unfortunately, many of these women and their works are still only names to me, and I look forward to the time when I have the opportunity (meaning – when they are in print, and when I have the leisure) to read more of them – and about them.

For example, I would like to know more about Agnes Littlejohn who was publishing at the very time that Louise Mack was silent. From before the First World War until the mid-1930s her poetry and prose were regularly published in the *Sydney Morning Herald* and the *Sydney Mail*: and she wrote a string of then highly praised novels which include *The Daughter of a Soldier*, 1907; *A Lapse of Memory*, 1901; *Mirage of the Desert*, 1910; *The Breath of India*, 1914; *The Silver Road*, 1915; *Star Dust and Sea Spray*, 1918; *Rainbow Dreams*, 1919; *The Sleeping Sea-Nymph*, 1921; *The Lost Emerald*, 1924; and *The Pipes o' Pan*, 1939. And there were at least ten volumes of poetry as well!

I am assured by the *Oxford Companion to Australian Literature* (1985) that Agnes Littlejohn's 'work has now more historical than literary value' (p. 425) – but how can I be sure? Because the work of so many women writers has been summarily dismissed in this way. So many contemporary readers and scholars have been dissuaded from pursuing the clues to past literary achievements by unsubstantiated assertions that the work of the woman no longer has literary merit, that I cannot afford to automatically accept such verdicts. There is such a lot of 'finding' and reading yet to do.

And difficult though it has been to establish the nature, scope, and 'value' of these prolific and popular women writers, the problem pales into insignificance alongside the obstacles that must be overcome in order to reclaim the woman who wrote but the occasional – or even only one – published book. Take Nancy Lloyd-Tayler, for instance. That

fossicking literary scholar, Sue Martin – who discovered *Kirkham's Find*[108] – came across another nineteenth-century novel with a comparable theme, but a completely different ending. *By Still Harder Fate* (1898) by Nancy Lloyd-Tayler is about a young Australian woman, Dorothy, who is urged by her father to do her 'duty' and marry, so that he can better provide for his sons. But whereas Phoebe – the heroine of *Kirkham's Find* – retains her independence and does her own thing, Dorothy bows under the pressure. Not that the man she marries (without love) is either hard or horrid: he was a wealthy and cultivated widower who was willing to share all his resources with his young wife.

Dorothy's material needs are more than met, and like Dorothea in *Middlemarch*[109] she has the option of helping her husband with his work. But there is no fulfilment for her in this: she can find no purpose in life. And Dorothy just pines away – and dies!

I was chilled by this novel: it is really about 'the death of the spirit' which is closely identified with marriage. One of the understandings that the author offers is that of the foolishness (and the risk) that goes with leaving one's loving sisters to enter on a life with a strange man.[110] This is a common theme in women's literature although it is not usually presented in the explicit form that it takes in *By Still Harder Fate*.

After reading the novel, I could not help but ask questions about the author: what had led her to portray Dorothy in this way? Were there any direct links between the experiences of her heroine, and her own life? As yet, however, my questions remain unanswered – although I must admit that I have great confidence in Sue Martin's enterprising scholarly skills. But all that she has been able to determine at this stage is that Nancy Lloyd-Tayler was the daughter of a landowner – one of Victoria's founding fathers – and that she was almost certainly born in Australia. There is a photo of Nancy Lloyd-Tayler in the *Tatler* (21 December 1897) in which the author appears to be in her early twenties, but so far there is little else: it seems that she had three sisters, and one brother, and – according to a letter in the La Trobe Library – she never married.

Another woman writer about whom I know little – and would like to know more – is Elizabeth P. Ramsay-Laye, who wrote under the name of 'Isabel Massary'. The author of books which dealt with social life in Australia, many of her novels now stand as useful documentaries. With her strong moral tone, 'Isabel Massary' clearly intended her works to serve as guidelines for good behaviour and the result is that they now tell us as much about the clash of values of the time as they do about those of the author. Another of Sue Martin's 'finds', 'Isabel Massary' appears to be an author whose reclamation could well be celebrated: her novels *Our Cousins in Australia* and *Two Years Folly* are the work of a talented writer and, along with *Social Life in Sydney*, deserve greater attention.

As with so many of these women writers about whom so tantalisingly little is known, questions arise in relation to their life and their work. I want to know if there were any more books of 'Isabel Massary's' published in the fifty years between *Our Cousins in Australia* (1867) and *Two Years Folly* (1916) – and if not, why not?

The same sort of questions occur with that versatile writer Julia Levy, another woman with a pen-name ('Juliet') who has aroused my interest: who was this author of a range of novels, poems and plays? Among her novels are *A Soul of Sincerity* (1923), *God's Good Woman* (1926), *Devotion* (1927) and *The Snob and the Lady* (1929). Some of her poetry was published in *Songs of Solace* (1922) and *Signposts on Life's Highway* (1926), and her entertaining plays include *The Way Out* (1925) *The Snob* (1925) *The Proposal* (1926) *Woman Disposes* (1927) and *The Choice* (1928). This appears to be a phenomenal burst of literary activity over a very brief period. As with 'Isabel Massary' I want to know whether the gaps are in the women's writing – or in our knowledge: did Julia Levy write more or was there only silence apart from those five short years? I would dearly *like* to know: for the construction of women's literary history in Australia, there is a real *need* to know.

Julia Levy could be another minor – or maybe even major – link in the chain of women's literary traditions, another woman whose work must be reclaimed and reassessed if we are to reconstruct not just the continuity, but the entire spectrum of styles and skills that comprise women's literary heritage. For as Virginia Woolf insisted in *A Room of One's Own*, when all the women writers of the past are placed in their chronological position, we will see not just a single line of literary women linked by a tenuous thread: we will see scores of women, rows of women, circles of women who provide the commonalities, complementarities and contrasts as well as the continuity, and who represent the range and diversity of women's literary traditions.

This is why it is important that no stone should be left unturned in the quest to find and formulate the scope of women's literary past. So many women writers have for so long been buried that no matter how unpromising the surface may appear – there are sound and sensible reasons to dig! Only when the bulk of women writers have been recovered, reviewed and relocated in the overall framework, will it be possible to assess their relative value and refer to a fully formed women's literary tradition.

It is not just for their own sake but for the contribution their part may make to the whole that there is a need to reinstate the many women writers who have disappeared. Who knows, for example, but that the work of Hilda Bridges (1881–1971) might cast light on the patterns of women's products of the period? Born in Hobart, she was the author of more than twenty novels (including *The Squatter's Daughter*, 1922) and

wrote numerous volumes of children's fiction: but as I have not read any of her work I cannot even begin to speculate on the significance that she should be given within women's traditions.

Yet because I know that a sexual double standard operates within he world of letters I must necessarily be suspicious of any superficial rejection of the offerings of women. I cannot afford to ignore Hilda Bridges simply on the grounds that she has been summarily dismissed as a writer of 'light fiction' in the *Oxford Companion to Australian Literature* (p. 111). One man's meat can well be another man's poison, and one male critic's burial of a woman writer can well be women's hidden treasure.

Gertrude Hart, too, could possibly come into this category. Born in Melbourne she was a poet and novelist whose work includes *The Dream Girl* (1912), *The Laughter Lady* (1914) and *Chubby* (1937). Remembered more for her contribution to the Derelicts Club (which later became the Melbourne Society of Australian Authors) there is some archaeological excavating to be done to determine this woman's place on the literary spectrum.

And Charlotte Dick, the Tasmanian, whose output spans a period of almost thirty years, what status should she be given? With her heroines who are governesses and orphaned immigrants, her writing stands squarely within women's literary traditions. Yet cursory commendations are of little use: We need to know what weight to attach to her novels *The Veil of Discretion* (1920) and *Country Heart* (1946) if we are to adequately assess the nature of her literary contribution.

Too frequently the fate of the woman writer has been like that which befell Helena Sumner Locke (1881–1917) who wrote under the name 'Sumner-Locke': in her we have a typical example of the way women's achievement can be eclipsed by a man. Although a playwright and novelist of considerable note – and in her own right – *Helena* Sumner Locke is often referred to as the mother of playwright and novelist, Sumner Locke Elliott. Yet Helena Sumner Locke wrote her 'Mum Dawson' series of novels which were satires on women's role in selection life. And while her characters are sometimes caricatures and her stories sometimes simply versions of the more eminently satirisable antics of men, her novels are none the less a woman's creation of a woman's world and they have a special and specific contribution to make to the Australian tradition. No coverage of the bush yarn, the outback adventure, or the use of satire in Australian fiction could be adequate or accurate without the inclusion of Helena Sumner Locke: that she has been given no place in such discussion points to the limitations of traditional coverage.

So many women writers have been left out of the reservoir of knowledge that is transmitted from one generation to the next, that any attempt to map the extent of this omission leads almost inevitably to the formulation of *a long list* – a long list of unknown women and a few of

their unknown works. And unfortunately such lists are not at all exciting: they cannot begin to convey the value or the joy that is to be found in the 'alternative' reservoir which has been overlooked. Yet this list of unknown women and some of their unknown works represents a rich store of fascinating literary treasures. And nowhere is this more the case than with some of Australian women's literary partnerships.

CHAPTER 9

Literary partnerships

The highly successful literary partnership of Marjorie Barnard (1897–1987) and Flora Eldershaw (1897–1956), who used the pen-name 'M. Barnard Eldershaw',[111] has been well publicised: what has been less publicised is that they were part of a well-established female literary tradition. Among their predecessors were Sydney Partrige (1871–1953) and Cecil Warren who were included in the Cassell's Magazine article 'Women Writers of Australasia' in January 1909 – where they were highly praised for not allowing the 'joins' in their joint effort to show:

> Their third joint serial novel, 'The Education of Clothilde', ran quite lately in the Melbourne *Leader*. Besides these, each has a long tale of work to herself. At the recent Commonwealth Women's Exhibition Miss Warren was awarded second prize for the short story and Miss Partrige (Mrs. H. E. Stone) first prize for the novel of 100,000 words.
> The latter has just published a collection of short stories under the title 'Life's Wallaby'. A peculiarity of this book is that it has been set up and printed by its author. . . . Both Miss Warren and Miss Partrige are English by descent and Australian to the core, though Mrs. Stone says of herself that she is a New Zealander by birth and prejudices. The two met as schoolgirls in Adelaide, where they now live, and became what they remain – fast friends.

> (C. Hay Thomson, 1909, pp. 192–3)

Such an account is most unusual. It was Virginia Woolf who commented in *A Room of One's Own* that it was rare to find women represented as

friends in fiction: but it is even rarer to find literary women represented as friends – and partners – in real life. Which is one reason why I want to know more about the collaborative and individual contributions of these two women writers. I want to know more about Kate Margaret Stone and her Wayside Press, more about Cecil Raworth than a name and a pseudonym, more about their writing, and more about their relationship. For while literary partnerships have been part of the fabric of the female literary tradition, little has been written about them.

Dorothea Mackellar (1885–1968), for example, is well known for the classic poem 'My Country', but her collaborative ventures with Ruth Bedford (1881–1963) have generally been ignored. Yet jointly these two women wrote the novels *The Little Blue Devil* (1912) and *Two's Company* (1914), and there will be significant gaps in literary history until we know more about the circumstances that brought these women together – and which were conducive to collaboration.

And clearly Dorothea Mackellar should be given credit for much more than one poem: she wrote four volumes of consciously Australian poems as well as a novel – *Outlaw's Luck* (1913). Ruth Bedford too has many more claims to fame than that of her partnership with Dorothea Mackellar: she was a poet (with two volumes of verse published) and a dramatist and novelist in her own right. Her book, *Think of Stephen, A Family Chronicle* (1954) can still charm, and inform, and there is no doubt that many of her plays could still profitably be performed.

This is one more link that needs to be known to illustrate the temper and texture of women's literary traditions. When all the individual threads have been recovered and all have been woven together, then some of the complex and subtle patterns of women's heritage will emerge: then we will see that Sydney Partrige and Cecil Warren, Dorothea Mackellar and Ruth Bedford were by no means alone. Then we will be able to place in context not just the work of Marjorie Barnard and Flora Eldershaw, but that of Dymphna Cusack and Miles Franklin (*Pioneers on Parade*, 1939) and Dymphna Cusack and Florence James (*Come in Spinner*, 1951). And this is only a beginning.

With the recognition that women have collaborated with each other – and with men – will come questions about the nature of writing partnerships and the part they have played in the literary tradition. Why is collaboration common in the cultural practices of women, but rare in those of men? What role does co-operation play within women's heritage? Currently these are nothing other than interesting questions: they point to the possibilities inherent in any reclamation of women's literary traditions. And they help to show how richly rewarding women's heritage will be when it is 'unearthed', polished – and placed on show for all to see.

CHAPTER 10

Women and children

One 'treasure' that will attract attention will be that of so-called 'children's fiction' for it is in this area that numerous women have excelled. Many are the women who have been classified as authors for children, but first among the ranks must be the work of Ethel Turner and Mary Grant Bruce – who were responsible for influencing the views and values, habits and tastes, of generations of young women.

While within the literary canon there has been little concern shown for 'adolescent fiction', women have long known the power and the pleasure of such a genre. Since the inception of the novel women have used fiction to inform, persuade and educate in the most positive sense of the word, so that most novels have had the potential to serve as women's curriculum in the school of life. But special attention has been paid to the novels for young women: sympathetic consideration has been given to what they need to know and how best they can acquire the necessary information. This is one reason why good fiction for girls has such a long history: it is why it has been at the same time so thoughtful – and so entertaining. Since Sarah Fielding wrote the first story for young ladies in 1749 – *The Governess or The Little Female Academy* – some of the best women writers (Maria Edgeworth among them[112]) have used their talents to produce 'quality' adolescent fiction.[113] And within this honourable tradition the Australian writer Ethel Turner[114] (1872–1958) warrants a permanent position.

Perhaps one reason why Ethel Turner's work struck such a chord was because she was a very young woman when she started writing. She professed to love writing, and wrote continually throughout her life (with more than thirty-five books to her credit, not to mention her incalculable contributions to anthologies and magazines), and her enthusiasm for her work often shines in her sparkling style. As one of the original thirty-

seven pupils to attend Sydney Girls' High School, Ethel Turner started
to learn her craft there in the years 1883–8. And one of the insights that
can be provided from a documented literary history is that this is where
she had her first tussle with an editor – which led to characteristic
resolution.

Louise Mack was the editor of the school magazine, and Ethel Turner
tells what happened when this particular editor proved to be unreceptive
to the budding writer's work:

> The editor of the school paper proper evidently considered the
> aspiring contributions I used to drop into her box as beneath
> contempt, so in a wrathful moment I rallied my particular friends
> around me and started a rival paper.
>
> (Ethel Turner, 1979, p. 12)

The new paper was called the *Iris*: its motto (translated) was 'While I
live, I sing'. There is every reason to believe that this was Ethel Turner's
motto for living as well as for writing.

But even for Ethel Turner, school days had to come to an end, and
with them – the *Iris*. Yet she couldn't keep away from the writing and
editing and, remarkable though it may seem, from the age of seventeen
Ethel Turner edited the *Parthenon* magazine (published by Gordon and
Gotch, who were agents for its sale) with her sister Lilian. And it was
no puerile or petty periodical either: from the outset the Turner sisters
determined that their publication should be provocative – although it is
also fair to add that they probably never intended the predicament that
helped to make them, and their magazine, famous.

The adolescent life of Ethel Turner helps to illustrate the stage that
women and writing had reached in Australia towards the end of the
nineteenth century. For here was a young woman who had set up and
edited an 'alternative' school magazine, who by the age of eighteen was
running a commercially viable periodical, was – under the supervision of
one Mr Astley – learning to write 'leaders' for the Press Association
(including ones on fiscal policy), was unimpressed with the offer of a job
as a fashion journalist, was having articles commended by Christopher
Brennan and published in *Hermes* (the University of Sydney under-
graduate magazine) and who, on account of her own editorialising, was
embroiled in a serious libel case.

These early – and amazing – feats of Ethel Turner are often lost
under the somewhat patronising dismissal of her work as 'children's
fiction'. Yet apart from the fact that it is frequently impossible to draw
a dividing line between her adult and adolescent fiction, what should
also be taken into consideration is that Ethel Turner never saw herself
as writing exclusively for the young! Some of her novels and many of

her short stories and articles were clearly directed at a specifically adult
audience, but this aspect of her work seems to have been submerged so
that she has been falsely labelled as the author of trite stories – a sort
of past queen of 'kid's lit.'.

But it is her capacity to encompass the reality of the young that is one
of Ethel Turner's greatest strengths – and one which has its attraction
for readers of all ages. It was because she could fuse the impatience and
curiosity of youth with some of the wisdom of experience that her work
was so successful. There is no great mystery as to how or why Ethel
Turner should have adopted this particular course: in many ways her
writing reflects the mixture of her own 'young/old' life – and of this the
Parthenon libel case affords a good example.

Partly because I think Ethel Turner has been so shabbily (but so
predictably) treated within the world of letters, I quote some of her diary
entries here, at length, to emphasise some of her very real achievements
of the time. And I include this traditional personal writing partly because
it tells such a good story (and after the preceding 'list' of women writers
I am assuming that the attention span of my readers is diminishing), and
partly because it reveals so much about Ethel Turner's life and the blend
of childish naïveté and literary sophistication that was at its very centre.
But I also use these entries to show just what was within the realm of
possibility for a young woman writer in Australia towards the end of the
nineteenth century.

Ethel and Lilian Turner, who wrote and ran the *Parthenon*, conducted
a competition to determine just how many words could be made from the
letters contained in the word 'regulation'. One reader, 'E.M.', submitted a
list of 687. Feeling, however, that the combinations 'E.M.' had provided
were going a bit too far – that many of her coinages were not real words
– the editors published a statement to this effect.

Then 'E.M.'s' irate father, Mr McKinney, entered upon the scene,
and promptly threatened to sue – unless of course the youthful editors
apologised and withdrew their offensive imputation. But aware of the
publicity for the *Parthenon* that would ensue, Ethel Turner decided
against retraction. Rather she tried to make the most out of the situation
– and proceeded to offer her paper for sale to the *Daily Telegraph* – for
a profit.

The only background information necessary to make sense of these
diary entries is that in 1880 Ethel's mother married her third husband,
Charles Cope, and that he quarrelled with his wife as well as the children
– Lilian, Ethel, Rose and Rex.

1889.
3rd April
Practised 1 hour, sang 20 minutes. Cleared out boxes and drawers,

cartloads of rubbish and old letters etc. Addressed *Parthenon* wrappers and then in afternoon went to town – Lil brought a new dress. I am penniless. At night, tried to write a poem and failed, so instead read and idled. . . .

24th July
Mother and I went to town to Anthony Hordens. I bought a pair of dancing shoes, a fan, a diary and some skates for a prize for *Parthenon* competition. Went to Fresh Food and Ice for lunch –

2nd August
Had a grand clearing out of boxes and drawers and the result is an abnormal state of tidiness exists in my bedroom. Sewed pearl beads on my evening dress, trimmed some pretty underclothing and stitched ribbons on my long gloves. Mr. McKinney and his little girl came; he said he was sure she had been very careless and took a list of words to see if they had been invented. Rex was very ill in the night, we were up with him for a long time.

14th August
We all went to Bondi for a picnic. It was a lovely day but Lil and I had so much writing to do we really ought not to have gone. A second letter came from Mr. McKinney requesting us to apologise and pay costs one guinea: Of course we refused to do it for her so I suppose they will take proceedings. . . .

19th August
Lil and I went to town, we are throroghly tired of the work of the *Parthenon* and quite ready to give it up. I should not at all mind being a governess on a station though I should not like it in Sydney. A third lawyer's letter on the McKinney case came, so we went to Mr. William Cope (– *Solicitor and brother of her stepfather* –) and asked him to defend our case – he is very nice indeed and said he will see to everything. We would rather the case went on; it would be so good for the *Parthenon*. Mother and I went to the editor of *The Bulletin* to see if he would take the *Parthenon* and retain us as writers. He is to let us know. At night wrote the Children's Page and several things till 11 o'clock.

2nd September
Copied out E. McKinney's words and went to Dr. Rutledge's he put us in a cab and took us first to the University, then to Professor Scott's. P. Scott said as far as he was concerned many of the words were absurd and he is going to write. He was very nice. Then we

went to Cope and King. Mr. William Cope came in and although I
hated him at first he has such good true eyes that I felt I could
trust him with anything and someway I could not help liking him
exceedingly. . . .

4th September
Tried again to write a tale and again could not get in the vein. . . .

27th September
Went with solicitor to the Supreme Court, it was all so strange; we
had the paper registered. Then Lil and I went to see Mr. William
Cope and he said the same as he always does. I don't like him much
now . . . at night I corrected proofs and did *Parthenon* work. . . .

4th October
Lil and I did some shopping at Farmers, I bought a brown parasol
for myself and a red one for Rosie. Then we went to Lavender Bay
and I had a bathe and Lil watched me but did not get in. I read this
afternoon and sent the rest of the *Parthenons*. Played a practical
joke on Mr. Cope [*her stepfather*] by sending him a letter containing
a formal proposal for 'my own hand'.

5th October
Tidied my bedroom, put flowers in the drawing room, etc. Mr. Cope
came home at 10.30a.m., funny about the letter – he thought it was
real, I never saw him in such a state. I am sorry now I did it but it
was only a joke. He declares he would rather bury me than see me
married. . . .

29th October
Got a letter from Press Association asking me to call. I went and the
editor Mr. Astley was very nice – he said he liked my style of writing
and offered me the position of fashion writer and warehouse noter
(about £60 a year). I refused for I should not like to go to the places
taking notes. He told me to write him a specimen Leader – Women's
College Bill. . . .

15th November
Singing lesson at 9.00am. Had a letter from Gordon and Gotch
saying they had been served with a *writ* for us, we shall have to go
to court. . . .

16th November
Letter from Mr. Astley asking me to go down to see him; he says if

I will practise leader writing under his correction, I shall write leaders for him. Read to Rex at night, he has such a bad cough.

18th November
Lil and I went to Sydney to Palings and School of Arts. Then to Free Library and looked out *the words* in Webster, unluckily most of them are given, though they are obsolete. I am afraid we are in rather a 'hole'.

23rd November
Practised quarter of an hour. Went to Sydney to buy a flower for my new hat and strawberries for dinner. Mother and Mr. Cope had a fearful row. He smashed her gold bangle to atoms to aggravate her and there was a terrible piece of work. Heigho – I wonder do all married people have rows. I wouldn't be married for *anything*. Mother and Rex have gone to Barry's for the night. Rex has whooping cough. . . .

29th November,
Mr. Davis, editor of *Hermes* called and I was alone. He says he and Mr. Brennan, the other editor, like the parody I wrote for *Hermes* and are going to put it in. . . .

7th December
There was a good review of the *Parthenon* in the *Herald* to-day. The parody I wrote for *Hermes* 'Altar of Examdomania' was put in this number. Lil and I went to town, did a little shopping; I went to Mr. Astley, he is to give me a lot of writing to do. He has engaged me for certain to write the Ladies letter, at a guinea a letter, I am to write some political leaders too, and an Australian story. I'll be a Millionairess soon.

13th December
Mother and I went to town to Edwards Dunlop to buy prizes. . . . Then to Mr. McHardy at *Daily Telegraph* and he has agreed to take the advertisements, subscribers, everything of *Parthenon* for 6 months, and we are to do the whole of the writing and have half share of profits. . . .

17th December
Got a letter from Mr. Astley, he sent back my leader with a number of notes in the margin – he said it 'showed good capacity for high class leader work'. He didn't use it because it was on the fiscal policy but he asked me to write one for Xmas. I wrote at it all the morning

and then *Bobbie*[115] in the afternoon. Copied out leader and *Bobbie* at
night until very late.

18th December
Went to Cope and King and saw our barrister Mr. G. W. Reid –
the brief is an immense one, about twenty huge closely written
sheets. He asked us a good many questions. Then shopping, I bought
a song, my first, *Only A Year Ago*, by Claribel. Afternoon we went
house-hunting to Glebe. Mother and Mr. Cope are still rowing about
moving. He is awfully selfish about it. . . .

1890
24th January
My birthday, Mr. Cope gave me a nice pair of gloves and Rose a
dear little butterfly handkerchief. Case came on, all morning we
were waiting about Sydney killing time and at 2.30 p.m. we went to
the District Court with Mr. Cornish. The upshot of the matter was
we lost the case, Fitzharding, the judge, seemed prejudiced against
our side the moment the other barrister spoke. The judge gave a
farthing damages against us and both of our costs to pay. I don't
know how we shall pay them.

25th January
All the papers were full of the libel case, the *S.M. Herald* had a
column in the Law report, a leader and a piece in News of the
Day. It is an awful shame that we have lost it, the child undoubtedly
cheated. Cope and King sent us two letters, they are not satisfied with
the verdict and want to see us.

(Ethel Turner, 1979, pp. 13–30)

So at the tender age of eighteen, Ethel Turner (and sister Lilian who,
it must be remembered, was also a remarkable author) lost a libel suit –
after having tried to persuade the *Bulletin* to take over her paper while
still retaining her services as a writer, and after having done a deal with
the *Daily Telegraph*! To some extent Ethel Turner's life story reads
stranger than fiction: no wonder she was able to write so convincingly
about some of the contradictions of adolescence.

While many a fictional Australian heroine was trying to balance the
conflicting demands of self-realisation and subordination – while Phoebe
Marsden, for example, struggled to reconcile the demands of work with
those of being a lady – Ethel Turner was living some of these contradic-
tions. As her diary reveals, she fluctuated between being the child and
the adult, between being the dilettante and the professional writer,
between duty and independence, and when to this was added her

penchant for practical jokes (such as sending an anonymous letter to her stepfather which requested Ethel Turner's hand in marriage) and her experience of marital discord and family friction, it is clear that from an early age Ethel Turner was well supplied with a store of useful and interesting experiences when she started to write fiction.

And what an astonishing start she did make: one that cannot be explained (or dismissed) in terms of privilege. For Ethel Turner certainly did not enjoy an exceedingly comfortable life either psychologically or materially. When she was but two years of age her father (George Burwell) had died, leaving her mother, Sarah Jane Shaw, with two young daughters to support. Ethel's mother then married again, this time to an older man, Henry Turner, who also died, leaving Sarah Turner in debt and with three daughters to provide for. Seeing little prospect of improvement in the family's health or fortunes in Northern England, Sarah Turner showed some of that resolve and determination later evident in her daughter when in 1879 she set sail for Australia. On arrival, circumstances bordered on the desperate when she was unable to find a position as a governess, but she was eventually employed as a supervisor in a Sydney department store.

Ethel Turner's upbringing was not that of a sheltered young lady. But that she should have been able to launch herself upon such a colourful literary career from such a base speaks for the way in which a few doors were opening up to women at the end of the nineteenth century. For Ethel Turner went on to become a reputable and regular contributor to a variety of periodicals and magazines (the *Bulletin* included) and, of course, as 'Dame Durden' wrote the children's column for the *Sydney Illustrated News*. Such achievement was above and beyond her contribution of adolescent 'classics'. *Seven Little Australians* (1894) and *The Family at Misrule* (1895) were the first two novels which helped to establish her early claim to literary fame: it is sometimes hard to realise that she was barely twenty when she wrote one of the best known Australian stories – which encompasses much of what is best in women's writing and Australian literature. In the more than thirty novels which followed, a multitude of 'real-life-issues' were frankly and fascinatingly explored: Ethel Turner knew enough first-hand about births, deaths and marriages – and was a skilled enough writer – to stretch the minds and meanings of her audience.

Ethel Turner's life and work should occupy a prominent position in any history of Australian letters: that she should have been 'put-down' and pigeon-holed as a writer of low-status children's fiction says more about the value of her critics than the nature of her work. For in so many way her writing can still serve as a source of illumination today.

Where her limitations are evident is in relation to race and sex, and yet even here she allows contemporary readers to measure some of

the shifts in perception that anti-racist and anti-sexist movements have achieved. And there are extenuating circumstances: for example, perhaps it was because she was too close to the patriarchal stepfather who was a figure to be feared that she sometimes reproduced such a character in her fiction.

However, because literary history has treated Ethel Turner so badly, I have no wish to be harsh on her here. While her work is often the product of her particular place and time there are still many occasions where she transcends some of the limitations of her period and produces work which challenges and charms. And for this she should be given due credit.

So too should her sister, Lilian Turner, (1870–1956) whose book *The Light of Sydney* won first prize in *Cassell's Magazine* novel competition in 1894: Lilian Turner followed this success with more than twenty novels primarily for the young. And more persistently and more perspicaciously than her sister Ethel, Lilian pursued in print some of the problems encountered by young women who wanted to lead independent and creative lives. Whereas Ethel Turner's focus was often the conflict and accommodation of family relationships, Lilian Turner was generally more concerned with individual and intellectual tensions, and the means by which artistic aspirations could be realised. Some of her titles tell their own story – for example, *Betty the Scribe* (1906) and *Anne Chooses Glory* (1928).

No discussion of adolescent fiction – or of sisters for that matter – would be complete without reference to Louise and Amy Mack. Louise (who has already made an appearance in an earlier section – and not just in the role of the editor who thwarted Ethel Turner's literary efforts) and a younger sister also trod the increasingly used female path of journalism and children's fiction. Amy Mack (1877–1939) was the editor of the *Sydney Morning Herald*'s 'Woman's Page' from 1907–14 and the author of numerous stories for young people, some of which were about the bush (e.g. *A Bush Calendar*, 1909; *The Wilderness*, 1922), and some of which reflected the priorities of her own youth (e.g. *Scribbling Sue and Other Stories*, 1913).

Lilian and Ethel Turner, Louise and Amy Mack were part of a small group of spirited literary pioneers who at very early ages adopted public profiles in relation to their work. When they moved into the rough and tumble world of journalism – when they entered competitions, won prizes, and published best-selling novels before they were barely out of their teens – they broke with some of the long-established literary conventions of female modesty and anonymity. They sought reputations and in doing so they show how far women had become full members of the literary profession: they also helped to pave the way for the equally youthful and exuberant Miles Franklin whose highly acclaimed novel,

My Brilliant Career (1901), was published when the author was only twenty-one.

When I now read about the ventures (and adventures) of these young writing women I not only marvel at their courage and commitment, but wonder whether there has been any great improvement in conditions since that 'merry band' took advantage of the expansion of local literature (and interest in the guidance of the young) that characterises the last decade of the nineteenth century. Ironic though it may seem, I sometimes think that Ethel Turner led a less constrained life, and enjoyed more intellectual opportunities and encouragement a century ago, than many of her counterparts do today.

What I do know is that had these been brothers (and 'mates') who formed such a colourful and creative community and who experienced such extensive literary success, we most certainly would have heard about *them* and the various interconnections of their lives. No doubt books would have been written about their 'literary mateship' and they would have been awarded a place in the readily accessible literary archives. But because these writers were women, and because they have been consigned to the less prestigious categories of journalism and children's fiction (both a classification and a status with which I do not agree) they, and their efforts, and their relationships – to rephrase Ethel Turner – go unsung.

Another minor link in the chain, who has suffered the same fate and who, upon re-evaluation, could well turn out to be a major contributor to women's literary traditions, is Mary Grant Bruce (1878–1958). Born in Victoria, she too began writing as a child and followed this with an entry to journalism and then to fiction – writing on average one book a year from 1910 to 1942. She was a constant contributor of articles and short stories to the *Age*, the *Leader*, *Lone Hand*, *Pastoralist's Review*, *Table Talk*, and of course *Woman* and *Woman's World*, both of which she at some time edited.

Mary Grant Bruce's first job was to run the 'Children's Page' of the *Leader*, and it was here that some of her 'contacts' were made. While the work did not pay very well (she had to choose between food and a potplant as 'the money rarely ran to both': see 'How I became a writer', 1986, p. 203), some of her stories were serialised in the *Leader* as *The Little Bush Maid* and were later published as a book – ushering in the famous Billabong era. Commenting on her career, Mary Grant Bruce said –

The success of my first book created a demand for a sequel, and so began the 'Billabong' series, for which I try to wriggle away, and to which the public and the publishers sternly draw me back. I followed the second one with *Glen Eyre*, of which the *Argus* said,

'It is a book that should be read by every man who wants to know his country'; and since then it has no longer been necessary to choose between a meal and a pot-plant. The books go on and people are kind enough to like them – at any rate, they demand new ones, and the old ones sell steadily. The Great War, following a wonder-year in England, interrupted freelance and journalistic work; and babies make writing by no means an easy matter. But still one hopes to go on 'becoming a writer'.

(Mary Grant Bruce, 1986, p. 206)

Mary Grant Bruce was one of the best known Australian authors of her time and her reputation did not rest upon her achievement as a writer of *children's* fiction. On the contrary, her amazing range of journal-istic pieces (many of which I have only recently discovered) *and* her novels helped to establish her credentials as a sound and serious writer, and if now her novels are seen as suitable only for the young this is certainly not how they were received at the time, as Prue McKay notes:

Mary Grant Bruce's novels have never been easy to categorize absolutely. They have always been read by adults – a fact acknowledged by her reviewers. An account of her visit to Durban on her voyage to England in 1913 appeared first as a travel piece in the *Age* in April that year: and the same account furnishes two chapters in *From Billabong to London*, when the Lintons[116] also visit Durban a year or so later. The book was listed in the 'Travel and History' section of the *London Book Monthly* when it was published in 1915. The third book in the Billabong series originally ran as a serial in the adult section of the *Leader* rather than on the children's page.

(Prue McKay, 1986, p. 10)

Like so many other women writers, Mary Grant Bruce confounds some of the literary categories and conventions and I have asked myself whether it was because her novels were so 'adult' – so unpatronising in tone – that I enjoyed them so much and remembered them with such affection. But when I now go back to some of the Billabong accounts, and to the role played by Norah Linton, the heroine, I realise that there is yet another dimension: only in the fiction of Mary Grant Bruce did I as an Australian adolescent consistently find a female character who was portrayed as independent.

A survey of some of the non-fiction articles that Mary Grant Bruce wrote[117] shows her enduring concern for improvement in the position of women, and this commitment steadily surfaces in her portrayal of her female characters, who not only demonstrate their autonomy and

resourcefulness, but also reveal the network of replenishing relationships that exist among women.

When 'Banjo' Paterson and Henry Lawson – and the *Bulletin* – were in the ascendancy, and when the mark of Australian literature was that it was about the bravery and the bonds between outback men, Mary Grant Bruce defied the dominant tradition and wrote about the world of women: the rub is that there was – and still is – a great demand for such work.

Prue McKay has assessed Mary Grant Bruce's contribution to Australian literature and has found it far from wanting: she shows how Mary Grant Bruce has helped to redress the balance with the introduction of her independent women. She notes that Mary Grant Bruce (like Miles Franklin) 'is more concerned with the contribution of pioneer women. . . . than with the men' (p. 8), and that in her autobiographical account of 'The Aunt' who joins her brother and sister in Sydney, 'Although the brother was an early Attorney General of New South Wales, it is characteristic of Mary Grant Bruce's preoccupation with the contribution of women that only the sister, "the wife of the general" is mentioned when the family's social connections are established' (p. 7).

Is it because Mary Grant Bruce did not write positively and primarily about boys that her work has been eclipsed? Is it because she wrote about strong girls that her reputation has been relegated to the lower ranks? Is it because Ethel Turner wrote domestic dramas and Lilian Turner wrote about artistic aspirations among *females* that the work of these women writers has been excluded from the mainstream?

What explanation can there be for the way the work of 'Banjo' Paterson and Henry Lawson has been embraced as that of the national heritage while that of their female counterparts is disqualified and cast aside? Why are 'Banjo' Paterson and Henry Lawson not referred to derisively as writers of children's fiction?

There is an old assertion (given substance by Margaret Mead[118]) that when women achieve some of the great heights attained by men, their accomplishment is called by another name; a name which detracts from their efforts and is decidedly disparaging.[119] Assumed as men to be the pillars of the Australian literary tradition, what happened when 'Banjo' Paterson and Henry Lawson wrote tales that were attractive to the young, was that this achievement was seen as an extension of their creativity and they were accorded even greater praise for their versatility and range. But when Ethel Turner and Mary Grant Bruce wrote work which had wide appeal among adolescents, there was no suggestion that they were to be congratulated on their creative extension; rather their success in this area was seen as a limitation. So 'Banjo' Paterson and Henry Lawson are granted a permanent place in the national heritage on the grounds that their admirable work attracted the interest of the young; and Ethel

Turner and Mary Grant Bruce are dismissed for the very same reason. One rule for women and another for men.

Without this double standard, Mary Grant Bruce could well be seen not just as a woman who wrote in comparable vein to some of the great literary men, but as an author who developed the outback theme and the bush genre in Australian literature. For as Prue McKay has pointed out, there are many respects in which Mary Grant Bruce could be said to have *refined* the emerging, chauvinistic tradition, an attribute which in other circumstances could well have resulted in greater recognition:

> Mary Grant Bruce improved upon the bush legend of these early writers ('Banjo' Paterson and Henry Lawson) which was essentially masculine to create a second generation legend of her own. As well as such qualities of the bushman's character as endurance, resourcefulness and independence, and a suitable adaptation of his bronzed, lean, keen-eyed appearance, she extended the concept of mateship to women.
>
> The result was a modernised and domesticated version of the original which now became accessible to a new audience, providing it with appropriate symbols of identity. . . . Her most familiar hero and heroine are Jim and Norah Linton, but Mary Grant Bruce had begun work on her heroic archetype well before she created Billabong. An early example . . . is Meta Warden, in 'Bess', a story published in 1901. By the time it appeared for a British audience in her London *Daily Mail* articles, her legend was completely developed, with an environmental framework and a woman-centred ideology.
>
> (Prue McKay, 1986, p. 4)

As with so many of the women writers of the nineteenth century who have been 'left out' of the literary mainstream, it seems that Mary Grant Bruce's 'failure' was that of failing to have the same interests and priorities as men: when the tradition is defined as one which deals with the lives and loves of the dominant sex, then the subordinates can soon become its victims, as Virginia Woolf knew only too well.

This is not to assert that *all* Australian women writers have produced work infinitely superior to that of men (although such an assertion could be the beginning of compensation for the current deficiency theory that has been applied to women), but it is to assert that we cannot know what women have done and what their work is worth until we rescue them from the oblivion to which they have been consigned and re-examine their contributions with fresh eyes. Only then will it be possible to state without fear of contradiction that women have as rich and varied a tradition as that of men – and that labels such as 'children's fiction' have

been given to women as one way of reducing their claim to literary fame and recognition. Only when the reclamation work has been done will it be possible to authoritatively place other 'children's' writers, such as May Gibbs (1876–1969) who wrote the eminently successful 'Gum Nut' books (including *Snugglepot and Cuddlepie*, 1918), and Annie Rattray Rentoul (1846–1926) who wrote numerous stories and poems for children (*Mollie's Bunyip*, 1904 to *Australian Bush Songs*, 1937), which were often illustrated by her sister Ida Rentoul Outhwaite. One thing we cannot afford to do is to take at face value the dismissal of women writers – on any grounds. So systematic has their suppression been, that be they classified as minor on the basis of their 'lightness', their 'romantic tendencies', their journalistic proclivities or their 'kid's lit.' propensities, we must look below the surface rejection and assess the nature and value of the work that has been buried beneath, if the literary contributions of the fair sex are to enjoy a fair hearing and to play a part in the formation of women's literary traditions.

PART IV

•

Present Position

Mena Abdullah 1930–
Glenda Adams 1940–
Ethel Anderson 1883–1958
Jessica Anderson n.d.
Thea Astley 1925–
Elizabeth Backhouse 1917–
Faith Bandler 1918–
Marjorie Barnard 1897–1987
Jean Bedford 1946–
Stefanie Bennet 1945–
Winifred Birkett 1897–1966
Dora Birtles 1904–
Norma Bloom 1924–
Mona Brand 1915–
Anne Brennan n.d.
Jenny Boult 1951–
Mabel Brookes 1899–1975
Annie Brooksbank 1943–
Colleen Burke 1943–
Mena Calthorpe 1905–
Jean Campbell 1906–
Deirdre Cash, 'Crienne Rohan'
 1925–63
Nancy Cato 1917–
Dorothy Catts 1896–1961
Doreen Clark 1928–
Charmian Clift 1923–69
Jennifer Compton 1949–

Dorothy Cottrell 1902–57
Zora Cross 1890–1964
Dymphna Cusack 1902–80
Blanche D'Alpuget 1944–
Eleanor Dark 1901–85
Dulcie Deamer 1890–1972
Jean Devanny 1894–1962
Rosemary Dobson 1920–
Sara Dowe 1939–
Henrietta Drake-Brockman
 1901–68
Catherine Duncan 1915–
Elizabeth Durack 1915–
Mary Durack 1913–
Edith Mary England 1899–1979
Flora Eldershaw 1897–1956
Suzanne Falkiner 1952–
Beverley Farmer 1941–
Miles Franklin 1879–1954
Mary Gage 1940–
Nene Gare 1919–
Helen Garner 1942–
Catherine Gaskin 1929–
Mary Gilmore 1865–1962
Oriel Gray 1921–
Germaine Greer 1939–
Margaret Gregory, 'Velia Ercole'
 1910–

Kate Grenville 1950–
Helen Haenke 1916–78
Barbara Hanrahan 1939–
Lesbia Harford 1891–1927
Elizabeth Harrower 1928–
Alexandra Hasluck 1908–
Jill Hellyer 1925–
Dorothy Hewett 1923–
Ernestine Hill 1900–72
Helen Hodgman 1945–
Gwen Harwood 1920–
Florence James 1902–
Barbara Jefferis 1917–
Kate Jennings 1949–
Elizabeth Jolley 1923–
Doris Egerton Jones 1889–1973
Beverley Kingston 1941–
Gwen Kelly 1922–
Nancy Keesing 1923–
Valerie Kirwan 1943–
Eve Langley 1908–74
Joan Lindsay 1896–1984
Jennifer Maiden 1949–
Colleen McCullough 1937–
Nan McDonald 1921–74
Rhyll McMaster 1947–
Olga Masters 1919–86
Gwen Meredith 1907–
Cynthia Nolan 1917–
Nettie Palmer 1885–1964
Ruth Park 1923–
Barbara Pepworth 1955–
Grace Perry 1927–

Nancy Phelan 1913–
Katharine Susannah Prichard
 1883–1969
Therese Radic 1935–
Jennifer Rankin 1941–79
Henry Handel Richardson
 1870–1946
Elizabeth Riddell 1910–
Elizabeth Riley n.d.
Judith Rodriguez 1936–
Betty Roland 1903–
Alice Grant Rosman, 'Rosna'
 1887–1961
Mary Rose Alpers, 'Sarah
 Campion' 1906–
Georgiana Savage n.d.
Jocelynne Scutt 1948–
Helen Simpson 1897–1940
Christina Stead 1902–80
Barbara Stellmach 1930–
Patricia Stonehouse ('Lindsay
 Russell', 'Harlingham Quinn',
 E. Hardingham Quinn') n.d.
Catherine Shepherd 1912–76
Patsy Adam-Smith 1926–
Bobbi Sykes 1943–
Kylie Tennant 1912–1988
Glen Tomasetti 1929–
Margaret Trist 1914–
Kath Walker 1920–
Myrtle Rose White 1888–1961
Judith Wright 1915–
Fay Zwicky 1933–

CHAPTER 1

Nettie's network

Of that famous couple Jane and Thomas Carlyle, Virginia Woolf was supposed to have said that civilisation would have been better served had Thomas done the housework – and Jane done the writing.[120] Comparable caustic comments could also be made about a famous Australian literary couple, Nettie and Vance Palmer. For Nettie's literary skills, which were undeniably considerable, were also domestically constrained: when freedom from household chores permitted, her writing ability was generally put to use for the ready cash required to support the family – husband included. Which is one reason why after marriage Vance Palmer worked as a novelist while Nettie assumed the status of ex-poet and worked as wife, journalist and critic. As literary commentator Drusilla Modjeska wryly relates, 'Nettie's domestic labour and her financial contributions to the family freed Vance for long periods of productive if not remunerative writing' (1982, p. 97).

In contrast, Nettie's work had to be fitted in after her husband's needs had been met: like so many women writers she was constantly struggling to make the time to write artistically – as the following letter reveals:

In a few minutes I'll knock off to get lunch ready ... [Vance is] working now and I've just finished a sort of article between some bouts of housework. ... I want a bigger talent, and of course I want enough leisure to exploit the tiny talent I've got. Nothing short of jail could give me the leisure I'd need – a good stretch of solitary. Thank heavens Vance is working steadily and well.

(Nettie Palmer to Frank Wilmot, 2 February 1928, Wilmot Papers, Mitchell Library, MS 4/7/111)

So does Nettie Palmer sum up some of the conflicting demands that are made upon the woman writer, demands few women writers have ever been able to avoid and that most – from Mary Wollstonecraft (1792) to Tillie Olsen (1978), from Elizabeth Gaskell (1966) to Katharine Susannah Prichard and Miles Franklin – have persistently protested against.

In so far as Nettie Palmer was not free to follow her own literary inclinations and to develop her own talent as she saw fit, she deserves sympathy: but to the extent that she used her interrupted and often isolated existence to contact, counsel, critique and commend Australian women writers, her efforts warrant admiration and respect. While it may have been to her a substitute literary activity – a way of overcoming some of her own problems – the reality is that through her supportive letters to a whole range of women writers Nettie Palmer helped to create a women's literary community and ironically, in the end, it could be that her supposedly secondary contribution to the world of letters could prove to be of more significance and value than the 'primary' contribution of her husband.

Today, Australia can boast of a new generation of exciting – even exemplary – women writers. But they have not come from 'nowhere': the way had already been prepared. And the fertile soil from which these contemporary creative writers have grown was enriched by the efforts of Nettie Palmer. It was she who unceasingly advocated the worth of Australian literature. It was she who looked to the literary past and projected a positive future and who wrote about the vitality, value and validity of these contributions for the new nation: it was she who recognised the increasing importance of the novel – and who put the women novelists at the centre of her construction of the Australian literary tradition.

In a context in which there was little or no serious feedback for the Australian writer, Nettie Palmer was a courageous and constructive critic: with a relatively small national population and where the very few women writers were separated by distance as well as domestic duties, Nettie Palmer wrote countless letters, introducing one woman to another, and keeping all informed. Through her own efforts she forged a literary circle which extended around Australia and which contained many aspiring unknowns as well as such eminent members as Katharine Susannah Prichard, Jean Devanny, Marjorie Barnard, Flora Eldershaw, Eleanor Dark and Miles Franklin.

It is not possible to state definitively just how important Nettie Palmer's contribution was to the development of these outstanding writers, but it is possible to say that the work of these women represents one of the highpoints in Australian (and English language) literary achievements – and that they all acknowledged their debts to Nettie Palmer.

Partly because of the bias that has operated against the acceptance

and preservation of women's writing, the great achievements of the 1920s, 1930s – and 1940s – have been eclipsed. To go back now and review the nature and extent of women's literary contribution then (as Drusilla Modjeska has done in her excellent book, *Exiles at Home: Australian Women Writers 1925–1945*, 1981) is to be astonished at the richness of the legacy – that was not passed on.

The women writers of the period were innovative – they were political, they were feminists, and they were unapologetically Australian. They were experimental, they were exciting, they were successful. It is difficult now to realise just how 'advanced', how committed and creative they were: their existence challenges all the received wisdom about progress and enlightenment when we begin to appreciate that sixty years ago these women writers were tackling issues in a form that is equally relevant now. It is only because their presence in the literary tradition has been blurred – their efforts even buried – that we can be led to believe that the contemporary scene represents something 'new'.

These woman writers have 'said it all before': and if we had known what they had said we would have been in a better position when it came to what we wanted to say today. If, for example, we had known that those talented authors Katharine Susannah Prichard, Jean Devanny and Dymphna Cusack had been members of or sympathisers with the Communist Party and that in their fiction they had tried to reconcile the personal and the political – that they had tried to meld their 'femininity', their feminism, their politics and their art into a force for social change – then some of the current debates on the relationship between politics and art could have taken a very different form.

Had we known that those equally gifted writers Marjorie Barnard, Flora Eldershaw, Eleanor Dark – and Miles Franklin – were equally political, and concerned that their fiction should facilitate awareness and promote change – particularly in relation to the position of women – then much contemporary discussion about the relationship between feminism and class could have been conducted from a very different perspective.

And were English-speaking societies to know that during the 1930s there were first-rate Australian women writers who were exploring experience that was a product of their own context, but at the same time was of considerable cross-cultural interest, then the present image of Australia, of its people and its problems, would be immeasurably different.

It is no easy matter to bring home the reality of these women writers' great achievements, although Drusilla Modjeska tries to show the heights they did attain:

The 1930s were remarkable years in Australian cultural history.

Women were producing the best fiction of the period and they were
for the first and indeed only time,[121] a dominant influence in
Australian literature. Women had, of course, been writers of fiction
for the better part of a century. And they had been so against unequal
odds. They had written in spite of poor financial returns, the
demands of family responsibilities, a frequently depressed publishing
industry, their own low self-esteem and a view of Australian literature
that was predominantly masculine.

(Drusilla Modjeska, 1981, p. 1)

But by the 1930s women – *Australian* women writers – had come into
their own and were creating an exciting and impressive national literature.
As Drusilla Modjeska says –

despite the difficulties, the many anxieties, women were writing and
publishing in large numbers during the thirties and they were able
to give each other comfort and support. They were politically active,
they were often angry, and they made sure their presence was felt as
writers and as women. Their remarkable history and the broader
tradition that stretches beyond them has been undervalued and
obscured.

(Drusilla Modjeska, 1981, p. 1)

Few comparable examples of a circle of women writers occur in literary
history:[122] perhaps it was a consequence of Australian circumstances –
of distance, isolation and a newly emerging national culture – or perhaps
it was a product of Nettie Palmer's intervention, or a combination of
both. But no matter its origin, this formation of a women's literary
community (often sustained significantly only by correspondence) helps
to explain the cohesive nature of their contribution – and to repudiate
the myth that 'mateship' was the provence of Australian men.

All the women were aware of the hostility of many of the literary men.
One of the reasons they were so appreciative of Nettie Palmer's critical
work was that she shared their values (and their status) rather than
slighted their writing on the grounds of their sex. The literary partners
Marjorie Barnard and Flora Eldershaw (who as 'M. Barnard Eldershaw'
wrote literary criticism as well as fiction) wryly remarked on the bias
against writing women: 'There are, of course, people who say they do
not care for books by women and who elevate their prejudices into a
principle . . .' (1938, p. 1). But because they were a community, because
they could provide constructive criticism, encouragement and comfort
for one another, the Australian women writers of the 1930s were in a
strong position to resist some of the prejudicial practices of influential
literary men. Not that the women ever underestimated what they were

up against. 'M. Barnard Eldershaw' was of the opinion that women writers had taken men by surprise, that 'women had won their spurs before anyone thought of telling them they were incapable of doing so' (1938, p. 1): once women had claimed a literary place, a backlash was fully expected.

The only defence against discrimination and the double standard that was used against women in the literary professions – at least as far as 'M. Barnard Eldershaw' was concerned – was logic and cool, calm, reason. *Essays in Australian Fiction* (1938, p. 1970) begins and ends with an analysis of the position of writing women:

> A great many silly women have written a great many silly novels – and a great many silly men have too. But the scores are kept differently. Out of chivalry perhaps an individual woman's failures are charged not against herself but against her sex. She is a bad novelist because she is a woman. A man's failures he must bear himself. A woman in the world is a sort of collective noun; a man remains an individual . . .
>
> (M. Barnard Eldershaw, 1938, pp. 1–2)

In this context it becomes clear why the women writers welcomed women critics who could dispense with the customary devaluation of women. It was good to be judged by one's peers – better if their views carried weight: and from the publication in 1924 of her award winning *Modern Australian Literature 1900–1923*, Nettie Palmer earned for herself a respected place in Australian literary criticism. While she used her position to advance the cause of Australian writers in general she also used it to particularly promote women.

That she was able to sustain a circle of women writers for virtually thirty years says much about the diplomacy and tact of Nettie Palmer. For criticism is a risky business where even the most sane and stalwart authors are liable to take exception, and the dangers of division were even greater in a small community where there was little or no anonymity. But Nettie Palmer walked the tightrope and was able to give honest commentary without allowing the women writers to experience feelings of rejection.

Of course, not all the women who wrote were full members of the Nettie Palmer network: Mary Gilmore (1865–1962), the 'grand dame' of Australian letters was not only outside Nettie's realm of patronage but twenty years older, and at the centre of a circle of aspiring writers who looked to her for advice and encouragement in their work. But if the two women each resourced their own circles they none the less corresponded frequently, respected each other, and invariably overlooked some of the differences in judgment that could have served to divide them. On the

surface they had much in common. They were both writers, both ardent supporters of women's writing and committed campaigners for the acceptance of Australian literature: they were both feminists and both concerned to see significant social change at a local as well as an international level. Yet despite these similarities they moved in somewhat different directions and encouraged different writers to different ends.

Mary Gilmore had no great start in life. At the age of twelve she was an assistant teacher and she served her apprenticeship in a variety of small mining towns. Familiar with poverty, pain, hardship – and exploitation – Mary Gilmore early determined that there should be a better and more just world. To this end she supported the great labour strikes in Australia in the 1890s and then – in 1896 – she set off for Paraguay to join William Lane, the founder of a socialist Utopian venture there. While living in this 'new world' Mary Gilmore married, and although there is probably no connection her personal circumstances, along with those of the colony, deteriorated markedly after this event. By 1902 the Utopian experiment had failed and Mary Gilmore returned to Australia where her conditions were little less impoverished.

Living a primitive existence out in the bush – and concerned that her child should not be neglected by her involvement in writing – Mary Gilmore was able to contribute the occasional poem and article to the *Bulletin* and the *Worker* during this period. Then in 1908 she began to edit the 'Woman's Page' of the *Worker*, and she continued with this commitment for twenty-three years.

Mary Gilmore was a sharp and uncompromising writer (and reformer) and through the pages of the *Worker* she conducted campaigns which influenced thousands of Australian women. She took up the plight of the Aborigines, she called for improved conditions for workers, she lobbied for health and social reforms – and she demanded justice for women. Mary Gilmore became a political force to be reckoned with – as well as a poet to be praised: from 1912 she published six volumes of verse (*Marri'd and Other Verses*, 1912; *The Passionate Heart*, 1918; *The Tilted Cart*, 1925; *The Wild Swan*, 1930; *Under the Wilgas*, 1932; *Battlefields*, 1939).

Mary Gilmore also 'led the way' with a broad feminist vision which would not confine women's politics to a narrow band of supposedly 'women's issues'. For Mary Gilmore, women's legitimate interests were those of the wide world: it was her creed that whenever injustice was to be found, there was work to be done by feminists. While this particular contribution of hers may have earned her the gratitude of later feminists it was probably not this strand of her politics that was responsible for her award of Dame of the British Empire in 1937. But it was probably why Nettie Palmer revealed understanding and warmth when required to deal with some of Dame Mary's 'eccentricities'.

Their letters to each other are lively accounts of the literary scene: they each discuss their deliberations, their 'discoveries', and their disagreements. There was a parting of the ways over one author whom Mary Gilmore championed: Drusilla Modjeska explains their differences over Dorothy Cottrell (1902–1957) –

> Nettie Palmer was sceptical of Mary Gilmore's protegies and never took any of them up. She criticised Dorothy Cottrell, one of the few who published successfully, because she considered her to be a commercial writer for the American market. What annoyed her was that she felt Dorothy Cottrell had the ability and the experience to write serious Australian literature.
>
> (Drusilla Modjeska, 1981, p. 96)

In this instance, I think Nettie was a bit tough on Dorothy, a polio victim who showed the most impressive courage and ingenuity (and who was years ahead of her time in writing convincingly about treating the disabled as full human beings). Dorothy Cottrell was able to make a living out of her writing in America in a way that would not have been possible had she stayed 'at home'.[123] *The Singing Gold* (Boston, 1928; London, 1929), *Earth Battle* (1930) and *The Silent Reefs* (1953) were among her publications, along with her 'bread and butter' short stories that were regularly published in the *Saturday Evening Post*.[124]

The biggest difference of opinion that Nettie Palmer and Mary Gilmore appear to have had was over Katharine Susannah Prichard's novel *Coonardoo* (1929). Because Mary Gilmore was such a staunch supporter of Aboriginal rights (and Nettie Palmer was a party-political and sexual 'moderate') it could have been assumed that Mary Gilmore would have endorsed this courageous novel in which Katharine Susannah Prichard exposes the white man's exploitation of the black woman: yet this was not so. *Coonardoo* was the novel that was praised by Nettie Palmer and condemned by Mary Gilmore, as the following letter reveals:

> What an appalling thing *Coonardoo* is. It is not merely a journalistic description of station life, it is vulgar and dirty. It has been a great blow to me as I thought it began so well. I am told A(ngus) and R(obertson) having read it said not if they were paid £10,000 would they have the name of publishing it. And I have not heard one solitary person, man or woman, speak well of it. It has disgusted everyone.
>
> (Mary Gilmore to Nettie Palmer, 18 December 1928: Palmer Papers, National Library of Australia, MS 1174/1/3274–5)

Coonardo has gone on to be one of the classics of Australian literature:

it is even one of the few novels by an Australian woman writer to have found its way into the local school curriculum. While some of the politics that permeate it could now be considered slightly dated it was a ground-breaking novel in its time: because of its portrayal of the plight of the black woman the book even now deserves international recognition. Were *Coonardoo* – and other novels of Katharine Susannah Prichard – to be more widely known they would alter dramatically the prevailing perceptions of Australia and its people.

Nettie Palmer was quick to recognise the talent and toughness of Katharine Susannah Prichard: and she was slow to take offence with Mary Gilmore. Instead she showed her tolerance, tact – and respect – for the contribution that the older woman had made to the development of Australian literature.

Nettie Palmer displayed some of these same strengths when it came to her relationship with that other grand dame of Australian letters, Henry Handel Richardson (1870–1946). One of Nettie's first contacts when she began to weave her correspondence web was Henry Handel Richardson – whom Nettie championed from the outset: her admiration for Henry Handel Richardson's work culminated in her publication *Henry Handel Richardson: A study* in 1950.

Even if a life of literary journalism had never been her intention, Nettie Palmer was well prepared for her profession. A graduate of Melbourne University in 1909, Nettie set sail for England as soon as her degree was finished. Her ambition was to further her study of languages and she spent three years absorbing the culture and literature of Europe. In 1911 she returned to Australia, completed a Masters Degree at Melbourne University: then it was marriage to Vance Palmer, back to Europe, and the beginning of her career in literary journalism.

But it was not just in the home that Nettie Palmer found that it was a man's needs determining the agenda. When she returned to Australia she soon realised that the literary 'establishment' was comprised exclusively of men who set the agenda without regard to women. The influential circle in the 1920s was in Sydney: it centred on Norman and Jack Lindsay and there was no room for women within its confines. The misogyny – and myopia – of these bohemian men who saw women solely in terms of their sexual availability was anathema to Nettie Palmer who turned her attention to forging a community in which the creative contri-butions of women would be treated seriously.

In embarking on this course Nettie Palmer fared better than another aspiring writer, Anne Brennan (daughter of that man of letters, Chris-topher Brennan). Anne tried to find a place within the acclaimed artistic circle but despite her obvious talent was treated not as writer, but as whore. Drusilla Modjeska tells the tale of Anne Brennan's isolation, alienation, exploitation – and despair – and provides another chapter in

women's literary history on the price that women have paid for wanting to be writers.[125]

Because she didn't write fiction – and because she had no desire to join the ranks of those men whose values she despised – Nettie Palmer's independent and challenging position did not draw direct fire. But she knew those whose work did. And she was constantly trying to contend with discrimination and ignorance in relation to women's writing, even among the literary men with whom she felt some affinity. This was certainly the case with Henry Handel Richardson, whom Nettie Palmer thought was being wilfully neglected in her own land. She comments on this in her journal on 3 March 1928:

> I remember some time ago, Louis Esson said to me dogmatically and not troubling about the evidence, that the next ten years would see a great development in our writing, especially in the novel. He had no inkling of Henry Handel Richardson who was there and fully grown at the time.
>
> (Nettie Palmer, 1948, p. 31)

Henry Handel Richardson is an Australian writer with an international reputation although whether – as I suspect is also the case with Christina Stead – this is primarily because she chose to lead her literary life outside Australia, or whether it is a testimony to the quality of her work, I cannot tell. For while I would never want to detract from the contribution that Henry Handel Richardson has made, I do not think that her work is demonstrably superior to that of other Australian writers (such as Katharine Susannah Prichard and Eleanor Dark), who stayed at home.

Like Nettie Palmer, I do recognise the novelty (and the status) of Henry Handel Richardson's remarkable achievement. When in her writing she inextricably linked material circumstances with psychological states, when for example she synthesised the Australian landscape with one man's decline, as she did in *The Fortunes of Richard Mahony*, she gave the novel new dimensions. She set the scene for the social realists – in Australia, Katharine Susannah Prichard, Jean Devanny, Kylie Tennant – who followed.

It was Nettie Palmer's belief that the way in which Henry Handel Richardson linked personality and setting had changed the direction of the novel: she believed that the way in which Henry Handel Richardson had successfully mapped the emotional state of an individual had set new standards of character delineation. I think Nettie Palmer was right. However, it was not just what she wrote that was remarkable: it was how Henry Handel Richardson wrote which also caused comment. She worked on *The Fortunes of Richard Mahony* for twenty years.

In 1888 Ethel Florence Lindesay Richardson left Australia to pursue

her musical studies at the Conservatorium of Leipzig. Soon she was completely immersed in European culture, and finding the study of languages and literature more congenial, the study of music was discontinued. Then she met the scholar J. G. Robertson, whom she married; thereafter she led a solitary and reflective life which she found conducive to the development of her literary craft.

There is a significant autobiographical element in Henry Handel Richardson's fiction. Her first novel, *Maurice Guest* (1908), had its origins in some of her experiences at Leipzig, while her second, *The Getting of Wisdom* (1910), was based upon her familiarity with an Australian girls' boarding school. Then came the trilogy known as *The Fortunes of Richard Mahony: Australia Felix* published in 1917, *The Way Home* in 1925 and *Ultima Thule* in 1929. The mental breakdown of her own father suggested the shape of this psychological epic.

In so far as it is characteristic of Henry Handel Richardson to explore the nature of relationships, the nuances of inner life, and the multiple realms of meaning within a family circle, her fiction stands firmly within the framework of women's literary traditions. In the Australian context there is a direct link between *The Fortunes of Richard Mahony* and Eleanor Dark's 'novel of consciousness', *Return to Coolami* (1936), in which Bret Maclean achieves a state of emotional awareness.

Nettie Palmer needed no spur to sing Henry Handel Richardson's praise: she gave her pride of place as a woman and a writer in the formation of the Australian tradition. But she also tried to account for Henry Handel Richardson's achievement: she compared their contrasting life styles without venting her frustration – or bitterness – on the circumstances that constrained her own output. Her journal contains the following entry for 19 December 1938:

But what makes up the special nature of this writer, HHR?

First of all, concentration: her life planned to fertilize those hours of creative work. But concentration to what end? Economically free, she had never thought of writing for money, never been tempted to please a publisher by writing a novel for the new season. Her impulse to create has all along come from a passionate interest in human relationships and character; perhaps a life long absorption in a few figures that have touched her feeling and imagination. Her need for human contacts is mainly satisfied by the people in the world she builds up. She seems to have few close friends, and has no love at all for large groups.

To write is her joy. Suggest to her that a writer's life is a hard one, an agonising struggle with intractable material and she will deny it. 'But I love every moment at my desk. How else could I have

kept on writing all these years, getting nothing for it but starvation fees and obscurity?'

Success, immediate and retrospective, came, ironically, with 'Ultima Thule,' her most intransigent book (one that had to be published privately). It might never have come in her life time. She would have kept on without it. She is a writer.

(Nettie Palmer, 1948, p. 194)

Between 1925 and 1939 Nettie Palmer moved between Australia and Britain (and around Australia in the attempt to find a place where the family could live cheaply – and Vance could write). During this period she kept a journal,[126] which provides a lively and fascinating literary commentary (and occasionally gossip) as well as insights about the author and the development of her own judgment and diplomacy. As Nettie Palmer documents her days – as she outlines some of her difficulties with the domestic demands, the rent, and the fragmented and often isolated nature of her life – she adds to our store of understandings about the everyday reality of a writing woman: as she lists what has been published, what she has read and reviewed, and who she has been supporting, encouraging, reassuring, she adds to our understandings about the growth and development of Australian literature. From her journal we can see how the bricks and mortar of Australian fiction are being shaped and set. From her wide and well-informed perspective we learn about her disagreement with Rebecca West over the worth of Henry Handel Richardson (p. 89), about her talks with Vera Brittain on writing and feminism (p. 195), and about her encounter with F. R. Leavis and his brilliant and hardworking wife Queenie (p. 205).

I have often wondered how much irony was intended when Nettie Palmer described her meeting with Queenie and F. R. Leavis. Commenting on the fact that his university appointment had not been renewed Nettie Palmer states – seemingly innocently – 'Yet he publishes *Scrutiny*, which is eagerly read by his old students all over the world. . . . As for his wife, she wrote her brilliant searching book "Fiction and the Reading Public" as a thesis years ago, but has not had leisure to do anything else except articles for *Scrutiny*.' Her 'faint praise' continues to damn the great critic:

Dr L. has fluency and pungency in talk, though he finds writing a slow, difficult matter. 'My wife's the making of *Scrutiny* you know. She's a born journalist, and comes to the rescue, especially when a promised article fails to turn up at the last moment. Incredible to me how she can write straight off like that. With me, writing's a long struggle. . . . But I'm so tired. I'm undertaking too much. Even

now I can't speak as I should because I've got my eyes on that boy
over there. There's no need as his mother's here and at leisure.'

(Nettie Palmer, 1948, pp. 205–6)

The parallels between the Palmer and the Leavis establishment are
obvious: I think Nettie Palmer was too careful a writer not to have
realised how her words would mock such an eminent man. And I suspect
that this is another example of the way in which women who are ostensibly
writing for a mixed audience manage to convey a more meaningful
message to members of their own sex.

Nettie Palmer provides a survey of the developments in Australian
literature over a period of forty years. Her journal picks up where her
book – *Modern Australian Literature 1900–1923* – leaves off. And some
of the women she focuses on as promising writers in her early critical
work have become fully-fledged witers – and often friends – in the years
of the journal. Not surprisingly, Nettie Palmer identified with them: not
surprisingly, she consistently championed and defended them.

It would be almost impossible to overestimate the extent to which
women were then (and some would say are still) devalued and disqualified
within the literary male-stream. Probably one of the most telling examples
of the problem that women had to contend with is provided by Nettie
Palmer's husband, Vance, who was clearly an expert in the daily business
of denial and disparagement. In 1926 he wrote an article 'Women and
the Novel' (*Bulletin*, 29 July, p. 3), in which he stated – in all seriousness
– that 'writing a novel seems as easy to almost any literate woman as
making a dress'!

For Vance Palmer, as for F. R. Leavis, writing was of course an
ennobling struggle: it was a creative endeavour of the highest order and
one which women could not be expected ordinarily to experience – or
comprehend. According to such distorted and discriminatory criteria if
by any chance women did produce good work then not only was the
process effortless but the results were not intended: the pronouncements
of many men of letters (Australian and otherwise) are replete with
assumptions that the achievements of women are accidental. So even
when the writing of women is deemed to have merit, the creative and
intellectual qualities of the authors can still be devalued. For as Vance
Palmer said – and as 'M. Barnard Eldershaw' observed – even when
women write good novels, the score is kept differently so that women's
achievements don't really count. And in Australian literary history, the
score has been kept differently throughout the twentieth century, as
Nettie Palmer was well aware. When she began to assess the emerging
trends and traditions from 1900 she came to realise that the mainly male
'gate-keepers' of the literary tradition would not allow entry to women

who challenged their central view of themselves and the significance of their work. Even a poet like Zora Cross (1890–1964), whose work presented an image of the passionate/sexual woman, was mocked by the men who saw their myths of mastery and mateship as paramount.[127]

In her private and public writing Nettie Palmer reflected on the relative literary status and style of the sexes and set out some of the pretexts that men – such as Jack Lindsay – used to discredit the work of women. Again and again she showed how male editors/publishers/critics and teachers used a male standard to judge women and measure their deficiencies. And nowhere was this distortion more evident than in the case of the short story.

Anyone who has had any acquaintance with the established tradition of Australian literature would have been informed that the foundation stones of this national heritage were laid during the 1890s by a group of men who wrote colourful and patriotic stories of mateship in the bush – primarily for the publication the *Bulletin*. But when Nettie Palmer began to analyse the basis of this claim for male fame she found that there was little evidence to support it. Writing in her diary on 9 February 1927, she commented on the unjustified pre-eminence of men within the literary tradition:

> Lately the idea of editing an Australian Storybook has set me reading the short stories of the 'nineties. Not that I intend to use any of them. . . . It certainly hasn't been a voyage of exciting discoveries. Who invented the legend that a band of brilliant short story writers existed in the 'nineties, and that in examining the early files of the *Bulletin* one would stumble upon masterpieces? There wasn't much basis for it.
>
> (Nettie Palmer, 1948, p. 22)

Apart from the short stories of Henry Lawson, Nettie Palmer was unable to find these gifted male writers who were supposed to have set Australian literature on its characteristic, commendable and anticolonial course. In contrast, she could find women short story writers who deserved a place in the canon but whose contributions had been ignored. She was quick to commend the harsh and relentless irony, the 'cold objectivity' of Barbara Baynton (1948, p. 47), and to praise the superb efforts of Katharine Susannah Prichard.

'The Cooboo' was one short story which Nettie Palmer believed placed Katharine Susannah Prichard in a class all of her own, and which earned for women the reputation of brilliant writers of short Australian fiction. It is a moving story of an Aboriginal stock woman who is out all day with her baby bound to her breast: the burden wearies her, restricts her riding, and causes her to be criticised – with chilling consequences.

Commenting on the same short story, Henrietta Drake-Brockman (1967) said that it 'tragically and bitterly emphasises the great feminist dilemma' (p. 21), and Nettie Palmer was no less impressed when she compared it with the male achievements of the nineteenth century:

> there is a greater mastery in Katharine Prichard's story, The Cooboo, published recently in the *Bulletin* than in the lot of them. What a world of tragedy and strange beauty she has compressed into a couple of thousand words! It is a marvel of economy as well as of feeling – so little stated directly, so much implied.

> (Nettie Palmer, 1948, p. 23)

Such praise for subtlety could not be handed out to the men who have been given the credit for creating the Australian tradition. Yet Katharine Susannah Prichard wrote short stories about Australia, in a manner that was remarkable – but she has never received due recognition. As Nettie Palmer has pointed out, this was because Katharine Susannah Prichard wrote about women – about women's view of the bush and work, about its harshness and brutality. And because they could not fit into the mould of men, Katharine Susannah Prichard and Barbara Baynton have been accorded no secure or ready place in the Australian tradition.

Nor has a place been accorded to Ethel Anderson (1883–1958), another short story writer who was drawn into Nettie Palmer's literary circle. Born in England, but of Australian parents, Ethel Anderson later lived in India with her officer husband and then in Australia where he served in the household of the Governor-General. She wrote two volumes of poetry, two volumes of essays and three of short stories, including *At Parramatta* (1956), which Nettie Palmer believed to be among the best in Australian fiction.

Yet all Nettie Palmer's correspondence, criticism, and championing of women has done little to challenge the legend that it was men who were the good short-story writers and who were the founders of the great Australian literary tradition. Were this legend to be laid to rest a very different cultural heritage with a very different emphasis would soon appear: it would be a heritage in which women held a central place and in which there was a radical shift in world view.

It would also be a heritage in which Katharine Susannah Prichard was undeniably one of the 'greats'. Katharine Susannah Prichard (1883–1969) is one of the best political writers in the English language: that she has not taken her place within the English tradition is no doubt because of the reservations that are held about mixing politics and art – and making propaganda – within some esoteric literary circles. It is also because she is a woman and, unlike Christina Stead who does enjoy an

international reputation, Katharine Susannah Prichard was an Australian who stayed at home.

The fact that she does not have a prominent place in the canon of English literature is not altogether surprising, given that she is not even accorded her full share of recognition in her native land. It is still regrettable, however, that John Steinbeck and Ernest Hemingway, political writers of much the same period, should have been able to cross the cultural divides while the women who have had comparable political purposes (and some would say executed with incomparable skill) should have had such entry denied.[128] The English tradition would be richer were it to include a greater range of resources and encompass the socialist/feminist perspectives of such good writers as Katharine Susannah Prichard and Tillie Olsen for example.

Katharine Susannah Prichard was born into a family with a literary/journalist background: her father was an editor and the author of one novel (*Retaliation*) and the daughter took up her pen at a very early age. Because of the financial difficulties of her parents she was prevented from obtaining a university education but – like the majority of women writers – she was an avid reader, another literary woman who was basically self-taught.

Along with her early literary interests went her burning political passion: Katharine Susannah Prichard always wanted to change the world. When she arrived in England in 1908 she quickly made the acquaintance of the Women's Social and Political Union which, in its attempts to improve the political position of women, was pursuing a campaign of 'civil disobedience' against the government.

To support herself, Katharine Susannah Prichard worked first as a governess, and then as a journalist (in Australia and England), but after a stint on the fashion pages she decided to abandon her journalism because she found it sapped her energy for her creative writing. She determined to earn her living by writing fiction and in 1915 she had her first taste of success when her novel *The Pioneers* won the Hodder and Stoughton Prize.

She returned to Australia, committed to continuing her writing and then in 1919 – and not without grave doubts – she married 'Jim' Throssell and moved to his home in Western Australia. Some of the significant events which mark this period of her life were her disillusionment with the Labour Party and its discriminatory practices towards women – and her decision to join the Communist movement. She never apologised for this commitment.

But in reading through the biographies and commentaries on Katharine Susannah Prichard it is interesting to note that among those who have tried to present her positively are some who have glossed over her political affinities and focused on her 'femininity'. Katharine

Susannah Prichard was a strong woman, a tough writer who, despite 'interruptions', was dedicated to her work. She invested in her fiction all her hopes, fears – and creeds – for radical social change, yet in their attempt to make her more acceptable some critics have concentrated on her domestic pliability rather than this uncompromising political stance. Whether this is because they believe a 'feminine' woman would realise a better reputation, or whether they simply do not know how to deal with her politics in a palatable manner, it is difficult to tell: but either way their efforts to minimise the politics and maximise the womanliness have proved to be counterproductive.

Of course, Katharine Susannah Prichard was a woman caught up in many of the conflicting demands that confront all women. With a husband and a son, a farm and no 'modern conveniences' she led a domestic life that was undoubtedly arduous. And like so many other women writers – Tillie Olsen among them – Katharine Susannah Prichard wanted to meet the needs of her family as well as to continue with her writing. Which is one of the reasons she wrote what she did and why Henry Handel Richardson wrote very differently. Of Katharine Susannah Prichard, Henrietta Drake-Brockman said that:

> When she began seriously to apply herself to *Working Bullocks*, she remained like every other Australian woman writer, involved in domesticity. While in England, Henry Handel Richardson, childless, advanced towards *Ultima Thule* behind baize doors attended by husband, housekeeper and secretary, Katharine Susannah Prichard laboured with the chores and, whenever she could, wrote at a desk on a creeper enclosed veranda open to access.

> (Henrietta Drake-Brockman, 1967, p. 22)

But if there were personal and political differences between these two great Australian women writers, there were also areas where they revealed remarkable similarities. In their art, both were concerned to integrate character with setting, to show how the Australian landscape leavened the life of the individual. And in their ways, both were relentlessly honest in their appraisals: there is not much froth or fancy in the fiction of Henry Handel Richardson or Katharine Susannah Prichard.

Domestic work, however, was not the demand that Katharine Susannah Prichard found most harrowing: nor was the poverty – though she spent her entire life struggling to make ends meet. More difficult to deal with in her daily life was the fact that her literary/political identity was rarely appreciated or understood: she had a husband who could not comprehend her need to write.

Visiting Katharine Susannah Prichard in 1930, Vance Palmer wrote

to Nettie about Katharine's working conditions. Without conscious irony he reveals his appreciation of Katharine's difficulties as a writer, and remains completely oblivious to the fact that an independent observer could make the same comments about *his* wife:

> I can see that Kathie must find it terribly hard to write there, though she has a bit of a maid and a woman to do the washing. Jim's considerate of her in obvious ways. He's building a place for her to write in, a little apart from the house, with a window overlooking a beautiful view: but there is something in his attitude to her writing that isn't quite happy. He's proud of it, but he's afraid of letting it 'worry' her – as though it should just flow out of her at odd hours. Yet they get along well enough underneath and are awfully nice to one another. Kathie's position is pretty hard. In a way Perth is much more unsophisticated than Brisbane and she's taken more seriously as Jimmy's wife than as a writer.

(Vance Palmer to Nettie Palmer, n.d. c. May 1930: Palmer Papers, National Library of Australia, MS 1174/1/3554–6)

One reason why Vance Palmer was able to see Katharine Susannah Prichard's predicament was because he identified with her as a writer: they were *both* writers from his point of view. For Nettie, the fact that her husband did not see her in this role – that he considered her a support for his own writing rather than a writer in her own right – must have been a bitter pill to swallow. It says much for her that despite such provocation she persisted with her support of Vance – much to the chagrin of writers like Miles Franklin and Jean Devanny, who thought that she was putting her energy into an inferior talent at the expense of her own.

But of course Nettie Palmer also supported the work of Katharine Susannah Prichard: she unstintingly gave her private reassurance and public praise. And this is a measure of the extent to which women writers were able to incorporate their political differences into their working community. There was an enormous discrepancy between the views and values of Katharine Susannah Prichard and Nettie Palmer – and the more conservatively minded Henrietta Drake-Brockman as well – but they were able to circumvent divisions and to provide each other with counsel, encouragement, and warmth. Though whether Katharine Susannah Prichard actually empathised with the working conditions – and family trials – of Nettie Palmer, is quite another matter.

Nettie Palmer did her utmost to advance the reputation of Katharine Susannah Prichard, for whom she had the greatest admiration. With enthusiasm she greeted the publication of *Black Opal* (1921), *Working*

Bullocks (1926) and *Coonardoo* (1929), and she wrote constructively and generously about this young woman writer who revealed such extraordinary skill in dealing with dual realities – in weaving together the personal and the political, and the world views of women and men.

Katharine Susannah Prichard was sensitive to the masculist tone of Australian literature: she was aware of the male monopoly on the 'bush' and 'bonding' in the struggle to work and survive. To her, such a reality was a gross distortion which was damaging to the land, and to human lives. She wanted to break with such narrow and negative notions of existence: she wanted to bring new vigour and values to the local literary tradition. It was her intention in her fiction to include autonomous women and men, who were products of their unique environment and who worked *together*, but not without conflict or change. Commenting on her purposes, Katharine Susannah Prichard wrote of her characters Red and Deb in *Working Bullocks* that:

> I could not be satisfied with a Red version of the Karri. I had to have the Deb outlook as well – indeed don't ever want to get behind a definitely male consciousness or subconsciousness, but to see the thing from my own, or objectively. I mean that I can't endure to stalk a man, as it were, behind a female signature.

> (Quoted in Ric Throssell, 1982, p. 46)

Katharine Susannah Prichard did not claim to be a feminist: this was partly because she went along with the conventions of the Communist Party that such commitment was diversionary and divisive. But no matter what she called herself, there is no concealing her belief in the desirability (and necessity) of independent women and her relentless presentation of the challenging 'woman's view'. Her novel, *Intimate Strangers* (1937), contains a veritable gallery of women, and exposes women's consciousness across a range of experiences: with its treatment of every issue from whether to marry (or get a divorce), whether to have children (or an abortion), whether to love (or to be independent), it stands among the great feminist novels in the English literary tradition. Except perhaps for the ending.

Intimate Strangers was not more than half finished when in 1933 Katharine Susannah Prichard left Perth for Europe – including Russia. In the draft of the novel, the husband (Greg), unable to live with all his apparent failures, committed suicide. To Katharine Susannah Prichard, suicide was an exceedingly disturbing event: she had early had an admirer who took poison when rejected, and later a lover who threatened to kill himself if she left him. Then her father committed suicide and understandably she found the idea – as well as the reality of suicide –

deeply distressing. And she left her 'hero', Greg, having committed suicide when she set off on her tour.

Jim Throssell, her husband, who had not enjoyed financial success in his life, took yet another gamble while his wife was abroad. It failed. He committed suicide. Katharine Susannah Prichard read of his death in a newspaper, while staying in a London hotel. She later confided in her son that she always feared that her husband had read the draft of *Intimate Strangers*, that he had seen his own marriage in the marital difficulties of the fictional couple, Elodie and Greg – and that he had followed the path that Katharine Susannah Prichard, the author, had prescribed. She changed the ending of *Intimate Strangers*: when published, Greg did not commit suicide.

The death of her husband was not the only change that took place in her life in 1933. This was the year that Katharine Susannah Prichard visited Russia and stayed with fellow Australian writer Betty Roland (1903–) and the lover with whom she had eloped – Guido Baracchi. And while this was the occasion on which Katharine Susannah Prichard wholeheartedly embraced the doctrine of social realism in art, it was unlikely that Betty Roland was her source of information, as Drusilla Modjeska (1981) has pointed out. The author of novels, plays, and the later diary *Caviar for Breakfast* (1979), Betty Roland's emphasis appears to have been more upon the personal than the party political (see Drusilla Modjeska, 1981, pp. 142–7, for further discussion).

On her return to Australia, Katharine Susannah Prichard became more committed to her political purposes – and more confident – in her fiction. She embarked upon her trilogy *The Roaring Nineties* (1946), *Golden Miles* (1948) and *Winged Seeds* (1950), which again reveal her impressive ability to blend the reality of the state with that of the individual and to explore the significance of work – particularly manual work – in life. With its combination of the family saga (presented through the eyes of the marvellous Sally Gough) and working conditions on the goldfields, the trilogy is a powerful and perceptive documentary on Australian political history. It provided me with one of the most illuminating experiences I have had in my life. Unfortunately the same cannot be said for some influential male critics.

When I now look over some of the criticisms that Katharine Susannah Prichard received, I am reminded of the reception that was given to that earlier writer of social realism, Elizabeth Gaskell (1810–65). She too wrote political fiction – novels about the exploitation of workers in factory life, about the women (who carried a double burden) as well as the men. But if and when Elizabeth Gaskell's politics were mentioned, reviewers revealed themselves to be more than ready to point to the error of the *lady's* ways. Once it was realised that the author of the novel on working-class life – *Mary Barton* (1848) – had been written by a woman, the early

praise that the work had enjoyed gave way to patronising pronouncements on the author's misguided intentions. She was admonished to stay away from politics and to confine herself instead to the more appropriate areas of 'personal feelings' and 'family life'.[129]

It was as if the critics could not cope with the political dimensions of this *lady* writer: as if they could not come to terms with her astute – and austere – political analysis. And unable to evaluate the significance of the political scene described by a woman, the critics concentrated on the 'manners', as they manifested themselves in the novel: this was a much more suitable context in which to discuss a lady's offerings.

A similar summary could be provided on the response that Katharine Susannah Prichard has received. On the publication of her trilogy, the critic on the *Manchester Guardian* commented that it was 'better on the human side. The actual writing rather undistinguished, but the people very much alive' (see Rick Throssell, 1982, p. 143). And the *Bulletin* achieved new intellectual heights with its rigorous analysis and considered verdict that the work was 'principally a large heap of words' (Rick Throssell, 1982, p. 143). Then too there was that young critic, Gerald Wilkes, now a distinguished professor in a department that continues to devalue and denigrate the work of women – who revealed the nature of his own scholarly judgment when he pronounced the trilogy to be 'a monument of lost opportunities', and substantiated this assertion with the reasoned and balanced statement that – in relation to the characters, for example – the author 'has not displayed them, she has displayed her admiration instead' (G. A. Wilkes, 1953, p. 166).

Contrast this with the constructive criticism of Nettie Palmer: in a context in which it was difficult for Australian writers, where it was even more difficult for the Australian woman writer – and extraordinarily difficult for the Australian woman political writer – there was no point in the women looking to Gerald A. Wilkes for support. There is something rather disturbing in seeing an aspiring critic embarking on a course to enhance his own reputation at the expense of the creative writer. It is possible for the unaccountable critic to discredit in a few lines the dedicated efforts of a creative lifetime.

Katharine Susannah Prichard's son said that his mother was 'hurt and discouraged by Wilkes' view of her work'. Displaying defiance in public she was none the less distressed in private and wrote that 'The debunking of KS seems to be a favourite pastime of Sydney University' (Rick Throssell, 1982, p. 166). She could have gone further and generalised from her own experience, for in the short history of the relationship between women writers and the academy in Australia, Katharine Susannah Prichard was by no means the only woman to find that her writing was devalued – and dismissed. In the same institution that Katharine Susannah Prichard called into question, such 'exclusive' prac-

tices still persist. In 1987 there was not one woman included for study in the course on twentieth-century English writers. Understandably, contemporary women writers are no less hurt and discouraged by this devaluation than was their gifted predecessor, Katharine Susannah Prichard.

Of course, things might have been different had Nettie Palmer still been berating the establishment for blatantly biased behaviour. Always ready to champion the cause of Australian writers, and women writers, who were not getting a fair deal, she was not averse to publicly challenging – and condemning – the personal prejudices of professors and the implications of their influence in the literary/academic world. Drusilla Modjeska outlines one occasion on which Nettie Palmer took to task a reactionary academic:

> In 1929 she took on the new Professor of English at Melbourne University, G. N. Cowling, for his cringing remarks that Australian literature was as yet underdeveloped and too thin to constitute a literary tradition or to merit inclusion in writing courses.

> (Drusilla Modjeska, 1981, p. 54)

There is a long tradition of professors pronouncing that the work of those who do not conform to their own image is not up to standard: while professors have been predominantly white, male, and 'Anglo' this has meant that the work of blacks, women, and ethnic groups including 'Australian', has often been categorised as thin, underdeveloped, and unable to match the preferences of the academic community. So the white, male, literary establishment continues to classify as 'good', and 'worthy of preservation and transmission', the writing which reflects their own views, values – and image. Because the men who do the selecting, who serve as gatekeepers, find their own experience and expression inherently more interesting, their preferences and prejudices become encoded as the canon, and form the limits of literary reality for the next generation.

The students who are raised on a diet of mainly men are channelled to believe that there have been no women who have made their mark in the world of letters – else they would be present in the course on twentieth-century writers, would they not? Students are taught to deny the value of women writers even when they encounter them on the shelves – for no matter how far women writers of the not-so-distant past have been pushed towards oblivion, the contemporary women writers like Jessica Anderson, Kate Grenville and Kylie Tennant, etc., cannot be completely hidden – but even when today's literary students confront this evidence that women have written, they are ready to assume that

such work cannot possibly be of the first order, else these women would
be included in their courses, would they not? And most students would
give their teachers the benefit of the doubt – if ever a doubt was to arise:
few would be sufficiently paranoid to believe that in their mostly male
literary courses they were being presented with a partisan and political
curriculum. Why should they suspect that they are being denied access
to the great range of writing by their 'reputable' teachers who maintain
that their motives and standards are purely scholarly and objective?

So the courses, the criticism, the canon, continue to be centred on
the writing of men – and *not* because the women have been assessed
and found wanting. Rather, the women writers have all too often been
defined as deficient and from the outset considered unsuitable for univer-
sity study. And from this much more flows: the low status that the
academy attaches to women's writing attracts few challenges from sources
other than feminists in the literary community. Thus the tradition of
Australia remains overwhelmingly masculist in identity: the represen-
tations of women writers, which are frequently so significantly and extra-
ordinarily different from those of the men, are not known, valued, utilised
– or transmitted to the next generation. And the women writers of
Australia are on their way to being lost!

There is no literary reason that the women writers in this book should
not be part of the curriculum: a course on Australian women writers
would serve as a substantial challenge to the masculist tradition in general
and to particular male writers who currently have guaranteed places in
most classrooms. And an academic course on the great Australian women
writers of the 1930s would stand as evidence of the emergence of a fully-
fledged Australian – and female – tradition. As Drusilla Modjeska has
so ably and aptly said, women were at the forefront of the literary scene
in the 1930s and 1940s – they were the dominant force in Australian
literature – 'for the first and only time' (1981, p. 1). But even this
ostensible heyday – an assessment with which I do not entirely agree,
for I think that women writers have often been in the ascendancy but
that their achievement has been denied – has been bypassed in academic
communities.

The contribution of Nettie Palmer in creating a vital and viable literary
community – and the achievements of such political/feminist writers as
Katharine Susannah Prichard, Dymphna Cusack and Jean Devanny –
have been devalued, neglected, ignored. For while Katharine Susannah
Prichard was clearly one of the best socialist/realist writers of the period,
she was but one of a band of women writers who held comparable
committed and controversial views. A stimulating, satisfying – and
subversive – course could be and should be presented on these humani-
tarian and responsible women of the 1930s: and on the list for study the

next name to appear after that of Katharine Susannah Prichard would be that of Jean Devanny.

Jean Devanny (1894–1962) and Katharine Susannah Prichard shared much in common: primarily a novelist and a long-time member of the Communist Party, Jean Devanny's relationship to the Party and the men within it was however much more fraught than it had been for her comrade. This was partly because of 'personal politics': Jean Devanny appears to have had a much shorter fuse and to have burnt with a much more obvious passion. But it was also partly because of 'personal circumstances', for Jean Devanny stood much closer to the edge of physical survival than Katharine Susannah Prichard did, despite her relative absence of material comfort.

Jean Devanny, who became another member of Nettie Palmer's circle, was born in New Zealand and watched her father endure an early and painful death from the miner's disease, phthisis.[130] The family was poor, the circumstances pitiful, and in order to keep body and soul together, Jean Devanny undertook some of the most arduous and menial work. Then at the age of seventeen she married Hal Devanny: in a short space of time she had no money, three children, and was desperately unhappy. She began to challenge the organisation and beliefs of society, particularly as they related to women; and she began to encode her protest in writing.

In 1929 Jean Devanny arrived in Sydney and had every resource stretched by the harshness of the depression. By this stage the author of numerous books (*The Butcher Shop*, 1926; *Lenore Divine*, 1926; *Old Savage and Other Stories*, 1927; *Dawn Beloved*, 1928; and *Riven*, 1929), she had no hope of being able to give her attention to her writing because she was locked into the struggle to find sufficient food and shelter for herself and her family. In the search for a social/political solution to such widespread suffering and misery, Jean Devanny turned to the Australian Labour Party: convinced that they had no remedy, in 1931 she joined the Communist Party – and like Katharine Susannah Prichard, she too visited the Soviet Union during the early 1930s.

Nettie Palmer, who was often critical of Katharine Susannah Prichard's intellectual commitment to the Communist Party and sometimes critical of the way her service to the Party eroded her writing time, was positively scathing in her condemnation of the Communist Party's treatment of Jean Devanny. As far as Nettie was concerned, Jean Devanny was called on to do far too much, and neither her energy nor her literary talent were appreciated by the male officials who consistently found her independence (and criticism of their authority) wholly unacceptable. Nettie Palmer deplored the way Jean Devanny's art was being dissipated by demands of Party – and family – as she saw Jean Devanny from necessity churning out novels too quickly and with too little satisfaction:

her writing was very uneven and she herself recognised that most of her novels were written either to make money or to make a political statement. Towards the end of her life she concluded, not without bitterness, that it was not possible to write successfully and be a member of the Communist Party.

(Drusilla Modjeska, 1981, p. 131)

Or perhaps even a mother!

If ever there was a 'monument of lost opportunities' it was in the circumstances of life that enmeshed Jean Devanny – woman, mother, political activist and writer. She was never able to enjoy the conditions that Virginia Woolf suggested were the prerequisites for good writing: 'A room of one's own' and five hundred pounds a year. Jean Devanny's daughter, Patricia Hurd, was acutely and agonisingly conscious of the pressures that undermined her mother as woman and as writer:

It is a fact that you can't work your guts out organising the Workers' International Relief . . . peace conferences, anti-war demonstrations, speaking on street corners, the Domain, travelling the country speaking and raising funds, fighting police, getting arrested, pamphleteering, electioneering, supporting your family, fighting the bureaucracy of the Communist Party and Government Departments etc. AND DO YOUR BEST WRITING AT THE SAME TIME.

(Patricia Hurd to Ian Reid, 16 July 1969: Letter held in Flinders University Library: quoted in Drusilla Modjeska, 1981, p. 123)

In her life and her writing, Jean Devanny persistently challenges patriarchal authority: this is one reason why she was so shamefully and shabbily treated by the Communist Party[131] – and one reason why I find her writing so stirring and strong. I do not always endorse her values, although my reservations are not associated with the pretext that her work was primarily propaganda and therefore 'beyond the pale': rather I am critical of *The Butcher Shop*, for example, which in its brave and bold assertion of women's right to sexuality, seems to give sex and satisfaction too much significance as a solution. But some of her political novels (and there are more than twenty novels in all from which to choose), such as *Sugar Heaven* (1936) and *Cindie* (1949), set in the Queensland cane-fields, were for me a salutary introduction to the political/social/racial – and misogynist – history of Australia. I would recommend Jean Devanny's fiction to all alert, intellectually active individuals who cherish the dream of a just world: I would be delighted to teach a course on the view of Australia, its people and traditions, as

encoded within the work of Jean Devanny. Such representations would match little with the prevailing perspective, but the literary heritage, and society, could be all the richer for the inclusion of Jean Devanny's views. Which is why I so much regret her exclusion from the valued literary tradition.

It was always tough for Jean Devanny: she never achieved widespread popular acceptance. While – thankfully – she was comforted and coun-selled within that literary community which comprised so many of the outstanding women writers of the time, the odds were always stacked against her. I am deeply moved by a letter she wrote to Miles Franklin in her later years:

> Oh Miles, how I have wasted my life. I'm done for now and yet I feel I had it in me to do good work. You at least have the compensation of knowing that you have done good literature that will stand as a monument to this era. . . . I realise now that I have not exploited the small measure of ability of writing I possess one whit. I have never really got down to it and *thought*. Thought was reserved for politics.

(Miles Franklin Papers, 14 August 1953: Mitchell Library, MS 364/ 32/163–5)

Jean Devanny deserves a much better literary fate than oblivion.

So too does 'M. Barnard Eldershaw', the writing team of Marjorie Barnard (1897–1987) and Flora Eldershaw (1897–1956), for whom living/working conditions were less stark but not much less antagonistic to writing than they were for Jean Devanny: middle-class women both, Marjorie Barnard and Flora Eldershaw none the less found that they had to make time to squeeze in their writing, and that they always felt they could have done better.

Marjorie Barnard and Flora Eldershaw were born in the same year, 1897, and each was a victim of the conventions that governed the behav-iour of good and proper women at the time. Allowed to attend university, for example, Marjorie Barnard was not permitted to pursue her studies at Oxford and so by default she became a librarian, a job which she found daunting – and draining.

Determined to find expression for her intellectual life, Marjorie Barnard faced the almost impossible task of trying to keep some time free for reading and writing. For although she never married, she was a middle-class spinster/daughter with extensive domestic responsibilities. She worked an eight-hour day at the library, and it took an hour to travel each way to and from work: and when she *was* at home she was required to spend a good deal of her time playing dutiful daughter – obliged

almost to compensate for her inconsiderate absence during the day. And of course when either of her parents were ill she had to be nurse and daily domestic.

In some respects, Marjorie Barnard was like many a modern woman: she had won the right to paid work but without any reduction in her workload at home. She simply found that 'progress' meant that women had two jobs and were required to work harder. And there were so few rewards: until the age of thirty-nine Marjorie Barnard lived at home and, unlike Jean Devanny, while she had a guaranteed roof over her head she had no autonomy and nowhere to entertain her friends. For Marjorie Barnard there was no easy access to an absorbing or exciting social/literary life.

Yet with so little encouragement, opportunity – or inclination, given the demands of the day – she and Flora Eldershaw (whose conditions as a resident mistress at a girls' school were no better) still managed to write their classic Australian novel *A House is Built* (1929), and another, *Green Memory*, in 1931.

As a partnership they wrote five novels (others were *The Glasshouse*, 1936; *Plaque with Laurel*, 1937; the 'censored' *Tomorrow and Tomorrow* in 1947 and the full length *Tomorrow and Tomorrow and Tomorrow*, published in 1983). They also wrote three histories (*Phillip of Australia*, 1938; *The Life and Times of Captain John Piper*, 1939; *My Australia*, 1939) as well as some short stories, a radio drama and their critical work, *Essays in Australian Fiction* (1938). But they did manage to improve their working conditions somewhat after the publication of their first two collaborative works. Drusilla Modjeska has summed up this phase of their lives:

> Marjorie Barnard lived with her parents, while Flora Eldershaw came to Sydney from the Riverina and for many years lived as a resident mistress at Presbyterian Ladies' College. She grew to loathe the restrictions and in 1935 Marjorie Barnard described Flora Eldershaw's existence as 'untenable', but pointed out that she had no alternative. At the end of 1936 the two women found a compromise, renting a small flat at Potts Point where they could give 'minute dinner parties' and retreat occasionally from home and school to somewhere that was at least their own.

> (Drusilla Modjeska, 1981, pp. 204–5)

Both women were thirty-nine before they had a 'room of their own' (sometimes) where they could entertain their friends, some of whom would have been considered bohemian and unacceptable in a girls' school or a decent middle-class home! But if without a base they were unable to join the social/literary circles, Marjorie Barnard and Flora Eldershaw

were still members of a literary *community*: they were part of Nettie Palmer's network.

During the difficult days both women were in contact with Nettie Palmer. She provided considerable encouragement and urged them to assume a more public profile in their local literary circles: she wanted them to join societies, attend debates, become members of the Fellowship of Australian writers – all sorts of activities which could be stimulating and supportive. It was Nettie Palmer to whom Marjorie Barnard turned for counsel when she contemplated the possibility of abandoning her job, accepting a small allowance from her father, and devoting herself to serious writing. Nettie Palmer appreciated the fact that Marjorie Barnard found the prospect of being a full-time writer threatening: she also understood that to Marjorie Barnard a literary partnership was confidence-boosting and reassuring. Which is why she saw the collaborative efforts of 'M. Barnard Eldershaw' as positive, and capable of great attainments. Writing in her journal on 23 December 1933, Nettie Palmer made the following comments:

> It isn't easy for an outsider to understand how a literary partnership is carried on but in this case it seems to work well. At any rate it has so far, for there are no visible gaps or joins in 'A House is Built'. Any difference in the characters of the two women doesn't make for a difference in their point of view or values. They both look at 'A House is Built' in much the same way – a solid piece of work made to standard design, something they rather hope to forget later when they've written a book that's 'all out'.
>
> (Nettie Palmer, 1948, p. 128)

Of course Nettie Palmer was not the only one who was fascinated with the whys and wherefores of the Barnard-Eldershaw collaboration. But 'M. Barnard Eldershaw' is just another example of some of the successful literary partnerships that appear in Australian history,[132] and there are numerous questions which could be asked about why such a co-operative practice is so much more common among women. A literature course designed to explore the advantages – or otherwise – of such collaborative arrangements could be a welcomed and worthwhile addition to the literary curriculum.

Marjorie Barnard and Flora Eldershaw always insisted that they had a genuine and generous partnership with a distinct division of labour. Flora Eldershaw was concerned with the structure, with organisation and development, while Marjorie Barnard did the major share of the creative writing. Partly because Flora Eldershaw was a more impressive public speaker (she became president of the Sydney branch of the Fellowship of Australian Writers in 1935 and again in 1943), it was widely but

erroneously assumed that she was the dominant of the two. But the contributions that each later made on their own attest to their own unique individual talent and worth.

Always there as a mentor when they were in need of support, Nettie Palmer provided these two women with constant counsel and warmth when she drew them into her circle. They trusted her. After their early initial success (which neither Marjorie Barnard nor Flora Eldershaw prized greatly for they were both convinced that under better circumstances they could produce better work) their efforts were greeted with silence and rejection. In a manner that is probably far more common then people think, Marjorie Barnard and Flora Eldershaw had difficulty in gaining further acceptance for their work.[133] When their collection of short stories was turned down for publication it was Nettie Palmer to whom they went for consolation and validation. And it must be a mark of her immeasurable tact that Nettie Palmer was able to persuade them that there were problems with the collection which would be better withdrawn from consideration – and at the same time remain their confidante and friend.

The partnership was not the only writing life of these two women: while very close they still retained separate literary interests. In her own name Marjorie Barnard wrote some superb short fiction (see for example, *The Persimmon Tree and Other Stories*, 1943) and a range of 'histories'. And Flora Eldershaw gave public addresses (such as the one on *Contemporary Australian Women Writers* for the English Association in 1931) and edited the *Australian Writers' Annual* (1936) as well as *The Peaceful Army* (1938), a celebration of the pioneering work of women for the 150th anniversary of white settlement in Australia.

In 1941, however, the partnership was stretched when Flora Eldershaw found a way of leaving her onerous teaching position and went to Canberra as a Civil Servant. Marjorie Barnard missed her companionship enormously, though in emergencies (such as illness) the two continued to provide each other with mutual support.

Their separation did not preclude the completion of their final (and to my mind, most impressive) collaborative work – *Tomorrow and Tomorrow*. Written in a context in which they were both politically (though not in 'party' terms) increasingly aware, and when as feminists they were increasingly frustrated, this book stands as one of the most challenging representations of the future – and of course, of the present. Denouncing violence as in any way affording a solution, *Tomorrow and Tomorrow* presents one of the best defences for the role of literature – for the value of human reflection as it is encoded in literary form. It goes a long way towards explaining women's affinity with fiction and their relationship to the written word. Of *Tomorrow and Tomorrow*, Drusilla Modjeska has said:

It is a novel which condemns capitalism, holds no faith in parliamentary democracy and raises doubts about socialism. While it is in many ways a pessimistic novel it is informed by that faith in the ability of literature to stir public opinion and the national interest.

(Drusilla Modjeska, 1981, p. 114)

Since Aphra Behn attempted to expose some of the horrors of slavery in one of the first novels in the English language – *Oroonoko*, 1688 – and Harriet Beecher Stowe tried to change the terms of the debate on slavery in the United States in *Uncle Tom's Cabin*, since Elizabeth Gaskell used her pen to portray the plight of the poor and the desperation of the socially rejected,[134] women writers have utilised fiction as a means of urging society to create a better world. *Tomorrow and Tomorrow* stands firmly within this tradition.

That such a book, such a fascinating literary partnership, and such outstanding women writers who are so much part of the recent provocative past in Australian literature should so unceremoniously be removed from the cultural heritage, borders on the tragic. These women and their work warrant national – and international – recognition. Ironically, with the Virago publication of *Tomorrow and Tomorrow and Tomorrow* (1983), and world-wide distribution, it could well be the international recognition that comes first!

Unless and until the literary establishment of Australia puts its own house in order, reinstating the many great women writers who are worthy of preservation and transmission, the reading public will remain relatively ignorant of the existence of these two women and the highly commendable nature of their work. Were the books of Marjorie Barnard and Flora Eldershaw to be available – and academically endorsed – no doubt volumes could and would be written on the detail of their lives and the contribution of their work to the world of letters. Then 'M. Barnard Eldershaw' could have a place, along with many other women, in challenging college courses on the significance of women and their view of the world in the Australian literary tradition. And along with the great women writers already mentioned such a course would have to take account of Eleanor Dark (1901–85), who has to be one of the best women writers within the Australian tradition.

Recently, I was asked to comment on the life and work of my favourite author by two different publications. Accustomed as I am to living with contradictions, I was in a position to split my choice and to provide one periodical with a review of the work of Katharine Susannah Prichard, and the other with commentary on the outstanding achievement of Eleanor Dark. In the process I compared the contributions of these two impressive writers and realised that while they both begin from very

different starting points, they journey to much the same place. Whereas
Katharine Susannah Prichard paints the broad lanscape and situates the
individual within it, Eleanor Dark takes individuals – and their innermost
thoughts – and sets them down in the demanding Australian landscape.
And, as each writer charts the development of their characters, they look
critically at the Australian heritage and at the historical influences, at the
abuse of Aborigines, the exploitation of women, and at the discrepancy
between the ideal and the actual Australian identity. While they offer
insights that have cross-cultural application their work is undeniably and
uniquely Australian. But more than most other Australian women writers,
Eleanor Dark is concerned with the inner workings of her characters'
lives: if ever novelist has represented creatively and convincingly the
consciousness of women (and the response of men), it is Eleanor Dark.

Born into a literary family, Eleanor O'Reilly married her medical
practitioner husband at the youthful age of twenty-one: she moved to a
relatively comfortable home in the quiet mountain area of Katoomba and
while she had a measure of financial security she cannot be presumed
to have had total freedom to pursue her art. For if Nettie Palmer had
Vance to support, Jean Devanny had political commitments to meet and
Marjorie Barnard her parents to 'oblige', Eleanor Dark had her
husband's patients to consider. Clearly there were times when she could
concentrate on her writing but – even so – the telephone, for example,
could not be left unattended. Despite the fact that she almost led the
life of a recluse, Eleanor Dark still complained that there was never
sufficient uninterrupted time in which to write.[135]

In 1921 Eleanor O'Reilly had her first poem published: in 1932 her
first novel, *Slow Dawning* (which she later chose to ignore), was published
in Sydney, and was later awarded the gold medal of the Australian
Literary Society. This was the novel that Nettie Palmer had been waiting
for: on 4 May 1934 she wrote in her journal:

> This morning Eleanor Dark's novel 'Prelude to Christopher' arrived
> – the first important book published by Stephensen since he left
> the Endeavour Press. It is also her first legitimate brainchild. . . .
> Read Prelude tonight. Its literary power gives it a unity, in spite of
> some unreality in the theme and a good many gaps. How hard a
> writer makes it for herself in choosing such a tangled, elaborate
> theme for her first novel. But perhaps that's a foolish way of looking
> at it. The theme's simple enough: it's the method that's tangled
> and elaborate. And the method's directed in the modern way at
> squeezing all the inwardness out of the subject . . .

(Nettie Palmer, 1948, p. 130)

When Nettie Palmer made this entry, Eleanor Dark was already a member of the network. Like so many of her contemporaries she was appreciative of the considerable contribution that Nettie Palmer was making to the world of letters, and she had no fears that her work would be summarily rejected when assessed by Nettie. Not that Eleanor Dark expected unalloyed praise: good, helpful criticism can profitably point to areas where improvement could be made, and it was in the interest of accurate and enlightening feedback that Eleanor Dark wrote to Nettie Palmer saying 'deal harshly with me if necessary for the good of my literary soul'.

Nettie Palmer, of course, did not deal 'harshly' with this new writer, although she did provide a careful and considered evaluation of the strengths and weaknesses of the work. And Eleanor Dark was grateful for the substance and the style of the response: I am 'well content for my head to remain in your jaws even if you should decide to bite it off one day', she wrote to Nettie.[136]

With growing confidence Eleanor Dark continued her creative career. In 1936 came *Return to Coolami* which also won the Australian Literary Society gold medal. This is the novel in which Eleanor Dark explores some of the emotional differences between women and men: it focuses on an emotionally sensitive woman and an unthinking but decent man who is jolted into imaginative awareness on a two-day car journey through the Australian outback. It is a brilliant 'psychological thriller' which goes right to the heart of some of the difficulties of communication between women and men. Then in 1937 came *Sun Across the Sky*; in 1938, *Waterway*; and in 1941, the first volume of that powerfully evocative trilogy on the history of the continent of Australia – *The Timeless Land*.

While Eleanor Dark has sometimes been criticised for her literary, as distinct from literal, treatment of Aboriginal existence before the advent of white settlement, her poetic insights can afford more illumination than any supposedly 'scientific' analysis ever could. Her empathy for the original inhabitants, her perspective which is through black eyes and which represents the Europeans as invaders, did much to shift the discussion about the relationship between 'savagery' and 'civilisation': the common theme in Australian literature of reconciling the old and the new assumes very different meanings when it is the Aborigines rather than the British who represent the 'old', the cultural yard stick, the reference point.

Storm of Time (1948) and *No Barrier* (1953), the additional volumes in the trilogy, constitute a documentation of culture-clash in a manner that no 'objective' survey could clarify, and in her commitment to 'wholeness', to inter-relationships, to an ecological view, I see links between the work of Eleanor Dark and that of the earlier writer, Louisa Atkinson, who also visualised a harmonious solution. And as with the trilogy of Katharine

Susannah Prichard, that of Eleanor Dark stands as one of the great artistic statements about a country approaching maturity – which must come to terms with its past, and its guilt.

Guilt is a theme which flits through Eleanor Dark's fiction but without ever becoming a major preoccupation: in *The Little Company* (1945), for example, we find a novel which shares many of the concerns of *Tomorrow and Tomorrow*. Eleanor Dark, while of 'the left' but without any specific affiliation, believed strongly that one of the most political things she could do was to keep writing: in *The Little Company* she writes about the part that literature can play in political change. She also writes about guilt – about guilt in relationships and guilt with writing when the committed political writer experiences 'a block' at the precise time when there is a desperate need for the word.

Lantana Lane (1959), Eleanor Dark's last work of fiction is also her most wryly amusing. With its realistic portrayal of a series of Australian characters (who congregate in Lantana Lane), Eleanor Dark sealed her reputation as a writer of enormous range. I have no hesitation in asserting that she is one of *the* great women writers of contemporary times – and not just in her native land! That Eleanor Dark is however so little known outside Australia,[137] is probably because she elected to spend most of her life in the land of her birth. And unlike Christina Stead (1902–83), who was also undeniably a great writer but who does enjoy an international reputation, Eleanor Dark made use of exclusively Australian material in her fiction.

Christina Stead, of course, started off with peculiarly Australian themes: for example, her home in 'Fisherman's Bay' (Watson's Bay) provided the actual setting for *Seven Poor Men of Sydney* (1934), and this was by no means the only autobiographical aspect of her life that was used – without great transformation – in her writing. When Christina Stead wrote about poverty and privation it was often with the authority of grim personal experience: as a young woman she had lived frugally to save her fare to Europe, and in England from 1928 to 1929, her living conditions were sometimes fairly desperate. But then she married William Blake and from that time on she was able to write without undue worry about financial difficulties.

Along with *Seven Poor Men of Sydney*, *The Salzburg Tales* was published in 1934, and these were soon followed by *The Beauties and the Furies* (1935), *The House of All Nations* (1938) and then a steady stream of significant novels situated in a variety of cultural settings. But despite the regular publications which flowed from her pen, Christina Stead was better known 'abroad' than she was 'at home' until relatively recent times. This was not simply because she lived outside Australia for so long but because it was not until 1965 that her work was published in her native land. Not that she was completely unknown or unadmired: her fellow

Australian writers (most of whom had also had their spell 'abroad') were quick to sing her praise. And Florence James, who knew Christina Stead all her adult life, was one member of the literary community who consistently made the case for Christina Stead's literary worth: to Florence James, Christina Stead was a genius who created her own world and then inhabited it.[138]

Christina Stead, however, was not a member of Nettie Palmer's circle. The two women did meet – once at the first International Congress of Writers in Paris in 1935 – but they certainly did not become bosom friends. Christina Stead had little patience with what she presumed to be a chauvinistic attitude to the development of a narrow Australian literature, and Nettie Palmer was not sympathetic to those who turned their backs on their native land and copied European cultural concerns. So when Christina Stead could make no use of Nettie's patronage and Nettie Palmer had no time for Christina's patronising style, there was no good reason for these two to correspond. Nettie Palmer always gave Christina Stead due credit for the remarkable nature of her work, but her words were never couched in the warm personal terms that characterised her comments on most of the other first-class Australian women writers.

That Christina Stead should have a primary place in the canon of Australian writers is a matter about which there should be no dispute. All the petty bickering of the past – as to whether Christina Stead did or did not qualify as Australian – should be put aside in the interest of evaluating the significance of her contribution. There are signs that her stature is growing within scholarly circles in Australia, and it would be unfortunate if this were the direct result of her acceptance overseas. The fiction of Christina Stead should stand alongside the other great Australian women writers of the period: precedence should not automatically be given to those of international reputation and at the expense of those who explored the realms closer to home.

That there may be no direct link between international and national reputation, however, is an issue raised in relation to Dymphna Cusack (1902–80): she achieved the distinction of being one of the most popular contemporary authors in Soviet Russia, yet her achievements have almost all faded into insignificance in her native land. Of course there still could be a link between international and national acceptance – one whereby the Australian reputation is hindered rather than enhanced by such 'suspect' popularity.

Of working-class background, Dymphna Cusack attended Sydney University (where she became the close friend of Florence James 1902–), and then worked as a schoolteacher until 1944 when illness forced her retirement. She had managed to write a little while still teaching: her astonishingly frank and feminist novel *Jungfrau* (1936) and

her collaborative sesqui-centenary satire with Miles Franklin (*Pioneers on Parade*, 1939) being two such efforts. But most of her published writing was done after her retirement.

At the end of the war, Dymphna Cusack and Florence James (with Florence's two daughters and Dymphna's niece) rented an inexpensive cottage 'up the mountains' as they waited for berths on a ship to Europe. And the two women decided that they should put what could be a long period of time to good use: they wrote that wonderful women's classic – *Come In Spinner*.[139] Dymphna Cusack was quite ill at the time and dictated much of her material to Florence James, but in the hallway between their bedrooms, the record of progress was kept as every incident, every character, every contingency plan, was pinned up upon the wall. Set in the Marie Antoinette Salon of a salubrious Sydney hotel, the novel is a social documentary dealing with women's war, women's work, and women's worries – the politics of half the population, which is generally omitted from official histories.

Come in Spinner won the 1948 *Daily Telegraph* competition, but much of it was considered too indecent for publication and a compromise was not reached until 1951, when a substantially edited version was released. With its coverage of all the traditional women's issues, from marriage to abortion[140] and the desirability of a man, this novel could still take the prize as one of the great achievements in women's fiction. Whenever male critics have attempted to devalue this novel, declaring it to be unrealistic, they have simply shown how far they have been prepared to go to dismiss as non-existent those aspects of the world which are to them unknown. That the male characters are not positive (and not central to the plot) probably also has something to do with the literary establishment's neglect of this remarkable novel – a novel which I would recommend as a coming-of-age present for all young Australian women.

Although *Come In Spinner* is an impressive achievement it was not Dymphna Cusack's only undertaking while she was living at Hazelbrook, waiting for a passage to London. Apart from *Four Winds and a Family*, a children's book that she and Florence wrote for 'the girls' (and which includes a chapter on Miles Franklin as 'the distinguished guest'), Dymphna Cusack also played a crucial role in encouraging 'Caddie' to write her life story. 'Caddie' was the woman who helped Florence James with some of the 'heavy work', and in the presence of the writers, Caddie declared that she had quite a story to tell: she expected the writers to take it down, but Dymphna insisted that 'Caddie' was perfectly capable of doing it herself. And she did. After many drafts, which Dymphna commented upon, *Caddie* was published in 1953.

Eventually the ship did sail and both Florence James and Dymphna Cusack travelled overseas, where Dymphna's international reputation was soon established. Her later novels (she wrote twelve in all) were

translated into thirty-four languages. In London, Florence James worked as a journalist, literary consultant, and reader for the publisher, Constable: she was instrumental in bringing to publication the work of a number of Australian writers – among them Mary Durack and Nene Gare.

And Dymphna Cusack, a highly-committed socialist, feminist, and writer, proceeded to produce fiction that dealt with the controversial issues of the times. *Jungfrau* (1936), with its forthright exploration of female sexuality (and some of its awesome consequences), stands as a work of considerable achievement in women's literary history. *The Sun in Exile* (1955), with its denunciation of racism, fits well within the Australian women's literary tradition. *The Half Burnt Tree* (1969), which tackles the issue of war in Vietnam, should have a central place in the cultural heritage. *Say No to Death* (1951) is about terminal illness; *A Bough in Hell* (1971) deals with alcoholism; *Heatwave in Berlin* (1961) exposes the conditions in post-war Germany, and *Picnic Races* (1962) casts a satirical eye on Australian rural life. Dymphna Cusack is very much a novelist of our times and it is regrettable that so many of her books, which are still so relevant and revealing today, should be out of print.

And she did not confine her writing to fiction: in her travel writing Dymphna Cusack also extended the Australian horizons when she introduced in her lively and illuminating style the realities of places far from the Australian experience: *Chinese Women Speak* (1958),[141] *Holidays Among the Russians* (1964) and *Illyria Reborn* (1966) all help to show the scope, the sensitivity and the skill of the author. Her many plays, too, brought home some of her political views in highly palatable form: for example, *Pacific Paradise* (1963), just one of her many plays to have been produced on stage, radio or television, deals with nuclear power and has been performed in a variety of countries outside Australia.

Dymphna Cusack was a gifted and great writer whose contribution has not been given the attention and status that it clearly deserves. The work of Dymphna Cusack, the impact of her writing on Australian audiences and her commentary on the Australian way of life, her concern with injustice on an international scale and the representation of these views and values in her work, could constitute a worthy and necessary chapter for study in Australian cultural history.

Neither Dymphna Cusack nor Florence James were intimate members of Nettie Palmer's network. Both knew her, and Florence James still praises Nettie Palmer's contribution to the creation of an Australian women writers' community. It was probably because Dymphna Cusack and Florence James were somewhat younger than Nettie Palmer – and because they spent a considerable time overseas – that they were not part of the circle that Nettie Palmer cultivated. But of course, Dymphna

Cusack was a firm friend of Miles Franklin, who – once she returned to Australia – was confidante and source of support to Nettie herself.

In a tribute to Miles Franklin in 1955, Dymphna Cusack reflected on their relationship:

> My friendship with Miles Franklin began one blistering day in February 1938, when we sat on the edge of the lily pond at Government House, Sydney (it was a Sesqui-Centenary Celebration for 'distinguished women'!), ate soggy sandwiches, sipped lukewarm lemonade and exchanged views, in keeping with the weather, on what Miles called the survivals of the 'garrison-mind' in a young country. We'd met before, certainly, but this was the first time we 'knocked sparks off each other' – again Miles is speaking.
>
> Out of this meeting came *Pioneers on Parade*, which sealed a friendship that lasted until her death, and its influence will be with me all my life.
>
> (from *Miles Franklin: A Tribute by Some of Her Friends*, 1955: Bread and Cheese Club, Melbourne)

While I find these reminiscences informative – and moving – I am more intrigued by the following statement of Dymphna Cusack's:

> We are sitting on her back porch in Carlton. A winter morning, the air as sparkling as Miles' wit. We are working at the first draft of 'Call Up Your Ghosts', the one act play that describes the attitude to Australian literature in 1944.
>
> (from *Miles Franklin: A Tribute by Some of Her Friends*, 1955)

I have not been able to locate the play or to determine its fate but I have no doubt that it would be a 'treasure'. The combination of Dymphna Cusack and Miles Franklin, in satiric form and on the subject of the attitude to Australian literature! The prospect is indeed appealing and I only hope that the manuscript of *Call Up Your Ghosts* can still be found.

Miles Franklin (1879–1954) is sometimes the only name that people know in relation to Australian women writers, and then their knowledge is often based not on her books – but a film! And for the woman who did so much for Australian writing, the very idea that her reputation should rest upon a movie could well be sufficient to make her turn in her grave. But perhaps I do Miles Franklin a disservice: perhaps she would not mind whatever medium was used to convey *My Brilliant Career*, provided its satirical and feminist statement was clearly presented – and understood.

The sometimes solitary prominence of Miles Franklin within the Australian tradition, however, is not due solely to the popular film that was made of her work. In some ways she has been singled out as a token to represent the female literary tradition: in a manner that Joanna Russ (1984) refers to as 'the myth of isolated achievement',[142] Miles Franklin has been left to stand alone while the many women writers who preceded her and surrounded her have been allowed to fade – first into the background and finally into oblivion.

Contrary to conventional wisdom, Miles Franklin was the inheritor of a healthy female literary tradition: through her feminist friends (particularly Rose Scott, for example) she was well aware of the women who had helped to pave the literary way. She was conscious of the calibre of Rosa Praed, Ada Cambridge, 'Tasma' – and Catherine Helen Spence – and could even see the parallels between her own early achievements and those of her immediate juvenile predecessor, Ethel Turner. When in 1905 Miles left Australia for the mandatory trip abroad and journeyed to Chicago to join fellow Australian feminist, Alice Henry, she recognised that she was one of a long line of literary feminists, as her friend Marjorie Barnard observed:

> Now in Alice Henry she met another . . . woman, who, in her turn
> had lit her torch at the flame of yet another Australian, Catherine
> Helen Spence, writer, pamphleteer, social reformer . . . Catherine
> Spence was born in Scotland in 1825: Rose Scott was born in the
> Hunter Valley, Australia, in 1847: Alice Henry in 1857. Miles
> Franklin in 1879. There was, you see, quite a dynasty of women,
> all unmarried, all practical philanthropists and reformers, all deeply
> interested in the cause of women, each in turn linked to another.
> Catherine Spence became one of Miles' heroines both as reformer
> and writer.
>
> (Majorie Barnard, 1967, p. 43)

Of course, how Miles Franklin came to be working in Chicago with Alice Henry on the pages of the *Union Labor Advocate* – and later the Women's Trade Union League Journal, *Life and Labor* (which began publication in 1911) – is quite another story: it begins with a clever, curious and confident young woman in the Australian bush – and a growing desire to write. Of this period, Miles Franklin has stated somewhat self-deprecatingly and satirically that:

> I must have been nearly thirteen when the idea of writing novels
> flowered into romances which adhered to the design of the trashy
> novelettes reprinted in the Supplement to the *Goulburn Evening Penny
> Post*. . . . An Englishman to whom some of these lucubrations were

shown, directed me to the Australian scene as the natural setting for my literary efforts. The idea sprouted. Huh! I'd show just how ridiculous the life around me would be as story material and began in sardonically humorous mood on a full fledged novel with the jibing title *My Brilliant (?) Career*.

(From 'To All Young Australian Writers – Greetings!' in *My Career Goes Bung*, Angus and Robertson, 1980, p. 5)

Miles Franklin had no intention of writing either an autobiography or a romance. As Marjorie Barnard – friend, fellow-writer and critic – declared, *My Brilliant Career* (with question mark omitted) 'was not intended to be a romance. It is its very antithesis and pours scorn on the ideas of romantic literature current in the 1890s' (1967, p. 48). Miles remained well within the traditions of literary women's concern with love and marriage, but she didn't merely ask questions – she rebelled, and with great gusto. In almost swashbuckling manner, she scoffed at some of the conventions that were supposed to be sacred in women's lives: the heroine Sybylla Melvyn rejects romance – and suitors – and determines to lead an independent, full and creative life.

The book was written very quickly (Miles was then nineteen): finding a publisher took longer. Miles received three rejection slips before enlisting the support of the prominent literary figure, Henry Lawson. At the age of twenty-one Miles Franklin had her first novel in print.

It was an extraordinary success. But this was not all: soon it was also a considerable problem. For despite the obvious irony and self-mockery of the title, despite the declared intention of the author in the introduction to provide the audience with a 'spoof', most commentators ignored the farce and the fiction and asserted that the novel was clearly autobiographical: the 'confessions' of a misunderstood girl. Miles Franklin was astonished: in reaction to this critical response she later wrote (with sustained irony) that 'the literalness with which *My Brilliant Career* was taken was a shock to anyone of imagination' (1980, p. 6).

Apart from the sheer disappointment of really being misunderstood as a writer, Miles Franklin had to cope with the discomfort that her book caused within her own community. Led to believe that the caricatures within the novel were indeed themselves, there were friends and members of Miles Franklin's family who were angered – and hurt. And of course, with all the experts insisting that the novel was the autobiography of an innocent, hardly done-by and mildly hysterical young woman, who was Miles to contradict them? How could she convince those around her that the work was an invention, a satire – the story of the fictional Sybylla – and not a cruel betrayal of kith and kin? For Miles

Franklin, the delight of publication was soon marred by the distress of causing pain.

It is regrettable that Miles Franklin should so early have had such an unfortunate experience with the reception of her work. According to Marjorie Barnard, it undermined her confidence and inhibited her subsequent literary career: she provides one explanation for the disappearance from the literary scene of Miles Franklin and her *Brilliant Career*:

> After a number of editions the author firmly withdrew it because the
> stupid literalness with which it was taken to be her own
> autobiography startled and disillusioned her and then constrained
> her.
>
> (Marjorie Barnard, 1967, p. 51)

That commentators should have failed to recognise the satirical elements of Miles Franklin's contribution is not at all surprising. For centuries women have been writing novels steeped in satirical and ironical intent which – for centuries – men of letters have failed to identify. Male critics have a long history of being unable to confront irony and intellectual sophistication in women: which is why they have preferred to presume, for example, that Jane Austen is prim and proper rather than poisonous in many of her portraits. Sadly, Miles Franklin fared no better than her satirical foremothers: much of the wit of women writers from Maria Edgeworth to Ada Cambridge has gone largely undetected, and the cynical and sophisticated exposé of romanticism provided by Miles Franklin has been classified by some critics as the artless outpourings of an adolescent!

Such is the double standard within literary criticism: while men are perceived to be the genuinely clever writers women's equally clever contributions are called by another (disparaging) name. For example, Jonathan Swift wrote satire but his female counterpart, Delarivière Manley – who even took over the editorship of the *Examiner* from him on his retirement and who wrote in a comparable vein – is called a scandal-monger.[143] Miles Franklin was aware of the extent to which the dice was loaded against women in the world of letters, which is why – as Marjorie Barnard points out – the name of *Miles* Franklin appears on the title page of *My Brilliant Career*:

> The reason for this selection from among her baptismal names was
> her fixed idea that the world belonged to men, and a book by a
> man, had more chance of success than one written by Stella Franklin
> could hope for.
>
> (Marjorie Barnard, 1967, p. 46)

Apart from a somewhat uneven novel about a 'suffragette', which was almost unknown in Australia (*Some Everyday Folk and Dawn*, published by Blackwood, Edinburgh, 1909), it was 1931 before Miles Franklin again published under her own name. Many have assumed (Marjorie Barnard among them) that because of the unfortunate repercussions of the first novel, Miles Franklin chose not to be a published author again for a very long time. But evidence suggests that while Miles was hurt – perhaps even harmed – by the response that her work received, she did not *choose* to stop publishing or writing during that thirty-year period.

Her first reaction to the literal interpretation of *My Brilliant Career* was to write a 'corrective': 'In 1902, little firebrand Miles completed a sequel, *The End of My Career*', states Vera Coleman (1980, p. 1), but this time a publisher was even harder to find. This new, outspoken satire that mocked men and manners of the time was considered too audacious – too libellous – by the publisher George Robertson, who could not under any circumstances be induced to print it. But Vera Coleman has suggested that the reluctance to publish was not based just on the fact that the new novel made fun of some of the identifiable leaders of the day: 'the audacity of the work went much deeper than the scratching satire of social pretensions' (p. 2). The novel was unapologetically and uncompromisingly feminist, and Vera Coleman is of the opinion that it was this the publishers found 'unsuitable' – even offensive:

This determined independence of spirit, lack of cant and naive straightforwardness about sex were too harshly honest for the sentimental conventions of the close of the Victorian era. Rebellious Sybylla-Miles rejected in too blunt a manner the role set out for women. 'You don't allow a woman any standing except by being the annexation of a man,' she said to Henry Beauchamp [sic]. Eighty years later this is still a familiar cry.

(Vera Coleman, 1980, p. 3)

The men in publishing didn't like the novel: had there been any women in publishing it is possible that some of them would not have liked it either. Marjorie Barnard estimates that for about three years Miles Franklin persevered to get her new novel into print but 'by 1905 it must have been clear that it would not find a publisher' (1967, p. 60). And this was the reason why Miles Franklin decided to go to Chicago, and throw in her lot with Alice Henry.

In Chicago, Miles Franklin organised, edited and wrote for *Life and Labor*: she accepted pieces from those outstanding feminist writers Charlotte Perkins Gilman and Elizabeth Robins. She wrote articles defending the British Women's Social and Political Union and she published favourable pieces on Mrs Pankhurst's visit to Northern America. She reported

on the events leading up to the First World War. She also did an enormous amount of creative writing: of her productivity during her American period, Drusilla Modjeska has said that the 'range of her unpublished writing over these years is quite remarkable and includes novels, plays and short stories'[144] (1981, p. 172).

When the War broke out, Miles Franklin went to London: at one stage she joined the Scottish Women's Hospital Unit and served as an orderly overseas. However, as Miles Franklin was very reticent about this period of her life, only fragments about what she did are known. She visited Australia for three months in 1923–4, and for almost four years from 1927–31, before returning to live permanently in Sydney at the end of 1932.

But in 1928 a mysterious writer appeared upon the literary scene: Blackwood (the Edinburgh publisher who had brought out *My Brilliant Career* and *Some Everyday Folk and Dawn*) printed a novel, *Up the Country* by Brent of Bin Bin. A story of the squattocracy in Australia – and the invaluable contribution of pioneering women – the book received a warm reception and in no time everyone was asking: who is Brent of Bin Bin? Marjorie Barnard writes –

No one had ever heard of him. His only address was the British Museum. There were all sorts of wild guesses. A famous Australian poet, Dame Mary Gilmore, assured me that Brent was her brother. He had not told her so but she knew it from internal evidence.

(Marjorie Barnard, 1907, p. 73)

While Miles Franklin did not admit to authorship, by the time Marjorie Barnard was writing her commentary the case was fairly clear. There was a great deal of internal evidence (including place names that appeared in other writings under her name, as well as the habit of coining striking words), and besides, no other author appeared. And this was not all:

Those who wrote to Brent at his table in the British Museum received answers. At least two reliable witnesses (Vance Palmer and P. R. Stephensen) corresponded with both Miles and Brent and they declared the letters from Brent were written on Miles' typewriter, a machine with various faults and tricks, and that both used the same type of flimsy paper.

(Marjorie Barnard, 1967, p. 76)

An alternative explanation of authorship that has sometimes been offered is that 'Brent of Bin Bin' was a literary partnership, that of Miles Franklin and her close friend Mary Fullerton, with whom she lived in

London during the 1920s. This was sparked off partly by the acknowledgment in a later novel, *Back to Bool Bool*, 'To MF but for whose loyalty and support this effort could not have thriven.' If this really was an acknowledgment of the help of Mary Fullerton (and not another authorship prank, whereby 'Brent of Bin Bin' was thanking Miles Franklin), it is more likely that Miles was expressing her gratitude to Mary Fullerton for her moral support rather than a literary contribution.

The fact that Miles Franklin concealed her indentity and published under a pen-name helps to account in part for the apparent thirty-year 'silence'. And 'Brent of Bin Bin' is not the only known pseudonym she adopted during this period: in 1915, Mills and Boon – who used to be publishers of serious and sometimes radical literature[145] – brought out a novel, *The Net of Circumstance*, by Mr and Mrs Ogniblat L'Artseau. On this choice of pen-name, Drusilla Modjeska has made the following comment:

> The extraordinary nom de plume makes a little more sense when it is deciphered: Ogniblat read backwards spells TALBINGO, her birthplace, always dear to her heart, and L'Artseau is an anagram for Austral (ia).
>
> (Drusilla Modjeska, 1981, p. 172)

The question which arises is, of course, why all this secrecy about authorship? No doubt Miles Franklin was influenced by the personal difficulties that publication under her own name had led to, regarding *My Brilliant Career*, but this was not necessarily the only contributory cause. Her inability to find a publisher for her second novel (and a consequent loss of confidence) could also have played a part in her decision to adopt a protective persona, for then no one but she would know whether her work had been accepted or rejected. But there is also the consideration that it was simply the amusement value such a hoax provided her with that led Miles Franklin to use a variety of pseudonyms. Marjorie Barnard points out that it was part of the personality of Miles Franklin to indulge in such playful pursuits:

> In many ways Miles showed a tendency to mystification. She submitted a novel for competition. When the accompanying sealed envelope was opened it contained no name or address, only the words 'Christopher Columbus'. Authorship had to be sheeted home to her. If you telephoned her she usually pretended to be someone else and went off to fetch 'Miles Franklin'.
>
> (Marjorie Barnard, 1967, p. 3)

Because Miles Franklin was equally secretive about the details of her life abroad, then what she did, what she felt, what she wrote – even the pseudonyms she used – must remain mostly a matter of speculation. Information that she did volunteer later in life was that she did not cease writing fiction when she went to Chicago, even though she may have had little to show for it. Outlining the history of the manuscript *My Career Goes Bung*, which she had taken with her to the United States, Miles Franklin explained the loss of some of her material:

> (*My Career Goes Bung*) was deposited in a portmanteau of MSS and finally left with someone in Chicago, USA, while I went to the World War, which is now seen to have been merely practical manoeuvres for Global Armageddons. When I returned this caretaker said Mr X had needed a bag and, as my old grip was quite out of fashion and contained nothing but useless papers, she had known I would be glad to oblige him. I was assured Mr X had put all the papers in the furnace: I need have no fear that they had been left about. I made no complaint, being as sure as the caretaker that my manuscripts were of no consequence. Nevertheless I regret the loss of stories and plays which glowed at the time, and which will not come again. I thought 'My Career Goes Bung' had gone with this collection, and had forgotten the copy of it which survived in an old trunk valiantly preserved all these years by my mother.

(Miles Franklin, 1980, p. 7)

Thank goodness for mothers: at least *My Career Goes Bung* can take its proper and prominent place in Australian women's literary traditions. But Miles Franklin's loss was a cultural loss as well. Who knows what other 'gems' there may have been among the files that went up in flames! Had these papers survived, not only would we have had the possibility of a bigger body of work from Miles Franklin, but we might have learned more about her experiences as an individual – and a writer – during the Chicago period: the consensus of friends and critics is that this was a time when Miles Franklin was emotionally stretched, and unhappy.

Dangers though there may be in accepting a direct link between the characters in Miles Franklin's fiction and the detail of her life, it must still be allowed that *The Net of Circumstances* is a novel which suggests that there are problems – and pain – for women who seek to lead an independent life. Constance Roberts, the heroine, struggles to be solely self-supporting, but the pressures are too great and she bends under the strain: she compromises and marries Osborne Lewis, despite his inability to understand 'the woman question'.

Fiction can of course be used to 'test out' experience by both writers

and readers alike (which is one of its great attractions for women), and it could have been that Miles Franklin was experimenting with her character Constance Roberts, rather than her own life. In there are some striking similarities between the existence of Miles Franklin and her heroine, there are also some significant departure points: for example, Miles Franklin never married. Besides, *The Net of Circumstance* was not the only novel that she wrote during this period. A very different picture of Chicago, and a heroine, is provided in *On Dearborn Street*, which was not published until 1981, but which is in some respects another (equally ebullient) version of *My Brilliant Career*.

If there is a difference between *The Net of Circumstance* and *On Dearborn Street*, there is an even greater distance between these 'American' novels and the series written by 'Brent of Bin Bin'. Set in Australia and looking to the past for enlightenment and meaning, these novels serve to integrate some of the predominant strands of Australian women's literary traditions. With the verdict of the *Oxford Companion to Australian Literature* that the series was 'old-fashioned', Drusilla Modjeska would clearly never agree. Looking at them in terms of women's experience, she states that:

> What is new about the Bin Bin novels, and where they depart from the legend, is in their insistence that the strength and success of pioneering society was based on the real but unacknowledged power of women.
>
> (Drusilla Modjeska, 1981, p. 176)

Like Mary Grant Bruce, Miles Franklin extended mateship – and strength – to the world of women, and in the process undermined the province and prowess of men.

Most of Miles Franklin's major characters were women: most of them confronted fairly and squarely all the aspects of 'the woman question'. The older ones were wise and the younger ones were rebels, and of the Miles Franklin heroines Marjorie Barnard has said:

> All these maidens were besieged by suitors but none of them would brook the slightest familiarity. Sybylla Melvyn slashed Harold Beecham across the face for wanting a kiss when he thought they were betrothed. Dawn threw dishwater over her Ernest for no reason at all except that she happened to be thinking all men were beasts. Rachel Mazere, when Simon proposed to her threw a cabbage and the knife she had just cut it with, at him. Milly fought on horseback for her honour which was not really threatened and then rode ninety miles to safety, her escort left lying unconscious in a pit.
>
> (Marjorie Barnard, 1967, p. 152)

Miles Franklin's heroines did not swoon: they much preferred to fight when faced with 'advances' from the men. And the author leaves the reader in no doubt that women must be prepared to fight if they are to further their position and achieve their independence. Australian literature is the richer for the existence of the image of the fisty young female whose rebellion is more than justified. I can only wish that my education had included an introduction to Miles Franklin: I can only hope that she and her heroines will be familiar figures to future generations. But I am not optimistic. For much the same reasons that publishers rejected *My Career Goes Bung* at the beginning of the century, I think the male-dominated literary establishment, which determines the entry of writers to college courses and the school curriculum, will reject Miles Franklin's work today. For her independent characters – who are often compatible with the Australian outback, who have comradeship, community concern, and the courage of their convictions – are women without men. With her active, adventurous, outback horseriding[146] – and autonomous heroines, Miles Franklin appropriated the territory of men in Australian fiction and her novels can be seen therefore as subversive – and audacious.

All those many emerging and distinctive strands, which characterised the early development of women's literary traditions in Australia, are to be found approaching maturity in the work of Miles Franklin. The 'letters home' have given way to a much more sophisticated personal/confessional style (as in *My Brilliant Career*): the 'Brent of Bin Bin' series[147] explores the peculiarities of the Australian landscape and way of life, and inextricably links them with personal growth and identity. There is a confident and open assertion of egalitarianism, of freedom of spirit and expression, which is (rightly or wrongly) associated with the Australian literary tradition: and there is a recognition that the Australian needs to be explained not just to those at home but also to those abroad. The fact that Miles Franklin wrote much of this series in the British Museum could help to account for the way in which this highly national literature looks out on the world, rather than in on itself. And, of course, the determination to depict the world through women's eyes runs through the entire body of Miles Franklin's work, and accords women a central and independent position in the reality that she describes.

The consensus is that *My Brilliant Career* was the achievement of Miles Franklin's youth while *All That Swagger* (1936) was the achievement of her mature years. It is certainly an impressive work. It tells a somewhat traditional story of Australian pioneering society, but with one very significant difference: it is filtered through the experience of women rather than – as is customary in the mainstream Australian tradition – through that of men:

It is a chronicle of Australia's national development. Once again

while the men swagger, it is the women who are the true progenitors
of the legendary Australia and who lay the foundations holding the
pioneering society together.

(Drusilla Modjeska, 1981, p. 178)

If any investigation were to be undertaken to help explain the relative
neglect of Miles Franklin's writing within literary circles there would be
little need to look much further than this: the fact that Miles Franklin
was a woman writer who, without apology, mediated the experiences of
women — often 'uppity women' -- gives the clue to the eclipse of her
work. For there is not much room to accommodate this version of reality
within the mainstream Australian tradition. As has happened with so
many of the great Australian women writers, when their work does not
fit into the established framework it hovers on the sidelines and then,
over time, almost inevitably 'disappears'.

Of course, Miles Franklin's practical contribution to the world of
Australian letters is much more widely known: she lived such a frugal
life that her friends were often worried as to whether she had the basic
necessities, but on her death the purpose of such saving became clear.
She left the means to fund the Miles Franklin Award for Australian
Literature, and such a bequest was consistent with the values she had
espoused in life. Like her friend, Nettie Palmer, Miles Franklin was
committed to the development of a national literature and she did her
utmost to encourage and assist the young writers: careful she may have
been with her money, but enormously generous was Miles Franklin with
her counsel and her time when it came to supporting the next generation
of contributors to a thriving Australian tradition. And she never missed
an opportunity to object to the disgracefully poor payments made to
writers, or to complain about the lack of appreciation for their efforts in
their own country:

Miles felt that writers, particularly in Australia, had a raw deal. Not
only did they receive poor financial reward for their books, but
there was practically no constructive or stimulating criticism. They
were lapped around by a vast public indifference. She aired their
wrongs in public and in private at every possible opportunity. Books
that were she claimed of national importance were allowed to go
and stay out of print. She campaigned for the republication of many
of them. . . . 'The Australian nation despite talkies and football and
tin shares and horse racing in pandemonial plenty is filthily poor
mentally and spiritually while it cannot afford to print and buy and
read *Such is Life*[148] in its entirety . . .'

(Marjorie Barnard, 1967, p. 142)

I think it typical of Miles Franklin's blend of realism/cynicism that part of her commitment to the development of Australian literature should have arisen out of her conviction that so many Australians were so awful that a national literature was needed to 'civilise' them. She commented caustically to Nettie Palmer that Australians were not interested in love of liberty – or art – but 'so long as they have beer and betting they are all right' (Brent of Bin Bin to Nettie Palmer, October 1930: Palmer Papers, National Library of Australia, MS 1174/1/3699).

But if writers in general needed a champion, if they needed financial and emotional support and a constructive critical climate in which to work, women writers in particular needed special support, as far as Miles Franklin was concerned. From the circumstances of her own life (when she returned to Australia) and from those endured by Nettie, Miles Franklin was fully aware that women writers laboured under difficulties that were often unknown to men. Drusilla Modjeska comments:

'A woman writer,' wrote Miles Franklin, 'except in rare instances, has no protection such as enjoyed by men who use their wives and mistresses as a marline to save themselves from the wear and tear of interruption.' She could have been writing of any one of the women in this book – indeed she probably was. Being a woman intersected at every point with being a writer. Being a wife, a mother, even a daughter could not be easily laid aside; these were constant conditions grounded in the needs of family, of husband of children and, not least, of the women themselves. So that even when there was someone to take over the chores, responsibility and involvement remained. Writer-women were, as they still are, frequently caught between their professional needs and capacities and their desires as well as their duties as women.

(Drusilla Modjeska, 1981, p. 191)

This conflict of interest between woman and writer is at the heart of women's literary traditions and this was recognised by both Miles Franklin and Nettie Palmer: they took it into account in their support of women writers – and in their support of each other. For if Nettie was often a source of comfort to Miles, Miles was one of the few who could serve to counsel and console Nettie. Both women were aware that Nettie had tried to resolve the conflict between woman and writer by abandoning her poetry on marriage and becoming the critic instead: both knew that Nettie put a higher premium on creative writing and felt that her own work was a compromise with the demands of domesticity. And when Nettie felt guilty about not doing her best by her writing, Miles' under-standing and comfort prevailed: but when Nettie felt guilty about not doing the best by her husband – it was quite another matter.

Nettie Palmer believed that she could not in good conscience act as a critic of her husband's work, yet without public commentary of a high calibre – in the absence of serious and sensible critics – Nettie was convinced that Vance was not getting due and fair attention: and somehow or other, all this was her fault. But of course, Miles Franklin would give no credence to such a line of thought. She knew that Vance had received more than his share of support from Nettie, a form of support that had certainly not been reciprocated. She was quick to disavow Nettie of any false sentiments she may have had about the sufferings of poor Vance:

> Your husband loses nothing compared with what he gains by having you on hand as his life's partner. Imagine what it would mean to me to have such as you read my stuff before it goes to the publisher. Even a proof reader would be a great help when I'm weary.

(Brent of Bin Bin to Nettie Palmer, 2 January 1930. Palmer Papers, National Library of Australia, MS 1174/1/3442)

And with Miles Franklin's support of Nettie Palmer, the women's literary circle really does go – full circle. Nettie Palmer helped to create and sustain a community of Australian women writers in the context of a male-dominated literary establishment: and Miles Franklin helped to sustain Nettie Palmer in the context of a male-dominated domestic establishment. Without the efforts and achievements of these two women, the Australian literary tradition would not be the rich one that it undoubtedly is. For the creation of Nettie Palmer's network, the contribution of Miles Franklin, and the cultural heritage that was forged as a result helps, in large measure, to account for the current exciting and expanding Australian literary scene – and women's prominent place within it.

The challenge that remains is to reclaim all the women who have been the significant links in the literary chain and to ensure that all have representation in the mainstream curriculum. This of course will mean a new literary canon and curriculum, a new image of Australia and a new recognition of the worth of women: it will also mean the end of a very old problem whereby the Australian literary tradition has been primarily that of men.

CHAPTER 2

Women's responsibility

A high point was reached in women's writing during the 1930s and the momentum was maintained for many more years, partly through the efforts of an outstanding woman writer – Kylie Tennant (1922–1988). Her first novel, *Tiburon*, was published in 1935 and because she continued to write until the day she died (February 28, 1988), she is one of the major links in the chain between the admirable achievements of the 1930s and the exciting scenario of the 1980s.

It is not possible to provide here a comprehensive coverage of the contribution made by the women and their writing in the last fifty years, but it wouldn't be sensible to assume, either, that teachers and students of literature – or the reading public in general – are aware of the quality and quantity of women's writing that has been produced during this period. Unfortunately far too many of the works are not known and so the myth can persist that women writers are without a past. One result of this is that comments are constantly being made which suggest that the current band of good women writers has somehow come from nowhere and burst upon the scene.

Such a view is not only mistaken, it can also be quite harmful. It deprives women of their literary tradition – their achievement, identity and strength. With the implication that women have no tradition on which to draw, the image of woman is undermined to the detriment of the society – and of the woman writer. In her impressive investigation of the treatment of women writers, entitled *How to Suppress Women's Writing*, the science-fiction author Joanna Russ discusses the significance of the denial of women's literary success:

> When the memory of one's predecessors is buried, the assumption persists that there were none, and each generation of women

believes itself to be faced with the burden of doing everything for
the first time. And if no one ever did it before, if no woman was
ever that socially sacred creature, 'a great writer,' why do we think
we can succeed now?

<div align="right">(Joanna Russ, 1984, p. 93)</div>

It is because the eclipse of women's literary past – of even women's
immediate past – can have enormous repercussions on women's perform-
ance in the present that it is vital that women know of the *existence* of
that past, and that they know it is one of distinction and merit. It is
important that there should be recognition of the continuum in women's
writing – that readers and writers, and students and teachers should be
aware of the tradition which extends from the contemporary writers
Jessica Anderson and Kate Grenville, back through Miles Franklin and
Rosa Praed, to Catherine Helen Spence and beyond. And this is why it
is necessary to provide here a brief survey of the contributions to women's
literary tradition over the past fifty years.

While most of the women mentioned in this context are not part of
the mainstream, their work is not so difficult to find as that of some of
their 'lost' nineteenth-century predecessors. Whenever possible I have
indicated whether I think the writing of a particular woman is worth the
effort of 'recovery', but such a brief survey and such cursory references
cannot possibly do justice to the nature of the work. Yet even an overview
and an inventory of the links in the chain is preferable to neglect: not
only does it make the dramatic point that there have been many women
writers and that they have produced an enormous volume of work, it
also helps to repudiate the received wisdom that there have been no
women writers, or else that where women have written their work has
not been worthy of inclusion in the canon for transmission from one
generation to the next.

Not that Kylie Tennant falls entirely into this category. She has been
a popular writer for more than fifty years and as such she does have a
place in the Australian literary scene. But it is not always one which is
commensurate with the quality of her contribution: I know of no college
courses which study the work of Kylie Tennant, for example.[149] Yet her
writing – and its significance – merits close attention.

Kylie Tennant is one of the most distinctive – and yet characteristic
– of Australian writers: while working well within the broad and bold
Australian tradition she still differentiates herself sharply from it, partly
through her habit of writing from the perspective of a woman. In concen-
trating on the 'outsiders', on the 'underdogs' in Australian society, she
takes some of the very same themes that have been developed by the
men, but they assume a different shape and are invested with quite

different meanings under Kylie Tennant's pen. The shift in perspective may be subtle but the view the author sees is dramatically different.

Kylie Tennant labels herself as a writer who simply tells it how it really is without cant or pretension.[150] She is part of the school of social realism, but unlike Katharine Susannah Prichard and some of the other writers who have tried to show how it is from the point of view of the underprivileged, Kylie Tennant had no party platform to provide the parameters for her work. I suspect that it is because she does not adhere to a particular party line that certain commentators have sometimes labelled her as apolitical. This has often happened to women whose politics are not the traditional ones of men – and whose analyses encompass a consideration of male power[151] – and Kylie Tennant could be said to be in good company: Virginia Woolf's *Three Guineas* (1938) was called apolitical and its indictment of patriarchy, violence and power was by some considered an indulgence in Britain when the country was on the brink of war!

To my mind, Kylie Tennant is about as political as a writer can get in her exploration of power and its manifestations in society. But I think if she has any particular political position, then because of her distrust of all forms of organisation it would have to be that of an anarchist. She constantly allows the purposeless and random nature of life to unfold and yet, in the face of almost overwhelming meaninglessness, she asserts the joy of the human spirit and the value of human dignity.

Because of her commitment to social realism Kylie Tennant's work also raises the issue of the usefulness and accuracy of the division between fact and fiction. In order to write her books about tramps, travellers, the impoverished and the jailed, Kylie Tennant insisted on having first-hand experience of their conditions of existence. She lived as a tramp, she went to jail – she even learnt to keep bees to write her novel *The Honeyflow* (1956). And she used her material to write moving narratives about the real world. Then later in life she wrote her autobiography – another moving narrative about a real life. And when her novels read like autobiographies (like that of Shannon Hicks in *Ride on Stranger*, 1943) and her autobiography *The Missing Heir* (1986) reads like a novel, there are perplexing questions to be asked about the point and purpose of literary genres.

With its documentation of the poverty and powerlessness of the rural poor – the malice of some of the townspeople, the wisdom of a clergyman and the fickleness of a teacher – Kylie Tennant's first novel *Tiburon* provides a mix that heralded much that was to follow. Her seven novels resonate the experience of Australians for Australians and yet they transcend narrow national limitations. Her work illuminates the relationship between the sexes and provides an unpatronising and perceptive portrayal

of those who are so often deprived of a voice: Kylie Tennant's writing represents an achievement of which any community could be proud.

But she wrote more than novels: her biographies, short stories and plays comprise an impressive body of work, and the numerous pieces that she wrote for children (and school magazines) give some indication of the range of her style and the enduring nature of her concerns. In 1959 *Speak You So Gently* appeared and, as an account of Aboriginal life and an exploration of power and identity, this volume of Kylie Tennant reveals its affinity with the Australian women's literary tradition.

While Kylie Tennant takes as her main characters those who could well be considered pitiful victims, it is a testimony to her skill as a writer that she is able to present them as human beings of stature and strength. She is a tough writer with no trace of sentimentality in her work. First and foremost a *woman* writer, her efforts give the lie to the entrenched belief that women writers have an apolitical or 'soft' view about the workings of the universe, and that the study of relationships is but a footnote on the agenda of significant human concerns. There is enduring wisdom, ready wit and enlightening truth to be found in Kylie Tennant's representation of Australia – which is why her work is so eminently suitable for study in, and outside, her native land.

Better known perhaps than Kylie Tennant for her portrayal of the destruction and disintegration of the Aboriginal way of life, is Mary Durack (1913–). Often in collaboration with her sister Elizabeth Durack (1915–) – who has contributed a series of superb illustrations – Mary Durack has written a number of books which are a celebration of outback existence in the remote Kimberley region of Western Australia. The first product of this literary partnership appeared in 1935 and pointed to Mary Durack's politics and priorities: entitled *All About: The Story of a Black Community on Argyle Station, Kimberley*, this volume was soon followed by a steady stream of children's books designed to portray the full humanity of the Aborigines – and to assert their rights in a country in which they had been dispossessed.

Radical though these books were they were simply not in the same league as *Keep Him My Country*, Mary Durack's major novel which was published in 1955. It stands as one of the most stark, stirring and salutary accounts of the relationship between the individual and the harsh, demanding land, between black and white, and woman and man. Following in the tradition of Katharine Susannah Prichard, Mary Durack courageously and carefully took up the issue of the white man's exploitation of the black woman. And it is in a context where the black woman, Dalgerie, retains her individuality, her beauty and her strength, and the white man, Rolt, reveals his sensitivity and his shame. Because of the way this revolutionary book breaks the bounds of bigotry and challenges narrow assumptions, it well deserves a central and significant

place in the national literary canon: its poetic and political presentation should give it pre-eminence in a literature that seeks to explain, enlighten and expand social horizons.

Although Mary Durack has published many other books which are concerned with the documentation of historical/personal development in Australia, to my mind none of them has quite the same magic as *Keep Him My Country*. But the excellence of this achievement should not be allowed to detract from the rest of her fine work: *Kings in Grass Castles* (1959) and *Sons in the Saddle* (1983) are family sagas (based upon the records of the Durack family) which are still an integral part of the cultural heritage and deserve serious attention. So many of the strands which run through the writing of Australian women come together in the work of Mary Durack, and she herself makes a contribution to their interweaving in her book, *The Aborigines in Australian Literature* (1978).

Nene Gare (1919–) is another writer whose work fits readily into this tradition. A popular writer of considerable substance, she too deals with the controversial issue of assimilation in the black community. Her novel, *The Fringe Dwellers* (1961) – which examines the dilemma of integration from an Aboriginal perspective – has received well-deserved praise: but it is still treated as something unusual, as a 'one-off', rather than as part of the pattern of persistent concerns in women's literature.

The prominence given to this one novel has also served to eclipse some of the other work of Nene Gare – which is undoubtedly worth further study. *A House With Verandahs* (1980), for example, is a refreshing, fascinating – and for the reader often very frustrating – account of the experiences of a young girl growing up in Adelaide in a not-so-wealthy, and certainly not-so-upwardly-mobile, family. An indirect exposé of the tyranny of man – of the means whereby 'the head of the house' always gets his own way while pretending that he is the easiest person on earth to please – the novel touches on the puzzling problem of the extent to which bricks and mortar make a home.

Another woman writer in this popular league (and who has also had her novels made into films) is Nancy Cato (1917–): her trilogy of historical novels (from 1958 to 1962) was published in one volume in 1978 as *All The Rivers Run* and lent itself admirably to the silver screen. An absorbing study of family relationships – a perceptive study of the conflict women must face if and when they try to combine motherhood and creativity – Nancy Cato sets her saga against the shifting backdrop of Australian development and 'progress'. With her probing and provocative questions about the role of art, the rewards of motherhood and the relationship between the sexes, it is not difficult to account for Nancy Cato's success: she manages to combine in her work most of the problems that have, over the centuries, concentrated the mind of the woman writer. And she has done this wonderfully well. As in some of her other novels

(such as *Green Grows the Vine*, 1960; *Brown Sugar*, 1974 and *Forefathers*, 1985), she reveals her very considerable narrative skills.

So many of the Australian women writers have looked to the past to provide meaning for the present, but most of them have been content to confine themselves to the pioneering days or the period just before. But this was not the form of the past that always appealed to Barbara Jefferis (1917–). Her novels are often historical and sometimes return to the Middle Ages (with *Time of the Unicorn*, 1974 and *The Tall One*, 1977, set in the twelfth century for example): they are also frequently feminist in perspective. This combination of the (ostensibly) old and the new, which is characteristic of Australian literature, helps to account for some of the challenge and the charm of Barbara Jefferis' achievement. She is the author of eight novels (which enjoyed a considerable reputation overseas) and of an enlightening biographical study, *Three of A Kind* (1982). She deserves much more recognition for her contribution to the literary scene and it is distressing that her relatively recently published novels are currently out of print.

If Barbara Jefferis' novels deserve a more prominent place in the cultural heritage so too does Dorothy Hewett's novel, *Bobbin Up* (1959). Known primarily for her plays (in particular *The Chapel Perilous*, 1972, and *The Golden Oldies*, 1976) the fiction of Dorothy Hewett (1923–) has generally been ignored. Yet *Bobbin Up* is a work of remarkable achievement and it fits comfortably within the tradition of socialist-feminist novels that was so firmly established in the 1930s.

There are many parallels between the life and work of Jean Devanny and her successor, Dorothy Hewett: like Jean Devanny, Dorothy Hewett was for many years a member of the Communist Party; like Jean Devanny she tried to combine party commitment with family responsibilities – not always with the best results for her work; and like Jean Devanny she explored the issue of sexual liberation in her representation of the oppression of women. There are differences, of course, between these two women writers, but the similarities can provide a basis for making the cross-links between women writers and for mapping the continuity that extends from one generation to the next. To compare and contrast some of Jean Devanny's heroines with the young factory worker in *Bobbin Up* – who must cope with a deadening regime along with an emerging sexuality – is to produce some of the threads which go to make the substance of women's literary traditions.

And while Ruth Park (1923–) is a contributor to that same tradition, there is a marked difference between the patterns that she provides and those which were formed by the socialist/feminist representations of the 1930s. Currently one of the most popular Australian writers (whose work has been widely adopted in schools), Ruth Park experienced many of the same hardships as Jean Devanny, Dorothy Hewett – and Kylie Tennant,

when she set out on her tramp through the outback. Born in New Zealand, Ruth Park moved to Australia and married the writer D'Arcy Niland in 1942, embarking on a literary as well as a marital partnership: it was their determination to earn their living by their pens (and to support their family in the process) that was largely responsible for the poverty they experienced. Literature is not often a lucrative business – for writers.

On her own Ruth Park has written eight novels for adults – of which *The Harp in the South* (1948) and *Poor Man's Orange* (1949) are probably the best known, while *Swords and Crowns and Rings* (1972) won the Miles Franklin Award for Australian Literature. Because she often describes the lives of the poor and the underprivileged without any attempt to make their conditions of existence palatable, Ruth Park has also been classified as a member of the school of social realism. There are stark scenes in her novels, and the picture of humanity that she sometimes presents can be awful and distressing. Of course, Kylie Tennant too has ventured into much the same territory and told much the same story – of tyranny, torment, and sheer tiredness: but with Kylie Tennant there has always been an assertion of independence and a statement about the possible joy of the struggle. Such a sense does not pervade Ruth Park's work: rather, the resolution that she at times suggests is that of resignation. A stance which is perfectly justified in context – but which has significant implications in relation to women's literary traditions.

Much of Ruth Park's children's fiction presents a more positive view: the Muddle Headed Wombat would have to be one of the most delightful creations in children's literature and its creator one of the most perceptive and provocative of educators. Her novels for adolescents, which deal with the growing pains of puberty, are understandably appreciated and applauded by old and young alike.

A meagre living it may sometimes have been but Ruth Park has not been the only Australian woman to make her living by her pen. Patsy Adam-Smith (1926) is another woman of this generation who was equally determined on a writing career – but who didn't look to fiction for financial success. Many of her books are documentaries which come within the category of *Australiana*, providing well-researched, well-written, and welcome additions to the cultural heritage. Patsy Adam-Smith has an impressively long list of publications, not a few of which are about trains and their importance in the development of Australia (*The Rails Go Westward*, 1969; *Across Australia by Indian Pacific*, 1971; *The Desert Railway*, 1974; *Romance of Australian Railways* 1973–4). Her series of sketchbooks which chart the changes made in Hobart, Port Arthur, Launceston and Melbourne, for example, helps to illustrate the range of topics that has been tackled under the rubric of women's writing.

Last but by no means least on this list of prominent women writers

who were born before the Second World War, and whose work has achieved a measure of acclaim, is Elizabeth Harrower (1928–). The author of four novels published in the 1950s and 1960s (prior to the feminist renaissance), her psychological dramas tend to concentrate on the evil that manifests itself in individuals and society. Perhaps Elizabeth Harrower anticipated the call for reform that the women's movement would bring when she presented a picture of marriage as an institution guaranteed to bring out the very worst in those who entered it. *Down in the City* (1957), *The Long Prospect* (1958), *The Catherine Wheel* (1960), and *The Watch Tower* (1966) could hardly be described as delightful studies in human relationships, but they do provide a link with the post-feminist novels of Elizabeth Jolley who, on occasion, also explores the darker side of human emotions.

So here we have a list of women who have been successful writers over the last fifty years. We have women who have published a wide range of books (at home and abroad) in which particular attention has been paid to the 'outsider' – to the poor, the dispossessed, the Aborigines. We have books which cover the various aspects of Australian history, from the pioneering period to the factory floor and railway links: we have books which deal with everything from social protest to character defects, from the violence of existence to the value of relationships.

What has happened to so many of these books – and to so many of the women who have written them? *All* of these authors (with the exception of Kylie Tennant) are alive: many of them continue to write – and to publish. Yet they are not to be found regularly touring the country, addressing audiences, being entertained in literary circles or interviewed on the television. Their wisdom, their experience, is not being sought. These women writers are the living evidence that it isn't necessary to be dead to be neglected, overlooked – eclipsed. There is a wealth of invaluable literary knowledge stored in this community, which stretches from Kylie Tennant to Nancy Cato, from Barbara Jefferis to Dorothy Hewett, from Nene Gare to Mary Durack – but we currently accord it little respect. Women too must make the effort to preserve and transmit our heritage.

CHAPTER 3

●

Postscript

While to some extent the endings of all books can be arbitrary, it could be taking the practice a bit too far to bring this survey to an end with the work of Elizabeth Harrower. For before her, and after her, have been many women writers whose contribution needs to be noted, evaluated and allowed the possibility of a place in the cultural heritage. It has been one of the prime purposes of this book to list the women writers, to ensure that their existence – and numbers – are known, and to encourage further study and acceptance of their work. Too often in the past women writers have not even been assessed: they have been excluded from the canon without benefit of a hearing. And it is to be hoped that in the future women writers will receive a better deal.

In order to make a case for the inclusion of particular women writers in the national literature, it is necessary to know where and with whom to begin. So the following – which is really little more than a check-list – is intended to point to further possibilities for study and to present a framework for the extensive, enriched, and well-documented reality of a female literary tradition.

First, there are all the women dramatists who deserve attention. Apart from Dorothy Hewett there is Oriel Gray (1921–), whose remarkable play *The Torrents* was co-prize-winner with the much acclaimed *Summer of the Seventeenth Doll* in 1955: another example of the way the work of a woman enjoys a very different fate from that of the man. A prolific and highly political playwright of praiseworthy skill, her work parallels some of the developments in the novel in the 1930s and 1940s: Oriel Gray provides an interesting and illuminating account of her life and work in her autobiography *Exit Left: Memoirs of a Scarlet Woman*, 1985.

Jennifer Compton (1949–) is another successful playwright who has written for radio and television as well as the stage, while Valerie Kirwan

(1943–) is a dramatist whose work warrants attention. Annie Brooksbank (1943–) is a scintillating script-writer and delightful dramatist, and Jennifer Rankin (1941–79) was a playwright and poet who pursued feminist themes in her work. Mary Gage was born in England in 1940 and moved to Australia in 1972: she is the author of the unconventional novel, *Praise The Egg* (1981), and of some entertaining plays as well. Therese Radic (1935–) is biographer, playwright (and music critic), and Barbara Stellmach (1930–) has a list of published and performed plays to her credit. Doreen Clarke (1928–) deserves a place in the long line of dramatic women, along with poet and playwright Norma Bloom (1924–). Elizabeth Backhouse (1917–) is the author of six impressive novels and a series of stage plays, and the case for Helen Haenke's (1916–78) inclusion in the canon rests on one published play (and many unpublished plays), along with two volumes of verse.

Actress, member of the Australian Film Board, and playwright extraordinaire across the range of media, Catherine Duncan (1915–) has made a considerable contribution to Australian drama, and Mona Brand (1915–) is a political playwright whose many satirical works have often been less popular at home than abroad. Catherine Shepherd (1912–76) wrote almost exclusively for radio – which relied heavily on the talented work of Gwen Meredith (1907): the creator of some of Australia's longest-running and most popular radio serials (such as *Blue Hills*), Gwen Meredith was also the author of some serious and successful stage plays.

The assertion is sometimes still made that women cannot write drama, that they have not made their mark in this medium – and such a claim is entirely without foundation. For women have been writing plays, often very political – and popular – plays throughout the twentieth century (and even before), and many have enjoyed outstanding success. But what women dramatists have *not* done is win a place in the literary stakes run by men: which is why there are grounds for studying women playwrights in their own right – and perhaps even for examining the rules made by men.

The same could be said of the poets: Australian women writers of verse have emerged in great numbers but they and their work remain under-represented (sometimes unrepresented!) in the literary canon. Jenny Boult (1951–), Jennifer Maiden (1949–), Kate Jennings (1948–), Rhyll McMaster (1947–), Stefanie Bennet (1945–), Colleen Burke (1943–), Judith Rodriguez (1936–), and Grace Perry (1927–87) – who successfully combined the roles of poet and paediatrician – could all pay dividends with further attention. While some of these women have been put forward for consideration by virtue of their inclusion in the *Penguin Book of Australian Women Poets*, because this publication is itself considered 'marginal', the status of the women falls far short of that of the 'mainstream'. If they are not to be confined to a

ghetto, greater effort must be made to establish the centrality and significance of many Australian women poets.

Jill Hellyer (1925–), Gwen Kelly (1922–) and Nan McDonald (1921–74) have all given to the literary heritage; and Bobbi Sykes (1943–), Kath Walker (1920–), and Faith Bandler (1918–) command attention in their own right as black women writers who must contend not just with the primacy of men, but the primacy of whites in the Australian tradition.

Rosemary Dobson (1920–), Gwen Harwood (1920–), and Judith Wright (1915–) are justifiably at the forefront of poets on the Australian scene, but they are not, nor have they ever been, entirely on their own. Around them have been numerous – albeit often unrecognised – women poets who have helped to form the fertile milieu in which these two great writers have worked. What is required now is that all these women – and their network of interconnections – should become the subject of investigation: it is through such study that traditions are traced – and forged.

After the playwrights and the poets come the women writers of fiction, who are currently enjoying what some see as unprecedented prominence. So visible are the women novelists in the late 1980s that it has been seriously suggested within certain literary circles that some form of female conspiracy is being practised: the contention is that women have 'organised' and cornered the market, and that they are buying the books written by their own sex. As if the only way to account for the success of women writers is in terms of some sort of plot or ploy!

Of course this is not the first time that women have been at the forefront of fiction – in Australian literary history or in the history of the novel in general. In the eighteenth century and at times in the nineteenth century the novel was considered 'the woman's form' in England, and as Drusilla Modjeska has pointed out, it was women who predominated on the Australian scene during the 1930s and 1940s. That this past achievement of women writers should be eclipsed – and that their present strength should be considered suspect – is part of the pattern of interruption, silence and denial that marks women's literary traditions, and this needs to be kept in mind in any overview of women's work.

On the contemporary literary scene, Elizabeth Jolley (1923–) is deservedly one of the leading fiction writers of the day and Kate Grenville (1950–) has earned her reputation as one of the best fiction writers that Australia has produced. Jessica Anderson (n.d.) has written outstanding novels that enjoy international appreciation, and Jean Bedford (1946–) has received accolades for her terse, tough style. Blanche D'Alpuget (1944–) has established herself as biographer and novelist, and is looking to script-writing for further creative challenges. Helen Garner (1942–) is provocative and popular, and while Barbara

Hanrahan (1939–) has an international following it is not of the same order as that of the best-selling novelist Colleen McCullough (1937–). The steady and clear stream which has flowed from Thea Astley (1925–) has been a refreshing element in Australian fiction and, sadly, with the death of Olga Masters (1919–86) there will be an end to those chilling and challenging portrayals of female experience which are characteristic of her work.

And within the literary community in which these admirable writers have worked are the many emerging and supporting women writers who have reached various stages of expertise in the practice of their craft: Barbara Pepworth (1955–); Suzanne Falkiner (1952–); Margaret Barbalet (1949–); Helen Hodgman (1945–); Beverley Farmer (1941–); Glenda Adams (1940–); Sara Dowse (1939–); Fay Zwicky (1933–); Mena Abdullah (1930); Glen Tomasetti (1929–); Nancy Keesing (1923–); and Georgia Savage (n.d.). And if Catherine Gaskin (1929–) could be claimed as an Australian (she spent her childhood in Australia where she published her first two novels, *The Other Eden* when she was just sixteen, and *With Every Year*, 1947), questions could reasonably be asked about the particularly fertile nature of the country which produced such an impressive array of prolific, proficient and popular women writers.

This check-list is by no means exhaustive: there are bound to be writers of merit who have slipped through this far-flung net, non-fiction writers included. No inventory of acclaimed Australian women writers would be complete without an entry on Germaine Greer (1939–), or Beverley Kingston (1941–), and Jocelynne Scutt (1948) – to name but a few.

At the risk of being repetitious it must be stressed that Australia has a rich heritage of women writers who have been shamefully ignored, and that it is the society and not just the writers who pay for this neglect. For it is the writers who can draw on and delineate the dimensions of their society – and give it back to the members to explore, to study, and to change. A community which does not have the reflections provided by literature is one deprived of ways of understanding and shaping its world: and a community which has but a distorted reflection – provided by a biased literature such as one which gives undue authority to the male voice – is a community deprived of ways of creating balanced and fair meanings for its world.

This is why it is important to redress the balance, to reclaim those lost women writers who will then enable us to construct a comprehensive world-view and a coverage of the full range of human experience. It is the work of these women writers which documents the existence of those who are *not* dominant (and who must relate to a dominant group) whose

contribution ensures the establishment of a whole and not a partial literary heritage.

This is why we need to go back to women like Winifred Birkett (1897–1966), for example: it is why we need to study her poetry and fiction and to become aware of her interest in and analysis of women's literary traditions. Not only was Winifred Birkett the author of the very popular novel *Three Goats on a Bender* (1934), and two other commendable books of fiction, she also presented a perceptive and persuasive case for the achievement of women in Australian fiction in the sesqui-centenary publication *The Peaceful Army* (1939, edited by Flora Eldershaw), which was designed to celebrate women's contribution to cultural history.

A more prolific novelist whose fascinating fiction has been seriously undervalued, and whose work forms one of the links in the literary chain, is Helen Simpson (1897–1940): her novels *Boomerang* (1932) and *Under Capricorn* (1937) could take their place among the first ranks of Australian literary achievement. That she did not live long and that she spent but a brief time in Australia are no doubt contributory factors in her sad neglect, but these two Australian novels are worthy of preservation and transmission. The author of verse, as well as more than a dozen novels under her own name, Helen Simpson also formed a literary partnership and wrote three works of fiction with the well-known British woman writer – Clemence Dane. And there were numerous published plays, including *The Women's Comedy*, 1926.

Henrietta Drake-Brockman (1901–68) – whose critical work on Katharine Susannah Prichard has already been mentioned – is another substantial woman writer whose efforts link some of the present great achievements with those of the past. A resident of Western Australia, Henrietta Drake-Brockman wrote two novels with local settings (*Blue North*, 1934; *Shelia Lane*, 1936) and played a prominent role in the local literary scene.

Among Henrietta Drake-Brockman's friends was another woman writer who made a commendable contribution to the national tradition: Alexandra Hasluck (1908–), who put much energy into reclaiming and representing women's documented experiences of the past, has performed an invaluable service. Her biography of the pioneering personal chronicler and botanist, Georgiana Molloy (*Portrait With Background*, 1955), and her edition of Lady Broome's letters – *Remembered With Affection*, 1963 – can now be counted in the cultural heritage along with *Unwilling Emigrants* (1959), a study of the convict era in Western Australia. Biographer and autobiographer, Alexandra Hasluck has also written short stories (*Of Ladies Dead*, 1970) and well deserves the title of Australian woman of letters.

But while the literary efforts of some women have been 'rescued' and set before the reading public for pleasure – and appraisal – the contri-

butions of other women writers continue to be 'lost'. What has happened to the work of that best-selling novelist, Jean Campbell (1906–), the author of so many books which dealt with relationships between individuals, and between communities? Her most successful novel was *Brass and Cymbals* (1933) which described the dilemma of a Jewish family facing the problems of integration in Australia, and this novel, along with *Greek Key Pattern* (1935) which explores a similar theme, reveals that Australia has a fifty-year literary tradition (at least!) of dealing with cultural conflict and integration. These are but two of the many 'multicultural' novels that Jean Campbell wrote: the 'old' books which can sometimes cast 'new' light on persistent problems and which are worth preserving.

What it takes to qualify as Australian is an issue that is not confined to fiction: it is consistently raised in relation to the authors. The question of whether or not she is an Australian writer is one which can appear at the forefront of discussion on Mary Rose Alpers (1906–), who wrote numerous books under the name of 'Sarah Campion'. On the one hand, 'Sarah Campion' spent but a few years of her early life in Australia (1938–40), but on the other hand, some of her novels exemplify the distinctive attributes of the Australian tradition. Her Australian trilogy (*Mo Burdekin*, 1941; *Bonanza* 1942; *The Pommy Cow*, 1944) is another pioneering saga which encompasses the quest for gold and the entanglement of emotions between individuals and across continents, and along with the other novels of 'Sarah Campion' which have a high Australian content, these books have a place in literary history.

So too do the unusual and illuminating 'twin' novels of Eve Langley (1908–74): she may have made only a small contribution to the Australian world of letters, yet *The Pea Pickers* (1942) and *White Topee* (1954) constitute a significant achievement. Like the author, the heroine in these novels – Steve – is a poet who wears pants and this is presented as a sensible choice for the fictional character. An itinerant worker, Steve – like Kylie Tennant and her heroines – was aware of the advantages of trousers not just because of the permitted freedom of movement but because in terms of personal safety it was often better to be able to pass as a man. But if Eve Langley knew the benefit of trousers, her critics did not: it is distressing to find that sometimes there is more comment about her eccentricities as a person than about the strengths of her writing.

I think her novels are gems: they stand well on their own as a documentation of the experiences of a sensitive woman earning an independent living in the outback – and they also form an integral part of that tradition exploring the conflict between creativity and 'femininity' in the Australian heroine. *The Pea Pickers* and *White Topee* have much in common with *My Brilliant Career* – and with the later *All The Rivers Run*.

While I deplore the way in which the details of the personal life of women writers are often used to discredit their work, this does not mean that there is no place for biographical documentation. On the contrary, it is important to have information on the private lives of women writers because, unlike male writers, personal circumstances can very often constitute women's conditions of work. Whether a woman is married, or has children, can actually determine whether or not she has the opportunity to write, and this is partly why marriage and motherhood feature so predominantly – and problematically – in women's literary work.

This is why I would like to know more about 'Velia Ercole' (Margaret Gregory, 1910–), for example. Born in Australia, she moved to England where she wrote numerous works of popular fiction – but not before she won the *Bulletin* award in 1932 for her novel, *No Escape*: this work, which dealt with the sometimes insurmountable problems faced by migrant women, was followed by another novel on identity crises, *Dark Windows* (1934).

The travel and fiction writer Nancy Phelan (1913–) is one more woman whose life and work intrigues me and about whom I would like further information. I have also been fascinated by the novels of the forgotten Margaret Trist (1914–86) and would welcome additional details about her art and her life. Her indirect indictment of a father – which is the substance of her novel, *Daddy* (1947) – challenges all I know about the ethos of the 1950s, and I am curious about the content of her other novels (*Now That We're Laughing*, 1945; *Morning in Queensland*, 1958) and short stories (*In The Sun*, 1943; *What Else is There?*, 1946).

I am also intensely curious about the real life of Charmian Clift (1923–69): sufficient evidence exists to suggest that she has not rightly been overshadowed by her husband's work. Where not presented as a liability she is sometimes seen simply as an appendage to her husband's contribution and such a portrayal does not fit readily with the Charmian Clift that I know. It was a proud and perceptive woman who wrote those weekly columns for the *Sydney Morning Herald* in the 1960s and whose views were in many respects years ahead of their time: the problems she posed and the way that she phrased them heralded the beginning of women's consciousness-raising sessions in the early 1970s.

While I am fully aware of the fact that Charmian Clift collaborated on three successful novels with her husband – and fully aware of the widespread assumption that it was he who was the major talent – these are not necessarily the novels I wish to study. *Walk to Paradise Gardens* (1960) and *Honour's Mimic* (1964), which are Charmian Clift's own efforts, are among the works I would prefer to see in print, so that when it comes to assessing the worth of this witty writing woman I can make the decision for myself.

This is the primary purpose behind the recovery of women writers

and their work. Because we can see the bias that has worked against women and their writing, because we can see that as a group they have been systematically and unfairly excluded from the literary canon, it is important to go back to the initial sources and to assess women's work for ourselves. We cannot rely on the received wisdom that would have us believe that the reason there are only a few women writers in the Australian literary tradition is because there have been only a few women whose work was any good. We cannot afford to accept the argument that the absence of women writers in school curricula, college courses, and literary histories is a measure of women's worth.

When it comes to assessing the value of women's writing, readers and critics have to start almost from scratch. First, we have to *find* all the women writers and make a list of their works, which is by no means an easy feat, but one which is positively elementary in comparison with the task of finding (and reading) all their books: for so much of women's work is out of print and so many of their works have been irretrievably lost.[152]

Only when the list has been made, the books have been read, and the obvious networks between writers and their writings have been traced, is it possible to begin to measure the comparative worth of the works. Which is one reason why this survey has not prematurely ventured into the controversial area of who are the great – and who are the greatest – among the community of writing women. At this stage, when there are so many 'unknowns', it would simply serve as another form of 'gate-keeping' if I were to let my individual/personal preferences prevail. Were I to suggest that there were women writers who were not worth reclaiming, whose contribution was below standard, sentimental or silly, I would be practising the art of excluding women, without benefit of a fair hearing – the very practice that I have criticised, and would like to see come to an end.

If ranking is really required (and I have my reservations about this) then rather than the subjective judgment of a man (and I use the term advisedly) what is needed is a well-informed consensus about the women writers who form the strong and the weak links in the literary chain. And such a consensus is not possible unless and until a number of these women writers are known and their works have been read – which is a good reason for getting many of them back in print.

There are plenty of names with which to begin: there is the fiction writer and journalist Alice Grant Rosman ('Rosna' 1887–1961), for example, who needs to be reclaimed and, with the novelist Myrtle Rose White (1888–1961), needs to be reassessed. Doris Egerton Jones (1889–1973) could well be a fiction writer who has much to contribute to the contemporary scene, and Mabel Brookes (1899–1975) could warrant current re-examination. The uninhibited poet, dramatist and fiction

writer Dulcie Deamer (1890–1972) could provide a fascinating source
of study, and Lesbia Harford (1891–1927) is beginning to attract what
could prove to be well-paid attention. Dorothy Catts (1896–1961) has
long been forgotten, and an appreciation of her fiction and biographical
writing, along with that of fellow fiction writer and poet Edith Mary
England (1899–1979), could well be in order. And Joan Lindsay
(1896–1984), author of *Picnic at Hanging Rock*, 1967, and Ernestine Hill
(1900–72), author of the highly successful *My Love Must Wait* and
numerous accounts of outback Australia, have a place yet to be deter-
mined in women's literary traditions.

The work of Dora Birtles (1904), travel writer, fiction writer and poet,
looks promising, as does that of Mena Calthorpe (1905) and Elizabeth
Riddell (1910), and in a context where the name *Nolan* is enlivened with
such artistic connotations, it could be considered unusual that the work
of Cynthia Nolan (1917–) has received so little attention.

Of course the list could continue: many are the names that have been
left out on the grounds of space (and style!). But even at this stage I
want to know more about Deirdre Cash ('Crienne Rohan', 1925–63),
and much more than the current entry in the *Oxford Companion to
Australian Literature* tells me about Elizabeth Riley and her daring and
engaging novel: under the heading 'Feminism in Australian Literature'
I am informed that 'Lesbian novels include Elizabeth Riley's *All That
False Instruction* (1975) and Beverley Farmer's *Alone* (1980).' Such state-
ments hardly suggest the stature of the work or the desirability of further
interest.

I started this study because – in defiance of the evidence – I was
convinced that there was a 'buried treasure' of Australian women's litera-
ture which would be of interest to general readers and the literary
community. Because I know from other contexts that women can present
a very different view of the world from the one encoded by men, I
pursued this study on the premise that I would find a different perspective
on the history of Australia, and a different scheme of values in the work
of the women. And from this study I have learnt that there have been
many wonderful Australian women writers who have been – and who
are still being – excluded from the literary heritage. I have also learnt
that we continue to keep out the view of the world and the values of
women – at our own risk. For without the women there can only be a
limited understanding of Australian history – and of humanity: with
them, there is a dramatic alteration in the image of Australia – and
Australians – and the possibility of representing the full range of human
experience.

Apart from being stimulating, the research for this book has been
enormously satisfying, yet there are still some tantalising loose ends which
will not let me rest: who was Patricia Stonehouse who wrote poetry and

novels (fifteen of them) under the names 'Lindsay Russell', 'Harlingham Quinn' and 'E. Hardingham Quinn'?

Notes

1 This situation has since been remedied by the compilation of the excellent *Australian Women Writers* by Debra Adelaide, forthcoming from Pandora Press.

2 Some of the nineteenth-century novelists, such as Catherine Spence, Rosa Praed, Ada Cambridge and 'Tasma', are currently being reprinted and have not therefore been quoted from extensively.

3 See Virginia Woolf, 1928, *A Room of One's Own*.

4 For further discussion of Margaret Cavendish and her contribution to literary forms, see Dale Spender, 1986, pp. 35–46.

5 See Eve Pownall, 1980, for further details.

6 See, for example, the Journal of Lt R. Clark and the Diary of Surgeon A. Bowes, both of which are available in manuscript in the Mitchell Library, Sydney, N.S.W.

7 Many of the early newspapers consisted almost entirely of such letters: for further discussion see Ruth Perry, 1980, and James Sutherland, 1986.

8 See, for example, the letters of Elizabeth Macarthur on page 18–26.

9 It should not be assumed that this was the only or the enduring attitude of white women to black women; on the contrary, women's literature is full of accounts in which the black woman is seen as a sister and is portrayed sympathetically.

10 For further information, see Dymphna Cusack, 1938.

11 See Candida Ann Lacey (ed.), 1987.

12 For example, virtually all the items on display in the shop of the State Library of NSW are those which relate to men; all the reproductions of letters and diaries are of those written by men; the posters, neckscarves and most of the postcards are those of men, and anyone could be forgiven for concluding from this that women played no part in the historical development of Australia.

13 The Mitchell Library holds a collection of Elizabeth Macarthur's letters dating from 1789 until 1849. All her known journal and letter writing for the period 1789–98 is contained in the publication edited by Joy N. Hughes,

1984: some of Elizabeth Macarthur's letters have also been published in Helen Heney, 1985.

14 For further discussion, see Dale Spender, 1986.

15 For further discussion, see the section on Annabella Boswell and Kylie Tennant.

16 Another of Biddulph's properties.

17 Whom Rachel Henning later married.

18 The journal was first published in contemporary form in 1965: previously it was published as *Early Recollections and Gleanings from an Old Journal*, no date.

19 For further discussion, see p. 112.

20 For further discussion of Georgiana McCrae, see p. 47.

21 Initially, the person who *received* the letter paid the postage.

22 For further discussion, see p. 59.

23 A monument at Parramatta Park marks the spot.

24 Henry Savery's *Quintus Servinton* was the first novel to be published – in Hobart Town, in 1831.

25 This changed when, more than twenty years later, she 'revised' her journal for publication.

26 See Jessie Bernard, 1972, *The Future of Marriage*, for further discussion of the advantages that marriage has for men.

27 The original letter is mis-dated as 1842.

28 See Pamela Statham, 1981, p. xxvii.

29 For further discussion, see E. Morris Miller, 1957, 'Australia's First Two Novels: Origins and Background', *Tasmanian Historical Research Association Proceedings*, vol. vl, no. 2 September and no. 3 December.

30 This was Annabella Boswell's point as well: see p. 41.

31 See Elizabeth Webby, forthcoming, for the emergence of the book in Australia.

32 For further information on Caroline Norton, see Dale Spender, 1982.

33 See E. Morris Miller, 1957, 'Australia's First Two Novels: Origins and Backgrounds', for further discussion.

34 See his poem 'Bluestocking Revels or The Feast of the Violets'.

35 I know of no woman writer of her calibre who precedes her.

36 Charles Meredith's financial incompetency did not preclude him from becoming Colonial Treasurer – in three ministries – when he embarked on his political career as a means of earning a living. See Vivienne Rae Ellis, 1979, p. 180.

37 Her book *How to Observe Morals and Manners*, 1838, is credited with being the first sociological text on methodology.

38 For further discussion, see Lucy Frost, 1984, pp. 87–150 as well as this volume, p. 82.

39 For further details of Annie Baxter and extracts from her diary, see Lucy Frost, 1984, pp. 87–150.

40 Women have a long tradition of using the novel for educational purposes: in the seventeenth and eighteenth centuries, when they first experimented with fiction, women were excluded from formal education and relied on the

novel for much of their learning: for further discussion, see Dale Spender, 1986, *Mothers of the Novel*.

41 'Silence and interruptions' is the description used by Adrienne Rich (1980) to characterise the patterns in the reception of women's writing.

42 There is another reason for reclaiming Ellen Clacy: in the prestigious and influential *History of Australian Literature* by H. M. Green (1984) she is referred to as Ellen Tracy (see pp. 349 and 1540). In this she affords a practical example of the unintended means by which a writer can get lost, so it is important to reinstate her in the records.

43 Ellen Clacy also wrote *Lights and Shadows of Australian Life* (2 vols), 1854, Hurst and Blackett, London.

44 This book is published by Virago under the name, Lady Barker.

45 In her excellent chapter 'Writers, Printers, Readers; The Production of Australian Literature to 1855', Elizabeth Webby has pointed out that *The Guardian* was never published for public sale. She adds to the information provided by Gwendoline Wilson (who in researching a biography of pioneer pastoralist and politician Terence Aubrey Murray found that it was his sister who had written *The Guardian*) when she reveals that the Murray family paid for the private printing of the novel, which Anna Maria Bunn may have written as a 'mental diversion' after her husband's death. But even though the cost of publication may go some way towards explaining the absence of further printed work there are still some questions which could be asked about if or why Anna Maria Bunn only wrote one novel, when she was clearly so capable.

46 While the term was a common one at the time it was more often than not a misnomer in the Australian context where the 'domestic realm' could be extended to encompass the care of dairies and orchards, the building of fences, planting crops – and fighting fires. When men engaged in these activities they were not of course 'domestic' and there are many parts of the Third World where this blatant distinction continues to prevail: when women work in the fields it does not count as work and is not included in the GNP; when men work in the fields it is most definitely called work!

47 For further discussion, see pp. 141 onwards.

48 Mulini Press, Canberra, has reprinted *Excursions from Berrima, and a Trip to Manaro and Molonglo in the 1870s* (1980) as well as *A Voice from the Country* (1978) and *Tom Hellicar's Children* (1983).

49 See Dale Spender, 1985, for further discussion.

50 Maud Franc, pp. 89–90, does deal with a woman alcoholic but in a much more sentimentalised manner.

51 For further discussion of the way men appropriate women's ideas – and the way women help to maintain men's image as the superior sex – see Dale Spender, 1985, and Sally Cline and Dale Spender, 1987.

52 I am indebted to Elizabeth Webby for drawing my attention to some additional information on Eliza Winstanley in *The Mrs Siddons of Sydney* by Eric Irvin, 1971, pp. 165–83.

53 This looks extraordinarily interesting – but I can't find a copy!

54 Virago was the first women's publishing house in London, established in 1979, and it has become highly influential in the world of letters.

55 See Lorna Ollif, 1978, p. 10.
56 This of course does not mean that they always wrote about Australia.
57 See *The Autobiography and Letters of Mrs O W Oliphant*, 1899.
58 I see my own development as a writer inextricably linked with letter writing: it was not until I was away from home and writing regular epistles to my family that I began to venture seriously into the realm of public writing.
59 For further discussion, see the section on Ethel Turner *et al*, p. 220.
60 See pp. 231 for more details on Mary Grant Bruce and the dismissal of her as a writer of children's fiction.
61 Because Australian women obtained the vote long before English women, this was one area where Australian women writers could assuredly 'lead the way'.
62 'Up the Murray', 1875; 'In Two Years Time, 1879; 'Dinah', 1879–80; 'A Mere Chance' 1880; 'Missed in the Crowd', 1881–2; 'Across the Grain', 1882; 'The Three Miss Kings', 1883; 'Mrs. Carnegie's Husband', 1884–5; 'Against the Rules', 1885–6. Three were later published in book form: *In Two Years Time*, 1879, Bentley, London; *A Mere Chance*, 1882, Bentley, London; *The Three Miss Kings*, 1891, Heinemann, London.
63 It has since been reprinted by Pandora Press; Virago has also reprinted *The Three Miss Kings*, 1987.
64 For further discussion, see Jill Roe, 1972, and Australian Women Writers, edited by Debra Adelaide.
65 Reprinted by Pandora Press in 1988.
66 More commonly spelt 'Rolf Boldrewood'.
67 This is not strictly accurate because Queensland did not become separated from New South Wales until 1867.
68 There is some inconsistency about the spelling of 'Marroon' – partly because it comes from the Aboriginal *Marroon* or *Murrun* meaning Iguana (see Rosa Praed, 1904, p. 35). The ABC notes which accompanied the broadcast of *Policy and Passion* (Nov./Dec. 1986) spelt it 'Maroon'; Raymond Beilby and Cecil Hadgraft (1979) spell it 'Marroon'; Colin Roderick (1948) spells it 'Marroon'.
69 Rosa Praed's autobiographical accounts – like those of Kylie Tennant – confound the categories: many of her novels are substantially autobiographical, and as Debra Adelaide, 1985, has pointed out, her autobiography reads very much like a novel.
70 My emphasis: done in part to make the link with Elaine Showalter's book, which aimed to construct women's literary tradition and which was entitled *A Literature of Their Own* (1978) in reference to a statement of John Stuart Mill's.
71 This has since been reprinted by Pandora Press, London, in the 'Mothers of the Novel' series.
72 *The Bond of Wedlock* has been reprinted by Pandora Press.
73 *The History of Betsy Thoughtless* has also been reprinted by Pandora Press: for further information on Eliza Haywood, see Dale Spender, 1986.
74 They are only non-conformist in terms of the male standard of course: in relation to women's writing they are traditional.
75 With Justin McCarthy, *The Right Honourable*, 1886, Chatto & Windus,

London; *The Rebel Rose*, 1888, Chatto & Windus, London; *The Ladies Gallery*, 1888, Bentley, London.

76 This was Virginia Woolf's criticism of a male-dominated critical tradition which penalised women for their different perspective: see *A Room of One's Own* and 'Women and Fiction' particularly.

77 See, in particular, Charlotte Perkins Gilman, 1899, *Women and Economics*: reprinted 1966. For further discussion of Charlotte Perkins Gilman's economic philosophy, see Dale Spender, 1982, pp. 373–80.

78 Serialised as 'Uphill Work' in the Adelaide *Weekly Mail* 1863–4, before being published as a book by Bentley in 1865.

79 See Dale Spender, 1986.

80 This was serialised as 'Hugh Lindsay's Guest' in the Adelaide *Observer* in 1867, and then published by Bentley in 1868.

81 It was published by Penguin Australia and skilfully edited by Helen Thomson, but has made no great impact on educational literary courses – not even those that are concerned with the contributions of Australia.

82 Catherine Spence is not included in the *Oxford Anthology of Australian Literature*.

83 For further details, see Susan Magarey's biography of Catherine Spence, *Unbridling the Tongues of Women*, 1985.

84 Both these novels have been reprinted by Pandora Press (1988).

85 Private correspondence.

86 See Dale Spender, forthcoming, *The Writing or the Sex? Judgement of Literary Men – or, You don't have to read women's writing to know it's no good.* This is a critique of the sexual double standard that operates in literary criticism and reveals that it is the sex rather than the writing which is ordinarily responsible for the status of work: once it is known that the work is that of a woman it can be dismissed *without* being assessed which is quite a different matter from being assessed, found wanting – and then dismissed!

87 I am deeply indebted to Sue Martin for introducing me to Mary Gaunt, and to Ian McLaren for his annotated bibliography.

88 The 'story was based on the experiences of her brother Guy, who, as part of his training with the Royal Navy Reserve, crossed the Atlantic to Nova Scotia.' Ian McLaren, 1986, p. xiii.

89 Private correspondence.

90 It would be interesting to do a study on how many reputable novelists have written stories on heroines who get married and are unhappy ever after – as in the case of Ada Cambridge's *Sisters* (1904), for example: and how many have written about 'wicked' heroines who go on to have wonderful lives – as in the case of Eliza Haywood's *Betsy Thoughtless* (1751): perhaps the image of the genre of romantic fiction would change if such a study were undertaken.

91 All the critical quotes are from the 1910 Laurie's Colonial Library Edition of *The Mummy Moves*.

92 See Sally Krimmer and Alan Lawson, 1980, for clarification.

93 Her third husband, from whom she separated not long after she was married, was Lord Headley – 'colourful engineer, sportsman and president of the Muslim Society', *Oxford Companion to Australian Literature*, p. 79.

94 'The Drover's Wife'; by Henry Lawson was published in 1892.
95 For further detail, see the section 'Polish, plagiarism and plain theft' in Dale Spender, *The Writing or the Sex? Judgement of Literary Men* (forthcoming), and Debra Adelaide, 1986.
96 This account is not strictly a novel, but a version of Aboriginal life.
97 At a class of mature women students in Sydney in 1987, a survey revealed that twelve of the thirty-two women present had at one period in their lives believed that *We of the Never Never* was the *only* book of note to have been written by an Australian woman!
98 For further discussion of Alice Henry, see Drusilla Modjeska, 1981.
99 See Dale Spender and Carole Hayman (eds), 1985, *How the Vote Was Won and other Suffragette Plays*, for further information.
100 I am again indebted to Debra Adelaide for drawing my attention to this article.
101 See C. Hay Thomson, 1909.
102 See Colleen Burke, 1985.
103 A selection of her poems have been included in Colleen Burke's *Doherty's Corner: The Life and Work of Poet Marie E. J. Pitt*.
104 The skills and resources of all these women were appropriated and used to enhance the reputation of particular men: for further discussion, see the section 'Polish, plagiarism and plain theft' in Dale Spender, *The Writing or the Sex: Judgement of Literary Men*, forthcoming.
105 See, for example, Elaine Showalter, 1984, who set out the case for and against in her article, 'Women who write are Women'.
106 See Fellowship of Australian Writers' meeting, 20 September 1933, in *All About Books*, 14 October 1933, pp. 169–70.
107 Private discussions.
108 *Middlemarch; a Study of Provincial Life* by George Eliot, 1871–2.
109 See Marjorie Barnard.
110 The life and work of these two women are discussed at greater length on p. 340.
111 See Dale Spender, 1986, *Mothers of the Novel*, for further details on Sarah Fielding, Maria Edgeworth and the growth of adolescent fiction.
112 For discussion of girls' stories, see Mary Cadogan and Patricia Craig, 1986, *You're A Brick, Angela*.
113 For further information, see Lynne Spender, *Ethel Turner*, unpublished.
114 *Miss Bobbie* was published in 1897.
115 The Lintons are the Billabong family – containing the children, Norah and Jim.
116 See, for example, Prue McKay, 1986.
117 See Margaret Mead, *Male and Female*, 1950.
118 There is even a name for this phenomenon, 'The Semantic Derogation of Women'; see Muriel Schulz in Dale Spender, 1985, pp. 16–19.
119 My thanks to Jane Marcus, private communication, for this snippet of information.
120 I have my reservations about this assertion.
121 The Bluestockings would be one example but they were more of an intellectual discussion group.

122 The financial rewards for women writers during this period are discussed by Drusilla Modjeska, 1981, pp. 193–4: Katharine Prichard's first royalty payment for *Working Bullocks*, for example, was £23 (when the typing bill was £25!); Dymphna Cusack received only £23 for her first novel, *Jungfrau*, 1936. And Marjorie Barnard (1967) insists that Miles Franklin earnt only £25 from *My Brilliant Career*.

123 Barbara Ross is currently working on a biography and letters of Dorothy Cottrell: hopefully her book will find a publisher and we can learn more about this particular Australian woman writer.

124 See Drusilla Modjeska, 1981, pp. 16–20.

125 *Fourteen Years: Extracts from a Private Journal 1925–1939*: (1948) Meanjin Press, Melbourne.

126 For further discussion of Zora Cross, see Drusilla Modjeska, 1981, pp. 21–2.

127 See Candida Lacey, 1986, for further discussion of proletarian women writers in the United States.

128 See Anna Walters, 1977, and Dale Spender, 1985, pp. 206–9, for further discussion.

129 There are many parallels between the life of Jean Devanny and that of Marie Pitt.

130 For further details about these difficulties in relation to her notion of art and her assertion of women's autonomous sexuality, see Drusilla Modjeska, 1981.

131 See, for example, 'Sydney Partrige and Cecil Warren', Dorothea Mackellar and Ruth Bedford, not to mention Dymphna Cusack and Florence James, and Miles Franklin and Dymphna Cusack; and Mary and Elizabeth Durack, and Helen Simpson and Clemence Dane. No doubt there are many more.

132 Miles Franklin could not find a publisher for her sequel to *My Brilliant Career* (1901) despite the great success of the initial work. *My Career Goes Bung* was not published until 1946.

133 Many of Elizabeth Gaskell's 'heroines' are 'fallen women'.

134 See A. Grove Day, 1976, for further discussion.

135 Eleanor Dark to Nettie Palmer, 16 May 1934. Palmer Papers, National Library of Australia, Manuscript 1174/1/4438: quoted in Drusilla Modjeska, 1981, p. 91.

136 My own surveys reveal that she remains virtually unknown in England, despite the Virago reissue of many of her works.

137 Private communication.

138 All personal information comes from interviews with Florence James – who has also just completed editing the unabridged version of *Come in Spinner*, for its first publication in 1988.

139 Most of the women writers raised the issue of abortion: in the novels of Katharine Susannah Prichard, Dymphna Cusack and Florence James, and Kylie Tennant, the woman who has the abortion dies.

140 This has been reprinted in the Hutchinson Series, 'The Century Travellers', 1985.

141 This is the means whereby so many women writers get lost and is discussed

extensively in *Mothers of the Novel: 100 Good Women Writers Before Jane Austen*, Dale Spender, 1986.

142 For further discussion, see Dale Spender, 1986.

143 Despite losses there are still approximately twenty unpublished Miles Franklin works.

144 Elizabeth Robins' radical/political drama, *Votes for Women*, was published by Mills and Boon in 1907.

145 The horse was crucially important to many of Miles Franklin's heroines: it represented mobility and independence in the Australian outback, in much the same way as the bicycle represented mobility and independence to British women.

146 *Up The Country*, 1928; *Ten Creeks Run*, 1930; *Back to Bool Bool*, 1931; *Prelude to Waking*, 1950; *Cockatoos*, 1954; *Gentlemen at Gyang Gyang*, 1956.

147 *Such is Life*, a 'classic' novel by Joseph Furphy, published by the Bulletin Publishing Co. in 1903.

148 There is not even a considerable body of critical material on Kylie Tennant, although to be ignored by the academic establishment could perhaps be construed as a blessing: one critical study of Kylie Tennant and her work is provided by Margaret Dick, 1966.

149 Private communication from a series of interviews made with Kylie Tennant.

150 Dora Russell, in 1984, consistently made the point that where women's politics departed from those of men women were labelled as *apolitical*.

151 Unfortunately, so many libraries are barely co-operative in this regard.

References

Adelaide, Debra, *Comments on My Australian Girlhood*, Unpublished, 1985.

Adelaide, Debra, 'Mollie Skinner and the Shadow of D. H. Lawrence', Paper given at the *Association for the Study of Australian Literature*, Annual Conference, Townsville, August 1986.

Adelaide, Debra, *Australian Women Writers: A Bibliographic Guide*, Pandora Press, London, 1988.

Allen, Margaret, 'Introduction', Catherine Martin, *The Incredible Journey*, Pandora Press, London, 1987, pp. vii–xiii.

Atkinson, Louisa, *Gertrude the Emigrant: A Tale of Colonial Life* (by An Australian Lady), J. R. Clarke, Sydney, 1987.

Auchterlonie, Dorothy, 'The Novels of Kylie Tennant', *Meanjin*, No. 4, 1953.

Barker, Lady, (*see also* Lady Broome) *Station Life in New Zealand*, Virago, London, 1984.

Barnard, Marjorie (1943), *The Persimmon Tree and other Stories*, Virago, London, ('Habit', pp. 126–39), 1985.

Barnard, Marjorie, *Miles Franklin*, Hill of Content, Melbourne, 1967.

Barnard Eldershaw, M. (1938), *Essays in Australian Fiction*, Melbourne University Press, 1970.

Barnes, John, 'Australian Fiction to 1920' in Geoffrey Dutton (ed.), *The Literature of Australia*, Penguin, Melbourne, 1982, pp. 149–95.

Baxter, Annie, '"Doing Rustic So Well"; Letters to Henrietta' and '"But What oh What Can I Do?"; Journal at Yesabba' in Lucy Frost, (ed.), *No Place for a Nervous Lady: Voices from the Australian Bush*, Penguin, Melbourne, Australia, 1984, pp. 87–150.

Baynton, Barbara, *Barbara Baynton: Portable Australian Authors*, University of Queensland Press, Brisbane, 1980.

Beasley, Jack, *The Rage for Life: The Work of Katharine Susannah Prichard*, Current Books, Sydney, 1964.

Behn, Aphra (1688), *Oroonoko and Other Stories*, edited by Maureen Duffy, Methuen, London, 1986.

Beilby, Raymond and Hadcraft, Cecil, 'Ada Cambridge, Tasma and Rosa Praed', *Australian Writers and Their Work*: Oxford University Press, Melbourne, 1979.

312 *References*

Bell, Diane, *Daughters of the Dreaming*, McPhee Gribble/George Allen & Unwin, Melbourne and Sydney, 1983.

Bernard, Jessie, *The Future of Marriage*, World Publishing, New York, 1972.

Birkett, Winifred, 'Some Pioneer Australian Women Writers' in Flora Eldershaw (ed.), *The Peaceful Army*, Women's Advisory Council, Sydney, 1938, pp. 109–24.

Bodichon, Barbara, *Women and Work*, Pamphlet reprint, Fawcett Library, London, 1857.

Boswell, Annabella, *Annabella Boswell's Journal*, Angus & Robertson, Sydney, 1981.

Broome, Lady Mary Anne, *Station Life in New Zealand*, Macmillan, London, 1870. See also Lady Barker, 1984.

Broome, Lady Mary Anne (1885), *Letters to Guy* published as *Remembered with Affection*, with 'Notes and A Short Life', by Alexandra Hasluck, Oxford University Press, Melbourne, 1963.

Broome, Lady Mary Anne, *Colonial Memories*, Smith Elder, London, 1904.

Brown, Eliza and Thomas, *A Faithful Picture: the letters of Eliza and Thomas Brown, at York in the Swan River Colony 1841–1852*, (edited by Peter Cowan: introduced by Alexandra Hasluck), Fremantle Arts Centre Press, Western Australia, 1977.

Bruce, Mary Grant, *The Peculiar Honeymoon and other writings* (edited by Prue Mckay), McPhee Gribble, Melbourne, 1986.

Bunn, Anna Maria, *The Guardian: A Tale by an Australian*, J. Spilsbury, Sydney, 1838.

Burke, Colleen, *Doherty's Corner: The Life and Work of Poet Marie E. J. Pitt*, Angus & Robertson, Sydney, 1985.

Cadogan, Mary, 'Introduction' to Sarah Fielding, *The Governess or The Little Female Academy (1749)*, Pandora Press, London, 1987.

Cadogan, Mary and Craig, Patricia, *You're A Brick Angela: The Girls' Story, 1839–1935*, Victor Gollancz, London, 1986.

Caffyn, Kathleen, *see* 'Iota'.

Cambridge, Ada, *Thirty Years in Australia*, Methuen, London, 1903.

Cambridge, Ada, *Sisters*, Hutchinson, London, 1904.

Clacy, Mrs Charles (Ellen) (1853), *A Lady's Visit to the Gold Diggings of Australia in 1852–1853, Written on the Spot*, reprinted 1963, edited by Patricia Thompson, Lansdowne Press, Melbourne, 1963.

Clarke, Patricia, *The Governesses: Letters from the Colonies 1862–1882*, Hutchinson Australia, Melbourne, 1985.

Cline, Sally and Spender, Dale, *Reflecting Men: At Twice Their Natural Size*, André Deustch, London, 1987.

Coleman, Verna, 'Foreword', in Franklin, Miles, *My Career Goes Bung*, Angus & Robertson, Sydney, 1980, pp. 1–4.

Craig, Caroline, 'Cambridge, Ada and Baynton, Barbara', *Refractory Girl*, March, 1979, pp. 31–4.

Cusack, Dymphna, 'Mary Reby' in Flora Eldershaw (ed.) *The Peaceful Army*, 1938. (reprinted Penguin, Melbourne, 1988)

Cusack, Dymphna, *'Miles Franklin' A Tribute by Some of Her Friends*, Bread and Cheese Club, Melbourne, 1955.

Cusack, Dymphna (1958), *Chinese Women Speak*, Century Hutchinson, London, 1985.

Dark, Eleanor (1936), *Return to Coolami*, Angus & Robertson, Sydney, 1981.

Dick, Margaret, *The Novels of Kylie Tennant*, Rigby, Adelaide, 1966.

Drake-Brockman, Henrietta, *Katharine Susannah Prichard*, Oxford University Press, Melbourne, 1967.

Dutton, Geoffrey (ed.), *The Australian Collection: Australia's Greatest Books*, Angus & Robertson, Sydney, 1985, pp. 1–4.

Ellis, Vivienne Rae, *Louisa Anne Meredith: A Tigress in Exile*, Blubber Head Press, Tasmania, 1979.

Fitzgerald, Robert D. (ed.), *Mary Gilmore: Australian Poets*, Angus & Robertson, Sydney, 1963.

Fitzgerald, R. D., 'Australian Women Poets', *Texas Quarterly*, Summer 1972, pp. 75–97.

Franklin, Miles (1946), 'To All Young Australian Writers, Greetings?' in *My Career Goes Bung*, Angus & Robertson, 1980, pp. 5–8.

Frost, Lucy, *No Place for a Nervous Lady: Voices from the Australian Bush*, McPhee Gribble/Penguin, Melbourne, Australia, 1984.

Gaskell, Elizabeth (1857), *The Life of Charlotte Brontë*, Penguin, Harmondsworth, Middlesex, 1985.

Gaskell, Elizabeth, *The Letters of Mrs Gaskell*, J. A. V. Chapple and A. Pollard (eds), Manchester University Press, 1966.

Gaunt, Mary, *Dave's Sweetheart*, Edward Arnold, London, 1894.

Gaunt, Mary, 'The Other Man', *Argus*, Melbourne, 13 October 1894–12 January 1895.

Gaunt, Mary, *Kirkham's Find*, Methuen, London, 1897.

Gaunt, Mary, *Deadman's*, Methuen, London, 1898.

Gaunt, Mary, '"An Australian Authoress at Home: Mary Gaunt of Warrnambool, Victoria" by E.M.F.', *Sydney Mail*, 26 February, reprinted *Warrnambool Echo*, 26 February 1898.

Gaunt, Mary, *Alone in West Africa*, T. Werner Laurie, London, 1912.

Gilman, Charlotte Perkins (1899), *Women and Economics: The Economic Factor between Men and Women as a Factor in Social Revolution*, Harper & Row, New York, 1966.

Gilmore, Mary, *Letters of Mary Gilmore* (selected and edited by W. H. Wilde and T. Inglis Moore), Melbourne University Press, Melbourne, 1980.

Gray, Oriel, *Exit Left, Memoirs of A Scarlet Woman*, Penguin, Melbourne, 1985.

Green, Dorothy (1973), *Henry Handel Richardson and Her Fiction*, Allen & Unwin, Sydney, 1986.

Green, H. M., *History of Australian Literature*, 2 vols (revised by Dorothy Green), Angus & Robertson, Sydney, 1984.

Grove Day, A., *Eleanor Dark*, Twayne Publishers, Boston, 1976.

Hampton, Susan and Llewellyn, Kate (eds), *Australian Women Poets*, Penguin, Melbourne, Australia, 1986.

Harris, Margaret, 'Introduction' in 'Tasma', *Uncle Piper of Piper's Hill*, Pandora Press, London, 1988.

Hasluck, Alexandra (ed.), *Remembered With Affection: A New Edition of Lady*

Broome's 'Letters to Guy' with Notes and a Short Life by Alexandra Hasluck, Oxford University Press, Melbourne, 1963.

Haywood, Eliza (1751), *The History of Betsy Thoughtless*, Pandora Press, London, 1986.

Heney, Helen, *Dear Fanny: Women's Letters to and from New South Wales, 1788–1857*, Australian National University Press, Canberra, 1985.

Henning, Rachel, *The Letters of Rachel Henning*, Penguin, Melbourne, 1985.

Herman, Morton, 'Introduction' in *Annabella Boswell's Journal*, Angus & Robertson, Sydney, 1981, pp. v–xii.

Hughes, Joy N. (ed.), *The Journal and Letters of Elizabeth Macarthur, 1789–1798*, Elizabeth Farm Occasional Series, Granville, NSW, 1984.

'Iota' (Kathleen Caffyn), *A Yellow Aster*, Hutchinson, London, 1894.

Irvin, Eric, *Theatre Comes to Australia*, University of Queensland Press, Brisbane, 1971.

Jelinek, Estelle, *The Tradition of Women's Autobiography from Antiquity to the Present*, Twayne Publishers, Boston, 1986.

Keesing, Nancy, 'Battle of the Sexes – 2', Letter to the Editor, *Australian Book Review*, 10, 1971, p. 60.

King, Hazel, *Elizabeth Macarthur and Her World*, Sydney University Press, 1981.

Klein, Renate, D., 'The Dynamics of Women's Studies: An exploratory study of its international ideas and practices in higher education', Unpublished, *University of London* PhD thesis, 1986.

Kramer, Leonie (ed.), *Oxford History of Australian Literature*, Oxford University Press, Melbourne, 1981.

Kramer, Leonie and Mitchell, Adrian (eds), *Oxford Anthology of Australian Literature*, Oxford University Press, Melbourne, 1985.

Krimmer, Sally and Lawson, Alan (eds), *Barbara Baynton: Portable Australian Authors*, 'Introduction', pp. ix–xxxiii, University of Queensland Press, Brisbane, 1980.

Lacey, Candida Ann (ed.), 'Political Fiction', Special Issue, *Women's Studies International Forum*, volume 9, no. 4, 1986.

Lacey, Candida Ann, 'Striking fictions: women writers and the making of a proletarian realism' in *Women's Studies International Forum*, volume 9, no. 4, 1986, pp. 373–84.

Lacey, Candida Ann (ed.), *Barbara Leigh Smith Bodichon and the Langham Place Group*, Routledge & Kegan Paul, London, 1987.

Lawson, Elizabeth, 'Introduction' in *Gertrude the Emigrant: A Tale of Colonial Life* by An Australian Lady (Louisa Atkinson), Penguin, Australia.

Leakey, Caroline, *The Broad Arrow: Being Passages from the History of Maida Gwynnham, a Lifer* (by Oline Leese), Bentley, London, 1859.

Leakey, Emily, *Clear Shining Light: A Memoir of Caroline Leakey*, J. F. Shaw, London, 1882.

Lindsay, Norman, 'Foreword' in *The Letters of Rachel Henning*, Penguin, Melbourne, 1985, pp. v–ix.

Lloyd, Jessie ('Silverleaf'), *The Wheel of Life: a domestic story of bush experience in Australia*, George Robertson, Melbourne, Adelaide and Brisbane, 1880.

Macarthur, Elizabeth, *The Journal and Letters of Elizabeth Macarthur 1789–1798*

(introduced and transcribed by Joy N. Hughes), Elizabeth Farm Occasional Series, Granville, NSW, 1984.

Magarey, Susan, *Unbridling the Tongues of Women: a biography of Catherine Helen Spence*, Hale and Iremonger, Sydney, 1985.

Malos, Ellen, 'Some Major Themes in the Novels of Katharine Susannah Prichard' in *Australian Literary Studies*, vol I, no. 1, June 1963, pp. 32–41.

Martin, Catherine (1890), *An Australian Girl*, Pandora Press, London, forthcoming, 1988.

Martin, Catherine (1923), *The Incredible Journey*, Pandora Press, London, 1987.

Martin, Sue, Private correspondence, 1987.

Martineau, Harriet, *Society in America* (3 vols), Saunders & Otley, New York, 1837.

Martineau, Harriet, *How to Observe Morals and Manners*, Charles Knight, London, 1838.

'Massaray, Isabel' (Elizabeth P. Ramsay-Laye), *Our Cousins in Australia: Reminiscences of Sarah Norris*, William Nimmo, Edinburgh, 1867.

Mathew, Ray, *Miles Franklin*, Lansdowne Press, Melbourne, 1963.

McCrae, Georgiana (1934), *Georgiana's Journal: Melbourne 1841–1865* (Hugh McCrae, editor), William Brooks, Sydney, 1983.

McKay, Prue, 'Introduction' in Mary Grant Bruce, *The Peculiar Honeymoon and Other Writings*, McPhee Gribble, Melbourne, 1986.

McLaren, Ian F., *Mary Gaunt: A Cosmopolitan Australian: An Annotated Bibliography*, University of Melbourne Library, Parkville, Victoria, 1986.

Mead, Margaret, *Male and Female*, Gollancz, London 1950 (reprinted 1971, Penguin, Harmondsworth).

Meredith, Mrs Charles (Louisa Anne), *Notes and Sketches of New South Wales during a residence in that Colony from 1839 to 1844*, John Murray, London, 1844.

Meredith, Mrs Charles (Louisa Anne), *My Home in Tasmania, during a residence of nine years*, 2 vols, John Murray, London, 1852.

Miller, E. Morris, 'Australia's First Two Novels: Origins and Background' in *Tasmanian Historical Research Association Proceedings*, vol. VI, no. 2 September and no. 3 December 1957.

Modjeska, Drusilla, 'Women Who Changed the Course of the Novel', *National Times*, 13–18 March 1978, pp. 25–7.

Modjeska, Drusilla, *Exiles at Home: Australian Women Writers 1925–1945*, Angus & Robertson, Sydney, 1981.

Murray, Elizabeth A. (1864), *Ella Norman or A Woman's Perils* (Hurst and Blackett, London) reprinted Hill of Content Publishing, Melbourne, 1985.

Oliphant, Margaret, *The Autobiography and Letters of Mrs O.W. Oliphant* (ed. Mrs Harry Coghill), Blackwood, Edinburgh and London, 1899.

Ollif, Lorna, *Louisa Lawson: Henry Lawson's Crusading Mother*, Rigby, Adelaide, 1978.

Olsen, Tillie, *Silences*, Delacorte Press/Seymour Lawrence, New York, 1978.

Osborne, Dorothy, *Letters from Dorothy Osborne to William Temple*, ed. Edward Abbot Parry, J. M. Dent, London, n.d.

Palmer, Nettie, *Modern Australian Literature, 1900–1923*, Lothian Book Publishing Co., Melbourne/Sydney, 1924.

Palmer, Nettie, *Fourteen Years: Extracts from a Private Journal, 1925–1939*, Meanjin Press, Melbourne, 1948.

Palmer, Nettie, *Henry Handel Richardson: A Study*, Angus & Robertson, Sydney, 1950.

Palmer, Vance, 'Women and the Novel', *Bulletin*, 29 July 1926.

Parker, Catherine, Langloh, *Australian Legendary Tales, being the two collections, Australian Legendary Tales and More Australian Legendary Tales*, Bodley Head, London, 1978.

Perry, Ruth, *Women, Letters and the Novel*, AMS Press, London, 1980.

Poole, Joan E., 'The Broad Arrow: A Reappraisal', *Southerly*, no. 2, 1966, pp. 117–24.

Poole, Philippa (ed.), *The Diaries of Ethel Turner*, Lansdowne Press, Sydney, 1979.

Pownall, Eve (1959), *Australian Pioneer Women*, Currey O'Neil, Melbourne, Australia, 1980.

Praed, Rosa, *An Australian Heroine*, Chapman and Hall, London, 1880.

Praed, Rosa, *Policy and Passion* (another edition as *Longleat of Kooralbyn*, 1887) Bentley, London, 1881.

Praed, Rosa, *Nadine*, Chapman and Hall, London, 1882.

Praed, Rosa, *Australian Life: Black and White*, Chapman and Hall, London, 1885.

Praed, Rosa, *Miss Jacobsen's Chance*, Bentley, London, 1886.

Praed, Rosa, *The Bond of Wedlock* (Another edition, *Ariane*, Routledge, 1888); Chatto and Windus, London, 1887; reprinted, 1987, Pandora Press, London.

Praed, Rosa, *Outlaw and Lawmaker*, Chatto & Windus, London, 1893; reprinted 1988, Pandora Press, London.

Praed, Rosa, *Fugitive Anne*, J. Long, London, 1903.

Praed, Rosa, *My Australian Girlhood*, T. Fisher Unwin, London, 1904.

Praed, Rosa, *Lady Bridget in the Never-Never Land*, Hutchinson, London, 1915; reprinted 1987, Pandora Press, London.

Praed, Rosa, *Sister Sorrow*, Hutchinson, London, 1916.

Praed, Rosa, *Soul of Nyria*, Rider, London, 1931.

Prichard, Katharine Susannah, 'Some Perceptions and Aspirations', *Southerly*, no. 4, 1968.

Prichard, Katharine Susannah, *Straight Left* (Ric Throssell, ed.), Wild and Woolley, Sydney, 1982.

Rich, Adrienne, *On Lies, Secrets and Silence*, Virago, London, 1980.

Richardson, Henry Handel (1948), *Myself When Young*, Heinemann, Sydney and London, 1964.

Rivers, Georgia, 'Early Women Writers of Victoria', F. Fraser and Nettie Palmer (eds), *Centenary Gift Book*, Robertson and Mullins, Melbourne, 1934, pp. 93–4.

Robins, Elizabeth, *Votes for Women*, Mills and Boon, London, 1907; reprinted Dale Spender and Carole Hayman (eds), *How the Vote was Won and Other Suffragette Plays*, Methuen, London, 1985, pp. 35–88.

Roderick, Colin, *In Mortal Bondage: The strange life of Rosa Praed*, Angus & Robertson, Sydney, 1948.

Roderick, Colin, *Miles Franklin: her brilliant career*, Rigby, Adelaide, 1982.

Roe, Jill, '"The Scope of Women's Thought is Necessarily Less": The Case of Ada Cambridge', *Australian Literary Studies*, vol. 5, no. 4, 1972, pp. 388–403.

Roe, Jill, 'The Significant Silence of Miles Franklin's Middle Years' in *Meanjin* volume 39/no. 1, April 1980, pp. 48–59.

Roland, Betty, *Caviar for Breakfast: A Russian Diary*, Quartet Books, Melbourne, London, 1979.

Russ, Joanna, *How to Suppress Women's Writing*, The Women's Press, London, 1984.

Russell, Dora, *The Religion of the Machine Age*, Routledge & Kegan Paul, London, 1984.

Rutherford, Anna, 'The Wages of Sin: Caroline Leakey's *The Broad Arrow*' in Alastair Niven (ed.), *Commonwealth Writers Overseas*, Didier, Bruxelles, 1976, pp. 245–54.

Showalter, Elaine, *A Literature of Their Own: British Women Novelists from Bronte to Lessing*, Virago, London, 1978.

Showalter, Elaine, 'Women Who Write are Women', *The New York Times Book Review*, 1984, pp. 1, 31, 33.

Spence, Catherine Helen, 'A Week in the Future', in *Centennial Magazine*, 1889.

Spence, Catherine Helen, *An Autobiography*, W. K. Thomas, Adelaide, 1910.

Spence, Catherine, *Gathered In*, Sydney University Press, 1977 (first serialised in the *Observer*, 1881–1882).

Spence, Catherine Helen, *Handfasted*, Penguin, Melbourne, 1984.

Spence, Catherine Helen, *Catherine Helen Spence: Portable Australian Authors* (edited by Helen Thomson), Queensland University Press, Brisbane, 1987.

Spender, Dale, *Women of Ideas – And What Men Have Done to Them*, Routledge & Kegan Paul, London, 1982.

Spender, Dale, *Man Made Language* (2nd edn), Routledge & Kegan Paul, London, 1985.

Spender, Dale, *Mothers of the Novel: 100 good women writers before Jane Austen*, Pandora Press, London, 1986.

Spender, Dale and Hayman, Carole (eds), *How the Vote was Won and other Suffragette Plays*, Methuen, London, 1985.

Spender, Lynne, 'Ethel Turner' in unpublished essay.

Stratham, Pamela (ed.), *The Tanner Letters: A Pioneer Saga of Swan River and Tasmania 1831–1845*, University of Western Australia Press, Nedlands, W.A., 1981.

Strauss, Jennifer, 'The Poetry of Dobson, Harwood, Wright: "Within the Bounds of Feminine Sensibility?" ', *Meanjin* 38, 3, 1979, pp. 334–49.

Sutherland, James, *The Restoration Newspaper and its Development*, Cambridge University Press, 1986.

Swann, Margaret, 'Mrs Meredith and Mrs Atkinson: Writers and naturalists' in *Journal of the Royal Australian Historical Society*, vol. 15, 1929, pp. 1–29.

Tennant, Kylie (1935), *Tiburon*, Angus & Robertson, Sydney, 1981.

Tennant, Kylie (1943), *Ride on Stranger*, Angus & Robertson, Sydney, 1984.

Tennant, Kylie, *The Missing Heir: Autobiography*, Macmillan, Australia, 1986.

Thompson, Patricia, 'Introduction' in Ellen Clacy, *A Lady's Visit to the Gold Diggings 1852–1853*, Lansdowne Press, Melbourne, 1963, pp. 7–8.

Thomson, C. Hay, 'Women Writers of Australasia' in *Cassell's Magazine*, January 1909, pp. 188–94.

Thomson, Helen, 'Preface' and 'Afterword' in Catherine Helen Spence, *Handfasted*, Penguin, Melbourne Australia, 1984, pp. vii–ix, 363–78.

Thomson, Helen, '"The Madwoman in the Bush": A feminist diagnosis', Paper presented at *Association for the Study of Australian Literature*, Townsville, July 1986.

Thomson, Helen (ed.), *Catherine Helen Spence: Portable Australian Authors*, University of Queensland Press, Brisbane, 1987.

Throssell, Ric (1975), *Wildweeds and Windflowers: The Life and Letters of Katharine Susannah Prichard*, Angus & Robertson, Sydney, 1982.

Throssell, Ric (ed.), *Katharine Susannah Prichard: Straight Left*, Wild & Woolley, Sydney, 1982.

Turner, Ethel, *The Diaries of Ethel Turner* (compiled by Philippa Poole), Lansdowne Press, Sydney, 1979.

Viveash, Ellen, 'Sisterly Concerns' in Pamela Stratham (ed.), *The Tanner Letters*, University of Western Australia Press, Nedlands, W.A., 1981, pp. 69–124.

Walters, Anna, 'The Value of the Work of Elizabeth Gaskell for Study at Advanced Level', Unpublished MA dissertation, University of London Institute of Education, 1977.

Waters, B. L. and Wilkes, G. A., 'Introduction' in Catherine Helen Spence, *Gathered In*, Sydney University Press, Sydney, 1977, pp. v–xii.

Webby, Elizabeth, 'Introduction' in Catherine Martin, *An Australian Girl*, Pandora Press, London, 1988.

Webby, Elizabeth, 'Writers, Printers, Readers: The Production of Australian Literature to 1855' in Laurie Hergenham *et al* (eds), *A New Literary History of Australia*, Penguin, Melbourne, forthcoming.

Wilde, William H., Hooton, Joy and Andrews, Barry (eds), *Oxford Companion to Australian Literature*, Oxford University Press, Melbourne, 1985.

Wilde, W. H. and Inglis Moore, T. (eds), *Letters of Mary Gilmore*, Melbourne University Press, Melbourne, 1980.

Wilkes, G. A., 'The Novels of Katharine Susannah Prichard', *Southerly* no. 1, 1953.

Winstanley, Eliza, *Twenty Straws*, Bow Bells, John Dicks, London, 1864.

Woolf, Virgina (1929), 'Women and Fiction', *The Forum*, March: reprinted 1972 in Leonard Woolf (ed.) *Collected Essays: Virginia Woolf*, vol III, Chatto & Windus, London, 1972, pp. 193–9.

Woolf, Virginia (1928), *A Room of One's Own*, Penguin, Harmondsworth, Middlesex, 1974.

Woolf, Virginia (1938), *Three Guineas*, Chatto and Windus/Hogarth Press, London, 1984.

Wollstonecraft, Mary (1792), *Vindication of the Rights of Woman*, Penguin, Harmondsworth, Middlesex, 1978.

Index

Abandoned women, 93, 126, 191, 192
Abaroo (Booroo), 21, 22
Abdullah, Mena, 296
Aborigines, 60, 61, 85, 182, 183, 194, 195, 196, 197, 198, 243, 249, 267, 288, 289; childcare, 23; food, 32; women, 86
abuse, 4, 125–6, 159, 172–3, 203
Adams, Glenda, 296
Adam-Smith, Patsy, 291
Adey, Lucy, 66
Adolescent fiction, 212, 213, 220, 221, 222, 227, 228, 229, 270, 291
alcohol, 78, 89, 90, 94, 119–20
Allen, Mrs, 12
'Alpenstock', see Fullerton, Mary
Alpers, Mary Rose, 298
Anderson, Ethel, 250
Anderson, Jessica, 257, 286, 295
anxiety, 50, 55–6, 120–21, 169
Astley, Mr, 221
Astley, Thea, 235
Atkinson, Louise, 35, 267
Austen, Jane, 39, 46, 154, 181, 275
Australian language, 75, 76, 124
Australian Library and Museum, 75
autonomy, 71–72, 105, 128, 143–44, 170

Backhouse, Elizabeth, 294
Bandler, Faith, 295
Barahgurrie, 196
Barbalet, Margaret, 196

Barnard, Marjorie, 218, 219, 238, 239, 240, 261–65, 273, 274, 275, 276, 277, 278, 280, 282
Barnes, John, 174–5
Bates, Daisy, 61, 197
Baxter, Andrew, 82, 84
Baxter, Annie, 77, 82–9, 90, 91
Baynton, Barbara, 182, 190–93, 249, 250
Baynton, Dr Thomas, 191
Bedford, Jean, 295
Bedford, Ruth, 219
Beemumny, 196
Behn, Aphra, 98, 178, 180, 265
'Bennelong' incident, 20–24
Bennet, Stephanie, 294
Bensusan, Inez, 199, 201
Birkett, Winifred, 297
Birtles, Dora, 301
Bjelke-Petersen, Marie, 211, 212
Blake, William, 268
Bloom, Norma, 294
Bodichon, Barbara, 12
'Bohemienne', see O'Ferral, Nannie
Bolderwood, Ralph, 156, 201 ('Rolf Boldrewood')
Boswell, Anabella, 34–46, 66, 77, 85
Boult, Jenny, 294
Brand, Mona, 294
Brennan, Anne, 244
Brennan, Christopher, 221
'Brent of Bin-Bin', see Franklin, Miles
Brewer, Frank, 133

Pandora Press

AUSTRALIAN LITERARY HERITAGE

Already published:

A MARKED MAN

Ada Cambridge

Introduced by Debra Adelaide

First published in 1890, *A Marked Man* is considered to be the
finest novel in Ada Cambridge's distinguished writing career.
It concerns two generations of the Delavel family, risen from
unhappy beginnings to colonial prosperity. In the marriage of
Richard and Annie we find love destroyed through petty
materialism, and its complement in the near-adulterous
relationship between Richard and the gentle Constance. The
sober union of Richard and Annie's daughter Sue with the
radical Noel Rutledge is based on lessons learnt from the
mistakes of their elders.

It is a fine tale which explores with subtlety the tensions
between radicalism and convention in the context of late
nineteenth century England and Australia.

Price: £5.95 net

AN AUSTRALIAN GIRL

Catherine Martin

Introduced by Elizabeth Webby

When *An Australian Girl* first appeared in 1890, reviewers showed great interest in the heroine, Stella Courtland, who, like Jane Austen's Emma Woodhouse, is handsome, clever and rich, and careful of her relative independence. Throughout the novel Stella toys with the idea of marriage but her journey to maturity is more painful and realistic than Emma Woodhouse's experience.

Written with great skill and empathy, Catherine Martin's novel encompasses some of the fundamental problems that confronted the Australian heroine and tackles those throny issues of background, education and worth which were being reshuffled in the new society.

Price: £6.95 net

THE INCREDIBLE JOURNEY

Catherine Martin

Introduced by Margaret Allen

First published in 1923, *The Incredible Journey* tells the story of an Aborigine woman's search for her son after he has been abducted by a white man. An exploration of the situation of the Aboriginal people, their culture, their dispossession and, in particular, this abhorrent white practice of taking Aboriginal children away from their parents, Catherine Martin said that she wrote the novel 'to put on record, as faithfully as possible, the heroic love and devotion of a black woman when robbed of her child.'

Price: £4.95

OUTLAW AND LAWMAKER

Rosa Praed

Introduced by Dale Spender

How can traditional values be preserved when many a
respectable citizen could well be concealing a convict past?
How far are people to be trusted? How can a young woman,
like Elsie Valliant, be expected to make a decision about the
man she is to marry when so many of the conventional
guidelines no longer apply in the new land?

First published in 1893 and set in the early days of poltical
struggle, Rosa Praed's probing novel explores this intriguing
aspect of Australian life where the lawmaker could well have
been – and might still be – the lawbreaker. And in presenting a
love story in this violent country, where the benefits of
security must be weighed against the dangers of excitement
and passion, Rosa Praed has woven together elements of the
thriller and fundamental questions about heredity and
environment.

Price: £6.95 net

THE BOND OF WEDLOCK

Rosa Praed

Introduced by Lynne Spender

First published in 1887, *The Bond of Wedlock* is set in London. The story is a dramatic one – told with irony and wit. Adrianne, married to Harvey, a violent and coarse man, is successfully courted by Sir Leopold d'Acosta, to all intents a classic romantic hero. All is not as it seems, however, and Sir Leopold's machinations have tragic consequences for Adrianne. She and Babette, 'the other woman', ostensibly so different, are shown to have the same moral understanding of what a woman must do to be 'free' in nineteenth-century society. An extremely popular novel in the 1889s and 1890s, it was adapted as a play for the London stage.

Price: £4.95

LADY BRIDGET IN THE NEVER-NEVER LAND

A Story of Australian Life

Rosa Praed

Introduced by Pam Gilbert

Set in Queensland and told from the viewpoints of three different characters, this novel relates the story of their interwoven lives and adventures. Briget O'Hara, an impulsive and intelligent heroine, battles to build a positive and equal relationship with a man and in so doing challenges conventional sexual stereotypes in ways familiar to readers of women's fiction today. First published in 1915, *Lady Bridget in the Never-Never Land* shocked the Australian reading public by tackling controversial social issues, such as marriage, the rights of women, unionisation of labour and the treatment of blacks in colonial Australia.

Price: £4.95

UNCLE PIPER OF PIPER'S HILL

Tasma (*Jessie Couvreur*)

Introduced by Margaret Harris

First published in 1889, *Uncle Piper of Piper's Hill* is an Australian classic which challenges the conventional image of the country and its inhabitants. Uncle Piper is a self-made man who has made his fortune as a butcher. When he sends the fare to Australia to his poor but pretentious relations living in England, the drama begins. This is a gripping yarn that expertly evokes a range of characters who must come to terms with the values of the new land. *Uncle Piper of Piper's Hill* helped to link the old country with the new and to make a claim for the establishment of Australian literature.

Price: £5.95

COMING OUT FROM UNDER

Contemporary Australian Women Writers

Pam Gilbert

James Cook University, Australia

A readable and informed discussion of some of the most influential and challenging of Australia's writers, *Coming Out from Under* makes their contribution to a new Australian literary tradition better understood and appreciated. Each chapter looks at a contemporary woman writer and incorporates interviews which reveal how the writers feel about their own work. The writers discussed represent a range of styles and forms. An excellent introduction to the Australian literary scene, this is a lively literary study of major contemporary writers, their approach to writing and the public response to their work.

Pam Gilbert is a lecturer in Education at James Cook University, Townsville, Australia.

Price: £5.95

AUSTRALIAN WOMEN WRITERS
A Bibliographic/Guide

Debra Adelaide

Australian Women Writers lists over 450 Australian women writers, including fiction writers, poets, playwrights and non-fiction writers, from the earliest days of white settlement to the present day. It includes biographical details, complete listings of the authors' published works and selective lists of secondary (biographical and critical) material. No other such book on Australian literature has covered as many women writers. Arranged alphabetically for ease of reference and with an engaging introduction by the author, this is an essential bibliographic guide for every serious student, researcher or teacher of Australian literature.

Price: £5.95